Performing Folk Songs

Performing Folk Songs

Affect, Landscape and Repertoire

Elizabeth Bennett

BLOOMSBURY ACADEMIC
NEW YORK • LONDON • OXFORD • NEW DELHI • SYDNEY

BLOOMSBURY ACADEMIC
Bloomsbury Publishing Inc
1385 Broadway, New York, NY 10018, USA
50 Bedford Square, London, WC1B 3DP, UK
29 Earlsfort Terrace, Dublin 2, Ireland

BLOOMSBURY, BLOOMSBURY ACADEMIC and the Diana logo are trademarks of Bloomsbury Publishing Plc

First published in the United States of America 2024

Copyright © Elizabeth Bennett, 2024

For legal purposes the Acknowledgements on p. 266 constitute an extension of this copyright page.

Cover design: Louise Dugdale
Cover image: Steve Speller / Alamy Stock Photo

All rights reserved. No part of this publication may be reproduced or transmitted in any form or by any means, electronic or mechanical, including photocopying, recording, or any information storage or retrieval system, without prior permission in writing from the publishers.

Bloomsbury Publishing Inc does not have any control over, or responsibility for, any third-party websites referred to or in this book. All internet addresses given in this book were correct at the time of going to press. The author and publisher regret any inconvenience caused if addresses have changed or sites have ceased to exist, but can accept no responsibility for any such changes.

Whilst every effort has been made to locate copyright holders the publishers would be grateful to hear from any person(s) not here acknowledged.

A catalog record for this book is available from the Library of Congress.

ISBN: HB: 978-1-5013-9018-0
ePDF: 978-1-5013-9020-3
eBook: 978-1-5013-9019-7

Typeset by Deanta Global Publishing Services, Chennai, India

To find out more about our authors and books visit www.bloomsbury.com and sign up for our newsletters.

Author Biography

Elizabeth Bennett is a lecturer in Drama in the Literature, Film, and Theatre Studies Department at the University of Essex, UK. Her research interests include folk singing as an affective performance practice, applied and socially engaged theatre, and contemporary performance in relation to space, place, and landscape.

*In loving memory of my aunt Alison Le Mare, my uncle Steve Le Mare, my grannie Joy Preston, my grandfather Gerald Moore, and my friend Sandra Goddard.
And for our beloved dog Lily/Tufty, the best dog that ever walked on four paws.
All are missed on the path.*

Contents

List of songs	viii
List of figures	xi
Prelude	xiii
Introduction	1
Part 1 Theory and methodology	
1.1 Affect theory	23
1.2 Auto/sensory/ethnography	32
1.3 The Archive in performance	53
1.4 Landscaping	77
Part 2 Practice	
2.1 Footpaths	87
2.2 Women	114
2.3 Lines	141
2.4 Childhood	164
2.5 Legacies	188
2.6 Dorothy Marshall: A small story	212
2.7 Life-writing	223
Conclusion: Part 1: 2017	237
Conclusion: Part 2: 2022	243
Bibliography	249
Acknowledgements	266
Index	268

Songs

1. *Through Bushes and Through Briars* (Trad.)
 Performed by Catherine and Elizabeth Bennett
2. *Ha'naker Mill* (Hilaire Belloc)
 Performed by Bob Lewis
3. *Blackberry Fold* (Trad.)
 Performed by Bob Lewis
4. *A Farmer There Lived in the North Country* (Trad.)
 Performed by Elizabeth Bennett and friends
 Collected from Frank Hutt by Dorothy Marshall, 1911
5. *Lady Maisry* (Trad.)
 Performed by Elizabeth Bennett
 Collected from Thomas Bulbeck by George Gardiner and J. F. Guyer, 1909
6. *The Sheep Stealer* (Trad.)
 Performed by Diane Ruinet
7. *Barbara Ellen* (Trad.)
 Performed by Elizabeth Bennett
 Collected from Betsy Moseley by Dorothy Marshall and Clive Carey, 1912
8. *Cold Blows the Wind* (Trad.)
 Performed by Elizabeth Bennett
 Collected from Helen Boniface by George Gardiner and J. F. Guyer, 1909
9. *The Wife of Usher's Well* (Trad.)
 Performed by Gerald Moore
10. *Green Bushes* (Trad.)
 Performed by Elizabeth Bennett
 Collected from Stephen Spooner by Dorothy Marshall, 1911
11. *O Spread the Green Bushes* (Trad.)
 Performed by Bob Lewis
 From the singing of his mother and Edith Wright
12. *The Spotted Cow* (Trad.)
 Performed by Bob Lewis

13. *The Cruel Father and Affectionate Lovers* (Trad.)
 Performed by Elizabeth Bennett
 Tune collected from Mr Viney by Clive Carey, 1919
 Words collected from Walter Searle by Lucy Broadwood, 1901
 Tune performed was written by Nancy Kerr for the Full English Band
14. *The Seasons Round* (Trad.)
 Performed by Christine Skinner
 Collected from John Burberry by Lucy Broadwood, 1892
 With added words from The Coppers
15. *The Silvery Tide* (Trad.)
 Performed by Elizabeth Bennett
 Collected from John Searle by Lucy Broadwood, 1901
16. *Long Lankin* (Trad.)
 Performed by Catherine Bennett and Elizabeth Bennett
17. *Young Jockey Walked Out* (Trad.)
 Performed by Elizabeth Bennett
 Collected from Sarah Humphrey by Dorothy Marshall, 1912
18. *Orion the Hunter*
 Performed by Christine Skinner
 Written by Maria Cunningham
19. *The Ploughman Lad* (Trad.)
 Performed by Catherine Bennett
 Learnt from the singing of Roddie Cowie
20. *Bonny Light Horseman* (Trad.)
 Performed by Catherine Bennett
 Learnt from the singing of Eliza Carthy
21. *Searching for Lambs* (Trad.)
 Performed by Sandra Goddard
22. *Come Write Me Down* (Trad.)
 Performed by Brighton Vox Choir
 Learnt from the singing of The Coppers
23. *The Sussex Shepherdess*
 Written and Performed by Charlotte Oliver
24. *How Cold, How Cold, the Wind Do Blow* (Trad.)
 Performed by Elizabeth Bennett
 Collected from Jimmy Brown, Mrs Brown and
 George Parrot by Dorothy Marshall, 1911

25. *The Lark in the Morning*
 Performed by Elizabeth Bennett
 Collected from Lily Cook by Bob Copper 1945
26. *Pleasant and Delightful* (Trad.)
 Performed by Elizabeth Bennett and Friends
 Learnt from the singing of The Coppers
27. *Dear Father, Dear Father* (Trad.)
 Performed by Elizabeth Bennett
 Collected from Shelia Smith by Peter Kennedy in 1952
28. *Ground for the Floor* (Trad.)
 Performed by Will Duke
 Learnt from the singing of George Maynard
29. *Morning Has Broken* (Trad. Hymn.)
 Performed by Elizabeth Bennett
30. *The Shepherd's Token*
 Written and performed by Suzanne Higgins
31. *The Wraggle Taggle Gypsies* (Trad.)
 Performed by Elizabeth Bennett
 Learnt from the singing of Peggy Angus and Joy Preston
32. *A-Maying* (Trad.)
 Performed by Valmai Goodyear
 Collected from Samuel Willet by Lucy Broadwood, 1891

Figures

1	Bennett, E, 2008. *Letter from Grandma*	56
2	Moseley, Mrs, 1912. *Barbara Ellen* – Lyrics	57
3	Bradbury, H, 2015. *Liz and Dawn – 'Barbara Ellen'*	104
4	Bennett, E, 2015. *Graffam Woods*	119
5	*Herring Salesman, Heyshott*, 1902	125
6	*The Forestry Corps in Petworth, Sussex*	128
7	*Lucy Broadwood at home with James Campbell MacInnes*	139
8	Searle, J, 1901. *The Silvery Tide* – Lyrics	149
9	Moseley, Mrs, 1912. *The Silver Tide*	150
10	Ingold, T (2016). *A Braid of Lines*	159
11	Dixon, J, 2015. *Walking Towards Chanctonbury Ring*	163
12	Bennett, E, 2017. *New Year's Day*. Sarah Bennett, Elizabeth Bennett, and Sarah Wales	172
13	Bennett Family Collection, *c.* 1950s	173
14	Worthing Museum. *Michael Blann*	174
15	The Copper Family Collection, *c.* 1950s	186
16	Bennett Family Collection, 1992. *Firle Beacon*	197
17	Faulkner, M, 2015. *Firle Beacon*	197
18	Bennett, E, 2015. *View Back to Firle Beacon from Windover Hill*	204
19	Bennett Family Collection, *c.* 1880s. *Mary Martin Page*	211
20	Marshall, D, 1912. *Dorothy's song notebook reusing her brother's Maths notebook from school*	213
21	Marshall, D, 1912. *I Wish You Could See the Trees*	217
22	Bennett, E, 2016. *Chithurst House*	220
23	Bennett, E, 2016. *Dorothy Marshall's Grave Amongst the Trees*	222
24	Marshall, D, 1911. *Isn't My Left Handwriting getting quite expert?*	232
25	Preston, J, 1990. *Cath on the Downs with Liz*	242

To walk three miles, or four miles, or five miles, or whatever it is, above her ankles in dirt, and alone, quite alone! What could she mean by it? It seems to me to show an abominable sort of conceited independence, a most country-town indifference to decorum.

<div style="text-align: right;">Jane Austen, Pride and Prejudice</div>

You came, and look'd, and loved the view,
Long known and loved by me
Green Sussex fading into blue
With one grey glimpse of sea.

<div style="text-align: right;">Alfred Tennyson, The Charge of the Heavy Brigade</div>

Prelude

Towards the end of 2013, at the age of twenty-four, I began my PhD research, moved home to Sussex and was reeling from a misguided affair. Although none of these three things were directly related, in terms of cause and effect, they were nonetheless experienced relationally. It was an emotionally demanding period of my life. In the springtime of the following year, I took our dog Lily for a walk with my mum. I found it regressive to be single and back living at home, whilst my peers were moving in with partners, buying houses, and making wedding plans. However, it was a happy outcome that I was able to spend time with my mum, as she had experienced periods of serious ill health during the previous few years. When she had become very ill, and we were uncertain whether she would live, I was painfully aware that I did not have all the time in the world to learn her songs. Perhaps that day we were discussing how well she was, her delight at the thought of an unencumbered walk or perhaps my, still fragmented, heart and need for better romantic choices, but somehow the issue of song learning was raised:

> Mum: *Didn't you say when I was well again, you'd like to learn some of the songs I sing?*
>
> Me: *Yes, very much, I don't think I'm confident enough to sing in the clubs, but I like to learn some from you.*
>
> Mum: *What would you like to start with?*
>
> Me: *I know the 'Bonny Light Horseman' from you performing it, but that's very much your song, and snatches from you and Grandad singing together but nothing else.*
>
> Mum: *When you hear songs and then you start to sing fragments from them, are you interested in the tunes or the words?*
>
> Me: *The story, I think. Or rather what that story means to me if I identify with it.*
>
> Mum: *Have you ever heard me sing 'Through Bushes and Through Briars?'*
>
> Me: *No, maybe, I don't know – sing it for me . . .*

She sang the tune a few times for me to repeat, and then brought in the words. We sang the verses out as we walked up on Lancing Ring. The Ring is a part of the South Downs where lots of dog walkers go. It can feel mundane or dull on days where it simply fits into routine life. Yet, on a clear day, if you manage to align your gaze and the sun at the right time, the brilliance of the white cliffs of the Seven Sisters shines through the frame of the hills. That day we were twisting though the wooded area and maze of hedges, where I liked to play hide-and-seek with our golden retriever. I carried on singing it in my head on the way back to the car because mum said I was beginning to drive her mad (I have continued to annoy her ever since when learning a song; I'm a very slow, methodical learner, whilst she can catch a tune instantly). Once I got home, I surveyed her bookshelf for any printed versions she might have. I did not think something was missing, nor did I mistrust the words my mum had taught me; it was simply that I wanted to know as much as possible about the song. I found two new verses in Stephen Sedley's *The Seeds of Love* (1967), and took care to sing them casually next time I was cooking so that mum would ask me what they were, which she did. My mum is not one to gush about how proud she is, so I knew I had completed my apprenticeship when she told me she would not teach me any more songs if I was going to steal them and sing them in folk clubs.

A voracious appetite for any knowledge I can gain on a song has continued to grow since then. I have also realized that, even if I sang a song for a hundred years, and found every scrap of information about it, I would never find a definitive version: songs are formed and reformed in each performance. I have discovered that my inability to read music does not hinder me, and that many traditional singers learn by ear, which has resulted in a fascination with how singers learn songs. I no longer simply dismiss all folk songs as sexist (although some are), as I did when I was a teenager, nor bemoan that it is always some woman walking in the fields and crying. Now, I recognize grief as an affective state within these sung tales, and why it helps to walk when you are sad. Part of my journey in this research has been asking what has made me gravitate towards certain folk songs in my twenties (and later others in my thirties). This has encompassed inheritance, a sense of time running out, the emotional resonance of some of the songs speaking to me at times of loss and healing, a sense of 'coming home' to Sussex after a period away, making the landscape of the Downs appear in the vitality of the music and simply becoming a singer.

In the days and years since that walk with my mum, I have experienced the capacity of a folk song to penetrate your emotional core, the affective forces at play when

you walk and sing, and how that visceral quality endures. I recall constricting my body to fit through an arched hedge when I was first learning *Through Bushes and Through Briars*, and I have reencountered that every time I have subsequently sung it. I plundered my family's repertoire, consulted the archive and engaged my body in the landscape. That day is where my research began, although it will turn around at moments and draw on incidents, songs, and lives from further reaches of time. That day I learnt a song, a song that sent me in search of more:

1. *Through Bushes and Through Briars*

Through bushes and through briars,
I lately took my way
All for to hear the small birds sing
And the lambs to skip and play.

I overheard my own true love,
His voice it rang so clear
Long time I have been waiting for
The coming of my dear.

Sometimes I am uneasy
And troubled in my mind
Sometimes I think I'll go to my love
And tell to him my mind.
But if I should go to my love,
What would my love say then?
It would show to him my boldness,
And he'd ne'r love me again.

Once upon a time I had
Colour like a rose
But now I am as pale
As the lily that grows.
Like a flower in the garden
My beauty is a-gone
Don't you see what I am come to
By the loving of a man?

So all ye pretty fair maids,
A-warning take by me
And never build your nest

At the top of any tree.
For the green leaves they will wither
And the roots they will decay
And the beauty of a false young man
Shall all soon fade away.

And the beauty of a false young man
Shall all soon fade away.

(Sedley, 1967)

Introduction

In prelude, I began with an autoethnographic account of a walk and a song that inspired the project, the resonance of folk songs in my life, and the desire to write scholarship on folk songs. In the introduction, I set out some of the aims of my research, contextualize it within the broader resurgence of folk traditions in Britain, and begin continuing conversations on diversity and folk music. In this book, I explore (mainly) English folk singing from the perspective of performance studies. I analyse folk singing as an affective performance practice through learning songs from the Full English Digital Archive, performing them in context whilst walking along the South Downs Way and interviewing other folk singers about songs that they associated with the Downs. Using archival sources, family repertoires, interviews, and performance, I argue that archives and repertoires are produced in sensory environments through embodied encounters. Autoethnography, sensory ethnography, life-writing, and landscape writing are used to explore unaccompanied folk singing and the affective and emotional aspects of learning songs *by heart*.

It is beyond the scope of this work to provide a full exploration of the term 'folk' and its histories and debates, but it is important to state that, for the purpose of this book, any song that my participants identified as a folk song was welcomed as a folk song, taking inspiration from Winter and Keegan-Phipps, who argue in *Performing Englishness: Identity and Politics in a Contemporary Folk Resurgence* that 'folk music is a cultural construct undergoing constant discursive renegotiation by the participants of that culture [. . .] folk is whatever those who identify [. . .] with it proclaim it to be' (Winter and Keegan-Phipps 2013: p. 8). As I will explore further, if we are going to widen participation to the folk song, new and composed songs from any genre need to be accepted to allow for, and actively seek, new voices in the folk scene. Similar sentiments were addressed in a recent Guardian interview with folk singer and English Folk Dance and Song Society (EFDSS) president Eliza Carthy, who stated 'I object to the Brit-centric definition of folk [. . .] which is very white and safe and fixated with acoustic instruments [. . .] I define folk as whatever you can sing in a pub – and for people to be able to join in and be as shit as you like' (Carthy 2022).

My own singing practice, and that of most of the participants in my research, takes places mostly in community settings such as folk clubs, rather than the professional folk music scene. Although there are often crossovers between these two areas, with singers often being part of both scenes, there is no hard and fast separation. Moreover, as Winter and Keegan-Phipps assert, both the 'folk industry' and the 'culture of participation' have been enjoying a period of growth (Winter and Keegan-Phipps 2013: p. 1). In this book, I contribute to discourse on contemporary English folk singing and broader scholarship on what Winter and Keegan-Phipps term the 'third folk song resurgence' (Winter and Keegan-Phipps 2013: p. 2). As such, it is first useful to briefly give an overview of the first and second folk song revivals, and how they intersect with my research. Second, I explore some of the aspects of the third folk song revival and the rationale for placing my work within this area.

Many of the songs featured in this book were collected during the first folk song revival, and prominent collectors from the time such as Lucy Broadwood are also discussed. In order to be aware of, and attempt to avoid, any exclusionary and/or nationalistic connotations of folk music, it is useful to consider some of the culturally nationalist, class-based, and romanticized aspects of the first folk song revival, and how understanding of them allows contemporary folk scholars and performers to be wary of similar patterns, assumptions or practices. Additionally, as this book in the main deals with mostly songs collected in Sussex, and therefore England – although for many this will have been one stop along the route – it is useful to explore the formation of the Full English Digital Archive from which many of the archival sources in this project are from.

The first folk song revival took place approximately between the 1870s and the 1920s. The starting point is often given as 1898, when the Folk Song Society was formed; however, there had been a growing interest and number of publications on the subject during the 1840/50s, such as John Broadwood's *Old English Songs* (1847), which was published for private circulation (Roud 2017: p. 70). Highlighting the wave of activity that took place before the turn of the century, Steve Roud states in *Folk Song in England* that:

> Between the years 1870 and about 1900, various individuals in England began to notice that certain people, mostly elderly members of the rural labouring classes, had repertoires of songs and styles of singing which seemed to operate under different rules, values and standards than either [classical] or commercial popular music of the day. These individuals called them folk songs, and [. . .]

motivated a campaign collect them and make the known to both the musical establishment and the general public. They quickly became convinced that these tunes were (a) musically very interesting and worthy of preservation; (b) very important because they reflected the very essence of the national musical soul; and (c) fast dying out under the onslaught of such factors universal education, urbanisation and commercial popular music.

(Roud 2017: pp. 5–6)

Thus, the revival was heavily influenced by the idea of folk song as 'a constructed vehicle of European romanticist during this period: a "pure" or "authentic" musical expression of a nation's people that could be harnessed to bolster nationalist sentiment in the face of growing cosmopolitanism and crisis of national identity' (Winter and Keegan-Phipps 2013: p. 5). Cecil Sharp, as a prominent collector and the popular figurehead of the first folk song revival, also perpetuated certain myths and tropes about the rural labouring classes, who were most of the singers collected from at the time. This included the idea that the 'folk' were 'the unlettered, whose faculties ha[d] undergone no formal training, and who ha[d] never been brought into close enough contact with educated persons to be influenced by them' (Sharp 1907: p. 4). However, as Winter and Keegan-Phipps argue, this romanticized notion of the 'folk' was 'a whimsical idea that was both symptomatic and a perpetuating construct of the essentialising nationalism to which he and his followers subscribed' and that by the end of the nineteenth century, 'literacy in England was steadily increasing, the church impacted upon the lives (and musical lives) of the vast majority, and the music hall was a ubiquitous phenomenon' (Winter and Keegan-Phipps 2013: p. 6).

Through a highly selective and narrow definition of what constituted a folk song, omitting a wide range of material such as music hall songs that did not fit their notion of what the 'folk' were singing, the collectors of the first folk song revival also [mostly] failed to document 'the whole range of songs sung by "working people" or consider 'the social context of the singing, or the lives or opinions of the singers' (Roud 2017: p. 7). Additionally, the songs were then transposed to completely different contexts, arranged 'for piano, performed in middle-class homes and on the professional concert platform' (Roud 2017: p. 6). I do not take the position of the Marxist scholarship of the 1980s, such as David Harker's *Fakesong: The Manufacture of British 'Folksong' from 1700 to the Present Day* (1985), that folk song as Roud summarizes 'never existed as a definable category of vernacular culture, but was a construct of the middle classes created

for their own purposes, and commercial gain' (Roud 2017: p. 8). Rather, I follow Vic Gammon in his assertion that:

> In the process of making their collections, these enthusiasts left us with some vital historical evidence on their views on rural popular music, activity, attitudes, and values. To use this music, we need to be aware of the conditions in which it was produced, the limitations and distortions.
>
> (Gammon 1980: p. 65)

Thus, contemporary collectors, enthusiasts, and researchers may be aware of their own limitations, attitudes, values, and seek to explore both contexts and conditions.

As the songs collected within this research are associated with Sussex, they are mostly, but not all, from the English tradition. It is important to state at the outset that I consider these songs as having been collected from Sussex, rather than songs that are intrinsically from Sussex; my interest is therefore where folk songs have *been*, and might *go*, rather than where they are notionally *from*. Songs have always been mobile, travelling with people wherever they go. However, there are distinct Welsh, Irish, and Scottish folk song traditions that it isn't possible to do justice to in this volume and therefore are not covered. Nonetheless, the English tradition shares rich ground with broader British and Transatlantic folk traditions, and songs in this book have been collected across Britain and into Ireland, as well as the United States.

My main source of songs for this research is the Full English Digital Archive, a groundbreaking project and database run by the Vaughan Williams Memorial Library housed at Cecil Sharp House. Launched in 2014, the Full English is the world's largest free digital archive of English traditional folk music and contains 'a variety of material ranging from full songs to fragments of melodies [. . .] it is rich in social, family and local history, and provides a snapshot of England's cultural heritage through voices rarely published and heard before' (EFDSS 2022). Although I would argue that it contains *one aspect* of England's cultural heritage, the scale and volume of material – 80,000 pages of traditional songs, dances, tunes, and customs – is groundbreaking and made my research for the project possible in a way that previously would have been considerably more arduous. Not least, as I was often immobilized by pain, it meant not travelling to their base in Camden or to other regional libraries to conduct archival research. The need to digitize archives continues to be an important factor in increasing access, to folk or any other archives for a wide range of people. Whilst the Full

English Digital Archive draws mostly from the first folk song revival, it also features collectors and collections from the second folk song revival.

The peak of the second folk song revival is broadly considered to have taken place between the late 1940s and the 1970s. Julia Mitchell in *Post War Politics, Society and the Folk Revival in England, 1945–65* states that 'the postwar English folk revival significantly occurred in the context of the nation's deindustrialization, and exposed tensions between, on the one hand, a nostalgic lament for a fast-disappearing working-class life, and a "forward-looking" socialist vision of working-class culture' (Mitchell 2020: p. ix). The English revival also took place alongside, was influenced by, and influenced, the revival in America: 'although they were in many ways distinct cultural movements, both developed as part of a unique transnational cultural exchange with the other' (Mitchell 2020: p. 2). On both sides of the Atlantic, there was also a 'new wave of collecting [. . .] with the benefit of the portable tape recorder', adding a great deal of new material to folk song collections, such as Bob Copper's recordings for the BBC (Roud 2017: p. 7). Some of the earlier notions of nationality and class from the first folk song revival – such as 'patronizing and romanticized portrayals of working people' – were also problematized or at least distanced from those taking part in the second folk revival, who were, as Mitchell identifies, 'singers from a variety of social backgrounds, incorporating a wide range of musical and cultural influences, elucidating a complex interaction of class and class consciousness during England's post-industrial "age of affluence"' (Mitchell 2020: p. 2).

The socialist context of post-war Britain also influenced the 'authenticity of an egalitarian performance context' (Winter and Keegan-Phipps 2013: p. 7), with most folk clubs and societies taking place in broadly working-class settings 'often located in the back or upstairs rooms of a local pub' (Mitchell 2020: p. 18) and encouraged 'participation from all attendees, performance opportunities for a new generation of solo artists, and run by committee' (Winter and Phipps 2013: p. 7). As my mum explores in our interview, she began singing at the Stanford Arms Folk Club and at the Springfield Arms, both in Brighton, and we both continue to sing in the Lewes Folk Club upstairs at the Elephant and Castle. It is beyond the scope of this book to provide a comprehensive overview of the history of folk clubs; however, it is necessary to highlight the vital role of folk clubs and session in both the second revival and in the continuing contemporary scene. Additionally, it is through the context of folk clubs that 'traditional' British folk music began to be recognized as sung amongst other styles of music, in particular the American folk and blues movement (Winter and Phipps 201: p. 7).

Many of the people that I interviewed and sang with in this research are broadly referred to as 'revivalists', having become involved in folk music during the second revival and through folk clubs. Conversely, those who are considered to have come through the broadly speaking oral tradition route and learnt folk songs at home or work prior to the revival are referred to as traditional singers. There is no official term for singers and musicians who have become involved in folk music since although those whose parents were involved in the second folk songs revival are sometimes colloquially referred to as 'children of revivalists'. However, these limited terms are only used briefly here to orientate the reader; folk music and folk adjacent music are something that people arrive at in all sorts of different ways.

Keegan-Phipps and Winter outline the 'third folk song resurgence' to describe the growth in popularity of folk practices in England and wider UK. They use the term resurgence to distinguish this from the previous two revivals, in part due to the resurgence not being concerned with 'rescuing' a dying tradition, its engagement with 'mainstream culture', 'diversification of stylistic approaches' and a lack of direct political statements or affiliations by its practitioners (Winter and Keegan-Phipps 2013: p. 10). However, as Winter and Keegan-Phipps argue, this does not mean the resurgence has no 'political meaning and implications', and it is important to note that it has taken place alongside 'a rise of interest in and concern for English national and cultural identity' (Winter and Keegan-Phipps 2013: p. 11) if not expressed in a nationalistic or exclusionary manner. Similarly, as I argue elsewhere, the whiteness of the folk scene is important to acknowledge, and diversity will be key to address in projects that seek to preserve or promote folk traditions in a modern, multicultural England/Britain.

Examples of this resurgence include Mark Radcliff's BBC Radio 2 Folk Show, the Radio 2 Folk Awards, the ever-growing popularity of folk festivals (Cambridge, Whitby, Sidmouth, etc.), contemporary urban folk clubs such as the Nest Collective and bands such as the Imagined Village. Additionally, in the last decade, there has been Sam Lee's touring performance Singing with Nightingales (often produced as part of large-scale cultural events such as Brighton Festival), the Folk on Foot podcast, which was launched by Matthew Bannister in August 2018 and The Full English Band, who recorded and toured an album in 2013 based on material from the newly launched Full English Digital Archive. In addition, numerous TV and radio programmes have been produced in the last few years including Radio 3's *Folk Connections* special from Cecil Sharp House in 2016, Radio 4's *The Folk of the Pennines* in 2015, Radio 4's *The Song Hunters* in 2009 and Radio 3's *The Essay, Folk at Home* in 2020 to name a few.

Performing Englishness provides a comprehensive overview of many of the events and artists mentioned above, and whilst it is not within the remit of this book to duplicate or expand upon their overview, it is important to highlight that the third folk song resurgence continues to grow and that it has set the backdrop for my research. Furthermore, within many of these examples, there are aspects of the key research areas of this book, such as walking, landscape, gender, archives, repertoires, and where English folk music sits in a modern multicultural England/Britain. Thus, it is my hope that some of the research in this book may illuminate such aspects and provide potential avenues for viewing contemporary folk singing practices through performance studies and the affective presence of the performative moment.

In my original research for my PhD, I made implicit arguments that viewing folk song from the performative present might make folk singing a more inclusive space. However, when reviewing my research for this book, I realized I needed to make these arguments more explicit. As such, I would like to first begin with why there is still a need for greater focus on diversity and inclusivity in the folk, some of the key work taking place in this field and my desire to consider this through an intersectional lens.

First, the why. I hear a fair amount in folk clubs about how anyone is welcome and how they would never intentionally exclude people. I can attest that from the very start of singing in folk clubs, I have always felt extremely welcome and seen others made to feel this way. I am also white, middle class, and the daughter of an established folk singer. However, I have also observed conversations, attitudes, and performances that work to exclude. Folk clubs take place in rooms of pubs, but there are also singarounds that take place in corners of pubs, and a number of folk events around the country that take place on the streets of villages, towns, and cities. As such, many of these events are witnessed by people outside of the performance or the immediate folk community. I have on occasion heard outdated, racist language in folk songs be defended on the grounds of 'tradition', and similarly heard arguments that Morris dancers stopping using black face is 'woke' which has 'has taken things too far'. Let me state loud and clearly – these do not create an inclusive space. It is important to remember that it was only in *2005* that the previously called 'Darkie Day' in Padstow was renamed 'Mummer's Day' and that this *still* involves elements of black-facing found in broader historical folk performance that are likely to have come 'directly from the blackface minstrel traditions' (Roud 2017: p. 367).

Additionally, I have also seen in initiatives to teach or share traditional English folk music, a tendency to talk about 'our' cultural heritage or to teach children about 'their' cultural heritage. In the multicultural society in which we live, this will not do. It is not acceptable to make assumptions about whether people will identify traditional English folk music as their heritage or their culture. English folk music is *one aspect* of cultural heritage amongst many in modern society, and we need to be careful about our language. Similarly, when I sing a song about sexual assault, I lead with a content warning. This is informed by my teaching practice in Higher Education where content warnings are given for potentially distressing and sensitive content as verbal or written 'notices to students that class material may evoke their past traumas' (Fenner 2018: p. 86.). This allows anyone in the immediate or wider audience for whom sexual assault may be traumatic or distressing to be informed and prepared ahead of a performance and to decide whether or not they would like to continue to engage with that content.

As Fay Hield outlines in her paper *Negotiating Participation at an English Folk Singing Session*, despite folk clubs and session often being explicitly participatory and taking place in venues such as pubs, or other public spaces 'further advocating the premise that all are welcome', there remain barriers to participation that we need to recognize, as Hield summarizes 'the underlying ideology of the English folk scene as being open and all-embracing belies a complex array of performance practices' (Hield 2013: p. 99). Additionally, as Hield highlights, people are unlikely to stumble across folk sessions and join in but are more likely to be introduced by a friend, and 'this mode of communication through existing relationships [. . .] can cause barriers for those with no previous contact' (Hield 2013: p. 106). Arguably, such introductions from friends to friends, and a need to understand aspects of the performance practice, contribute to a lack of diversity and inclusivity. Whilst it is beyond the scope of this book to comprehensively consider and analyse the multiple different factors of diversity, folk music, and participation, I hope that by asking questions, making whiteness visible, and providing a framework that focuses on the affective present of folk singing, this book resonates with a wider set of growing scholarship considering these issues. In particular, Fay Hield's new project Access Folk aims to 'explore ways to increase and diversify participation in English folk singing' (Access Folk 2022).

For the reasons stated above, it is further important to consider the research included within this book through the lens of intersectional feminism. Here, I set out some of the areas of intersectionality that my research contributes

to, and outline others where there remains work to do. Between 2013, when I started my PhD, and 2022, as I write this research into a monograph, I have learnt a lot about intersectionality (and still have a lot to learn). There are certain things that I would have done differently were I to design this project now. It is, therefore, useful to highlight some of these areas here to inform this and further research.

It is widely stated that Kimberlé Crenshaw 'coined' the term intersectionality, in her Stanford Law Review article *Mapping the Margins: Intersectionality, Identity Politics, and Violence against Women of Color* (Crenshaw 1991). However, Patricia Hill Collins and Silma Bilge caution in their volume *Intersectionality* that such a reading obscures the foundational work already undertaken by scholars in critical race theory before this point:

> Across numerous journal articles, one sees the same language of 'coining' repeated verbatim. These practices not only routinely neglect the writings and activities of many people who came before Crenshaw, but they also misread the full extent of Crenshaw's arguments. They also ignore her subsequent work, which has advanced intersectionality as a form of critical inquiry and praxis.
> (Hill Collins and Bilge 2000: p. 93)

As Collins and Bilge assert, intersectionality is generally applied as analytical tool that 'views categories of race, class, gender, sexuality, class, nation, ability, ethnicity, and age – among others – as interrelated and mutually shaping one another' and that

> in a given society at a given time, power relations of race, class, and gender, for example, are not discrete and mutually exclusive entities, but rather build on each other and work together; and that, while often invisible, these intersecting power relations affect all aspects of the social world.
> (Hill Collins and Bilge 2000: p. 1)

In this book, I use this broader application, whilst also recognizing the foundation of intersectional theory in black feminist scholarship and 'intersectionality as a social justice construct, not as a theory of truth disconnected from social justice concerns' (Hill Collins and Bilge 2000: p. 93). As such, the intersectionality in this book is inevitably partial and flawed but constitutes what I hope will be the beginnings of a conversation about intersectional concerns in English folk music, echoing Sara Ahmed's words in *Living a Feminist Life* that 'intersectionality is a starting point, the point from which we must proceed if we are to offer an account of how power works' (Ahmed 2017: p. 5).

The four main categories I consider in depth in this research are gender, class, disability (in relation to chronic illness), and race. It was never my explicit intention to write a feminist PhD, although given my politics outside of the research, it was somewhat inevitable. As I will explore in further detail in Part 2, the presence and absence of women became a preoccupation of the work and autoethnography was a methodology that allowed me to account for that. This preoccupation has led to me designing and co-organizing (with Sussex Traditions, EFDSS, and the University of Sussex) the first ever conference on women in folk traditions, *Women in 'the Folk'* (2018). Since that conference, there have been numerous events that have contributed to a growing interest in the role of women in folk traditions, including *Trad. Reclaimed: Women in Folk Music*, a music-based series in 2019 at Kings Place, London; a *Women and Tradition Music* research symposium at NUI Galway in 2019 and a BBC Radio 4 Woman's Hour special on *Women and Folk* music in 2022. Furthermore, there has been some vital work undertaken by Esperance Folk on folk music and gender equality. Esperance was founded in 2020 by Nicola Beazley, Rosie Hood, Sarah Jones, and Emily Portman, following 'several disclosures and reports of sexual violence by men in the folk and traditional music work in the UK and Ireland' (Esperance 2020). Designed as a grassroots collective, which offers space and resources for discussing and addressing issue of gender equality in both the amateur and professional folk scene, they aim to

> increase awareness and understanding of gender-related barriers, support people who experience gender-based discrimination, and facilitate conversations that lead to positive change [. . .] in order to create a safer, more inclusive community and an equal, sustainable future for the folk scene in England.
>
> (Esperance 2020)

In terms of intersectionality in the research that informs this monograph, it is important to state that all the women I interviewed for this research were white – including myself – and to my knowledge, all of the archival songs came from white women. As mentioned, if I were designing this project again, I would do this differently, explicitly seeking participants of colour (and not relying on a public call-out), and explicitly stating that I was interested in folk songs from any culture. However, it is important to clearly state the whiteness of this research, countering the 'invisibility of whiteness' (Dyer in Rothenberg 2005: p. 11). By noticing whiteness, I also hope to engage with Ahmed's work on the

'Phenomenology of Whiteness' (2007), and how 'whiteness becomes worldly through the noticeability of the arrival of some bodies more than others' (Ahmed 2007: p. 149). It is not enough to say that folk clubs routinely state that anyone is welcome; we need to spend more time attending to the experiences of people of colour entering 'a sea of whiteness', experiences that those who already feel 'in place' at folk clubs cannot anticipate (Ahmed 2007: pp. 155, 157). Additionally, the term woman is used as an inclusive term throughout the research to include, as Ahmed so perfectly articulates, 'any and all who travel under that sign' (Ahmed 2017: p. 5). The research in the main deals with cis-women (as far as I know), but is not only for or about them.

At the time of undertaking and writing the initial research for my thesis, I had been suffering for many years with endometriosis, and latterly adenomyosis. This led to a six-month break towards the end of the PhD to have a partial hysterectomy, removing my uterus and cervix. Consequently, I had chronic pain that regularly incapacitated me. Again, this was not the explicit focus of my research, but my ill body is part of my autoethnographic explorations and led me to consider the embodied lives and disabilities of both my participants and archival subjects. It is important to state that endometriosis is not automatically registered as a disability, with 'decisions made on individual circumstances as to whether a person meets the criteria for a disability' (Endometriosis UK 2022), and mine was never officially registered as such. However, campaigners continue to call for endometriosis to be automatically considered a disability and placed under the Equality Act. It is also my hope that providing some of my narrative of pain, I can contribute to Sara E. Green and Donileen R. Loseke's call in *New Narratives of Disability: Constructions, Clashes, and Controversies* 'for richer, more diverse understandings of disability [. . .] how narrative inquiry can broaden perspectives in disability to include pain, suffering, and chronic illness' (Green and Loseke 2020: n.p.).

Class was not a topic of the interviews, but I would say that my conversational partners broadly came from both the working and middle classes, and it was important that I was clear about being middle class as an autoethnographer. Class comes into the foreground more in my exploration of the encounters between the collectors and singers in the first folk song revival. However, were I to redesign this project, it would be discussed explicitly with my conversational partners and reflected upon further.

Diversity in English folk music is currently being engaged with by a number of projects. In 2022, the aforementioned Imagined Village band reunited for two

gigs at FolkEast and Beautiful Days festivals. The folk-fusion band's original aims were to 'match English traditional songs against the sounds of contemporary multi-cultural England, with influences from Asia, the Caribbean and elsewhere' (Folk East 2022). In 2021, the EFDSS held a conference *Diversity in Folk*, with papers that discussed 'any aspect of folk music or dance and the issue of racial and ethnic diversity, both historically focused and in contemporary discourse' (EFDSS 2021). Although this was a much-needed start, it was remarked upon during the day that the majority of the presenters were white or white presenting. This is also observable at many folk clubs up and down the country, as expressed by singer and academic Angeline Morrison in her recent interview in *The Guardian* that she can 'can count on one hand the amount of times I've been in a folk club with other people of colour' (Morrison 2022a). At the *Diversity in Folk* conference, Morrison introduced her new project and forthcoming album *The Sorrow Songs: Folk Songs of Black British Experience*, in which she explores how

> the traditional songs of the UK are rich with storytelling, and you can find songs with examples of almost any kind of situation or person you can think of. But whilst people of the African diaspora have been present in these islands since at least Roman times, their histories are little known – and these histories don't tend to appear in the folk songs of these islands.
>
> (Morrison 2022b)

Thus, Morrison began to research these neglected histories and compose folk songs that honoured them.

Also presenting at the conference was Fay Hield's aforementioned UKRI funded five-year project, Access Folk. The project aims to explore ways to increase and diversify participation in English folk singing and 'will trial and evaluate new approaches in collaboration with the wider folk singing scene' with the intention that the project is 'built on co-production principles where the people affected have real power to direct the research' (Access Folk 2022). The three initial aims identified by Access Folk are as follows: 'What is the place of folk singing in contemporary England? How do people want to engage with English cultural traditions through song? [and] How can we facilitate participation in folk singing in England?' (Access Folk 2022).

Another project that suggests exciting and inclusive new avenues for folk music include Sophie Crawford and George Samsom's *Queer Folk*, which was 'created to amplify the voices of LGBTQIA+ performers, foster collaborations, and encourage the building of LGBTQIA+ community within the folk, roots, and

traditional music scene' (Queer Folk 2021). I have found their work highlighting queer narratives within traditional music particularly instructive, and have also reflected and sought to disrupt – as a result of George Samsom's presentation at the Access Folk symposium 2023 – the assumption of a heterosexual norm in places that this is not stated and to identify where I can sing queer narratives and perspectives. The 'queering' of folk performance also opens up further possibilities for an intersectional approach to folk song research and scholarship, as well as performance.

In terms of this research project, it was always my intention that by placing the folk song in the performative present, this approach would provide more scope for diversity and to make my research applicable to, or at least in conversation with, other folk traditions, cultures, and bodies. Similarly, I made the decision that I would not be purist about what constitutes a folk song, accepting traditional songs alongside composed songs and any others that the participant themselves identified as a folk song that they associated with Sussex. Stories of people in the margins of a tradition – or society – are often found in songs that are written in the folk style, and songs that help us to reimagine the tradition. Furthermore, I strongly believe that a hierarchy of folk song classification does not make the stories we tell inclusive, and risks repeating the mistakes of the first folk song revival collectors in their partial collections of material. However, in retrospect, I could have done more to engage with wider communities and traditions in Sussex. When I came to design the Women in the Folk conference, I applied some of this learning. The conference was made explicitly international and open to people beyond the academy, transcending the heterogeneity of academia and traditional folk music. Aspects of this were successful but now I would move beyond simply an open call for papers, and actively seek diversity in our invited speakers and performers. The move to inclusivity and diversity in folk traditions is a process, and this book joins part of this process, but there is much more work to be done both in my own research and in the wider folk scene.

Intersectional concerns are important to consider alongside the growing focus on intangible cultural heritage in organizations such as UNESCO, the EU, and other heritage organizations and funders. The 2003 Convention for the Safeguarding of the Intangible Cultural Heritage identifies cultural heritage as

> The practices, representations, expressions, knowledge, skills – as well as the instruments, objects, artefacts and cultural spaces associated therewith – that communities, groups and, in some cases, individuals recognize as part of their cultural heritage. This intangible cultural heritage, transmitted from generation

to generation, is constantly recreated by communities and groups in response to their environment, their interaction with nature and their history, and provides them with a sense of identity and continuity, thus promoting respect for cultural diversity and human creativity.

Although England is not a signed party to this convention it is worth considering some of the questions that would emerge as part of such an endeavour were we to. For example, as we know, the late Victorian and Edwardian collectors, as well as editing aspects of the words of the songs, also collected largely from men, leaving a neglected female collection (as I explore further in Part 2). It leads to questions of which versions of songs we would seek to include and whether efforts would be made to find some of the marginal figures that are still eclipsed in major collections, following projects such as the AWARE: Archives of Women Artists, Research and Exhibitions, which was co-founded in 2014, and directed by Camille Morineau, curator and art historian, specializing in women artists. The primary ambition of AWARE 'is to rewrite the history of art on an equal footing. Placing women on the same level as their male counterparts and making their works known is long overdue' (AWARE 2022), and the website hosts a database which 'brings together women artists born between 1790 and 1972 working in visual arts, with no limitations on medium or country' (AWARE 2022). Aspects of my research into Dorothy Marshall and the singers she collected from suggest that a project which explores women in the folk archives – both nationally and internationally – is urgent. Additionally, there is the question of whether the work of scholars and artists like Angeline Morrison, who are reclaiming and reviving the tradition to include stories of black British experience, would be protected by the convention.

Tensions between traditional performance, archival research, and contemporary revisions are prominent in these efforts to preserve intangible cultural heritage in the form of 'living expressions inherited from our ancestors and passed on to our descendants, such as oral traditions, performing arts, social practices, rituals, arts, festive events, knowledge' (UNESCO 2002). Use of the term *our* is problematic, as Thomaidis and Magnat states in 'Voicing Belonging: Traditional Singing in a Globalized World', 'current debates on cultural diversity demonstrate that rethinking regional, national, transnational and global notions of cultural identity is becoming increasingly urgent' (Thomaidis and Magnat 2017: p. 98). I continue these conversations around the archive and the repertoire in Part 1; however, it is important to highlight here how performance studies and theoretical areas I explore in this book may help to highlight – and perhaps address – some of these challenges.

In this introduction, I have begun with an autoethnographic account of a walk and a song that inspired the project, the resonance of folk songs in my life and the desire to write scholarship on folk song. I have contextualized my work within the broader resurgence of folk traditions in England and Britain and continuing conversations on diversity and folk music.

In Part 1: Theory and Methodology, I will explore affect theory, auto/sensory/ethnography, the archive in performance and landscape writing. In 1.1 Affect Theory, I explore the emergence of the affective turn in performance studies and how theories of affect as 'an interface between body and world' may allow for the question to shift from, 'What does music mean' to 'What does music do?' (Biddle and Thompson 2013: p. 19). In being attuned to the emotional and sensory components of learning a song by heart, and how these elements are interwoven, I contend that affect theory provides a productive ground for questions of bodies, contingencies, and contexts of folk singing in the performative present. Furthermore, I introduce how affective folk singing may be used to illuminate the archive and the repertoire not as dualistic, oppositional realms, but as related practices in a body of performance.

In 1.2 Auto/Sensory/Ethnography, I introduce methodologies that facilitate insights into affective processes, drawing on Knudsen and Stage's recent work on developing and accounting for 'methodologies that enable cultural researchers to investigate affective processes' (Knudsen and Stage 2015: p. 1). The first methodology I explore is autoethnography. I consider how autoethnography enables an identification, analysis, and articulation of experiences of affective encounters in songs, archives and landscapes. Second, I address how sense of self may be formed through autoethnographic processes of performance and writing and discuss how such areas may also be illuminated and instructed by the field of autobiographical performance. In particular, the work of walking artists, and how they have theorized their work through geographical concepts such as space, place, and landscape, and how these in turn relate to notions of identity. Third, I consider how autoethnography enabled me to write in a way that allowed for, and celebrated, fragments, and fractures, and gave voice to moments of my life and research that were fragile, complex, and interwoven. In finding that voice, I also became aware that I needed to find ways for autoethnography to welcome and interact with other voices. Thus, I began to explore how autoethnography could also be a generous, dialogical methodology, and how I might seek to engage with Ron Pelias's observation that 'when I tell the most intimate details of my life, I do so always aware that all my personal

feelings are located interpersonally. To be personal is to be with others' (Pelias 2014: p. 151).

The focus of the chapter will subsequently shift to sensory ethnography. I outline my need for a methodology that would blend with autoethnography, to explore the sensory, affective, and emotional elements of my interviews with conversational partners. Approaches to this include working with loosely structured interviews where I explore particular songs they associated with the South Downs, engaging both with Valerie Walkerdine's work on opening up the potential of interviews to deal with affect by performing 'long, unstructured, narrative-based interviews, which aimed at engaging with feelings' (Walkerdine 2010: p. 92), and with Pink's research on 'interviewer and interviewee communic(ating) as embodied and emplaced people [...] interviewing might be rethought in terms of a sensory paradigm' (Pink 2015: p. 75). Second, I consider how blended methodologies of auto/sensory/ethnography developed ways of presenting the performances of other singers and their experiences of learning and singing folk songs. Finally, I explore my use of walking with research participants and place it within mobile research methodologies in performance studies, cultural geography and the broader humanities. These approaches to fieldwork and methodologies aim to incorporate, account for and investigate 'more-than-representation layers and emotional/affective practices embodied by informants' (Knudsen and Stage 2015: p. 19).

In 1.3 The Archive in Performance, I argue for an understanding of archival research as a sensory, affective, emotional, and embodied practice. In their volume *Out of the Closet, into the Archives* (2015), Cantrell and Stone consider a need for researchers to 'engage with their affective experience of being in the archive', and to recognize the ways that researchers create and collate information as amateur archivists, sharing Carolyn Dinshaw's call to 'remember the etymology of the word amateur: love or labours of love', and, as they continue, 'positions of affect and attachment' involved in these labours of love (Cantrell and Stone 2015: p. 10). I interrogate this particularly in reference to the notion of 'taking care' in the archives proposed by performance theorist Heike Roms (2013), and how this has the potential to illuminate the affective capacities of materials and highlight how performance 'remains differently' (Schneider 2001: p. 100). The second aim of this chapter is to investigate, find, and experiment with different modes of critical writing that may account for, or open up, the role of affectivity in archival research and documenting performance. As such, I engage with recent disciplinary enquiries into alternative writing practices that communicate the

affective ranges produced by performances, and thus 'enact the affective force of performance in our writing' (Thompson 2009: p. 90), and, further, how writing itself may be seen as an affective methodology. As Anna Gibbs argues in her chapter *Writing as Method: Attunement, Resonance and Rhythm*, writing is a 'process, implicitly dialogical, in conversation with the world, with other writing, and, reflexively, with itself. It is this very means of procedure – a turning and returning – that characterizes it as an affective methodology' (Gibbs in Knudsen and Stage 2015: p. 224). Furthermore, in this chapter I will begin assessing how affective language may function in folk songs, and how rhythms and words that are stored in singing repertoire may make visible traces and reanimate residues of previous landscaping practises, and, beyond this, how texts might 'express orality in writing through rhythm' (Gibbs in Knudsen and Stage 2015: p. 225).

In 1.4. Landscaping, I embrace an overall idea of landscape as an active, affective practice, termed by Wylie as *landscaping* (Wylie). I consider walking and singing on the South Downs Way and the sensory knowledge gained in relation to non-representational theory and landscaping practices. I endeavour to explore this notion of performance through singing and movement, and to account for how folk songs contributed to my experience of landscape as a set of activities and processes rather than as a fixed, exterior, objective reality. Second, I consider how an understanding of landscaping as a process poses questions to researchers in how they write and perform their experience of landscaping. Additionally, I consider how a conception of participatory landscaping may allow for the importance of understanding the different terrain and topographies that folk songs have encountered during their histories, and how these practices and landscapes continue to be embodied in performance. Finally, I consider current landscape writing practices, and investigated the theorists, writers, and methods that have enabled me to write in a way that explores my relationship to, with and in the landscape of Sussex and the hills of the South Downs, and to compose an account of the way in which they are formed through participation.

In Part 2: Practice, I begin an evocative, autoethnographic account of the walk I undertook along the South Downs Way in May 2015. Each chapter considers a portion of the walk alongside questions developed thus far on affect, performance, documentation, and landscaping. In each chapter, I focus on a particular thematic preoccupation and the questions that began to form as I journeyed across Sussex. In 2.1 Footpaths, I make tentative steps in exploring my practice of learning songs from singers to sing 'along the way', and how this practice began to illuminate generative comparisons in the respective formation

of folk songs and footpaths through engagement, attachment, and preservation. I also discuss how the archive became woven in with the performances and the walk, through singing songs from the Full English Digital Archive, but also through the stories these fragments and shards began to illuminate. These stories, in turn, create reflective openings and pauses for me to examine changing relationships to these materials, but also aspects of my life, my *stories*.

In 2.2 Women, I reflect on how walking, performing, and autobiographies construct, animate, and relate to each other. These thoughts find particular focus in the place of women in 'the folk'. These considerations take several forms: First, I consider what set me on my path, and the women I began to find – or look for – along the way. Second, I contemplate how the walk led me to a growing understanding of the pioneering work of female folk song collectors in Sussex and the female tradition of folk singing in domestic settings. Finally, I examine how these reflections contribute to wider questions about marginalized voices in archives, landscapes, and performance.

In 2.3 Lines, I focus on how sensory, affective, and emotional impressions fold together in my autoethnographic explorations of lineage, heritage, and inheritance. Lines grow through this day's walking. I turn first to how they are woven through songs as wayfaring protagonists; through seasonal work and landscaping practices, such as threshing and flaying and how singers 'find their way' though songs. Second, I consider the traces of the landscape in tunes and phrases of the songs: the dialect, vocabulary, and the evocative handwriting in the archive. Third, I consider lines that become erased, such as those of women, and how lines may allow for a concept of place that is about process rather than belonging, and how this may disrupt exclusionary ideas of who 'belongs' in places, and where or to who songs 'belong'. Additionally, I consider my own place in a line of singers and sense how inheritance and heritage might be reconceived beyond the linear, and how folk singing may act as a form of remembrance. Finally, I consider how multiple lines of enquiry in this chapter may contribute to processes of landscaping, archiving, and performance.

In 2.4 Childhood, I continue from the previous chapter's reflections on descent and derivation, and I turn around to look back to my younger self and the past lives of my family, as I walk forward towards the most familiar, storied stretch of my route. Sensory, emplaced interviews with my family about spaces of childhood and adolescence run alongside a walk of reverie and performances of songs passed through families. These open out to questions and working lives in relationship to footpaths and folk songs, and further explorations of

inheritance and archives. Furthermore, these conversations and reflections raise the notion of intimacy. Intimacy is explored in the sharing of memories, between conversational partners and the interviewee, in walking alongside companions and in the caring for and carrying archival fragments.

Covering the last two days of my walk, in 2.5 Legacies, I foreground affectivity in the songs that are inherited, gifted, composed, preserved, forgotten, recycled, or reclaimed and how the immediacy of such songs is a working of the past through the present. Thus, I return to research avenues pursued in 1.3 The Archive in Performance around the archive and the repertoire, and how understandings of processes of care-taking may allow a destabilizing of these categories. I also contribute to avenues begun in 2.2 Women, as I extend my research to the pioneering women of the Downs and the stories and spirits of their legacies. Lastly, I explore how this research may function as my own archive or legacy, and if so who I am creating that for, or whether the process of recovery is for myself.

In 2.6 Dorothy Marshall: A Small Story, I begin to tell my small story of Dorothy Marshall, a female amateur folk song collector. Dorothy's collecting took place in early 1900s rural West Sussex, and I encountered many of the songs she collected during my research. However, her role became marginalized by the archives. Using the model of 'creative incorporation' introduced by cultural geographer Hayden Lorimer, archival material, published records, and photographs are used alongside imagining-in-practice (Pink 2015) to consider and comment on the difficulties of studying affect in relation to past lives. I will explore how such research allowed me to imagine or enliven Dorothy's collecting activities, and thus the embodied practices that formed (and continue to re-form and per-from) her archive. Additionally, I build upon these explorations of 'a co-scripting of landscape, movement, and biography' (Wylie 2007: p. 208) by considering my relationship to Dorothy, and the difficulties of communicating modes of affect felt from the past.

Chapter 2.7, Life-writing, explores my experiments with life-writing in relation to Dorothy Marshall and how these experiments may provide further models for researching marginalized figures in folk traditions. I argue for life-writing as a means to account for the importance of the local and the spatialized and emplaced contexts of lives, as well as how life writing as well as how life-writing might create 'affect worlds' where 'strangers meet through emotional connection' (Jolly 2011: p. v). Additionally, I will continue to analyse the intensities, practices, and coincidences that have drawn me to certain lives and performances in the

archives; what geographer de Leeuw in her paper 'Alice through the looking glass: emotion, personal connection, and reading colonial archives along the grain' identifies as the 'heartfelt and emotive orientation to both the physical spaces of an archive and to the materials and narratives housed therein [. . .] feeling the pulse of the archive, recognizing its affective nature and the affective nature of the subjects within it' (de Leeuw 2012: p. 276). This affective connection to Dorothy proved to be at the heart of many of the concerns and aims of this research. Thus, I conclude by exploring how trying to tell her story enabled me to reflect on affect in relation to archives and repertoires, marginalized voices in 'the folk', landscaping and emplaced lives, identities as evolving and fragile and how writing has allowed me to take care of the fragments of my own life as well as the small stories I have sought to share. In so doing, I consider autoethnography and landscape writing, in relation to biography and life-writing.

In Conclusions 1 and 2, I continue my desire to remain 'radically open', reflecting upon the knowledge which my research methodologies have afforded me, but also upon the ongoing 'doings' of affective practice and research beyond conclusions (Trezise 2014: p. 19). I consider the implications and possibilities of attending to the act of performing folk songs through affective enquiry, and the continuing place of performance studies in shaping our understanding of 'the force or forces of encounter' (Gregg and Seigworth 2010: p. 2). I revisit the contributions this research makes to the study of folk singing as a performance practice, and folk traditions in a modern multicultural England, as well as reasserting the aim of an affective approach to move beyond the borders of tradition and towards an understanding of the arrival of a song in the performative present. Finally, by pausing beside my research (Thompson 2009: p. 134) and considering where I find myself at the conclusion of this thesis, I turn once more and to how performance 'remains, but remains differently' (Schneider 2001: p. 1).

The two parts of the book are loosely termed 'theory' and 'practice', this is done in order to separate for the reader the theoretical work that underpinned the walk, and then the walk itself. However, this is done with an understanding that in performance studies there is no distinct separation between theory and practice nor are they a binary, but rather that they are seen as a holistic whole. The theory in Part 1 informs, relates to and synthesizes with the practice in Part 2. Similarly, the practice in Part 2 loops back, illuminates and converses with the theory in Part 1. The structure is only a guide for the reader, who may choose to take a different journey through the book. Like any good walk, the path is yours to choose.

Part 1

Theory and methodology

1.1

Affect theory

In this chapter, I explore affect theory and the affective turn in order to consider what folk songs *do*. I aim to use my explorations of what folk songs do to consider wider questions of process and performance. As such, this research aspires to investigate how folk singing as an affective practice might enable insights into the relationship between the archive and the repertoire. These are represented in this book, respectively, as materials from the Full English Digital Archive at the Vaughan Williams Memorial Library and songs learnt from singers in Sussex who participated in the research, as well as songs learnt from my mum, Catherine.

By examining what folk songs do, in the body, in the archive, in understandings of landscape and in one's sense of self, this research draws on interdisciplinary investigations into theories broadly considered under the umbrella of affect. As Marie Thompson and Ian Biddle state in their volume *Sound, Music, Affect: Theorising Sonic Experience*, 'affect remains stubbornly ungeneralizable, referring to a myriad of approaches [. . .] the structure of affect theory mirrors the ambiguity, open-endedness, and messiness of that which we might call affect' (Biddle and Thompson 2013: p. 6). In the parameters of this study, I explore the theoretical history of affect, the 'affective turn' within theatre and performance studies, and interdisciplinary theory, and how conceiving of affect as an 'echo within ourselves of what our body does or undergoes' – like the echoing refrain of a folk song – may allow for a way of exploring what it means to learn a song *by heart*.

The increased attention in the early twenty-first century to ideas of affect, emotion, and feeling within performance studies has coincided with a broader interest in the arts and humanities towards the role of feelings and bodies, and this shift has come to be known as the 'affective turn'. In the *Routledge Companion to Theatre and Performance* (2014), Paul Allain and Jen Harvie argue that the affective turn has resulted in a shift away from what theatre

means towards what theatre *does*, with scholars exploring how the experience of being a spectator registers in the body, and that this appreciation 'importantly recalibrates historical hierarchies of meaning that have denigrated bodies and feelings', and, further, that as 'practices which feature and foreground feelings and bodies, theatre and performance can help us to better understand the cultural work of feelings' (Allain and Harvie 2014: p. 149). Singers who perform folk music often inherit the songs from someone significant in their lives. However, there will be songs that the new singer will sing that original singer will not, as I have experienced through learning songs from my own mum, and thus I became interested during my research in how repertoires might be continually formed and reformed through what affect theorists Melissa Gregg and Gregory J. Seigworth term 'the forces of the encounter' (Gregg and Seigworth 2010: p. 2). In discussions that took place during my interviews and walks with other singers in Sussex, exploring how they perceived the relationship between the landscape of Sussex and the performance of folk songs, phrases such as 'falling in love with a song', or 'a song haunts you', or 'it becomes part of you' were often repeated. As Allain and Harvie identify, theories of affect allow us to explore and validate 'audience responses which are apparently irrational or initially unexplainable, giving authority to such claims as "I liked it" or "it moved me" [and] an audience member's intimate, immediate gut feelings' (Allain and Harvie 2014: p. 149). Allain and Harvie continue that feelings can be understood as our 'recognition of affect', and alongside this, that emotions are 'how we understand and interpret affects through social agreement and personal memory, for example as fear, pity, or desire' (Allain and Harvie 2014: p. 149).

The affective turn as a shift towards understanding and valuing the cultural currency of feelings is also highlighted by the importance to, and the contribution of, feminist, disability, and queer studies, as well as critical race theory. As Allain and Harvie state, the shift from 'semiotic systems, representation, sense-making and interpretation onto bodily experience, feelings and emotions' is particularly instructive and vital in these areas of academic inquiry because 'the historical denigration of feeling has been linked frequently and intimately to historical prejudices against women, queers and people of colour' (Allain and Harvie 2014: p. 149). However, this does not mean that the former has superseded the latter, but rather that affect has evolved our considerations of texts and representations. As Disch and Hawkesworth state in *The Oxford Handbook of*

Feminist Theory, feminist theorists understand, 'how affect and interpretation are inseparable, how interpretation is always a question of contagious affects and dynamic meetings between texts and readers' (Disch and Hawkesworth 2015: p. 18). This is echoed by Margaret Wetherell in her statement, 'the main things that an affective practice folds or composes together are bodies and meaning-making' (Wetherell 2012: p. 20).

In the first few months of reading about folk singing I came across many discussions of musical theory and the ways that certain tunes had developed, the categorization of songs and their variants such as Roud numbers and discussions about the politics of 'folk' in relation to identity. However, as a performance scholar, the question that kept forming in my mind was: How does it *feel* when you sing a song? And further, as I began to explore the practices of collecting from traditional singers in the first and second folk song revival, how *did* it feel to sing those songs, and how were those encounters that produced this material experienced? Thus, I began to ask how a focus on what songs *do*, rather than solely what songs mean, or what songs are, might allow in terms of researching marginalized voices in the history of folk, such as female singers. And thus, echoing Wetherell, by understanding what folk songs do, we might also understand further what they mean.

There are significant gaps in our understanding of the history of folk singing for women. In the first folk song revival, female singers did not sing in pubs, and not recorded from at work, as the men were. Moreover, many (but not all) of the prominent folk song collectors were male and this created certain conditions for collecting from female singers. As collector Cecil Sharp observed that in is experience:

> Women never perform in public, and only very rarely when men are present. If you prevail upon a married woman to sing to you, you must call upon her when her man is away at work . . . she will never sing to you in his presence until you come to know both her and her husband very intimately.
> (Sharp 1907 in Korczynski et al. 2013: p. 41)

Affect-based enquiry, with its focus on 'atmospheres, fleeting fragments and traces, gut feelings and embodied reactions and in felt intensities and sensations' (Blackman in Knudsen and Stage 2015: p. 26), provides a framework through which to seek research methodologies that might allow me to listen to the silence of these women's voices in the archive and to creatively animate or reimagine what may have been there, echoing Ahmed's call to take care of feminism as a 'fragile archive' (Ahmed 2017: p. 17).

In *Theatre and Feeling* (2010), Erin Hurley identifies four categories of feeling that she considers as related but separate states of experience: affect, mood, sensation, and emotion. For Hurley, affect is an 'immediate, uncontrollable, skin-level', bodily response to changes in the environment. If I feel thrilled my heart might beat faster, or goosebumps appear when I am afraid or chilled by something, and thus affect 'makes itself known through autonomic reactions [. . .] affects are sets of sets muscular/glandular responses' (Hurley 2010: p. 13). These responses, Hurley argues, are beyond our conscious control; we do not contrive to blush or make our teeth chatter or plan for our spines to shiver, and as such affect is unruly – 'it exceeds us by happening against our will' (Hurley 2010: p. 13). Further, in Hurley's summary of affect, these autonomic reactions happen within one person and therefore are entirely felt within the individual, 'meaning that only the person whose blood is rushing to his or her extremities can feel it' (Hurley 2010: p. 17). Hurley continues that this subjective skin-level response may then register on a person's body in an emotional manifestation that is socially readable, for example, wide-eyed surprise or toe-curling embarrassment, 'by casting subjective experience into readable moulds (grimaces, and so on), emotional expression objectifies, if you will, the subjective experience' (Hurley 2010: p. 18).

However, in seeking ways to communicate my experience of affective states whilst walking, singing or in the archives, I wondered if affect was simply a physical reaction, or whether the echo *felt within* was felt as emotions. Additionally, I wanted to find an understanding of affect that was concerned with more-than the individual. Thus, I became interested in theories of affect that considered the in-between-ness of physical feelings and emotions and of other bodies and environments. However, there was no one neat definition of affect that could be applied to all of my research; as performance theorist James Thompson states in *Performance Affects: Applied Theatre and the End of Effect* (2009) that writing about performance should 'maintain the difficultness of affect' rather than aiming for a conclusive understanding (Thompson 2009: p. 10). Rather, I gravitated towards explorations of affect that, as Ahmed argues, 'avoid making analytical differences between bodily sensation, emotion, and thought as if they could be "experienced" as distinct realms of human "experience"' (Ahmed 2004: p. 6). Ahmed uses the word 'impression' to encompass what is felt or marked on the body, affective charges or gut feelings, and the emotional effects of an encounter, that is, the song made an impression on me. Asking her readers to remember the *press* in impression, Ahmed emphasizes her interest in what

emotions *do* rather than what they are. Thus, her use of the word impression allows 'us to associate the experience of having an emotion with the very affect of one surface upon another' (Ahmed 2004: p. 6). Moreover, Ahmed's asserts that to categorize affect as separate from emotions risks disembodying our feelings, 'emotions clearly involve sensations: this analytic distinction between affect and emotion risks cutting emotions off from the lived experiences of being and having a body' (Ahmed 2004: p. 8).

My desire to use affect as a malleable term, 'concerning both physiological sensations and psychological states, that is, affects, emotions and feelings' (Aragay et al. 2021: p. 8), and to foreground Ahmed's work, both relate the importance of feminist theory and feminist research to considerations of affect and the 'affective turn'. As political theorist Linda Åhäll states: 'feminist knowledge on affect must not be ignored' (Åhäll 2018: p. 38). The importance of emotion is a key component of the ongoing relationship between feminist theory and affect theory, with both seeking to disrupt and problematize binaries such as mind/body and emotion/reason. Moreover, both affect and feminist theory utilize embodied research and challenge 'knowledge as objective, particularly through a focus on the importance of *being as a mode of knowing*' (Åhäll 2018: p. 41).

In *Performance in the Twenty-First Century: Theatres of Engagement* (2016), Andy Lavender identifies affect as a means to 'consider the sensations and feelings that tell us what experiences we are having' (Lavender 2016: p. 162). Lavender also asserts that due to the wide range of disciplinary approaches to affect ('neuro-cognitive, psychological bioscience, cultural studies and philosophy, aesthetics, social geography, anthropology and theatre studies'), the term can become 'rather slippery, or at least shimmery, like a fish whose colour appears to change depending on the water in which it swims' (Lavender 2016: p. 162), echoing Gregg and Seigworth's use of an 'inventory of shimmers' (Gregg and Seigworth 2010: p. 2). In this research, affect is used across disciplines, mainly performance studies and cultural geography. Non-representational theory, an area of cultural geography developed by Nigel Thrift, takes as its starting point Deleuzian theories of affect – 'something passing from one to the other. This something can be specified only as sensation. It is a zone of indetermination, of indiscernability . . . this is what is called an affect' (Deleuze and Guattari 1991: p. 173). Whilst I shall be exploring non-representational theory in more depth in Part 3, what is important to highlight here is the fundamental quality of 'in-between-ness' of affect, 'something passing from one to another', that Gregg and Seigworth also speak of in their introduction to *The Affect Theory*

Reader (2010) – 'affect arises in the midst of *in-between-ness:* in the capacities to act and be acted upon' (Gregg and Seigworth 2010: p. 6). To affect and to be affected is always a process of relation and something that happens between bodies and environments; for Brian Massumi, Deleuzian translator and theorist, this positions affect as 'the bodies feeling capacity' (Massumi 2002: p. 21), or as Lavender summarizes 'a part of a set of becomings and intensities relating to motion and action' (Lavender 2016: p. 162). What Kathleen Stewart foregrounds in her work, *Ordinary Affects*, is that these bodies may not just be the songs, the archive, the performance site or the singers themselves, but the knowledge or feelings that arise from these encounters:

> Ordinary affect is a surging, a rubbing, a connection of some kind that has an impact. Its transpersonal or prepersonal – not about one person's feelings becoming another's but about bodies literally affecting one another and generating intensities: human bodies, discursive bodies, bodies of thought, bodies of water.
>
> (Stewart 2007: p. 128)

In phenomenological terms, the immediate encounter of perceiving bodies and what these encounters make us *feel* become the area of study. Thus, affect intersects and 'swims' beside theories of embodiment, which, as Elizabeth Ellsworth states, allows an understanding of bodies as 'continuously and radically in relation with the world, with others, and with what we make of them' (Ellsworth 2005: p. 4). A broadly phenomenological position on affect creates a means through which to understand learning a song by heart in both a bodily and emotionally *felt* way. As Bryony Trezise expands in *Performing Feeling in Cultures of Memory* (2014), 'we feel *through,* and *as,* we touch. We feel *about* how we touch at the same time as we touch. In this way, we might develop feelings about feeling' (Trezise 2014: p. 19). Similarly, Lavender observes that 'we can think of affect as an immediate sensory access that has a basis in biochemical human interactions. It shapes how we feel, and moreover how we feel about that feeling' (Lavender 2016: p. 163). Additionally, in Martin Welton's work on *Feeling Theatre* (2012), he observes that to 'feel' in English 'describes a sensory-affective continuum whose terms range from the particularity of various emotional states to sensations at the tips of the fingers' (2012: p. 8).

The relationality of affect is also important in considering that affects can happen beyond, and between, individuals. For example, one of the singers I met

with to discuss the affective experience of folk singing, Chris Skinner, reflected on the experience of singing chorus songs in folk clubs and the atmosphere that is created, in part, by all breathing at the same time. That a performance of a song might *move* me in ways that register in my body does not distinguish that process as only happening in the single unit of my body, as Trezise reflects: 'feelings possess us such that we feel ontologically unique, separate and self-bound in the very moment that we might just be radically, affectively open' (Trezise 2014: p. 19). And thus, as Lavender suggests, the notion of affective atmosphere might be particularly relevant to performance-based enquiry, 'activities, events, and encounters produce feelings not only in us but also in others. Adjudicating the nature of such feelings, and the relationship between the person, the event, the felt engagement and its cultural context is the task of performance criticism' (Lavender 2016: p. 165).

Although this study deals primarily with the English tradition of folk songs, there is also vital work on illuminating the folk performance and affect in other cultural contexts. In *Cultural Labour: Conceptualizing the 'Folk Performance' in India* (2019), Brahma Prakash explores affective and performative approach from theatre and performance studies to analyse folk performance and 'its production of social and cultural values in Indian caste-based societies' (Prakash 2019: p. 5). As an example of the embodied nature of the affective relationship between folk songs and landscape, Prakash relates that in paddy songs:

> agricultural labourers sing and ask crops to follow their movements. George Thomson (1954) gives an example of potato dance among Maori communities of New Zealand, where young girls dance and ask potato plants to follow their moves. In Gaddar's song voriselu adiginayi, basmati rice and cotton plants weep and ask, 'where are my farmers?' Of course, basmati rice and cotton will not ask questions; paddy and potato will not follow their movements. The songs may not have any direct effect on the crop. But these practices have a palpable affect on the farmers and labourers who believe that their song will nurture their crops with great care. With this belief, they proceed to the task of tending the crops with greater confidence and energy than before, and that does have a real effect on production. It is obvious that this effect on the crop is made possible through the affective dimension of performance.

Theories of embodiment I consider in relation to walking and singing, such as landscaping and non-representational theory, focus on processes and practices and how they shape our understanding and perceptions of our environments. Considering affective atmospheres through the importance of setting – in this

study the South Downs Way – enables a greater sense of the felt engagement and cultural context in understanding how affects are produced. Similarly, it affords an analysis where affects are not fully formed entities ready to be transferred onto another body at the point of contact, but formed through encounters. Wetherell's criticisms of a vocabulary in which affect emerges as 'a self-contained packed of emotional stuff that is being transferred from one body to another' is particularly instructive here (Wetherell 2012: p. 141). Considering how affect is experienced and formed through processes of landscaping engages with Wetherell's unease about viewing affect as an 'ethereal, floating entity, simply "landing" on people' (2012: p. 14), and is part of the broader work of non-representation theorists such as Ben Anderson who conceptualize affective atmospheres as connected to settings such as space, place and site and 'always emerging and transforming' (Anderson 2009: p. 80). Anderson's work on affective atmospheres also provides a way of considering the in-between-ness and entanglement of affect, feeling, and emotion:

> Atmospheres do not fit neatly into either an analytical or pragmatic distinction between affect and emotion [. . .] they are impersonal in that they belong to collective situations and yet can be felt as intensely personal. On this account atmospheres are spatially discharged affective qualities that are autonomous from the bodies that they emerge from, enable and perish with. As such, to attend to affective atmospheres is to learn to be affected by the ambiguities of affect/emotion, by that which determinate and indeterminate, present and absent, singular and vague.
> (Anderson 2009: p. 80)

Moreover, any affective atmosphere will not pass unchanged to each body, nor will any individual feel that affective atmosphere in the same way. Instead, it will be dependent on the always becoming affective state that they arrive with. As Ahmed argues, 'if bodies do not arrive in neutral, if we are always in some way or another moody, then what we will receive as an impression will depend upon our affective situation' (Ahmed 2010: p. 36). Furthermore, social aspects such as gender will have a bearing upon our received impression, as Åhäll reason, 'that affective processes – both between and within bodies – [have] everything to do with gender. This is because gender plays a fundamental role in how our social worlds work' (Åhäll 2018: p. 41).

Learning to be open to the ambiguities and contingencies of affect and emotion is something that has extended across my research, from the first

feverish search hunt for songs from villages along the South Downs Way, to the process of writing and rewriting this research in the proceeding years; as Blackman evokes, 'writing itself is an affect-laden process: driven by interest and desire, subject to frustration and misery as well as productive of joy and excitement' (Blackman in Knudsen and Stage 2015: p. 224). Thus, whilst this opening chapters assesses the ground of affect from which my research rises, the ambiguous, visceral shimmers of affect continue to appear and be investigated throughout the following chapters.

What I hope to have opened up in this introduction to affect theory are the generative possibilities of considering folk songs in the act of performance, and the myriad processes that may formulate a singer's repertoire. In being attuned to the emotional and sensory components of learning a song by heart, and how these elements are interwoven, I contend that affect theory provides a productive ground for considering how folk traditions arrive to us in the here and now. Thus, through paying attention to the force of folk singing on the level of my own body at a particular time, in a particular landscape, in a particular period of my life, I hope to contribute further to questions of context – both embodied and emplaced – in debates about UNESCO identifying traditional singing as intangible cultural heritage, and what this might mean if England ratified the convention. Furthermore, by contributing a performance studies aspect to scholarship on folk songs, I have also begun to highlight possibilities for using affective folk singing to illuminate the archive and the repertoire not as dualistic, oppositional realms, but as related practices in a body of performance.

1.2

Auto/sensory/ethnography

In this chapter, I explore the different methodologies that have enabled me to position myself within folk singing as an affective practice. During the period after my mother began to teach me songs, I started to sing regularly with other traditional singers. This has become an ongoing apprenticeship, and one that has resulted in my curiosity into how other singers learn their songs 'by heart'. In order to explore this ongoing apprenticeship, I examine the performative processes involved in unaccompanied singing. First, I consider the methodology of autoethnography, and how it enables me to locate myself in the work, as well as analysing my positionality. Second, I consider the embodied modes of sensory memory and *imagining-in-practice*, explored by social anthropologist Sarah Pink in her work *Doing Sensory Ethnography* (Pink 2015), and how these enabled me to explore embodiment in relation to archiving, interviewing, and performing. Third, I engage with the work of performance scholars who have explored different modes of accessing performances that have taken place in the past. Thus, through a blended methodology of auto/sensory/ethnography, I consider how embodied practice illuminates the active work that the remains and materials of the past *do* in the present.

Throughout this book I explicitly locate myself as a researcher and investigate how my perspective and positionality have guided my exploration and findings of folk singing. This follows Stacey Holman Jones's use of autoethnography as 'performance that ask how our personal accounts count' (Holman Jones 2005: p. 763). Adams, Holman Jones and Ellis, in the *Handbook of Autoethnography*, identify the three main elements of autoethnography as 'the "auto," or self; the "ethno," or culture; and the "graphy," or representation/writing/story' (Adams et al. 2021: p. 3). In this study, the 'auto' allows me to chart my journey of learning folk songs, alongside moments of change, pain and vulnerability, that shaped certain areas of enquiry, such as my evolving interest into female singers. The 'ethno' became the singers and walkers that met with me, as well as the wider

community of Sussex folk clubs and events. Finally, in different modes through this book, the story or 'graphy' of this research is told, through intersections between autoethnography, sensory ethnography, performance, life-writing and landscape writing. All of these elements synthesize to create, 'accessible, concrete, and evocative representations [. . .] a carefully written, vibrant story that revels in rich description' (Adams et al. 2021: pp. 3–4).

An autoethnographic approach enables me to identify patterns in my decision-making processes and intellectual curiosities, and led to moments of epiphany (Denzin 2014: p. 53). During my research, I considered only using oral performances that people could teach me 'by ear', rather than through any archival material, as I cannot read music. However, areas of strain can be productive, and this friction resulted in one of the main areas of investigation within the research, becoming how I might use affect to consider the relationship between archiving and performance, the contradictions, tensions and overlaps. Epiphanies came in moments where I discovered some of my conversational partners could not read music. Nor, it transpired, could a lot of the traditional singers the tunes were taken down from, or indeed many of those continuing to perform the songs in folk clubs today. This led me to see that these archived songs become silent to those who cannot read music if the archive does not also contain a sound file, suggesting possibilities for further work to make archives accessible.

Additionally, I became interested in whether my participants were drawn to the words, or the music, of certain songs and what first hooks people into learning a song. Many of the songs I was drawn to in the archive explored feelings of loss, and I began to feel it was important to recognize that the period of writing coincided with episodes of personal grief in different varieties and intensities. As Adams, Bochner and Ellis state:

> Autoethnographers recognize the innumerable ways personal experience influences the research process. For instance, a researcher decides who, what, where, when and how to research [. . .] consequently, autoethnography is one of the approaches that acknowledges and accommodates subjectivity, emotionality, and the researcher's influence on the research.
> (Adams et al. 2021: p. 274)

The basis for my exploration into the how singers experience the act of performing a folk song is how it *feels* for me to sing a song. As such, my experience, and the various contexts that shape that experience, is held up for

examination alongside my research subjects, past and present. This demands, as Adams, Ellis and Bochner (2021) state in their article 'Autoethnography: An Overview', 'unusually rigorous levels of researcher reflexivity, given that researcher/researched are usually the same people' (Adams et al. 2021: p. 3). Autoethnography, although encompassing varied approaches, broadly aims to achieve academic knowledge through the production of texts that link the self to the research environment expressively and critically. As Grant, Short and Turner assert in their introduction to *Contemporary British Autoethnography* (2013), 'autoethnography is concerned with producing creatively written, detailed, local, and evocative first-person accounts of the relationship between personal autobiography and culture' (Grant et al. 2013: p. 2).

The experience of researching songs, performing them in the sites of their collection and sharing in how other singers learn songs are areas that require different registers of writing. I use each of the registers – autoethnography, landscape writing and life-writing – in order to produce 'aesthetic and evocative thick descriptions of personal and interpersonal experience' (Adams et al. 2021: p. 277). Yet 'I' am a single, childless, chronically ill, cis-woman, in my late twenties, born and living in Sussex to a white-British middle-class family, and these are all factors that would influence such a lived experience. Nor are most of these categories necessarily stable. As I return to forming this research into a book, I am a white-British, post-hysterectomy, middle-class cis-woman, in my mid-thirties, living in with my partner and cats in Colchester. Tami Spry addresses the need for identifying the contexts that contribute to your study as an autoethnographer, and opening up the relevance of these for your reader, when she asks:

> But whose body? Whose words? Where or who does the telling come from? What is the social, cultural and temporal location and implication of the autoethnographer?
>
> (Spry 2013: p. 224)

My research uses affect theory to illuminate the relationship between performers, songs and landscapes, and in doing so it returns to the body as a refrain. Thus, throughout my investigations I engage with Spry's concept of a performative researcher embodiment that calls 'on the body as a site of scholarly awareness and corporeal literacy' (Spry 2001: p. 706).

One of the vital elements of my research that is enabled by autoethnography enables is to explore and account for is the fragmentary, in-between nature

of affect, stories, landscapes and selves. Stories of the past, of the present, of memories, of archival subjects, of my family, of being lost, of being 'caught in the world' (Merleau-Ponty 1979: p. 256) are woven through an autoethnographic account in which I hope to celebrate and accommodate that which is messy, partial and *held*. The threads of reflecting on my own moments of becoming and recovering, alongside exploring the experience of learning songs from my mum, creating small stories from the archives, finding inspiration and solace from the tales of women along my walk and analysing how songs may be a means of being-in-the-world, are held together and braided by autoethnography – as Jane Speedy describes after Doreen Massey 'a simultaneity of stories so far' (Speedy 2015: p. 27). Furthermore, I layer autoethnographic reflections with creative impressions from my participants, song lyrics and other forms of biographical writing, to produce a 'provocative weave of story and theory' (Spry 2001: p. 713).

The relationship between autoethnography and feminist research is a rich and established tradition. Autoethnography emerged, in part, as a way of doing and writing research that disrupted 'white, masculine, heterosexual, middle/upper-classed, Christian, able-bodied perspective' (Adams et al. 2021: p. 275), and to challenge any idea of a distanced authorial 'I', 'In our rejection of an objective "view from nowhere," autoethnographers recognize and embrace the reality that the person and the personal are always present in social life as well as in the processes of research and representation' (Adams et al. 2021: p. 1). Thus, autoethnographers seek to recognize the importance of identity, subjectivity, intersectionality and the positionality and race, gender, sexuality, age and ability (Adams et al. 2021: p. 275). Recent research has also explored explicitly feminist autoethnography, such as Elizabeth Ettorre's *Autoethnography as Feminist Method: Sensitising the feminist 'I'* (2017), which focuses on 'autoethnography as feminist method' (Ettorre 2017: p. ix) and Elizabeth Mackinlay's *Writing Feminist Autoethnography: In Love with Theory, Words, and the Language of Women Writers* (2022), which investigates 'the personal-is-political relationship between autoethnography and feminist theory and practice' (Mackinlay 2022: n.p.). Although in this book I had not initially intended to focus on women in relation to folk singing and collecting, autoethnography has allowed me to account for this evolution and to chart moments in my research where affective pulls, embodied transitions and evolving identities shifted the focus of my work.

In addition to my use of autoethnography, I also undertook semi-structured interviews with my research participants. Adams, Ellis and Jones state that for autoethnographers 'interviews are a way to connect our personal experiences,

epiphanies, and intuitions to those of others' (Adams et al. 2014: p. 54). My interviews were initially conducted to understand and explore how other performers identified the relationship between folk songs and the South Downs. However, through the process of undertaking these interviews, they expanded to include other areas, such as how they began to sing folk songs. I originally conceived that I would use walking interviews as a mobile method of research with each participant. However, circumstances and participant preferences soon meant that I conducted interviews in a variety of contexts, and both autoethnography and sensory ethnography enabled me to analyse the knowledge created in these environments. There were certain markers in the path that I worked towards with each conversational partner. I asked them to perform a song for me that they associated with the South Downs, or the Sussex landscape, and then invited them to discuss how those associations manifested for them in the performance process. As my interviews progressed, I identified a few additional questions, but I endeavoured predominantly to be flexible and allow my conversational partners to pursue areas of discussion that particularly interested them. In addition to using the term 'participants' for those who walked and sang with me in this project, I employ in place of 'interviewee' the term 'conversational partners', as proposed by Rubin and Rubin, in order to make explicit the dialogical nature of my research and interviews, 'the respect the researcher has for the interviewee's experience and insights and emphasizes that interviewing is a joint process of discovery [...] both interviewee and researcher play an active role in shaping the discussion' (Rubin and Rubin 2012: p. 7). In their volume *Qualitative Interviewing: The Art of Hearing Data* Irene Rubin and Herbert Rubin state:

> The researcher's role is to gather narratives, descriptions, and interpretations from an array of conversational partners and put them together in a reasoned way, which recreates a culture or describes a process or set of events in a way that participants would recognise as real.
>
> (Rubin and Rubin 2012: p. 7)

These 'narratives, descriptions, and interpretations' are processes that navigate, and are negotiated by, sensory environments. In order to recognize that, my record of these conversations will be accompanied by evocative and embodied reflection and analysis. Thus, reflecting in the writing that putting them together in a reasoned way is itself a deeply felt practice. As Walkerdine identifies, engaging with interviews stimulates 'an affective within the author'

(Walkerdine 2010: p. 92). In Lisa Blackman's chapter 'Researching Affect and Embodied Hauntologies: Exploring an Analytics of Experimentation' in *Affective Methodologies: Developing Strategies for Cultural Affect* (2015), autoethnography is a methodology highlighted as a vehicle that allows for researchers to 'reflect on whether we can do research with which we are already entangled, and on that basis, what sort of methods might allow for such sensitivities' (Blackman 2015: p. 25). Some of my conversational partners have become friends, some are members of my family, and that necessarily has an influence (sensory, affective, emotional) on my analysis; autoethnography provides a vehicle for reflection on those entanglements. Pink acknowledges this responsibility to how our research impacts beyond the production of knowledge when she argues that 'sensory ethnography should be based in a collaborative and participatory approach to research, which respects research participants and recognises that ethnography might have a role in the real world as well as academia' (Pink 2015 p. 68). Implementing autoethnography as a methodology enables me to be attentive and responsive towards my role in the interview process. It also allowed me to experience a certain level of vulnerability, which enabled me to see what research can *do*, and to be responsive to the role of research in lives. It was my mum's illness and subsequent recovery period and the ending of an affair that set the parts in motion for my becoming involved in folk clubs in Sussex. I have been interested, in turn, about how or why my participants became involved with folk singing. Autoethnography allows me a frame within which both to acknowledge biases and impulses, and to assess what the implications may be for my approaches to research participants, including myself:

> When researchers do autoethnography, they retrospectively and selectively write about epiphanies that stem from, or are made possible by, being part of a culture and/or possessing a particular cultural identity [. . .] autoethnographers must not only use their methodological tools and research literature to analyse experience, but also must consider ways others may experience similar epiphanies.
>
> (Adams et al. 2021: p. 276)

Ellis identifies that most autoethnographies fall under the 'broad rubric of loss narratives' and it became apparent when listening to the transcripts of my interviews that I would need to be attentive and aware to when my own emotions, or preoccupations, led the interview in a certain way, or where the conversational partner's articulation of loss became a source of focus for my

understanding, 'to seek to tell stories that show our experiences as lived deeply and intimately; that represent the uniqueness of our losses, yet connect them to the losses of others' (Ellis 1999: p. 49). Furthermore, through discussions of my own experience and other's experiences of that experience, or experience they identify as similar, it is possible to see how interviews are a place where moments of significance, such as my mother stopping singing when she became depressed, are 'reconstructed and re*lived* through conversation *with* respondents [. . .] within the space of the interview as both researcher and respondent reflect upon their experiences within the same, or similar contexts' (Scarles 2010: p. 509). Thus, visual ethnographer Caroline Scarles argues, whilst these conversations are invariably 'imbued with researcher intention' they also 'emerge through mutual co-construction' and, therefore, 'flexibility within interviews becomes vital' (Scarles 2010: p. 509). In interviews such as the one I undertook with my father and my uncle, their shared experiences lead to a blurring of who is interviewing whom, as their conversation becomes mutual recollections and experiences. Thus, as well as recognizing that 'conversations engage both researcher and respondents in a mutual process of non-linear improvisation; each proffering or withholding remembrances and selectively sharing experiences as deemed appropriate', interviews may also become collaborative and interactive amongst participants that produce *co-constructed narratives*, 'which refer to tales jointly constructed by relational partners about an epiphanic event in their lives' (Ellis 1999: p. 50). As such, by reflecting upon moments of realization and sensory knowledge within my interviews, forms of motion during them, the environments in which they took place and by providing edited, but substantial passages of these conversations, I hope to explore Scarles's identification of how 'interviews become fluid, dynamic and mutually responsive performances within which the unpredictable and the unexpected fuse with more apparent pathways of discussion' (Scarles 2010: p. 509)

In her work *Leaving the Blood in: Experiences with an Autoethnographic Doctoral Thesis*, Jessica Moriarty states that 'autoethnography seeks to engage readers of the research in evocative texts that detail the complex and messy lives of the researcher and the researched' (Moriarty 2012: p. 1). This book includes deeply personal aspects of my life, rendered in such a way as to try to share with the reader something of my own complex and messy life: a life that affects the research I conduct. Furthermore, by creating a text responsive to the difficult messiness of affective lives, I aim to follow Moriarty's desire to 'represent the fracturing and splintering of my own life via an evocative and

messy text that aims to empower the reader with an enlightened reading, facilitating meaning making that is not determined by an omnipotent author telling them how and what to think' (Moriarty 2012: p. 1). Endeavouring, thus, to be a vulnerable, empathetic researcher, engaging with a mode of telling that produces 'meaningful, accessible, and evocative research grounded in personal experience' (Adams et al. 2021: p. 274) and which both makes that personal experience clear and celebrates knowledge as found in lived experience and in fractured, messy lives.

I have explored how my desire to locate my embodied, sensory and emotional experiences within my scholarship finds its home in autoethnographic writing practices. However, it also shares and inherits from the related field of autobiographical performance. Nicola Shaughnessey states in *Applying Performance: Live Art, Socially Engaged Theatre and Affective Practice* that 'the self is source and the body speaks' (Shaughnessey 2012: p. 47). Modes of engagement throughout this study are concerned with how I account for my 'self' in the research and the practice I undertake and create, and how I can articulate the role of my body both in, and through, my research. As I became aware of my inclination towards stories about women in the folk tradition, the use of autobiographical performance by women became a possible pathway for exploring that context of my work. Through these investigations I became interested more broadly in the role of walking artists, in particular women.

The period spent studying for the PhD that would inform this monograph coincided with significant moments of transition in my life. Moments of significance, or *epiphanies* as elucidated by Ellis, Adams and Bochner as 'remembered moments perceived to have significantly impacted the trajectory of a person's life [. . .] times of existential crises that forced a person to attend to and analyse lived experience' (Adams et al. 2021: p. 2), are also explored by practitioners working in the field of autobiographical walking performances. Such practice is often concerned with place and memory and explores how the performance of 'selves' offers space for further/other encounters and interpretations. Shaughnessey utilizes the work of Daniel Schacter on how researchers may 'construct our autobiographies from fragments of experience that change over time' (Schacter 2002 in Shaughnessey 2012: p. 50) to highlight the ability of autobiographical performances to make visible a 'performative mode of consciousness which is fluid, mobile and ephemeral, a process of becoming' (Shaughnessey 2012: p. 50). This 'process of becoming' feels particularly relevant to an autoethnographic mode of telling. There have been multiple transitions and

adaptations both in the work, and for my 'self', during the period of writing this research – both as a thesis and then as a book. Furthermore, the idea of mobility is particularly pertinent to ideas of landscape, performing and becoming. Thus, I began to consider the relationship between personal epiphanies and the desire to create or undertake performative walks.

In the introduction to *Walking, Writing, and Performance: Autobiographical Texts by Deirdre Heddon, Carl Lavery and Phil Smith* (2009), Roberta Mock observes a symbiosis between the processes of creating narrative selves and the making of performance sites, and therefore that the 'acts of walking, remembering, and writing [. . .] [are] intimately related' (Mock 2009: p. 7). As each piece in the edited collection deals with memory and landscapes, in one form or another, Mock explores how it may be possible to view the work as nostalgic. However, she contends that nostalgia does not need to be seen as 'sentimental, regressive, and reactionary' (Mock 2009: p. 9), but rather that it is possible to see nostalgia through different contexts and with varied intent. One critical mode through which to view nostalgia that Mock identifies is Svetlana Boym's notion of reflexive nostalgia. Reflexive nostalgia is viewed against its nationalistic counterpart restorative nostalgia and is argued by Boym to cherish 'shattered fragments of memory and temporalize space' (Boym in Mock 2009: p. 9). Such cherishing, or taking care of memory thus, Mock contends, 'positions the individual in a flexible historical trajectory' (Mock 2009: p. 11). As such, walking performances, and the process of writing them, become affective means of taking care of fragments of experience and memory.

Within the volume, Carl Lavery's *Mourning Walk* (2004) further demonstrates how walks may be occasioned by moments of significance, and the possibility of viewing nostalgia as a form of forward momentum. In the piece, he documents of process of devising and performing a walk taken on the ninth anniversary of his father's death. Lavery explores how walking practices enable researchers and performers to 'rediscover a holistic experience of place' and outlines his aim to create an autobiographical text of his walk which folds together 'memory, reverie, and landscape' (Lavery in Mock 2009: p. 46). However, the process of creating the text led him to question if the walk and the work – the performance and the document – could be divided or considered separately (Lavery in Mock 2009: p. 41). Consequently, Lavery argues that both performance and writing are a 'response to a loss of some kind, an imaginative way of dealing with lack', and thus considers *Mourning Walk* in the context of viewing writing as 'an enchantment or spell that heals the self by allowing it to recover the past through

signs' (Lavery in Mock 2009: p. 41). Recovery, in this instance, is not the act of retrieving something in its original form, but rather, 'it designates a poetic or an enchanted process in which the subject negotiates the past from the standpoint of the present' (Lavery in Mock 2009: p. 41). For Lavery, walking and writing become an active engagement with environment, embodied acts of landscaping, which allows fragments of experiences and fragile aspects of self and memory to become apparent, 'the experience of being in that environment, the assault on my senses, appeared to be the very cause of my enchantment [. . .] I felt a sense of expansion, as if something fragile and hidden was on the point of emerging' (Lavery in Mock 2009: p. 42). Responding to the potential for a holistic approach to walking to be perceived as apolitical, Lavery contends that conversely it 'points forward to an alternative way of being in, and caring for the world' (Lavery in Mock 2009: p. 48). Lavery's evocation of care resonates for me throughout my research; it speaks to the different ways that singers take care of the songs they are temporary custodians for; it has crossovers with Heike Roms's explorations into how researchers take care of archival materials (2013); it illuminates how singing has allowed me to take care of my 'self' during processes of transition and healing; it resounds in my autoethnographic writing and how I seek to look after participants' 'shattered fragments of memory' and it elucidates how songs may preserve past practices of taking care in/of the landscape, and how experiences of both self and landscape can be emergent.

Dee Heddon also considers the writing of 'selves' in relation to place and landscapes through her practice of *autotopography*, which 'brings into view the "self" that plots place and that plots self in place, admitting (and indeed actively embracing) the subjectivity and inevitable partiality or bias of that process' (Heddon 2008: p. 92). As autoethnographers use the subjectivity of their work to challenge dominant narratives (Grant 2012), Heddon similarly foregrounds the importance of subjectivity and diversity in autobiographical/ autotopographical work highlighting that such diversity leaves performances open for further discussion and debate from other perspectives, 'the challenge for all autobiographical performance is to harness the dialogic potential afforded by the medium, using it in the service of difference rather than sameness' (Heddon in Mock 2009: p. 15). Accounting for diversity in the practice of performing the self, either through practice or the documenting of practice, is fundamental in autoethnography, autobiography and Heddon's concept of autotopography. Charting the influence that post-structuralism has on notions of autobiography, Heddon outlines the movement from the understanding of

autobiography as an 'account, or recounting, of a life', a life that 'necessarily precedes the autobiography', to conceiving of the self and its performance as 'bound up in the social and cultural discourses that allow certain selves to exist' (Heddon in Mock 2009: p. 161). Autobiography, Heddon argues, is thus a creative act, one that 'proposes or produces a certain life, a certain self' (Heddon in Mock 2009: p. 161). Therefore, in common with autoethnographers, Heddon views the production of autobiographical texts as a way of challenging dominant narratives or certain selves that have become the authority:

> Autobiography at least provides the space to write differently [. . .] more and more selves and possible selves are written and performed into existence [. . .] in writing and performing an autobiography one becomes an agent, becomes active, becomes self-determining, choosing what stories to tell, what self to portray.
>
> (Heddon in Mock 2009: p. 161)

Heddon positions place alongside self in terms of each being constantly made. She utilizes geographer Tim Cresswell's work on the notion of place being formed through people's activities, and thus places are never finished but, rather, are 'constantly being performed' (Cresswell 2004: p. 37). Consequently, as with perceiving landscape through embodied activities, this view of place as a process requires researchers and performers to be aware of their role in both the creation and communication of environments, where 'place and self are deeply imbricated, and both are contingent, shifting, always "becoming"' (Heddon in Mock 2009: p. 162).

In addition to the potential within autobiography to write and foreground different selves and lives, Heddon sees autotopography as a possible means of rewriting or reclaiming places (Heddon in Mock 2009: p. 162). One of the modes that Heddon outlines for this is the telling of local stories. Heddon's notion of autotopography can be applied to performances that both draw on autobiographical material and 'take place' in sites of significance, or what Heddon terms 'personalised space' (Heddon 2002: p. 1). I have decided to tell a local story to explore folk singing in the county that I am from, allowing for a rich autoethnographic perspective, and to give the study manageable parameters. Furthermore, I have chosen to do this as a means of recognizing how landscaping processes contribute to the context of folk songs from particular regions. Grant, Short and Turner outline the impact of the narrative turn on the social and human sciences, a development in these disciplines that

signified 'scepticism towards positive-informed "master" or "grand" narratives, which claim objectivity, authority, and researcher neutrality in the study of cultural and social life' (Grant et al. 2013: p. 3). This, they argue, broke the ground that enabled autoethnography and other qualitative methodologies to pursue pluralistic agendas, acknowledging and advancing 'multiple forms of experience in diverse research and representational practices' (Grant et al. 2013: p. 3). Grant, Turner and Short select local, short stories as a celebrated example of such practice and emphasize that 'many autoethnographic writers consider local narratives essential in balancing, and destabilizing the exclusivity of grand narrative accounts' (Grant et al. 2013: p. 3). The need for local narratives, and small stories, in accounts of landscaping and past lives is further explored in my chapter on Dorothy Marshall, and my attempts to voice one of the 'unsung heroines of folk music' (Roud 2017: p. 150).

In her volume *Doing Sensory Ethnography*, Sarah Pink states that sensory ethnography takes as its starting point 'the multisensorality of experience, perception, knowing, and practice' (Pink 2015: p. xi). In terms of this study, this involves theorizing and documenting the sensory aspects of performance articulated by my participants, exploring the embodied practices that folk songs document and evoke, but also reflecting upon, and accounting for, how my process of creating knowledge through research has been sensory. My modes of enquiry have included undertaking a long-distance walk through consecutive collection sites situated along the public footpaths of the South Downs Way, walking with conversational partners and visiting their homes, engaging in archiving activities both online and in the Vaughan Williams Memorial Library, using imagining-in-practice to reanimate the embodied contexts of past lives and attending to the affective aspects of the analysis process. All of these approaches have sought to engage with Pink's argument for 'a process of doing ethnography that accounts for how this multisensorality is integral both to the lives of people who participate in our research *and* to how we ethnographers practice our craft' (Pink 2015: p. xi).

A key aspect of my research this methodology has allowed me to reflect upon, and analyse, is the sensory dimension of the interview process. Such a position views research as a form of participation and considers it through a 'sensory paradigm' (Pink 2015: p. 75), which requires 'conceptualising the interview as a multisensorial event [...] a process through which we might learn (in multiple ways) about how research participants categorise their experiences [...] by attending to their treatment of the senses' (Pink 2009: p. 81). Thus, I am

interested in how my conversational partners articulated sensory meanings, the embodied knowledge I acquired or shared during the interview and the sensory environment that the interview took place in and through which aspects of the knowledge were formed. Furthermore, it enabled me to investigate the different modes through which my conversational partners expressed their experience of what folk songs *do*. As Pink states: 'in interviews, researchers participate or collaborate with research participants in the process of defining and representing their (past, present or imagined) emplacement and their sensory embodied experiences' (Pink 2015: p. 77). By exploring the sensory context of my interviews, I can also bring them into dialogue with the affective and emotional feelings engendered by the process of both singing and participating in the research. As Pink suggests, interviews may be for both researcher's and participant's 'social, sensorial, and emotive encounters' (Pink 2015: p. 76).

Pink argues that it is necessary to produce ethnographic studies in which the role of the senses is explicitly accounted for, and, further, that returning to ethnographic studies and reinterpreting them through sensory analysis may produce new understandings of the knowledge produced. She positions this revisioning alongside existing arguments for viewing ethnography through other paradigms, such as reflexivity, embodiment and the role of gender (Pink 2015: p. 6). Pink's position on ethnography as 'a reflexive and experiential process through which understanding, knowing and (academic) knowledge are produced' (Pink 2015: pp. 4–5) also relates to my use of autoethnography as a methodology. By using autoethnography, I create writing that communicates 'versions of [the] ethnographers' experiences of reality that are as loyal as possible to the context, negotiations and intersubjectivities through which the knowledge was produced' (Pink 2007: p. 22). Thus, I foreground the process of my understanding of my embodied relationship to participants, the research environment and my autobiographical experiences.

As introduced in the previous chapter on autoethnography and the 'local', by focusing on parts of Sussex, this study on folk singing and affective processes of performance and collection contributes to a growing focus on local environments. Pink observes in recent geographical ethnographies growing attention to the senses, landscape, the local and anthropological studies with an emphasis on practices such as walking, housework and gardening:

> such sensory ethnographies both attend to and interpret the experiential, individual, idiosyncratic and contextual nature of research participants' sensory

practices *and* also seek to comprehend the culturally specific categories, conventions, moralities and knowledge that informs how people understand their experiences.

(Pink 2015: p. 13)

Similarly, I consider folk singing as both a sensory and a landscaping practice. Throughout, I harness Pink's notion of the emplaced ethnographer as well as considering what adjustments I may need to make in reference to landscape. Pink proposes that one of the aims of a sensory, emplaced ethnographer is to 'seek to know places in other people's worlds that are similar to the places and ways of knowing of those others' (Pink 2015: p. 25). This process of engagement and alignment in other people's environments and how they perceive them, Pink argues, gives the researcher a potential insight into how those people 'experience, remember and imagine' (Pink 2015: p. 25). Pink's notion of the emplaced researcher also allows for an appreciation of 'the emplaced ethnographer as [. . .] part of a social, sensory, and material environment *and* acknowledges the political and ideological agendas and power relations integral to the contexts and circumstances of ethnographic practice' (Pink 2015: p. 25). Within this study, I assimilate Pink's methods of knowing participants' environments through sharing these and participating in their daily settings. However, I am viewing this located engagement through theories on landscape, rather than through the paradigm of place.

In this book, I include accounts from the people I shared my walk with, in order to understand their own embodied and emplaced reflections, and further illuminate how, 'any consideration of a person's sensory engagement in the world must therefore be considered within the frame of a person in reflective action among other persons and other consciousnesses' (Desjarlais 2003: p. 342 in Pink 2009: p. 54). Walking and talking with my conversational partners were key aspects of this reflective action amongst 'other persons and other consciousnesses', with both the main route of the walk and other moments of finding myself alongside other people providing both planned and spontaneous points of conversation. Performance scholar Misha Myers uses 'conversive wayfinding' as a methodology in her article '"Walk with Me, Talk with Me": The Art of Conversive Wayfinding' (2010). She explores guided walks as a form of performance that creates a 'convivial potentiality as a form of knowing and expressing people's perceptions and experiences of places' (Myers 2010: p. 65). Myers stresses the importance of the body in relation to the conversive aspect

of wayfinding, and as such convivial potentiality is considered as much in terms of embodiment as it is a spoken conversation, 'an active mode of participation is set in motion, which calls upon a range of perceptual, imaginative and bodily sensitivities and skills' (Myers 2010: p. 66). In consideration of these guided walks, Myers engages particularly with Vergunst and Ingold's concept of the 'shared walk'. Myers highlights the companionable elements of a shared walk, where 'the walker's rhythm and the aspect of their bodies converge to become similar' (Myers 2010: p. 66). Further, Myers relates this to Wunderlich's concept of discursive walking, which draws on how the rhythm of the walker aligns with the rhythms of the place they are walking through (Myers 2010: p. 66). Engaging with both these positions, Myers argues that although this does not result in walkers sharing exactly the 'same view':

> Rather, the convergence, and/or mutual alignment and adaption, of rhythm and heading *with* one another and *with* place may encourage modes of emphatic witnessing and the co-production of knowledge through collaborative and connected encounter.
>
> (Myers 2010: p. 66)

Similarly, through mobile research methods such as the shared walk, I extend Pink's concept of emplaced research beyond walking to explore singing with others. This allows me to understand how practices such as folk singing form my participants' experiences of landscapes. James Thompson elucidates mobile research methods through a frame of intimacy, utilizing Eve Sedgework's concept of 'beside' to propose 'research that coexists alongside experiences, processes or objects of interest' (Thompson 2009: p. 133). Thus, Thompson conceives of walking interviews as a 'horizontal' method – 'standing or sitting for that matter beside colleagues, co-participants, audience members and other members of our communities and pausing to acknowledge the affective resonance of any art practice' (Thompson 2009: p. 134). Throughout this research, I have sought to pause beside those I have walked and sung with, and be attuned to the affect in performance.

In this study, I utilize a concept of *landscaping*, which rejects a static and objective idea of landscape and encompasses embodied practices such as walking, climbing and gardening in the creation and process of landscape. There are questions that arise in relation to processes of *landscaping* in folk singing and songs that share in common issues which Pink identifies when categorizing participant's experience of a place. Therefore, I have reframed some of the

questions that Pink has outlined in relation to place, in order to relate them to landscape. The first question Pink poses is, 'how can place be defined if it is something that is not fixed or enclosed, if it is constituted as much through the flows that link it to other locations, persons, things, as it is through what goes on "inside it"?' (Pink 2015: p. 33). This led me to consider how I can understand landscaping as a process formed of embodied acts and how this might manifest in the performance of folk songs. Additionally, I needed to examine how I could maintain awareness of the contexts and subjectivities that produce these processes. Furthermore, it was important to consider which techniques enable me to gain knowledge and insight into ways participants' experience landscape, or landscaping, in relation to song. I have a responsibility to portray participants' experiences, requiring sensitive and rigorous accounts of their sensory modalities and embodied relationships to their performances. These accounts require commitment to explicating and evoking the emergent nature of landscaping, and the researcher's role in how such knowledge was created, and subsequently communicated. This responsibility intersects with Pink's second question in relation to representation, 'given that places are continually constituted rather than fixed, then how can we understand the role of the emplaced ethnographer as a participant in and eventual author of the places she or he studies?' (Pink 2015: p. 33).

I engaged in different techniques and methods in order to generate a sense of the affective relationship between landscape, song and singer. These approaches each engaged with Pink's position on research as 'social, participatory and embodied' (Pink 2015: p. 39). They included being taken on walks by my conversational partners; walking in crowds on footpaths and singing; walking alone; singing as I passed other walkers; meeting singers in churchyards; performing songs in sites of their collection such as pubs and outside houses, archival research in official institutions; revisiting archival research *en route*; asking singers to describe to me the internal processes of performance, activities they undertake whilst singing, or associate with singing; observing singers as they perform folk songs in different contexts, in homes, gardens and as we catch our breath at the top of hills. These all contributed to a process of learning to 'occupy or imagine [. . .] ways of perceiving and being that are similar, parallel to or indeed interrelated with and contingent on those engaged in by research participants' (Pink 2015: p. 39).

Pink suggests that knowledge produced by participatory methods is knowing-in-practice, a concept that was developed by educationalist Etienne Wenger

as a 'social perspective on learning' (Wenger 1998: p. 226). Such an approach views knowledge, as defined through participation, as 'an active process of producing meaning that is both dynamic and historical' (Wenger 1998: p. 53), a process which cannot be produced in the vacuum of the individual researcher. Pink assesses that the implication of Wenger's model of knowing, as situated in practice, 'is that it implies that to "know" as others do, we need to engage in practices with them, making participation central to this task' (Pink 2015: p. 40). By undertaking a participatory approach, I sought not only to share my participant's locations, but further, to reflect on how I was relating to my participants on an embodied level. Furthermore, this participatory approach means that my reflections were *project specific,* 'an embodied and multisensorial way of knowing that is inextricable from our sensorial and material engagements with our environments' (Pink 2015: p. 40).

Knowing-in-practice thus affords a model for thinking in, and with, other people's landscapes. However, it relies upon direct contact with the participant, and therefore it does not provide a model for an embodied study of people's experience in the past. Addressing these limitations, Pink extends Wenger's notion of knowing-in-practice to one of *imagining-in-practice,* in order for ethnographers to 'use their own imaginations to generate a sense of the pasts and futures of others' (Pink 2015: p. 43). Thus, I explore whether imagining-in-practice can be developed being located in the same environment at the same time as participants and investigate whether imagining-in-practice can be extended to historical research subjects to gain a sense of their singing practices across time. Furthermore, I ask whether archival and performative approaches enable such research and whether sensory memory may be accessed through fragments left in songs, letters, diaries or notebooks.

Anthropologist Nadia Seremetakis stresses that the active nature of sensory memory is not reducible to a reflection on the past, but a transformative action that brings that past into the experiential moment of the present 'as a natal event' (Seremetakis 1994: p. 7 in Pink 2015: p. 44). Pink further argues that sensory memory is part of how we know, and this knowledge can be related to current and previous environments, our 'invocation, creation and reinvestment of memories' becoming an 'inextricable element of how we know in practice, and indeed part of the processes through which ways of knowing are constituted' (Pink 2015: p. 44). This affective intensity of the past in the present, a folding together and collapsing of distance, speaks to Carl Lavery's experience of the environment's assault on his senses, and how landscaping practices such as

walking unlock sensory memory in a way that becomes 'an enchanted process in which the subject negotiates the past from the standpoint of the present' (Lavery in Mock 2009: p. 41). It also speaks to my some of my experiences of researching singers and songs in the archive, and then remembering details of these archival encounters in the performative present.

Pink argues that attending to sensory memories opens up varied ways of knowing and imagining for ethnographers. Consequently, I became curious about whether this could be relevant for the sensory memories/lives of the people I read about in the archive, as well as my conversational partners. However, accessing the sensory memories of past lives encountered in the archive presents challenges. One of the areas that Pink identifies is how a sensory focus allows researchers to understand the memories that conversational partners 'recount, enact, define, or reflect on for researchers' (Pink 2015: p. 44). This approach can be applied to archival materials such as letters, and thus I aimed to be attuned to discussions of sensory memory gain an impression of Dorothy Marshall's collecting activities and her sense of the lives of traditional singers she collected from. Pink also identifies that sensory memory can provide a focus, or technique, for the researcher and participant to share environmental stimuli with each other, and gain an understanding of how they each remember (Pink 2015: p. 44). Though it is not possible for me to have conversations with Dorothy Marshall and identify her sensory stimuli, it is possible to attend to clues as to her sensory experience within archival remains, and by engaging in practices she might have undertaken.

Interviewing participants whilst walking, swapping songs and sharing personal experiences, are all participatory methods I undertook that can be understood in terms of what Pink phrases as 'creatively constructing correspondences' (Pink 2015: p. 47). These correspondences were created between my experience and my participants' experience in the present. However, understanding archiving as a practice that brings the past into the present, 'a natal event', also enabled me a framework to creatively construct correspondences with past lives. Thus, I carried Dorothy Marshall's letters with me as I walked, and I wondered not only about the routes she took, but also about smaller details, how she encouraged people to sing, whether she joined in at the wassailing ceremonies she recorded and whether she hummed the tunes she'd collected on her way home. I view these correspondences as acts of opening up possibilities and imaginative potentials, rather than historical reconstructions:

> We cannot directly access or share their [participants] personal, individual, biographical, shared or 'collective' memories, experiences, or imaginations. [...] However, we can, by aligning our bodies, rhythms, tastes, ways of seeing and more with theirs, begin to become involved in making places that are similar to theirs and thus feel that we are similarly emplaced.
>
> (Pink 2015: p. 46)

Within Part 3, I look for the way that Dorothy Marshall used sensory language when she wrote about her life in Chithurst and the traditional singers she collected from. In his article 'Folk Song Collecting in Sussex and Surrey, 1843–1914' (1980), an essay on historical source criticism, music scholar Vic Gammon states that

> In the process of making their collections, these enthusiasts left us with some vital historical evidence on their views on rural popular music, activity, attitudes, and values. To use this music, we need to be aware of the conditions in which it was produced, the limitations and distortions. Once we have broken through, we can attempt to enjoy the music of the rural working people of the period on the terms of those who made it.
>
> (Gammon 1980: p. 65)

These conditions were in part *sensory*. These singers were asked to perform songs that suddenly had different significance, in different environments. These encounters were out of the ordinary, both through the collectors' request for performances of 'old songs' or 'work songs' thought commonplace by the singers, and through the fact of socializing across class boundaries. Similarly, the collectors would have visited to house different to their own, and to places of work where the labour was of a different nature than their own professional pursuits.

One of the conditions identified by Gammon is that the musically literate were taking songs from singers who often didn't read music themselves and attempting to pin these down in different forms. As I have learnt from observing contemporary living traditions, tunes can change from singer to singer, but also subtly in each performance by the same singer; voices mature and change in texture, depth and interpretation over the course of a singer's life; folk singing is a process, and processes present challenges to preservation attempts. The stories I have encountered, and seek to tell, have not only come to me through the content of the archival materials (biographical details, lyrical incarnations) but also the very *stuff* of the materials; my emotional attachment to someone's

handwriting, an instinctive feeling that a small note on the sideline of a music manuscript might be worth deciphering, incidental notes in my workbook made on the day of interviews that transport me back to a shopping list long completed and forgotten. This *implicatedness*, this sensory immersion, is elucidated by Pink:

> When the lone ethnographer is working with his or her own materials, these materials become meaningful in terms of the ethnographer's whole biographical experience of the research process. In this situation, the materials help evoke the sensorality of the research encounter itself (and concomitant memories and imaginaries), rather than just suggesting, for instance, textures and smells.
>
> (Pink 2015: p. 124)

It is possible to view the analysis as a distanced space away from the immediacy of the field, the empathetic relationships to participants and the practices of the archive. However, this sensory and emotional experience of research materials can also be present in the stage of analysis:

> It is indeed as sensorial a process as the research itself: a context where sensory memories and imaginaries are at their full force as the ethnographer draws relationships between the experiential field of the research and the scholarly practices of academia.
>
> (Pink 2015: p. xiv)

My own experience of analysis is that it has decidedly affective resonances and emotional qualities. I have returned to a recording to check the accuracy of the lyrics, only to find myself dissolving into tears as moments of significance or resonance strike me afresh or anew. I reviewed my grandfather's interview not long before my original PhD submission and his mention of my great-aunt Valerie's singing was pressingly poignant two years on. In that 'now', it was one week after I had sung *It Was a Lover and His Lass*, Valerie's favourite Sunday sing-around-the-house song, at her funeral. The process of writing itself can be deeply sensuous, not only in terms of habits, superstitions and atmospheres researchers create in order to get words down on paper but also in how they place themselves back into their research encounters. In the following chapter, I explore different modes of critical writing that may account for the affective experiences of undertaking, and communicating, research. It also engages with debates on how researchers document performance, and as such, how performance may remain in different ways.

In this chapter, I have outlined my use of autoethnography as a research method, and why a methodology that foregrounds personal experience is important to this study. I have begun to locate how autoethnography and messy narratives enable me to draw on the multiple pasts and futures in the performative present of folk songs, following Moriarty's example in creating a text that 'interweaves, overlaps, stops and starts and reflects and represents the splintered narratives of my real life' (Moriarty 2012: p. 2). I have explored how the work of performance scholars can illuminate aspects of the relationship between walking, self and landscape. Additionally, I have discussed sensory ethnography as a research methodology, in particular Pink's concept of emplaced ethnography and its relationship to landscaping practices, and introduced how I may analyse the affective realms of my interviews. In conclusion, I have sought to show how a blended methodology of auto/sensory/ethnography may enable me to understand how the walk produced, as Denzin proposes, a knowing that

> Refers to those embodied, sensuous experiences that create the conditions for understanding [. . .] performed experiences are the sites where felt emotion, memory, desire and understanding come together.
> (Denzin 2003: p. 13)

1.3

The Archive in performance

One of the key areas that affect can illuminate is the ongoing debate around whether archives and performances are seen as binary – one fixed, one transitory. As well as a focus on the performative present of a folk song destabilizing some of the aspects of tradition that hinder progress and inclusion, it also allows for an understanding of both archive and performance as processes. In the introduction to their volume *Performing Archives/Archives of Performance* (2013) editors Gunhild Borggreen and Rune Gade state that 'performance and archive, are often understood as opposed, one representing the fleeting and ephemeral, the other signifying stability and permanence' (Borggreen and Gade 2013: p. 9). However, they also identify that scholars have troubled the opposition between the archive and the performance across different disciplines, disturbing and refreshing the divisions and boundaries between these concepts. They state that one of the core issues at the heart of performance studies is how performance theorists respond to performance as a potentially disappearing art and keep practice 'present for the here and now' (Borggreen and Gade 2013: p. 10). Additionally, they argue, performance scholars are fundamentally concerned with the 'performative powers at work in documentation and archives' (Borggreen and Gade 2013: p. 10).

One of the ways I explore these *performative powers* is through the notion of affect in relation to archival materials and sensory environments. I am interested in how embodied practices of archival research form part of the researcher's role in keeping past performances present in the 'here and now' and how affect can further illuminate the in-between-ness of the archive and the repertoire – 'the productive tensions between ephemerality and permanence' (Borggreen and Gade 2013: p. 16). By viewing folk singing from a performing arts perspective, I wish to investigate how archival activities are absorbed into singers' repertoires. Furthermore, I am interested in how studying folk singing in a particular geographical area illuminates the

environmental (work, topography, agriculture) rhythms traced in singer's intonations, pitch and tempo, and the way that traditional songs might archive certain practices that contribute to their performance. To consider this, I also intend to explore how landscaping processes can animate material that has been preserved in a seemingly fixed format; for example, I am interested in whether walking and singing might bring these affective rhythms to the fore. Thus, through active engagement with archival materials, I hope to analyse and communicate the possible advantages and challenges of destabilizing the archive as a place of fixity and autonomy. Through these considerations I engage with Borggreen and Gade's desire that, 'on however small a scale – the book is experienced as comprising its own "performing archive" that readers return to and add to, thus keeping the ongoing work in motion' (Borggreen and Gade 2013: p. 29).

I encountered a variety of things during my archival research for songs linked to the Downs: stories, songs, dead ends, diaries, manuscripts, and with these instincts, impulses, frustration, boredom, obsession. As Mathias Danbolt states, 'we can't know in advance what the past will turn out to do to us' (Danbolt 2013: p. 462). Materials have affective, sensory, and emotional elements; they *do* things to us. During this chapter, I explore the different affective registers that my archival research engendered, and how performance scholars have understood performance through what 'remains' (Schneider 2001). Moreover, I analyse what strategies can be undertaken to recover performance, and illuminate the ways documents, and fragments animate researchers. As such, I consider why I am drawn to certain subjects in the archive, and how the process of 'knowing' them changes over time, and relates to my sensory experience of their voice, writing or choice of notebook. I also assess whether an auto/sensory/ethnographic account is, itself, a form of performance.

Throughout my initial archival research, I was drawn to the handwriting of Mrs Moseley and thus kept returning to her songs. This was because I found her handwriting attractive, but also because she chose scraps of paper to write on that evoked the period, such as Rowntree's Cocoa blotting paper. However, months later, when I was preparing an academic paper in which I sang one of her songs, I realized that I was drawn to it because it reminded me of something. I opened the box where I keep special letters and cards – a small, personal archive – and took out twenty-two years' worth of correspondence from my late grandmother. I laid one of the letters next to the song script and saw the beautiful similarities between the ways they formed their figures:

Figure 1 Bennett, E, 2008. *Letter from Grandma* [Digital Image].

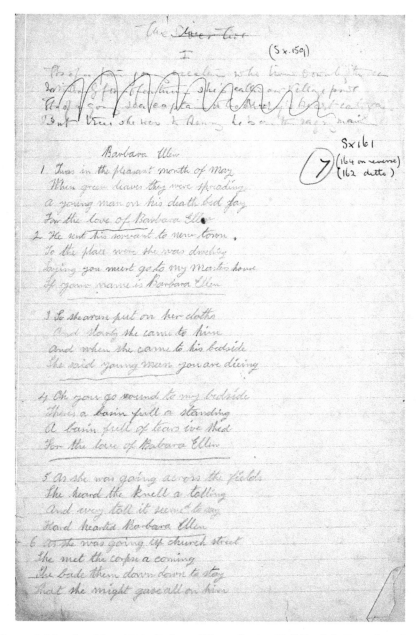

Figure 2 Moseley, Mrs, 1912. *Barbara Ellen* – Lyrics (Full English Digital Archive, English Folk Dance and Song Society (CC/1/161) [Digital Image].

the looped 'I', the slight slant to the right, the strong 'y' with trail leading in. It was an emotional discovery; it *moved* me. Through this encounter, I also began to see the many ways that we *do* things to materials and *they* do things to us. I *kept* those letters through the many houses of my twenties, I *held* on to them and they *came* with me. During the research itself, I *read* the manuscripts, I *laid* them next to each other, I *walked* with them, I *sang* them, I *moved* them, I *returned* them and some instances I *renamed* them. In other words, as performance scholar Heike Roms argues, I 'took care' of them (Roms 2013: pp. 35–52).

In her chapter 'Archiving Legacies: Who Cares for Performance Remains?', Roms explores the possibilities of making the past permanently present through 'actual and physical encounters with the archive in a research context' (Borggreen and Gade 2013: p. 16). Roms observes that through her research into Welsh performance art from the 1960s and 1970s, she became less concerned with whether archival documents and materials can store the 'liveness' of the past event, and instead began to recognize how they might contribute to our overall understanding of the artist's work over their career:

> Not primarily how the documentary remains of performance can (or cannot) offer an insight into the past event [...] but, rather, how those remains speak of performance as an artistic project that is sustained over a body of work.
> (Roms 2013: p. 36)

Thus, the focus becomes a way of viewing performance that values process, in this case the ongoing nature of an oeuvre, or repertoire, rather than Peggy Phelan's notion of the innate temporality of performance, 'Performance's only life is in the present. Performance cannot be saved, recorded, documented, or otherwise participate in the circulation of representations of representations: once it does so, it becomes something other than performance' (Phelan 1993: p. 146). Performance as a process enables a way of viewing how archival records contribute to my understanding of the performance history of a song, by illuminating elements of how it was sung at that time and its ongoing evolution, rather than seeking to represent directly, or replace one single live performance. In relation to living traditions and intangible cultural heritage, such as folk singing, this understanding allows for a conception performance as an ongoing endeavour. As performance theorist Paul Clark states in his chapter 'Performing the Archive: The Future of the Past':

> The intangible field of performance is customarily maintained and adapted between generations – the form's convention and traditions are transmitted and retained through on-going re-articulation, remaining recognisably consistent and becoming transformed.
>
> (Clark 2013: p. 376)

The archival materials I encountered during my research were fragments of performance histories. These fragments enabled me, as a performer, to enter into the history of those songs and give them 'another beginning despite already happening' (Clark 2013: p. 378). However, such material does not simply offer these stories up; it has to be engaged with, touched, tended, and listened to. As Roms argues, 'instead of lamenting performance's inevitable "pastness", the archive encourages us to explore performance's continuing presence in our encounter with these ideas [. . .] and to do so repeatedly' (Roms 2013: p. 37). This exploration can be exacting upon the body and mind of the researcher, requiring reflexive practice and an understanding of what Ann Laura Stoler terms the 'force of writing and the feel of documents' (Stoler 2009: p. 1), and will also be only a partial exploration because 'the archive offers a potential site for engagement that even the most scholarly critique or artistic reimagining can never fully exhaust' (Roms 2013: p. 37).

These engagements are comprised of different affective and emotional realms. One of the main examples of charged encounters explored by performance studies theorists has been the thrill of discovery (Roms 2013: p. 27). In addition to the associations of allure, seduction, and intimacy, illuminated by Helen Freshwater in her paper 'The Allure of the Archive' (2003), Roms explores the notion of the 'intellectually affective charge, which emanates from the ideas that these documents promise to give access to' (Roms 2013: p. 37). For Roms, in relation to performance art, these ideas are 'conceptual dimensions', which continue over the body of work. In terms of folk singing, I would argue these ideas reflect the researcher's propensities towards certain themes, locations, sites of work or styles that constitute a repertoire. As such, I have endeavoured to be alive to the *forces of the encounter* that have led my research avenues. The notion of the imagining-in-practice that may emanate from repeated engagement with fragmented materials is also evoked by historian Carolyn Steedman in her work *Dust: The Archive and Cultural History*, 'a place where a whole world, a social order, may be imagined by the recurrence of a name in a register, through a scrap of paper, or some other little piece of flotsam' (Steedman 2001: p. 76).

This affective charge is argued by Roms to be one of the *legacies* of performance art, which can be thought of as an element of *what remains*. Such a legacy, she continues, is fluid and shaped by the 'archival practices of care' that are carried out by 'archivists, family members, scholars, and the artists themselves' (Roms 2013: p. 38). These practices of care ('selecting, sorting, classifying, preserving, tending, handling' (Roms 2013: p. 37)) have affective dimensions, which contribute to the legacies – 'what remains when not just the performance but also the performer herself is no longer present and her body is replaced by the body of the work' (Roms 2013: p. 37). Roms also explores affective and active aspects of legacy, 'people place material in her [Roms] hands and trust her to look after them', arguing that the sensory practices of care involved in archival work blur 'archival and scholarly and artistic work as distinct activities and reconsiders them as mutual sites of collaboration' (Roms 2013: p. 38).

Conceiving of legacies through practices of care in the archive also allows a different framework for considering a multiplicity of relationships between the researcher and the body of work over time, how the story of a life, or a set of ideas, might change through these engagements and move beyond the narrative of seduction and discovery associated with 'the lure of new material and undiscovered textual territory' (Freshwater 2003: p. 5). The things we do to materials are various, and so are the affects that objects might enact upon us:

> The notion of legacy in English refers to a double existence between tangibility – denoting a material stuff that is being bequeathed – and intangibility – as a synonym for the impact a person's work can exercise. Legacy's performance thus creates both: objects and affects, and frequently (particularly in the case of artists) one with the help of the other.
>
> (Roms 2013: p. 40)

Roms's notion of care-taking in the archive has given me a framework to consider how archival materials may contribute to, and be illuminated through, performances of folk songs in the affective present, and, as such, a sense of the 'double existence' (Roms 2013: p. 40) between intangibility and tangibility. Roms's position attends to how the body functions in, and forms, the archive – 'an archive constituted through continual practices of care – such may be the legacy of art' (Roms 2013: p. 48). Accordingly, the idea of a legacy of performance – a legacy that continues to exercise an impact – also contributes to a conception of the ongoing life of folk songs when they are preserved in the archive, and what they continue to do in the world thereafter. Furthermore, Roms's work provides

a basis for me to contemplate both the tactile and emotional relationship I had to the archival materials I encountered. For instance, the ways in which I took care of my copies of the manuscripts during my walk, and what motivated me to carry them with me and keep them safe.

Understanding the role of my body and its capacity to affect and be affected in the archive provides possibilities for challenging the ontology of performance as *that which disappears*. It also creates a way of conceiving of performance as process, and thus as something that might 'have another beginning despite already happening' (Clark 2013: p. 376). Furthermore, a focus on practices within the archive and how they might animate fragmented, fragile or fringe narratives may in turn illuminate the productive losses that may be gained from rejecting archives as fixed entities. As Schneider proposes, there are political and social implications involved in viewing performance as a disappearing form:

> In privileging an understanding of performance as a refusal to remain [. . .] do we ignore other ways of knowing, other modes of remembering, that might be situated precisely in the ways in which performance remains, but remains differently?
>
> (Schneider 2001: p.101)

Consequently, by giving documents the status of permanence, and performance that of instability, it is possible that these categorizations allow certain groups to speak for others. For instance, the broadly speaking middle-class first folk song collectors for traditional singers, mostly from the rural working classes. Performance theorist Diana Taylor argues that viewing performance as impermanent, or perceiving it through what Matthew Reason terms a 'discourse of transience' (Reason 2006: p. 9), prioritizes certain cultures and aspects of art over others. Additionally, it creates the idea that which is fixed and catalogued has an authority which exceeds that which is transmitted through bodies, as Taylor states:

> Debates about the 'ephemerality' of performance are, of course, profoundly political. Whose memories, traditions, and claims to history disappear if performance practices lack the staying power to transmit vital knowledge?
>
> (Taylor 2003: p. 5)

The term that Taylor employs to covey embodied expressions as learnt, stored, and transferred is the *repertoire* (Taylor 2003: p. xvii). Taylor states that she does not consider the divide between the archive and repertoire as that of the spoken

and written word, but rather a line between artefacts and actions, 'the *archive* of supposedly enduring materials (i.e. texts, documents, buildings, bones) and the so-called ephemeral *repertoire* of embodied practice/knowledge (i.e. spoken language, dance, sports, ritual)' (Taylor 2003: p. 19).

A focus on *process* may provide a means to evolve these distinctions, by positioning documentations of intangible cultural heritage as collaborative and open-ended, whilst still recognizing the power dynamics of collection, curation, and whose heritage is seen as permanent. As I have stated above, there are ways of viewing the archive that foreground the role of actions in its ongoing arrival into the present. Archiving can be an intensely sensuous and tactile experience, involving versions of repertoire-based practices that Taylor outlines ('performance, gestures, orality, movement, dance, singing' [Taylor 2003: p. 19]). Moreover, although folk singing was historically perceived to pass directly from person to person, ballad sheets, and broadsides have intersected with the oral tradition for hundreds of years, and the contemporary tradition inherits from oral, written, and recorded version and other styles and cultures of music. For Taylor, 'the video is part of the archive; what it represents is part of the repertoire' (Taylor 2003: p. 21). And yet, as I have highlighted, a recording may, in contrast, be seen as part of the process of a performance, part of the body of work that relates to that song. As I explore through my interviews with current singers, living traditions are also influenced by that singer's experience of archival materials (such as sound recordings of previous generations). Thus, embodied and sensory experiences of artefacts may be complexly interwoven with performers' repertoires.

Performance practices pose challenges to researchers in how to communicate their traditions and forms through the medium of the written word. Taylor identifies a resurgent interest in how bodies transmit and store cultural memory but argues that researchers not only need to change the subject of our studies but also the tools of our inquiry. Reminiscent of Pink's argument that sensory ethnography should be seen and utilized as a methodology in its own right, rather than simply an add-on to existing modes of ethnography, Taylor argues that researchers need to be attuned to how knowledge is produced in performances, and how we render that knowledge in our tellings and retellings:

> It's imperative now, however overdue, to pay attention to the repertoire. But what would that entail methodologically? It's not simply that we shift to the live as the

focus of our analysis, or develop various strategies for garnering information, such as undertaking ethnographic research, interviews, and field notes. Or even alter our hierarchies of legitimation that structure our traditional academic practice (such as book learning, written sources, and documents). We need to rethink our method of analysis.

(Taylor 2003: p. 24)

Art theorist Laura Luise Schultz in her chapter 'The Archive Is Here and Now: Reframing Political Events as Theatre' uses Schneider's work to argue that 'maybe performance does not disappear at all, even if it does transform, change, jump between bodies. Performance itself is a means of transferring cultural knowledge between bodies and thus a means of preservation and documentation' (Schultz 2013: p. 203). Such an idea of performance as process, able to remain differently through embodied processes, also speaks to the notion of affective archives encounters. However, both require attention paid to the specificity of the bodies, social and political contexts, and the environments in which these processes of transferral and practices of taking care happen. If, as Clark summarizes, a 'constellation of performance residues remains present, held in a network of relations, between bodies and objects, embodied and remembered collectively' (Clark 2013: p. 278), it is vital to think through the various dimensions of those networks, such as the environment of performances, the position and positionality of the bodies in question and how these affective networks and residues may necessitate modes of writing that both perform and build these relationships for/to the reader, and allow the researcher to acknowledge and account for their specific contexts, such as autoethnography.

Notions of continuing impact, affectivity and processes of embodiment pose both challenges and possibilities in the documentation and writing of performance research. Art theorist Amelia Jones discusses an element of these challenges in relation to remembering embodied and time-based work in her chapter 'Unpredictable Temporalities: The Body and Performance in (Art) History'. In this chapter Jones argues for 'more careful attention to modes of writing [. . .] that take *account* of (rather than ignoring or disavowing) the durational' (Jones 2013: p. 54). One of the possibilities afforded by being explicit about performance and temporality, Jones contends, is that it makes visible the fissile nature of scholarship, 'excavating and re-narrating their traces in creative and self-reflexive ways so as to attend to her own unease and lack of finality in positioning herself in relation to them' (Jones 2013: p. 54). Therefore, Jones argues,

scholars should view durational performance as active and allow their work to be open to contingencies. In doing so, she proposes a position on performance as receptive and responsive, rather than 'the tendency to simplify the past by disavowing the potential of performance work to continuing resonating through interpretative acts in the future' (Jones 2013: p. 62). In her work *Building Histories: The Archival and Affective Lives of Five Monuments in Modern Delhi*, Mrinalini Rajagopalan harnesses Sara Ahmed's concept of affect as an economy of emotions capable of moving beyond our private spheres through and into other bodies; 'affect is what sticks, or what sustains or preserves the connection between ideas, values, and objects' (Ahmed 2010: p. 29). Further, Rajagopalan argues that such connections are contingent on contexts such as setting, the presence of both human and nonhuman agents and the necessities and demands of time. Thus, affect works across multiple platforms, disrupting easy categorizations and sequences in relation to performance history and the archive. Furthermore, she posits affect as something that works through us, and in some circumstances, beyond our conscious control, highlighting once more the need to be receptive of the future lives of one's creative output, in performance and/or documentation. As Rajagopalan contends in relation to monuments and the archive:

> Affect is also unpredictable and slippery, in that it appears and disappears unbidden. It may be argued then that, given its fleeting ephemerality, affect has very little stability compared to the archive which is both situated and sturdy, created and managed as it is for posterity. Yet it is precisely this numinous quality of affect, its potential to manifest impetuously [. . .] that threatens the presumed sturdiness of the archive [and] the stable representations of time and place that the archive lays claim to.
>
> (Rajagopalan 2017: p. 3)

Viewing archival research as an affective act of care stresses its live, active nature. This approach disrupts easy categorizations of the archive as fixed and authoritative, making it possible for subjectivities to be acknowledged and embraced in the different stories researchers tell, 'to activate and *become activated by* the traces of past performance works, all the while retaining an awareness of how these processes of activation are occurring' (Jones 2013: p. 67). To retain such awareness both echoes and evokes the sensory modes and techniques outlined by Pink (2015), allowing the researcher to view the role of the body in their production of knowledge. Furthermore, of particular relevance to my work on past performers and collectors of folk songs, and my desire to create resonances with historical

lives, Jones states that a crucial question is 'how are such moments of affect and potential change *registered historically?* How have we accessed them in the present tense of our interpretation?' (Jones 2013: p. 68). The following chapter considers ways in which other performance practitioners have accessed and communicated past performances in the present tense of their interpretation, and how I might apply these approaches to my own desire to sing the South Downs Way.

An area in which Phelan's disappearance ontology of performance can be productively assessed is where researchers write about work that they did not see or experience themselves. Such research often encompasses physical activities or emplaced interventions in sites, which seek to animate or illuminate documentation, oral memory, and artefacts 'left behind' after a live performance, that is, photographs or artists' sketches. This affective immersion in materials and performance sites opens up exchanges and contingencies between the archive and performance. It also speaks to the traces of lived landscapes that reside in performance forms such as folk songs, and to how imagining-in-practice might allow researchers a method through which to discuss affective relationships across time. In an interview with internationally renowned Sussex folk singer Shirley Collins to mark her eightieth birthday, music journalist Justin Hopper articulated these sensory impressions that reach forward through time in the act of performing:

> When Shirley Collins talks about folksong, it isn't a conversation of historical information, musicological data sets, Roud or Child numbers. It is of the corner of a Sussex field. It is a mother strolling through that field's corner and becoming, for a moment, every young woman who'd ever strolled past it. To Shirley Collins [...] each age-old song is that corner field – a magical locus in which the singer is no longer merely themselves, but becomes every man and woman who has ever sung that song.
>
> (Hopper 2015)

By investigating how performing songs in the sites of their collections, and using acts of landscaping such as walking, may illuminate how residues of past performances arrive to us through rhythms, phrasing, words, and intonations, it is also important to consider how they arrive to us *differently* and are received and reconstituted through our own inscribed bodies, as Spry contends:

> Coaxing the body from the shadows of academe and consciously integrating it into the process and production of knowledge requires that we view knowledge from the context of the body in which it was produced.
>
> (Spry 2001: p. 725)

In this way folk songs and archives are opened up to a performative present, but their different bodies and their different affects, politics, and experiences are also acknowledged and celebrated. English folk traditions need to become a space where everyone can feel included but equally not expected to conform to a homogenous group and its practices, nor be alienated by one idea of a country's 'heritage'.

These preoccupations led me to consider how other scholars have engaged with performances they did not witness live through embodied and emplaced research methods: ways in which they have taken the archive for a walk. The work of performance theorist Deirdre Heddon in her paper 'Performing the Archive: Following in the Footsteps', charting her search for Mike Pearson's performance *Bubbling Tom*, was particularly illuminative in this area. Heddon's work engages and develops questions raised above about how researchers may 'activate and become activated by traces of the past', whilst also illuminating the various modes of documentation that allow scholars to communicate how these 'processes of activation' are occurring (Jones 2013: p. 67). Heddon considers Phelan's statement on performance's transitory ontology, 'surely this is not all that can be said! Isn't this only where the conversation begins? I wonder whether it can't be some(thing) other (than) performance' (Heddon 2002: p. 175). Heddon's question relates to her desire to experience Mike Pearson's production of *Bubbling Tom* (2000) after the event had taken place, 'I was not there, and yet I love this performance. I was not there, can I write about this performance'? (Heddon 2002: p. 175). Her explorations become partly a search for an experience of the event through taking care of performance remains, but also an active contribution to these remains through further documentation. Furthermore, Heddon's explorations become an act of re-performing the piece, through seeking embodied resonances as she follows in Pearson's footsteps.

One of the main archival sources Heddon utilizes is Pearson's documented post-performance reflection, which is, Pearson asserts, 'as fragmentary and partial as the memories which inspired the work, and the memories of the performance work itself after a couple of days have passed' (Pearson 2000: p. 176). If one takes the view that performance's life is only in the present, does such a position account for the fact that even those who create the work may not be able to accurately recall it? How does a disappearing ontology of performance account for memory, even with its slippages? Is the memory of performance makers also a 'part of the circulations of representations of representations [. . .] something other than performance' (Phelan 1993: 146). What if the engagement

of theorists and practitioners after the initial event of the performance could be viewed as contributions to the body of the performance, its ongoing process of being-in-the-world? As such, these post-performance continuing(s) would be as fragile and tangential as the continuing existence of things and practices that inspired, or are implicated in, the beginnings of the performance. In the case of Pearson's work, these include local performance traditions, superstitions, and anecdotes. Heddon explores such a processual possibility of performance in her hypothesis:

> Pearson's documentation of *Bubbling Tom* is not, cannot be, the live performance; although it may constitute another (textual) performance. I have not seen *Bubbling Tom*, but I have 'seen' its documentation. If I take this documentation, this other performance, and 'write' about it, then perhaps this 'writing' is itself another document/performance. And these documenting/performance activities will themselves contribute to the archive of various performances, each going by the name *Bubbling Tom*.
>
> (Heddon 2002: p. 176)

Heddon employed various modes of engagement in seeking to create or co-construct her own version of experiencing *Bubbling Tom*, thinking herself into the performance and becoming a 'spectator after the event' (Heddon 2002: p. 175). This 'creative-interpretative process', Heddon argues, can be seen as 'active, and is perhaps even another performance, a third-level *Bubbling Tom*, if you will' (Heddon 2002: p. 176). One of the means Heddon harnessed in order to construct this creative-interpretative process was interviewing. Heddon interviewed people who were present at the event, gaining memories, impressions, and imaginings from these spectators (Heddon 2002: p. 176). Additionally, she spoke to the performer, Mike Pearson, who himself possessed only his own creative interpretation of the event, 'the folklore of practice coloured by aspiration, intention and rationalization, preserved in memory as anecdote and analects' (Pearson and Shanks 2001: p. 57). Second, Heddon visited the site, contending that the site is something that was there, and still remains (Heddon 2002: p. 177). She conceives of site as a 'palimpsest', a place where things might collect, therefore she endeavoured to 'note – touch, feel – any marks in it that are witnessed by the performance' (Heddon 2002: p. 177). Thus, through her sensory perception she inhabited the site, using the relationship between the environment, second-hand memory, and her body to *imagine-in-practice*. Furthermore, if sites are places of collection, they may also collect and assemble

stories; both those told on the day, and those that the day generated. Listening to the re-sounding of these stories may be a means through which researchers can attend to how people experienced their own relations to the landscape, engendered by the performance. In addition, such receptiveness may allow these re-spoken words to resonate through other practices, such as walking and writing, 'I was not there, but the words were, and having been spoken, they leave (regenerative) traces. [. . .] Hear some stories. Stories, and their way of being told' (Heddon 2002: p. 177). Finally, during these explorations, Heddon carried, *bore*, artefacts from the performance. These archival remains enabled her a tactile link to the event through items that she could 'hold in her hands', and a means through which to 'find what is already there' (Heddon 2002: p. 178). Taking these materials for a walk enabled Heddon to gain a palpable entry point to further felt connections to this piece, 'I do now have a feel of (some) *Bubbling Tom*, of its texture, of where it went to and where it came from, of its history and its people, of its affect and its purpose' (Heddon 2002: p. 185).

The different approaches that Heddon employed demonstrate how taking care of performance remains can enable active interventions and contributions to works of performances that scholars have 'never seen but have variously experienced' (Heddon 2002: p. 178). They also share aspects of my own approach to my practice of walking on site on the South Downs Way, carrying and tending to archival materials, and attending to the stories in these documents and from my conversational partners. Art theorist Mathias Danbolt in his chapter 'The Trouble with Straight Time' in *Performing Archives/Archives of Performance* refers to such activities as *touching history*. This term evokes the visceral pulls of the past making themselves known in the present, the active aspects, for example, of sensory memory and imagination:

> I use this phrase with all its sensuous and haptic connotations in order to scrutinize the ways in which we affect and are affected by the past in the present. This entails paying attention to the touching that takes place in our physical and mental labour of doing historical and archival work – searching, digging, reading, writing, desiring, breaking, and shaking things – as well as maintaining an awareness of how history touches us in the present.
> (Danbolt 2013: p. 460)

My fragile imaginings of the encounters between collectors and traditional singers that took place in the first folk revival found its beginning in the small stories told in the field notes and letters that the first collectors sent to the

Folk Song Society; from these, I began to seek other ways of touching that might illuminate these partial records: the paper the stories were written on, the texture of the voices that have survived on phonograph recordings, the feel of chalk impressed by foot upon foot. Moreover, Danbolt's concept of active affectivity also illuminates how these forms of touching might *move* researchers, such as relationships they form through archival encounters, 'how these touches destabilize the relationship between the researcher and the researched, the past and the present' (Danbolt 2013: p. 460). All of these touches exist in worlds of imagining, creativity, and interpretation. Thus, Danbolt's concept of the performative dimension of touching highlights the importance of the possibilities of the archive over closed results or historical authority, 'an inventive act of "reaching towards" rather than a secure arrival' (Danbolt 2013: p. 460).

In addition to the possibilities of active practices of care outlined above, I illuminated these stories by using historical knowledge about the social conditions of the collectors, and photos of the practices of the communities at the time. These areas of research enabled a rich context for imagining-in-practice, whilst also providing inspiration for the ways in which folk songs might evoke or contain previous ways of landscaping. For, in addition to archival materials, I also had songs that had remained through the repertoire of traditional singers. Thus, it is important to explore methods through which it may be possible to listen to and observe the traces, resonances, and vestiges that might be found in collective art forms as they exist today – 'in the way that performance remains, but remains differently' (Schneider 2001: p. 101).

My explorations of practices of care in the archive, and the active, sensory, and emotional relationships I have developed through these materials to archival subjects, require modes of writing that can communicate the 'felt' force of this process. Furthermore, through my consideration of Roms's notion of legacy and Jones's arguments for the durational nature of performance and documentation, such modes of writing need to both communicate my relationship to an ongoing body of performance and be open to further reinterpretations and further performances. For example, the stream of *Bubbling Tom* that resonates through Heddon in her response to Pearson's performance, 'deep pulsating resonances, heart beats, which are not difficult to hear' (Heddon 2002: p. 185), may in turn inspire others to go in search of that spot and give *Bubbling Tom* 'another beginning despite already happening' (Clark 2013: p. 378).

Furthermore, a focus on affectivity highlights the visceral narratives of folk song as they arrive to us through the archives, and how the embodied language they contain illuminates previous and creative ways of relating to the landscape, those 'ordinary occupations', such as the spinning wheel, or the steady rhythm of a cobbler, for example, or the saluting arms of a harvest toast (Warner 2014: p. 1470). The rhythms of everyday activities that accompanied these stories make themselves known, or imagined, through the language and the pattern of the songs, as they have arrived to us today. One way that the visceral language of folk songs is illuminated is by evaluating how language has been identified to act in folk tales, as Marina Warner elucidates in *Once Upon a Time: A Short History of the Fairy Tale* when she considers the 'symbolic Esperanto' of these tales:

> Imagery of strong contrasts and sensations, evoking simple, sensuous phenomena that glint and sparkle, pierce and flow, by these means striking recognition in the reader or listener's body at a visceral depth (glass and forests; gold and silver; diamonds and rubies; thorns and knifes; wells and tunnels).
>
> (Warner 2014: 190)

Such image and sensation-based language, which A. S. Byatt terms 'narrative grammar' (Warner 2014: p.190), should be conceived of as *affective*. This notion of narrative grammar, of words that carry affective histories and produce embodied association, provides a way of conceiving how folk songs have phrases that conjure the way we perceive landscape and the way our activities of relating to that landscape create that perception. That words might contain and transfer embodied ways of being in the world, that they may *behave* in certain ways ('glint and sparkle, pierce and flow' (Warner 2014: p. 190)), may be illuminated by considering aspects of phenomenological theory relating to communication. In particular, the work of phenomenologist Maurice Merleau-Ponty concerns both how we experience the *felt* immediacy of the world, and how such immediacy can be articulated – 'to describe as closely as possible the way the world makes itself evident to awareness, the way things first arise in our direct, sensorial experience' (Abram 1997: p. 35).

In his work, *The Spell of The Sensuous* (1997), David Abram explores what uses of language might help to draw us 'into the sensuous depths of the life-world' (Abram 1997: p. 44). In Merleau-Ponty's understanding of the experiencing 'self', it is through our bodies that we engage in this life-world. Our bodies thus enable us to interact and be affected by things,

have predispositions to certain places and people, leaving ourselves open to other lives. If our embodied relationship with the world is a sensory, affective process, one that isn't closed, but rather ongoing ('these mortal limits in no way close me off from things around me or render my relations to them wholly predictable and determinate' (Abram 1997: p. 47)'), then a means of communicating the animate nature of this process is needed. Abram states that this need for an active means of communication is the reason that Merleau-Ponty 'so consistently uses the active voice to describe things, qualities, and even the enveloping world itself' (Abram 1997: p. 56). Furthermore, Abram focuses on Merleau-Ponty's efforts to theorize how language not just represents experience but absorbs and embodies qualities of the phenomena or materiality, thus a 'communicative meaning is always, in its depths, affective; it remains rooted in the sensual dimension of experience, born of the body's native capacity to resonate with other bodies and with the landscape as a whole' (Abram 1997: pp. 74–5). Abram argues, therefore, that language is always of the body, it both originates in the body and seeks to impart our embodied relationship to the world:

> We thus learn our native language not mentally but bodily. We appropriate new words and phrases first through their expressive tonality and texture, through the way the feel in the mouth or roll off the tongue, and it is this direct, felt significance – the *taste* of a word or phrase, the way it influences or modulates the body – that provides the fertile, polyvalent source for all the more refined and rarefied meanings which that term may come to have for us.
>
> (Abram 1997: pp. 80–2)

Thus, through this embodied relationship to the world, words may be seen to be topographical; they mimic or evoke the lay of the land as it arrives to people through their sensory perception. Whilst Abram's looked specifically at indigenous cultures and traditions such as Balinese shamanism, Apache shamanism, and Apache storytelling, I began to see how some of his insights in relation to Merleau-Ponty's work could be applied to different cultures and contexts. In my interviews with Sussex folk singers, there was a strong sense of the relationship between the form of songs and 'the contour and scale of the local landscape, to the depth of its valleys or the open stretch of its distances, to the visual rhythms of its local topography' (Abram 1997: p. 140). In a recent radio interview Sussex-based folk singer Shirley Collins

recognizes this influence of the local landscape upon her performance of traditional songs, observing that:

> The South Downs is, for me, the finest landscape in the world [...] some of the melodies, especially the Sussex melodies, of the Copper Family, for instance, a family who have sung traditional songs, or had them in their family for generations... *long* lines, so that they rise and fall in a beautiful way, and it just reminds you of the Downs, it just feels like them.
>
> (Collins 2016)

Furthermore, these long lines may be means through which to imagine-in-practice, and therefore to commit these songs to memory. As I discussed with various conversational partners, when I sing, I see coloured lines that relate to the emotion of the song, and move like the terrain of the setting. These lines help to guide me through the song. I became fascinated by how other singers *picture, feel,* and *see* songs that they have learnt by heart. Additionally, this has led me to explore how it is possible to communicate these experiences through writing, in order to capture the animate forces at play in these encounters and performances, 'finding phrases that place us in contact with the trembling neck-muscles of a deer holding its antlers high as it swims toward the mainland' (Abram 1997: p. 274). In addition to the poetics of autoethnography explored by scholars that have influenced this work, in particular Spry and Speedy, I also became drawn to Della Pollock's influential work on performative writing, finding there something of what I was coming to know through writing, rather than writing what I already knew:

> Writing as *doing* displaces writing as meaning; writing becomes meaningful in the material dis/continuous act of writing [...] after-texts, after turning itself out, writing turns again only to discover the power and pleasure of turning.
>
> (Pollock 1998: p. 75)

Furthermore, Pollock's perspective of evocative, performative writing allows 'the generative and lucid capacities of language and language encounters – the interplay of reader and writer in the joint production of meaning' (Pollock 1998: p. 80). This is further echoed by Jessica Moriarty in her book *Analytical Autoethnodrama: Autobiographed and Researched Experiences with Academic Writing*, where autoethnography and autoethnodrama

> Provides an opportunity for co-creation on the part of the reader and writer [...] producing necessarily vulnerable and evocative texts, which offer insight

into how life is (or was) for the writer, can foster empathy, understanding, and meaning-making for both writer and reader.

(Moriarty 2014: p. 2)

In his volume *Documentation, Disappearance, and the Representation of Live Performance* (2006), performance scholar Matthew Reason addresses the documents and materials that surround performance and outlines his intention to 're-focus attention on what it means to see performance through its documentations' (Reason 2006: p. 2). Reason views documentation as an 'interrogative opportunity, by which we may interpret performance' (Reason 2006: p. 3). These interrogative tools, Reason contends, are active. Furthermore, through these active means, performance becomes knowable (Reason 2006: p. 3). One such active means of documentation that Reason proposes is Pollock's concept of performative writing. Performative writing, Reason contends, provides a mode of documentation that both captures and continues the live element of performance. This mode of writing contains 'a memory of transience' (Reason 2006: p. 28) and uses the creative and evocative possibilities of critical writing to allow for reinterpretation:

> Such representation would be partial, transformative, evaluative, and interpretative, yet crucially would also focus on lived experience, on the distant character of being there in the auditorium.
>
> (Reason 2006: p. 205)

This notion of *being there*, of the body of the researcher in the performance space, calls for ways of writing that can communicate embodiment. Reason explores Pollock's intention that performative writing should strive beyond reporting performance, and instead aim for documentation that foregrounds the subjective and the *felt*. Thus, such writing celebrates rather than negates such partiality, and uses 'language like paint to create what is self-evidently a version of what was, is, and/or what might be' (Pollock 1998: p. 80). In instances where the researcher was not present at the live performance, such as Heddon performing in the footsteps of *Bubbling Tom*, using partial and interpretative writing to conjure 'what might be' becomes a way of transcending the borders of 'reporting' into an imaginative account of experiencing archival materials and sites in the affective 'after-lives' of performances.

Writing that seeks to engage with 'intangible, unlocatable worlds' is illuminated by Merleau-Ponty's studies on embodied human consciousness (Pollock 1998:

p. 80). Merleau-Ponty argues that humans' experience of the world is necessarily through the body, 'to be a body is to be tied to a certain world . . . our body is not primarily in space, it is of it' (Merleau-Ponty 2002: p. 171). Consequently, as Reason argues, we also develop ways of relating to other people through our body, to 'feel the thoughts, actions, pleasures and pains of other people through an intersubjective empathy with their body: we literally know how they feel' (Reason 2006: p. 218). Reason continues that performance and performance settings, *being there*, can contribute to, and highlight, such intersubjective affectivity.

However, I develop Reason's position by exploring how this heightened intensity between bodies not only requires the 'being there' of performance, but is fostered through the 'taking care' of archival materials. Practices of custody, protection, cherishing, and even mundane systems of organizing for files that have been left out of place, may encourage and foster affinities to archival subjects. Affinities between your body and theirs, knowing how they feel, may be present before the research began and part of why that archival figure may speak to you, or there may be certain aspects of their character or their life that surface and resurface through one's research that lead to be attuned to similar experiences or traits in your own life. In 'Alice Through the Looking Glass: Emotion, Personal Connection, and Reading Colonial Archives Along the Grain', Sarah de Leeuw positions her intention to explore the biography of Alice Ravenhill, a colonial settler of British Colombia, alongside and at times entwined with autobiographical elements of her own life and research. Leeuw discusses a recent focus within geography on the intersubjectivity of archival research and argues for the worth of:

> Recognizing emotion, confusion, [and] connection to the colonial subjects of the past [. . .] paying close and critical attention to the intimate and personal nature of historic and present-day colonialism [. . .] might offer possibilities for future historical and geographic research aimed at broadening understandings about the colonial present.
>
> (de Leeuw 2012: p. 274)

Sarah de Leeuw's work deals specifically with reading colonial archives and archive subjects 'along the grain', to produce 'a committed, impassioned and emotive response', and encourage researchers to understand themselves as 'deeply and emotionally connected to past colonial settlers', with the aim that such reflections might allow researchers the potential to see 'colonial settlers as more than monolithic, seamless, dispassionate, homogenous and logical powers [. . .] and who, over time, changed and altered their understandings of the work they did and

the roles they played in colonial projects' (de Leeuw 2012: p. 276). Furthermore, de Leeuw argues, if researchers from British Colombia or post-colonial settings understand colonial lives and work as similar to their own, 'there is a chance we might avoid some of their more egregious undertakings' (de Leeuw 2012: p. 273).

The first folk song collectors were predominantly middle-class collectors, recording working-class traditions and transposing them to different settings in a way that we would now understand as cultural appropriation. By exploring archival folk song collector Dorothy Marshall's life and reflecting upon the contexts of collection at the time, I hope not to distance myself from some of the ethical issues of the first folk song revival, but rather to understand the contexts and relationships that made such collections possible, and to remain conscious of areas where modern attempts at preservation, such as my own, might run into comparable complexities of representation. As de Leeuw contends, this is not ignoring the cultural and social hierarchies that produced archival material, but rather working 'along the grain' and assessing where our own practice might require a deeper sensitivity to cultural implications and privileges (de Leeuw 2012). Further, whilst we are able to acknowledge that the work of the Edwardian/Victorian collectors contain limitations, distortions, and biases, they also allow us a means to see, hear, read about the songs. Songs, which are themselves a process.

In writing the walk I undertook along the South Downs Way and my own performances, I am also in part creating the walk again for both myself and the reader, by finding out as I/you go along. Such a mode of writing may be seen as 'walking the walk of "as if"' (Heddon 2002) and a version of 'what was, is, and/or what might be' (Pollock 2007). The embodied phenomenological experience of our landscapes and worlds proposed by Merleau-Ponty, and recognizing ways that this might be stuck to words (echoing Ahmed's concept of affect as 'what sticks' [Ahmed 2010: p. 29]), both relate to my experience of folk songs as performance and how I articulate, or collaboratively produce, 'being there' for the reader. As Reason contends, it raises the question of whether 'the bodily and intersubjective nature of the experience informs the language we use to write about the experience of live performance' (Reason 2006: p. 218).

In terms of representing how it *feels* for my conversational partners to sing songs, it is useful to refer back to Pink's suggestion that the interrelation of senses be considered when discussing, and documenting, the experience of research participants:

> By attempting to become similarly situated to one's research participants and by attending to the bodily sensations and culturally specific sensory categories

(e.g. in the west, smell, touch, sound, vision, taste) through which these feelings are communicated and given value, ethnographer's can come to know other people's lives in ways that are particularly intense. By making similarly reflexive and body-conscious uses of this sensory knowing in the representation of this work, ethnographers can hope to produce texts that can have a powerful impact on their readers or audiences.

(Pink 2015: p. 59)

Reason discusses Thomas Clifton's work on embodied consciousness and music as one means of finding language 'that paints', in this instance through attending to synaesthesia. Clifton's work *Music as Heard: A Study in Applied Phenomenology* (1983) explores the way that music is experienced through the entire body, rather than simply being an auditory phenomenon. Thus, Clifton argues, emotions or affects stimulating one sense can prompt responses in others. As such, Clifton continues, reflecting on synesthetic experience is an important element of research that utilizes Merleau-Ponty's phenomenological view of the body as a general 'instrument of comprehension' (Clifton 1983: p. 69 in Reason 2006: p. 221). Reason develops Clifton's observations by arguing for employing language that can communicate the interrelation of the senses, and by extension, perhaps, intersubjective experience in performance:

> To create an 'embodied' writing that places the reader in the bodily, physical and spatial location of the performance [. . .] Clifton suggests that the spatially or bodily orientated terms to discuss music – terms such as high, low, pointed, bright, dark, bouncy, round, hollow – are not merely metaphorical or allegorical, but are the pointers to the synesthetic of perception [. . .] it is language chosen to discuss an experience because of the bodily nature of that experience.
>
> (Reason 2006: p. 222)

Voices can change in pitch and register throughout a singer's life. However, as I have discovered through this research, they can also change in the harder to locate and communicate sense of *texture*. These are the qualities of people's voices I have not found it easy to categorize in writing, but rather I have found they require a way of telling how the voice resonates through you, how it *affects* you. Reason explores how Clifton's work demonstrates that bodily located words allow for communicating 'textures, space, [and] dimensions durations, registers, intensities and tone qualities' (Clifton 1983: p. 69). Therefore, when describing a singer's voice as willowy in Part 2, it is not the sound of voice itself, but rather my

bodily perception of the sound, 'not stimulus impinging on the body, but effects produced by the body, without which the responses would not exist' (Reason 2006: p. 223).

Through engaging with Pollack's concept of performative writing, and seeking to evoke and interrogate 'worlds that are otherwise intangible, unlocatable: worlds of pleasure, sensation, imagination, affect, and in-sight' (Pollack 1998: p. 80), I create critical research which explicates 'the intimate co-performance of language and experience' (Pollock 1998: p. 81) and uses 'elements of language that instigate a reverberation of the live experience in the mind of the reader' (Reason 2006: p. 227). One of the means through which I might be able to realize these aims is through my use of dialect words, words that have been formed and practiced through years of engagement with particular landscapes. This does not mean, however, that I have found obscure phrases and dragged them back into being, but rather that the Sussex words I know or have come to know during my growing interest in local history have enabled both my appreciation and communication of affect in some instances. Pollock's writes that 'words and the world intersect in active interpretation, where each pulses, cajoles, entrances the other into alternative formations, where words press into and are deeply impressed by the "sensuousness of their referents"' (Pollock 1998: pp. 80–1). It is in dialect words that such sensuousness of their referents appears to me; the word 'shay' for a faint ray of light, performs in its speaking its whispering movement from sky to earth, like Hopkins 'new-skeined score' of the lark in reverse (Hopkins 1877). In doing so, I seek these words in their places of becoming, and contribute to the desire MacFarlane gives rise to in his book *Landmarks* (2015), to assemble 'some of this fine-grained vocabulary' and to release 'its poetry back into imaginative circulation' (MacFarlane 2015: p. 3).

In this chapter, I have considered aspects of affect in relation to archives, and how an affective lens may allow for a way of looking at the performance of folk songs as a process. I have also explored how the process of performance in this book also contains taking care of archival material. Furthermore, I have considered how performance writing and poetics may intersect with auto/sensory ethnography and help to both communicate and create affects for the reader. In all of these avenues, I have been asking what do we do with archives and performances, and what they do to us. The next chapter continues my exploration of affect and affective writing, through non-representational ideas of landscape and how we write them.

1.4

Landscaping

In this chapter, I theorize the embodied knowledge that emerged during the walk through the central concept of *landscaping*: 'practices of being in the world in which self and landscape are entwined and emergent' (Wylie 2007: p. 14). I demonstrate how landscaping allows for an idea of landscape that may be understood through processes and practices, such as walking, and the theoretical developments that have contributed to this conception of landscaping. Specifically, I argue for singing more broadly, and folk singing in particular, as a form of landscaping. To return here to Ingold's illuminating question on lines, 'What do walking, weaving, observing, storytelling, singing, drawing and writing have in common?' (Ingold 2016: n.p.), I would argue that in addition to being types of lines, they are also forms of *landscaping*. Landscaping is informed by both affect and non-representational theory, as Emma Waterton states in *The Routledge Companion to Landscape Studies*, 'affect and non-representational theories have started to animate new and creative approaches, triggering research responses that attempt to access, understand and communicate the ways in which people perform and embody the landscapes that surround them' (Waterton 2013: p. 69).

Landscaping as a concept emerged from non-representational theory, and area of theory developed by geographer Nigel Thrift, which seeks to consider our practices of being in the world, and 'get in touch with the full range of registers of thought by stressing affect and sensation' (Thrift 2008: p. 12). Lorimer identifies non-representational theory as 'an umbrella term for diverse work that seeks to better cope with our self-evidently more-than-human, more-than-textual, multisensory worlds' (Lorimer 2005: p. 83). Non-representation theories, then, can be seen as a collection of arguments for living geographies where the experiential concerns of everyday life, the immediate, tangible, and physical aspects of existing in the world, are considered foremost. Echoing J. B. Jackson's

descriptions of 'our nerves and muscles' being 'brought into play' (Jackson 1997: p. 205) in mobile landscapes, Lorimer states:

> The focus falls on how life takes shapes and gains expression in shared experiences, everyday routines, fleeting encounters, embodied movements, precognitive triggers, practical skills, affective intensities, enduring urges, unexceptional interactions and sensuous dispositions.
>
> (Lorimer 2005: p. 84)

Within studies on embodied landscaping practices the focus shifts away from a primarily visual conception of landscape, to that of a tacit and haptic engagement with environments. This involves understanding how such practices register in senses of self, and furthermore how such registers contribute to multisensory knowledge, imagination, and performance in different contexts:

> The defining feature of recent landscape writing by UK-based cultural geographers is that it is very much written in the light of *both* phenomenological understanding of the self as embodied and of-the-world *and* poststructural understandings of selfhood as contingent, fractured, multiple and in various ways historically and culturally constituent. The accent . . . is therefore upon how different senses of self and landscape are *emergent* and changeable through practices such as writing.
>
> (Wylie 2007: p. 214)

Landscaping as embodied practice utilizes the area of phenomenology developed by Merleau-Ponty, whilst embracing the importance of accounting for, and communicating, perspective, and subjectivity. Non-representational does not mean that representation is supplanted, but rather it produces work that shows how representation can be illuminated through our everyday actions in the landscape: *more-than-representational* (Lorimer 2005). As such non-representational work in this area may be conceived of as post-phenomenological, 'a reconsideration of our relations with alterity, taking this as central to the constitution of phenomenological experience' (Ash and Simpson 2014: p. 50).

As geographer Jennifer Lea states, this 'does not reflect a turn away from phenomenological theories; rather it reflects a critical engagement which rereads them through post-structuralist theories [. . .] combined with a disciplinary context of a turn to practice and the "more than human"' (Lea 2009: p. 373). This turn to the 'more-than-human' results in a focus upon the affective forces and intensities at play in the formation of the experiencing subject in place, space, site or landscape. Lea continues that this focus upon how inhuman,

nonhuman, and more-than-human forces contribute to 'processes of subject formation, place making, and inhabiting the world' has also required a shift in the way that researchers seek to document their discoveries, ways such as 'the use of experiential research methods, and also experimentation with the form of narrating these experiential methods' (Lea 2009: p. 373). By focusing on folk singing as an act of landscaping, and thus as a means of inhabiting the world, I have also sought to experience with research methods such as 'go along' walking interviews. In addition to autoethnography, I have also sought to find ways of narrating that allow me to communicate my experience of landscaping and how my conversation partners have articulated theirs.

Non-representational theories have also come under criticism from feminist theorists and geographers, who are 'concerned with non-representational geographies' reproduction of an undifferentiated body-subject' (Colls 2012: p. 430). Divya P Toila-Kelly in her paper 'Affect – An Ethnocentric Encounter? Exploring the "Universalist" Imperative of Emotional/Affectual Geographies' calls for affective registers 'to be understood within the context of power geometries that shape our social world, and thus research in this field requires an engagement with the political fact of different bodies having different affective capacities' (2006: p. 213). Thus, in my use of landscaping and landscape writing it is important to be informed by autoethnographers such as Spry and ask 'But whose body? Whose words? Where or who does the telling come from?' (Spry 2013: p. 224). By focusing on the bodies in which these practices register present, I hope that my account may join with other, intersectional voices and bodies, claiming landscaping for their own purposes and perspectives.

Writing the experience of *landscaping* has been termed by Wylie as 'landscape writing', which uses creative and critical registers as a means to express self and landscape as emergent, evolving processes 'a co-scripting of landscape, movement, and biography' (Wylie 2007: p. 2008). Wylie observes amongst the key theorists he identifies in this area, Hayden Lorimer, Jessica Dubow and Mitch Rose, a reintroduction of questions of self and perspective, 'the figure who writes, narrates and perceives [. . .] the continuing trace of the subject, of subjects, however ghostly or embodied, relational and contingent' (Wylie 2007: p. 213).

Such work requires innovative and creative ways of writing the relationship between landscape, movement, and biography; 'the advent and advocacy of a more sinuously post-structural geography must necessarily be experimental and affective' (Wylie 2005: p. 237). This relationship between our more-than-

representational worlds and attention to how words may communicate them is evidenced in Thrift's call for non-representational work to 'weave a poetic of the common practices and skills which produce people, selves, and worlds' (Thrift 2006: p. 216). That these practices and skills are created and comprehended first and foremost through the body, necessitates that communicating these practices through the perceived permanency of documentation, must also capture and acknowledge the ephemeral and fleeting, the *affective*, 'stress is placed upon the central role of bodily presence – of sensuous, tactile, and experiential being – in the co-constitution of self and landscape' (Wylie 2006: p. 278). Similarly, these practices operate within the constraints and structures of writing identified by Spry in relation to autoethnography, and 'the sometimes messy, resistant, and epistemologically overwhelming performing body' (Spry 2013: p. 497). Thus, the challenge is to develop embodied registers of writing, whilst also accepting what might be lost in the borderlands of body and word, 'the rupture and rapture of performance that may well exceed the constraints of its (and this) writing' (Spry 2013: p. 497). The different registers in this book – auto/sensory/ethnography, landscape writing, and life-writing – are all utilized to communicate such borderlands of body and world, whilst accepting the partiality of such accounts and the 'the messiness of the experiential [. . .] how bodies unfold into worlds' (Ahmed 2010: p. 210).

The processes of walking, singing, and writing further illuminated to me the specifics of the environment in which these 'common practice and skills which produce, people, selves and worlds' take place. It was my experience of Sussex during a particular period of my life, and in a specific body, which different registers of autoethnography enabled me to reflect on. As a result, the task becomes finding ways of writing that might illuminate and communicate the Sussex Downs as I experienced them then, how my research participants articulated their experience of the Downs, moments where layers of words from other writers of other times swam into the natal present and how all these contributed to my understanding of singing as a way that self and landscape emerge.

In terms of articulating the Downs, my approach was to capture parts that are imprinted on me, such as the run of hills East of the Adur, my mother's account of the line of the Downs when she returned from hospital and the mundane beauty of a dog walk. Foregrounding the importance of the local topography to writing landscaping accounts, Lorimer intimately animates the local landscape of the Cairngorms in his article 'Herding Memories of Humans and Animals':

But you have not studied with your own eyes the long upwards sweep of the land that lifts sheer at the northern corries and then once on high stretches out across the granite expanse of the mountain plateau not the stands of the pines that survive on the lower slopes, nor the sharply incised ravine that must be crossed to reach the grazing grounds. And since I cannot take for granted that you know this topography and its peculiar brand of local information, these responses require careful animation.

(Lorimer 2004: pp. 497–8)

Further to my own impressions of the Downland landscape on my walk, the sensory immediacy of the moment was also at times already captured by the words of others, 'and the great hills of the South Country, come back into my mind' (Belloc 1920). As Pink states, when writing ethnographies researchers may use 'both literary sources – fiction and poetry – as well as existing ethnographic description to demonstrate the sensorality of our experience of physical environments' (Pink 2015: p. 55).

The folding together, and becoming, of these sensory impressions was also contingent on the scale of the walk. My repeated movement over a few consecutive days allowed me to experience patterns of different walkers, varying assemblages of affects and the sheer variance of the walk's topography. Thus, in addition to Pink's emplaced knowledge, I discovered what Lorimer terms knowledge-in-practice, or knowledge-on-the-ground, 'our inquiry must, for the time being, continue to focus on how exactly the steady effort of keeping mobile is spaced by collective action, and how understandings of geography emerge from repeated motion over a terrain' (Lorimer 2004: p. 499).

Lorimer's concept of knowledge-on-the-ground was developed in relation to herding practices and reindeer. Referring to the work of novelist John Berger, and his treatment of animate encounters in his trilogy *Into Their Labours* (1979–90), Lorimer identifies how Berger captures the ways in which emotions emerge from encounters, particularly with the animals of a lived landscape, 'thus, calving, tending, milking, leading, selling, slaughtering, and skinning are treated as practical matters to be taken in hand, but also as emotional entanglements in animal lives' (Lorimer 2004: p. 504). Berger's work leads Lorimer to question:

How best to encounter the textures and cycles of work that leave a landscape replete with meaning. What creative strategies might be employed to reanimate, however temporarily, this embodied relationship between individual subjects and an environment?

(Lorimer 2004: p. 504)

In Part 2, such entanglements can be found in Diane Ruinet's eerie performance of stealing sheep for necessity, but also in lambs dancing around young Jockey and his fair maid, and sucking the fingers of Sandra Goddard, thus becoming part of her narrative recall. They also feature in the isolation of Charlotte Oliver's shepherdess and in Suzanne Higgins's moving story of the use of wool in burial practices for shepherds. This contradictory range of affects – joy, sorrow, desperation, and pleasure – is found in songs and through the singing of them. Thus, through conceiving of folk singing as a landscaping process, it is possible to see how songs give texture to and reanimate the 'embodied relationship between individual subjects and an environment' (Lorimer 2004: p. 504).

By communicating different registers of my landscaping practices along the walk, I join with the search, 'a language attuned to affective worlds of hope, anxiety, care, desperation, joy, wonder, enchantment, dread and desire' (Lorimer 2014b: p. 544). Such affective language can also be found in the songs themselves. One example is the state of loss in Hilaire Belloc's *Ha'nacker Mill* as sung by Bob Lewis, one of my conversational partners. Affective loss runs through why I went walking; why Belloc wrote the song; why the collectors set to noting down the tunes and why people I met, walked, and sang with are still singing them. Loss recalls Boym's reflexive nostalgia in which people cherish 'shattered fragments of memory and temporalize space' (Boym in Mock 2009: p. 9).

In Bob's articulation of the song, there is a process of 'relating and unrelating' to the landscape (Wylie 2007: p. 11). He swings his arms to the sails of the mill and measures his singing of the song thus. There, in Bob's immaculate sitting room, laughing at Bob's apology for still having his gardening shoes on and then having my breath taken away by him bringing a long-lost windmill into the room with his voice, I saw how singing can be an embodied act of landscaping:

BOB: *I'll Sing Ha'nacker Mill for you*

2. *Ha'nacker Mill*

Sally is gone that was so kindly
Sally is gone from ha'nacker hill
Ever since then the briar grows blindly
Ever since then the clapper is still
And the sweeps have fallen from Ha'nacker Mill

Ha'nacker mill is in desolation
Ruin a top and a field unploughed
Spirits that call on a fallen nation
Spirits that loved her calling aloud
Spirits abroad in a windy cloud

Spirits that call and no-one answers
Ha'nacker's down and England's done
Wind and thistle for pipe and dancers
And never a ploughman under the sun
Never a ploughman, never a one

Sally is gone that was so kindly
Sally is gone from Ha'nacker Hill
Ever since then the briar grows blindly
Ever since then the clapper is still
And the sweeps have fallen from Ha'nacker Mill

LIZ: *Wow – that's extraordinary*
BOB: *My pacing of that is the pace of a Mill wheel, the sails of a Mill. I pace it and think about the speed that the Mill is turning.*

(Lewis 2015)

In this chapter, I have explored how it is through participation that we form our experiences of landscapes, and how such a conception foregrounds the importance of understanding the terrains, topographies, and biographies that folk songs have encountered during their performance histories. However, such a conception also allows for an understanding of the future places, people, and landscapes that the songs may encounter – tradition as an evolving form, not as a fixed place of exclusion. In Part 2, these concerns begin again in practice, as I too walk the walk of as if/is/was.

Part 2

Practice

2.1

Footpaths

In this chapter, I begin an autoethnographic account of what unfolded over 66 miles of the South Downs Way. I illuminate how my practice of walking on a long-distance footpath, singings songs that I had found and learnt from the archive, and meeting other singers to listen to them perform may be analysed by, and provide insights into, some of the theoretical considerations discussed in the proceeding chapters on affect, performance, and documentation.

Around the time that I first started to learn songs from my mum, I was asked by an archaeologist friend of mine about participating in a project called Public Archaeology 2015 (PA2015). The project would 'seek to undertake a year of public engagement led equally by archaeologists and non-archaeologists aimed solely at the creation of public engagement with archaeology' (Dixon 2015). Each researcher would have a month where they were encouraged to post regularly and engage others in the process of their research. I was reading Robert MacFarlane's *The Old Ways: A Journey on Foot* and had become drawn to an idea that he explored of Edward Thomas's that folk songs and footpaths were both acts of communal making, kept in existence, preserved, and altered by each act of performance:

> The paths offered (Edward) Thomas cover from himself: proof of a participation in communal history and the suggestion of continuity, but also the dispersal of egotism [...] folk songs and footpaths are, to his mind, both major democratic forms: collective in origin but re-inflected by each new walker.
>
> (MacFarlane 2012: p. 307)

I was also struck by these new songs in my repertoire, shifting senses of self, and moments of emotional significance, becoming bound up with being *in* the landscape. A sense of feelings such as awe, or loss, or lust entwined with, or interrelated with, actions such as walking. Thus, I decided to engage with the growing interest in intangible cultural heritage in archaeology, and search for the

ways that folk songs might *move* people. In order to explore these early thoughts in practice, I considered the possibility of walking along some local footpaths and singing some songs I already knew. However, with the encouragement of James Dixon and a project in the form of Public Archaeology that would provide both parameters and an audience for the research, my plans grew more ambitious and I became curious about how experimenting with length and scale might provide varying contexts in which to consider the relationship between folk songs and footpaths.

After reading John Wylie's account of affect and walking on a long-distance footpath in 'A Single Day's Walking: Narrating Self and Landscape on the South West Coast Path' (2005), I was curious about scale and what repeated movement on a path, or a line of paths, might afford. I began to work on the idea of a long-distance singing walk, which would take place in the first week of May 2015 and cover the South Downs Way from the east to the west of Sussex. Through the Public Archaeology blog, twitter, and word of mouth, I invited people to meet me and perform songs, become an audience for my roughly learnt songs or accompany me for the walk. Additionally, I conducted interviews with local folk singers and asked them to perform or teach me songs that they associated with Sussex.

A strong influence at the time of planning this walk was theatre maker and scholar Mike Pearson's book, *'In Comes I': Performance, Memory and Landscape* (2006). Pearson incorporates family history, personal narrative, and reminiscences into academic enquiry, articulating that he does this both to comment on and appraise what he sees as the ever-expanding profile of personal narrative in site-based work (Pearson 2006: p. 4). Region is 'the lens' through which his research operates; he focuses on the location of his childhood, returning for ethnography in the present, but also reflecting on previous visits both personal and professional. Region is applied here as the 'affective ties between people and place' (Pearson 2006: n.p.). Through this, I saw how I could discuss affect and becoming, or belonging, in relation to walking a sustained stretch of a path that was the 'local' region to me. In addition, Pearson's work, employing archaeology, folklore, local and family history, enabled me to see the importance of an interdisciplinary study of a landscape, and how cultural geography approaches allow me to understand how folk songs and footpaths interwove in my experience walking on the South Downs (Pearson 2006).

As May is a frequent setting of folk songs, I decided to immerse myself in-season and begin on the verge of the month. I was also drawn to the ubiquitous start of

many English folk songs, 'As I Walked Out One May Morning', and the immediacy of movement that it foregrounds from the outset. I began to talk to my parents about the route they had taken when we were little along the South Downs Way, a long-distance walking trail in Sussex, and to contact people who might like to join me either in singing or walking. I then spent a month or so absorbed in finding songs from the archive, mostly from the Full English Digital Collection – via my computer – and via two trips to the Vaughan Williams Memorial Library in Cecil Sharp House, London. I learnt to sing them from the recordings of an afternoon with my friend Dinah Goss, who graciously played the piano from printed out notations, before hastily booking places to stay along the route. On 30 April 2015, I set off for a six-day walk along the South Downs Way, from the west of Sussex to the east (the original trail did not include the parts in Hampshire), armed with a map, a few folders of songs, and a small recording device.

South Harting to Cocking is a 7-mile stretch of the South Downs Way. Near the start of the path is the National Trust property Uppark House, an eighteenth-century private residence. The area of the Downs here has a particular character: dramatic, imposing, sylvan, and bosky – very different from the domestic beauty of my stamping ground of East Sussex – and I had never walked in these hills. However, my association with the area was already strongly of song, having interviewed traditional singer Bob Lewis in his home in Saltdean, Sussex, before my walk began, and heard his tale of Uppark Park resident Sir Harry Fetherstonhaugh. In 1825, Sir Fetherstonhaugh, aged 70, married his 21-year-old milkmaid; Bob wondered if the song *Blackberry Fold* might be based on this event:

3. *Blackberry Fold*

Tis of a young squire as ever I tell
There is ladies of honour that do love him well
That do love him well, but always in vain
For he was in love with a charming milk maid.

Now the squire and his sister were sitting in the hall
As they were talking to each and to all
That squire was singing his sister a song
When pretty Betsy came trippling along.

'Do you want any milk?' pretty Betsy did cry
'Oh yes' said the squire 'step in pretty maid

Step in pretty maid tis you I adore
Was there ever a milkmaid so honoured before?'

'Oh, hold your tongue squire and let me go free
And do not make game of my poverty
There's ladies of honour more fitting for thee
Then I a poor milkmaid brought up by my cows.'

Then the ring from his finger he instantly drew
And right in the middle he snapped it in two
One half he gave to her as I have been told
And away they went walking in Blackberry Fold.

With a huggling and a struggling, pretty Betsy got free
And with his own weapon she pierced his body
She pierced his body and the blood it did flow
And home to her uncle like lightening she flew.

'Oh Uncle, Oh Uncle Oh Uncle' she cried
'I've wounded the squire I'm afraid he will die
All on my fair body he grew very bold
And I left him a-bleeding in Blackberry Fold'.

Now a coach was got ready, that squire brought home
And likewise a doctor to heal up the wounds
To heal up the wounds as he lay in bed
'Pray fetch me my Betsy, my charming milkmaid'.

Pretty Betsy was sent for, pretty Betsy she came
All trembling and shaking for fear of much blame
'The wounds that you gave me were all my own fault
So please don't let my rudeness once enter your thoughts'.

A couple was sent for this couple to wed
And happy we hope is their sweet marriage bed
Their sweet marriage bed, my story I've told
And I've left them a-walking in Blackberry fold.

> *Now there's obviously a verse missing, and I think I've seen something in print about when he tries to have his way with her.*
>
> (Lewis 2015)

Not remembering the words at the time, and only fragments of the tune, I hummed this song under my breath as I waited in the car park for the others to arrive. During Bob's performance, I was struck by the idea of a milkmaid brought up by her cows and of the practice of singing to cows to encourage milk production. As I stood on the Downs, my mind went to the very particular idea of 'trippling', the lightness of treading so as not to spill from the pails, the lilt of such movement in the word and the way the tune, as Bob sings it, tripples along:

> And I've left them a-walking in Blackberry fold
> *Dee-dee-dum dee-dee-dum dee-dee-dum dee-dee-dee*

However, the striking image of a squire left bleeding dark blood amongst the blackberries reminded me that this is also a tale of a woman resisting sexual assault (aside from the complexities of her then marrying the perpetrator), and as such, gives us a more multidimensional view of the life of women in agricultural service at the time, aside from just happily singing to her cows. As Steve Roud summarizes in *Folk Song in England*:

> The more we read about milkmaids in the literature of the time [. . .] the more we realise that they are stock characters, or stereotypes. One clue to this is that they seem to live in a perpetual May-time or summer Arcadia, and they are frequently described as 'carefree' or something similar. No one ever writes of a forlorn milkmaid in February or December.
>
> (Roud 2017: p. 254)

My mum had driven me to South Harting and was going to walk a bit of the first stretch with me, along with our golden retriever Lily, as neither were up to the steep climbs but wanted to set me on my way. I had posted a message on the PA2015 blog giving my starting time and place, welcoming anyone who wanted to come and walk some of the route with me, listen to me sing or sing a song of their own. Around 1.00 pm, I was joined in the car park by Dawn Cansfield, a PhD student and local archaeologist from Midhurst, Diane Ruinet, and Helen Bradbury – both long-time Morris dancers and folk club attenders from West Sussex – all of whom had heard about the walk from the blog or social media. We were also joined 10 minutes on by Paul, a walker, who had heard about the project from a friend and had arrived at the first gate hoping to catch

us. Introductions made and farewells to my mum and the dog, we began the first ascent to Beacon Hill.

Beacon Hill is a Late Bronze Age to Iron Age hill fort, 242 metres above sea level. It was used as a telegraph station during the Napoleonic Wars, a popular period in folk singing, putting me in mind of my mum's Napoleonic songs, and wishing she could have joined us for the view. On that day, dropping down into a hollow on the other side of Beacon Hill, five wind-blown figures gathered for the first song and to shelter my digital recorder. Ingold and Vergunst propose in *Ways of Walking: Ethnography and Practice on Foot* that at the start of a walk 'the first steps we take are tentative, even experimental [. . .] only after quite a few steps, when the feet have found their rhythm and the body its momentum, do we discover [. . .] that we are already walking' (Ingold and Vergunst 2008: p. 3). In a similar way to needing to find one's walking stride upon commencing a long-distance walk, I found that many of the songs took time to become embedded during the performance process – they were tentative and experimental – so whilst I was able to recall the tune of this song, its rhythms and contours had not yet fully reached my body. Nor had I memorized the verses. It was from collector Dorothy Marshall's handwriting that I sang, following uncertainly the lines set out for me. The wind was insistent, billowing in our raincoats, and my chest was rising and falling in mirrored puffs. The spirit of enthusiasm to keep warm, the adrenaline from the climb, the slightly jittery dynamic of a new group of strangers singing together on the refrain, the 'bowing down' at the knees creating moments of laughter and looks of mirth across the circle at the juxtaposition of the jaunty tune with a fairly grim tale, all combined in an affective performance quality of nervous excitement:

4. A Farmer There Lived in the North Country

A farmer there lived in the North country
Bow down, bow down
And he had daughters one, two, and three
Blithe and fair and bonny to see
And I'll be true to my own love
And my love will be true to me

The sisters were walking by the riverside
Bow down, bow down
The sisters were walking by the riverside,
And they popped his fair maid into the tide
And I'll be true . . .

Down she sank and away she swam
Bow down, bow down
Down she sank and away she swam
Until she came to the Miller's dam
And I'll be true . . .

O, miller I'll give you guineas ten
Bow down, bow down
O, miller I'll give you guineas ten
If you take me back to your father again
And I'll be true . . .

The miller took his guineas ten
Bow down, bow down
The miller he took his guineas ten
And he popped her into the water again
And I'll be true . . .

The constable came at the inquest too
Bow down, bow down
The constable came at the inquest too
And together kicked up such a hullabaloo
And I'll be true . . .

The miller was hanged at his garden gate
Bow down, bow down
The miller was hanged at his garden gate
For drowning the farmer's daughter Kate
And I'll be true . . .

The sisters were sent beyond the seas
Bow down, bow down
The sisters were sent beyond the seas
And they died old maids in the Caribees
And I'll be true . . .

(Hutt 1911: CC/1/339)

A Farmer There Lived in the North Country was collected from Frank Hutt of South Harting by Dorothy Marshall on 3 October 1911 (Hutt 1911: CC/1/339). During

the process of learning these songs, I discovered that my curiosity was focused as much on the singers as the songs. I found that the acts of searching for songs in the digital archive and libraries, and then printing and transcribing the words, left me feeling connected to the materials through care-taking, but also connected in a way that meant I felt uncomfortable or distant from the music unless I knew who its previous caretaker had been. I soon found that a lot of my time was spent searching census records and local history volumes rather than learning the words or polishing the performance of the songs. I felt that, by singing these songs in the site of their collection, I needed to have a sense of *who* as well as *where* they came from.

From my census research, Frank Hutt appeared to be Francis Rhodes Hutt, born in 1866, making him forty-five at the time of collection (Francis Hutt 1911). Further information was provided by the transcript for the South Harting War Memorial which lists him as killed in action at Loos on 25 September 1915, aged 49. His widow is given as Mrs Katherine Hutt of Manor House, Harting. I was unsure about this, as to reside at Manor House, Frank would have been a different social class to many of the traditional singers collected from by the Late Victorian and Early Edwardian folk song enthusiasts. As Vic Gammon states, 'the collectors were a small group of professional musicians and musical amateurs, the singers were overwhelmingly from the labouring poor of the countryside' (Gammon 1980: p. 42). Therefore, I returned to the archival image of the song for any further information and found that the residence of Manor House was handwritten in the corner and that Mr Hutt had sung for Dorothy at her house in Chithurst. In my subsequent research into Dorothy Marshall, I was pulled back to the bobbing jollity of our rendition on the hill, by a letter from Dorothy to Clive Carey on 3 October 1911:

> A song which a man who was here today at tea sung when he heard us talk about folk song – the subject crops up a good deal! He had known it [A Farmer there lived in the North Country] all his life and my mother has glimmerings of it too [. . .] the singer lives at Harting, and I think I have 'enthused' him so that he'll do some hunting.
>
> (Marshall 1911: CC/1/339)

It was tantalizing to wonder how he and his mother had learnt his song, and it struck me that his singing for Dorothy is a further challenge to the myth of the generic 'illiterate' or 'unlearned' folk singers. A myth created, in part, by the early collectors in their efforts to claim that, 'folk song constituted the musical soul of the nation, stemming from an unspoilt folk' (Roud 2017: p. 29).

I found the looming presence of the First World War when these songs were being collected during the first folk revival impossible to ignore. I had not been expecting the cumulative effect of my biographical research into these singers, nearly always involving a war memorial, to be as affecting as it was; a repeated pattern across a geographical area resonated strongly as dread as it began to appear and reappear, sharing with film theorist Reyes an experience of dread as 'an emotional state of suggestion in which fear is made possible and imminent' (Reyes 2016: p. 112). If I saw military record, I found I was unconsciously physically crossing my fingers hoping that it wouldn't be a singer or a singer's son. In crossing of my fingers, I was enacting elements of what Anderson calls hope's precariousness, 'hope and other affects are made and remade, come and go, in the midst of temporary, more or less, fragile encounters' (Anderson 2014: p. 101). Hearing *The Steyning Poem* sung at a small singaround in a Sussex barn a year after my walk, brought tears, Frank Hutt, and a palpable sense of both hope and dread into my natal present:

> I can't forget the lane that goes from Steyning to the Ring
> In summer time, and on the Downs how larks and linnets sing.
> High in the sun. The wind comes off the sea, and . . . oh the air!
> I never knew till now that life in old days was so fair
> But now I know it in this filthy rat-infested ditch
> When every shell may spare or kill – and God alone knows which
> And I am made a beast of prey, and this trench is my lair.
> My God! I never knew till now that those days were so fair
> So we assault in half an hour, and, – it's a silly thing –
> I can't forget the narrow lane to Chanctonbury Ring.

(Purvis 1914)

Returning to 30 April 2015, as we passed through Phillis Wood Down, we came across a memorial to the German WW2 pilot Hauptmann Joseph Oestermann. He crashed into the site on 13 August 1940, the first day of the Battle of Britain, having stayed with the plane after it had been shot down to allow two of his fellow crewman to parachute out to safety. We each read the inscription in silence:

<div style="text-align:center">

In Memoriam

Hauptmann Joseph Oestermann

Pilot

1915–40

</div>

Shortly after the memorial, we met a fork in the path, with one way leading towards Treyford, and the other branching off to Midhurst via Hooksway, which Paul would take home. The rain had been arriving in bursts since the hailstorm that heralded the start of our walk and, with a break in the weather, it felt like the right time to sing something to bring that section to a close. A couple of miles south of that spot is Lady Holt Park. It was once the seat of the Caryll Family but the house was demolished in 1770, and it is now a forestry commission estate. Thomas Bulbeck was a labourer at Lady Holt Park when he was visited by George Gardiner and J. F. Guyer in April 1909. His age is given as seventy-six on the manuscript, and census data records him living with his wife Anne Bulbeck; the couple were originally both from the village of Charlton in West Sussex and had five children. Thomas's occupations are listed variously as agricultural labourer and railway labourer (Thomas Bulbeck 1901). He sang thirteen songs for the collectors. I was particularly interested in *Lady Maisry*, as I had not come across any other versions during my archival research. The texts to Thomas Bulbeck's songs are all missing beyond the first verses; the note on the manuscript reads 'the note-book containing the text is missing. The above is from the music manuscript' (Bulbeck 1909). Beyond the lost notebook, texts can also be missing due to the singer writing out the full texts and sending them to the collector after their meeting, and these becoming separated from the collector's tune manuscripts, or because the collector didn't record them in the first place. As Gammon states, taking songs down by pencil and paper was

> An arduous business. It required the complete attention of the collector and the complete cooperation of the singer [. . .] it was best done by two collectors working together, one to take the words, the other the tunes [. . .] usually tunes were collected without full words.
>
> (Gammon 1980: p. 64)

I cast the net a bit wider in Sussex and was able to find a fuller version collected from Mrs Agnes Ford of Withyham, Sussex, situated in the high weald near the Ashdown Forest. The song was collected by Anne Geddes Gilchrist sometime between 1906 and 1907 who was staying with her brother in the area. In the margins of the page she has written that Agnes learnt the song from her mother, as I will be exploring in the next chapter, the female singing tradition is often found in the margins. There is also a related version of the song, *The Little Footmen Boys*, recorded from the Sussex traveller singer Alice Penfold by Mike Yates in 1973. Alice's recording was released

as part of the topic anthology of songs, stories and tunes from English travellers, (Travellers 1979). I met Alice's daughter, Romany Poet Chris Penfold-Brown, as part of my research, and after I had sung the song for her, we discussed Alice's more straightforward, conscious storytelling style of singing and its prevalence in traveller singers. Chris recalled her family knowing some Bulbecks when they lived in the Heyshott area! However, I remember our meeting less for the possibility that Alice might have learnt from, or taught the song to one of the Bulbecks, and more for the sheer pleasure of swapping songs, hearing about the amazing work she does as a member of the Gypsy and Traveller advisory group for Sussex Police, and her experience in 2011 of being part of the first Romany and Traveller History group included on the march to the Cenotaph on Remembrance day.

One of the more challenging aspects of performing Bulbeck's version of this song is that it had a momentum that urged me forward, counter to standing and singing as I was in the clearing, and like the little footmen boys, my impulse was to run:

5. *Lady Maisry*

O mother, mother make my bed
And spread a milk white sheet
That I might go and lie on a soft bed of down
For to see whether I can sleep

And send to me the two bailies
Likewise my sister's sons
That they may fetch me my own love
Or I shall die before even he can come.

The first few miles they walked
The next few miles they ran
Until they came to the high-water side
And laid on their breasts and swam.

They swam till they came to the high castle
Where the Lord he was sitting at meat
If you did know what news I brought
Not one my mouthful would you eat.

What news, what news have you brought me?
Is my castle burnt down?

Oh no, your true live is very, very ill
And she'll die before even you can come.

Saddle me my milk white steed
And bridle him so neat
That I may kiss of her lily-white lips
That are to me so sweet.

They saddled him his milk white steed
At 12 o'clock at night
He rode, he rode till he met six young men
With a corpse all dressed in white.

Come set her down, come set her down
Come set her down by men
That I may kiss of her lily, lily lips
Before she is taken away.

My lady she died on the Saturday night
Before the sun went down
My Lord he dies on the Sunday following
Before evening prayers began.

My lady was buried in the high castle
My Lord he was buried in the choir
Out of my lady there grew a sweet rose
And of my Lord a sweet briar.

The rose did grow, and so did the briar
Until they reached the choir
They met at the top, in a true lovers knot
And the rose it clung round the sweet briar.

(Bulbeck 1909: GG/1/21/1379 and Ford 1906/7: AGG/8/48)

After snaking round and up onto the line of the hills above Bepton Woods, we came across some well-positioned tree trunks that could double as benches. Here, the Downs afford views out to the villages in the plain below, and I asked Dawn if she could tell me which were Treyford, Elsted, and Bepton. One aspect of the first day that has occurred to me upon reflection is that I didn't sing whilst

walking. This was perhaps precipitated by a slight shyness on my part, not having settled into the rhythm of the walk, but also, I think, because the dynamic in the group meant that the songs provided punctuations in our journey, occasioning pauses in which to sit or stand in a group together, rather than walking two by two. As Heddon explores in 'Turning 40: 40 Turns: Walking and Friendship':

> A feature of the companionable walk is its collaborative, inter-active nature, an activity of mutuality. Whilst walkers might accommodate each other's pace, the ground accommodates particular forms or shapes of companionship, of being together [. . .] the physicality required by the walk – the walk's materiality – also prompts certain forms of relationships.
>
> (Heddon 2012: p. 71)

To sing whilst walking may have disrupted these shifting formations, forged along the path, by dint of the focus becoming uneasily located or pointed towards a solo performer, thus throwing our working rhythm 'out-of-step'.

Another possible missed opportunity arising from needing to find my feet during the first day was that I didn't explicitly invite anyone to sing. I became slightly apprehensive about putting anyone on the spot, and I was enjoying listening to the local knowledge of the three women who walked with me, telling tales of old schoolteachers who lived in remote cottages that we passed. However, this had the effect of me taking the role of performer, rather than the facilitator of songs that I had planned. Happily, Diane asked me if – as we were above Didling Church – I might like to hear a 'sheep stealing' song. St Andrews Church in Didling is known as the Shepherd's Church, dating from at least the early thirteenth century. It has no electricity and its simple, whitewashed façade sits as a lone building in the landscape, often surrounded by sheep. Although the song is based beyond these chalk hills and in Dorset, the Downs brought the song to Diane's mind and her performance of the song gave it a particularly local presence and atmosphere, with the wide expanse of the view falling below, and the wind leaving the hills feeling bare and sparse. In this it is possible to see the material landscape of the Downs collaborate in the act of singing as a non-representational acting landscape. As we huddled around the mic, sheltered by the logs, the image of building a house on the moor provoked a longing in my bones. I had never heard the song before, and although I have heard it sung by many other singers since, the atmosphere created both by the setting and the sonorous, earthy tones of Diane's voice – whipped by wind on the recording but never diminished in intensity – was completely unforgettable:

6. *The Sheep Stealer*

I am a brisk lad, though my fortune is bad
And I am most wonderful poor
But indeed I intend, oh my life for to mend
And to build a house out on the moor, my brave boys,
And to build a house out on the moor.

The farmer he keeps fat oxen and sheep
And a neat little nag in the downs
In the middle of the night, when the moon does shine bright
There's a number of work to be done, my brave boys,
There's a number of work to be done.

I'll ride all around in some other man's land,
And I'll take a fat ewe for my own
With the end of my knife, I will end of its life
And then I will carry it home, my brave boys,
And then I will carry it home.

And my children they will pull the skin from the ewe
And I'll be in a place where there's none
When the constable comes I will stand with my gun
And I'll swear all I have is my own, my brave boys,
I'll swear all I have is my own.

It had a yearning for solace, and an intensity of spookiness or thrall, that stories around the fire I was told during childhood camping trips had, when I was both frightened *and* extremely cosy and safe and warm, pulling my sleeping bag around my ears when I got the chills. This thrilling/chilling elucidated for me Sedgwick's proposal that 'affects can be, and are, attached to things, people, ideas, sensations, relations, activities, ambitions, institutions, and any other number of things, including other affects. Thus, one can be excited by anger, disgusted by shame, or surprised by joy' (Sedgwick 2003: p. 19).

Partly from being immersed in Diane's performance, it took me a whilst to remember the tune for the next song I was going to sing up on Bepton Down. It was also due to the song being *Barbara Ellen*, a variant of *Barbara Allen*, thought to be the most widely collected folk song in the English language, and one that I know several variants of. This version is one that I now perform and generally have

an easy passage along its winding flow. However, on this occasion, it was only just settling on my vocal chords, like a song bird ruffling its feathers on a newly found branch. Altogether, there were nine versions of *Barbara Allen* collected across Sussex that appeared on my searches in the Full English Digital Archive. This tune was taken down from Mrs Moseley of Treyford, Sussex, one of the villages laid out below us on the blanket of the weald. She was visited on 14 September 1912 by Dorothy Marshall and Clive Carey and sang a great variety of songs. As with many of the singers, I could have picked any one of her songs, but this one was the first time that I encountered Mrs Moseley's handwriting and, as I have explored, it bore an affective resemblance to my grandmother's. There was an undeniable charge in that encounter, of both the familiarity and comfort of writing that looked so like my grandma's, and an acute sadness for not being able to call her up and tell her about the project. Ingold and Vergunst capture something of my affective encounter with Mrs Moseley's writing, when they contend that

> Our familiarity with words as they appear on the printed page or the computer screen [should not] lead us to forget the deeply sensuous, embodied and improvisatory effort of writing by hand, the sheer physical effort involved, and the expressivity of the inscribed lines themselves, quite apart from the words written in them.
>
> (Ingold and Vergunst 2008: p. 10)

Within this area of the Bepton plains, about 7 miles further north in Redford, West Sussex, Mr Charles Moseley was also visited in the same month by Dorothy Marshall and Clive Carey, and I was curious as to whether there was a connection. Once more, the threads led me to the local war memorial. Frederick Moseley is listed as being killed in action on 4 October 1917, aged 38, in Broodseinde, near Ypres, Flanders. His parents are given as Charles Moseley, born 1837, and Betsy Mosely nee Boxall, born 1842, and it also states that he was born in Chithurst in 1879. I had been wondering whether perhaps Dorothy Marshall knew Mrs Moseley well, as she had given Dorothy Marshall a great number of songs and written down the words herself. Frederick being born in Chithurst provided a connection, as that was where Dorothy Marshall lived. Thus, I worked on the basis that her first name was Betsy, later supporting this with an address in Treyford, and found that she had married Charles in her hometown of Stedham, Sussex, on Boxing Day in 1816. Their first child Charles was born earlier the following year, with six more children – including Frederick – to follow over the next eighteen years. It is perhaps this first son, Charles, who performed the songs

for Dorothy Marshall and Clive Carey, and certain overlaps in their repertoires may support this idea, as well as the addition of songs that Charles may have learnt from pubs and work. Frederick worked as a brickmaker, and his war memorial entry details that the Moseleys were a long established local family in Treyford and that a number of them were involved in brickmaking at Elsted and Ingrams Yard. Betsy and Charles Sr lived in different areas around the cluster of villages during their married life. At the time of the 1881 census they, and all seven children, were recorded as living in Minsted, with Charles Sr's parents, Charles and Mary Mosely, living next door. Ten years later, the family moved to Elsted March and their son Albert is recorded as working at Little Crowshole Farm, a place at which, I later discovered, several traditional singers had worked. In 1901, the family are recorded as living at Station Road, Elsted Green, and Charles Sr is listed as farm labourer aged 65. In around 1905, the family moved to one of the newly built cottages of New House Farm, later moving to 11 Mill Cottages at Treyford in 1910. Betsy predeceased her son in July 1916. Frederick was awarded both the British War Medal and the Victory Medal (RVWM 2022):

7. Barbara Ellen

'Twas in the pleasant month of May
When green leaves they were spreading
A young man on his death bed lay
For the love of Barbara Ellen

He sent his servant down New Town
To the place where she was dwelling
Saying you must go to my master's house
If your name is Barbara Ellen

So she arose, put on her clothes
And slowly (hourly) she came to him
And when she came to his bedside
She said young man you are dying

Oh, you go round to my bed side
There's a basin full a-standing
A basin full of tears I've cried
For the love of Barbara Ellen

As she was going across the field
She heard the knell a tolling
And every toll it seemed to say
Hard-hearted Barbara Ellen

As she was going up Church Street
She met the corpse a coming
She bade them down, down to stay
That she might gaze all on him

The more she gazed, the more she smiled
At length she burst out laughing
When all her friends cried out for shame
Hard hearted Barbara Ellen

Oh I'll go home and make my bed
And make it long and narrow
A young man died for me today
I'll die for him tomorrow

They both were buried in one grave
As in one vault together
And out of their sweet bosoms grow
Red roses and sweet briar

O let it grow, O let it grow
Unto the church high spire
And there entwine in a true lovers knot
Red roses and sweet briar.

(Moseley 1912: CC/1/161)

In addition to the common elements in this folk song – such as the remorseful lover and the floating verse of roses and briars intertwined – as I was performing, I became aware of the functional names of streets that I take for granted and the layers of history that they contain: the familiar becoming unfamiliar. Barbara Allen meets the corpse as she walks up the *Church Street*; pallbearers would often walk long distances to the 'home' church of the district with coffins, and such paths were commonly known folklorically as corpse roads, although local variants include corpse-line or lych-way. The original purpose of corpse roads,

some of which are now public footpaths, can be hard to trace if features such as coffin stones for resting are no longer present. However, stories and place names can play a part in keeping names alive. Superstition has long been linked to corpse paths. In the *Dictionary of Omens and Superstitions*, Philippa Waring contends that one of the enduring and oldest superstitions associated with such routes is that any land over which a corpse is carried becomes a public right of way (Waring 1978: p. 66). Blackdog Hill in Ditchling, Sussex, is so named because of the black dog that is said to guard the old corpse path running from Ditchling to St Martin's Church in Westmeston, the 'home' church for burials in that area. The bell that knells across the fields tolling 'hard-hearted Barbara Ellen' sits at the affective core of this song for me, setting the pace and tone of my singing, and foreshadowing a sense of death from the outset of the tune, a cloying chime reminiscent of the scent of decay emanating from Hawthorn blossoms on a May Day.

One aspect I noticed about having company that day is that my affective field increased because there were more bodies to absorb the immediate moment; I attuned to their attunements. It made me think of the solace of walking with my stepfather, where I am made aware of the names of flora and fauna, noticing them because he notices them. My brain has never retained the examples of wildflowers growing on the way, but if the names haven't stuck, the feelings have. In moments like that, one learns to value ephemeral, blink-and-you-miss-it knowledge, 'affect is the common place, labor-intensive process of sensing modes of living as they come into being. It hums with the background noise of obstinacies and promises, ruts and disorientations, intensities and resting points' (Stewart 2010: p. 40). There were two memorable examples of attunement as we

Figure 3 Bradbury, H, 2015. *Liz and Dawn – 'Barbara Ellen'*. 30 April 2015 [Photograph].

passed along the ridge, down the beautiful open fields descending into Cocking, and through into a wooded path that ran along streams and dovecots. In the fields, whilst I had been deep in conversation with Dawn, Diane had stopped very suddenly, her whole body manifesting an in breath, and with a slight inclination and release of the tension she directed our attention left. There, about 200 metres away, were the shifting forms of springing deer, a brace passing in the opposite direction to us, coming in and out of the long grass and as if they were an extension of it. Half an hour or so later, our bodies collectively stopping again as we meandered down the wooden path and heard the call of a turtle dove, recognized by Helen. Turtle dove populations have declined drastically – 91 per cent since 1995 – and are on the brink of extinction (Sussex Wildlife Trust 2022). I felt its soft purr in my solar plexus, like the feeling of waking in the night and snuggling next to your lover. Ralph Vaughan Williams collected the song *Turtle Dove* from David Penfold – the landlord of the Plough Inn at Rusper, Sussex – during one of his trips to the county in 1907:

> O yonder doth sit that little turtle dove
> He doth sit on yonder high tree
> A-making a moan for the loss of his love
> As I will do for thee, my dear
> As I will do for thee.
>
> (Penfold 1907: RVW2/1/253)

Speaking with Dawn a couple of years after the walk, I said that I wished I had recorded other people's impressions of the songs and the walk in some way. Dawn said that she would be happy to jot down what she could remember, and through this I was able to discover that the unexpected appearance of the turtle dove also remained with her, reaching her in visual rather than auditory impressions:

> DAWN: *In May 2015, I was lucky enough to join a group led by Lizzie Bennett on the first leg of her 'footpaths and folk songs' walk along seven miles of the beautiful South Downs in Sussex from Harting to Cocking. I volunteered to participate for several reasons. I am an archaeology PhD student researching mortuary practice in south-east England during the early Neolithic period, that is, around 6000 years ago. As such, the landscape of the South Downs is an important element of my research, holding as it does clues to the lives of people who have lived and walked there over thousands of years and the memories and traditions that have been passed down over time. I also have a keen interest in folk music and spend a lot of my spare time going to live performances where I enjoy the stories and history*

> behind the songs as much as the music itself. Furthermore, I am Sussex born and bred and grew up in the town of Midhurst, not far from Harting and Cocking. So, it was, for all these reasons plus a love of rambling in the countryside and getting close to nature, that I was drawn to participate.
>
> I remember it turning out to be a sunny day and that the first hill at Harting was steeper than I recalled! The view from the top, however, was well worth the exertion and the route as a whole was very pretty, passing through a variety of landscapes including expanses of chalk grassland with fields of cows and sheep, colonies of cowslips, and shady woodland paths. We even saw a turtledove (my first), right at the end.
>
> We stopped several times for Lizzie to sing local folk songs near their place of origin. I recall being struck by the beauty of her voice, and at Treyford, in particular, it was poignant for me to hear a traditional song from that little Sussex hamlet where a school friend of mine used to live, quite some years ago now. It inspired me to try and find out more about folk songs local to me and how they can link us to the past and connect us in the present.
>
> On our route, our merry little band passed a few other walkers, but we were largely alone in this most wonderful of landscapes, chatting, singing, making our way along, immersed in nature and all its beauty and treading in the footsteps of past generations. It was something of a jolt to reach the A286 in Cocking at the end of the route and be confronted with the twenty-first century again!
>
> <div align="right">(Cansfield 2017)</div>

One of the areas that Dawn's thought-provoking account brought to my mind was that we indeed barely passed anyone. In fact, I cannot recall a single person. As author Eleanor Farjeon wrote in a letter to a friend, 'I can't imagine why the Downs are always deserted [. . .] perhaps they aren't deserted but have the power to make their lovers and wanderers invisible and so keep to themselves' (Farjeon 1986: p. 138). Dawn's description of 'a merry little band' also resonated strongly with me and, in hindsight, this formed relatively quickly after the initial shyness of the first step at Harting. The conquering of a much steeper hill than any of us expected seems to be to be where an ease developed, as we paused conspiratorially to 'look at the view', and came to know more about each other and our interest in folk music. As such, that day's journeying and our reflections on it made visible to me the innately interactive aspects of walking proposed by Ingold and Vergunst:

> Our principle contention is that walking is a profoundly social activity: that in their timings, rhythms, and inflections, the feet respond as much as does the

voice to the presence and activity of others. Social relations, we maintain, are not enacted in situ but are paced out along the ground.

(Ingold and Vergunst 2008: p. 1)

Once we reached Cocking, Diane, Helen, and Dawn went to catch buses and lifts towards home and I checked into the Bull Inn. Hilaire Belloc stayed at the Bull Inn when he undertook a walk from Robertsbridge, in the east of Sussex, to Harting, chronicled in his novel *The Four Men: A Farrago* (1911), and later by Bob Copper when he retraced the steps of Belloc in *Across Sussex with Belloc: In the Footsteps of 'The Four Men'* (1994). It had been my plan to explore a bit and soak up the atmosphere of the building, perhaps performing in the pub if they were interested, contributing my own small part to its folk song history. In fact, the second I dropped my rucksack down on the bed, the orderly room with its generic television and tightly tucked sheets made me long to be outdoors again. With a lightened load, and walking boots discarded for flip-flops, I padded back out into the eventide, letting my toes breathe. When I arrived at Cocking Church, I settled down on the doorstep and looked through my manuscripts for some songs to sing in the intimacy of the stone porch. There were three versions of *The Unquiet Grave* that I had found dotted along the line of the Downs, amongst nine in wider Sussex that were present in the Full English Digital Archive. The song was also taken down from a young Sussex girl by folklore collector Charlotte Latham in 1868, although unfortunately the singer wasn't named. Helen Boniface, Thomas Bulbeck's daughter, was the source of the version that I chose to sing that day. It was performed by her for George Gardiner and John F. Guyer when they visited her father (20 April 1909); she was thirty-eight years old. In the margin by the tune on the manuscript is written 'very nice'. As with her father's songs, only the first verse remains. However, I decided on this occasion to embrace the fragmentary nature of this version, as the tale of the two lovers could be told in full through other renditions further down the road. I took care with this splintered verse and sang it into the peace of St Catherine of Sienna's graveyard, letting the words meet the air of the last night of April, and sending my breath up towards the Downs and above the graves of people who had chosen this as their resting place:

8. *Cold Blows the Wind*

Cold winter winds do blow, sweetheart
Down fell three drops of rain
The first love that ever I had

In green wood, she lies slain
In green wood, she lies slain.

<div style="text-align: right;">(Boniface 1909: GG/1/21/1390)</div>

As I sang, it occurred to me that dying is the last form of landscaping we engage in yet it will be others who do it for us. Ashes-to-ashes, dust-to-dust:

> In an uncertain world, the only thing of which each of us can be sure is that we will eventually die. As we walk through life, with greater or lesser degrees of confidence, we do so with care and concern, and with the knowledge that the ultimate question is not *whether* we will eventually lose the way, but *when*. But even as we mourn those who we have lost, they live on in the memories of those who follow in their footsteps. As one journey ends, others begin, and life goes on.

<div style="text-align: right;">(Ingold and Vergunst 2008: p. 18)</div>

The superstition that to grieve for more than twelve months would bring back the dead is central to *The Unquiet Grave*, and also at the heart of the ballad that my grandfather picked to sing for me. Folk songs are often recorded as having been learnt through people of significance, such as a parent, grandparent or indeed servant, or through social settings like the pub and work where songs were swapped, performed or formed a background to daily activities. On the heightened profile of the pub in singing, and the necessarily gendered picture such a profile creates, Roud asserts that 'the pub was indeed one of the key places for folk performance, [but] its profile has been overemphasized precisely because it was "public"', and thus it is necessary to understand the 'vital role that the family, the home and the workplace played in tradition, as both performance venues and the places where basic repertoires were acquired' (Roud 2017: p. 596). Singing in car journeys is a formative part of how I view both my family's identity and our collective repertoire. The music we sang on these occasions, when we had tired of cassettes or later CDs, was often extremely varied, ranging from Scottish ballads to calypsos to musicals like Oklahoma, and many of these songs came from my grandfather, Gerald. Thus, it was this musical aspect of family life that was the starting point for exploration in our interview, when mum and I visited him in his sheltered housing in Worthing:

> ME: *So, Aunty Alison was telling me the other day that your mother Norah sang . . .*
> GRANDAD: *She sang a bit yes, my dad didn't. It was my grandmother who had the good voice. I remember that she had this beautiful contralto voice. That's all I*

remember about her was sitting by the piano as she was playing and singing, and it was a beautiful sound. My mother liked singing but she didn't have such a good voice, my sister Valerie had a good voice, but it's gone now, she can't sing anymore – poor thing. Now it's jumped to you lot.

ME: And did you sing growing up? Was it something you did together? Did you sing in the house?

GRANDAD: No, we didn't sing as a family, but my mother used to sing when she was washing up, and she used to smoke as well [laughs], so it was not a very good combination because she had smoke in her eyes and so on, but I do remember her singing some nice songs.

ME: When did you then start to sing? As grandchildren that's probably what we would associate you with . . .

GRANDAD: Well, I used to sing to the children before they were going to bed, and before that I sang in the choir at Emmanuel College, and I sang in the Cambridge University Musical Society.

ME: So, when the children were young, first in Hong Kong, and then in Uganda, would you sing English songs to them or a mixture with things like calypsos?

GRANDAD: Oh, we'd sing English songs but I taught them some African stories because at that time I knew quite a lot of African short stories.

ME: And do you remember what sort of songs?

[Pause]

MUM: Well, dad sang a range of songs . . . mum and dad both sang to us. If we were on long journeys, we would sing lots of contemporary songs, but we would also sing songs from their old song books, quite a lot of American songs and old English songs that aren't folk songs like 'Drink to me only with thine eyes'. When dad sang to us on his own in the evening that would often be an English folk song, and there are particular ones that I can remember him singing very vividly for example 'Long Lambkin', 'Lord Bateman', 'The Grey Cock'; songs that for me conjured up a particular kind of Englishness.

ME: So, growing up in Uganda but coming back to England occasionally for holidays your experience of Englishness, then, as a child, is mostly through songs and stories?

MUM: Sort of yes, I mean my only experience of England really was going back to see granny and grandad in Hampstead Garden Suburb. However, because of mum and dad both telling us stories we had this . . . the kind of songs that they used to sing would conjure up really vivid pictures in our minds. For example, 'Lord Bateman', to me, I know the song because I see a great long row of images, which I associated with that song when I was little, I saw it painted in my head. And that's now how I learn a song, I learn it through the pictures in my head'

GRANDAD: *Do you want 'The Wife of Usher's Well?':*

9. *The Wife of Usher's Well*

There lived a wife at Usher's Well
A worthy wife was she
She had three stout and stalwart sons
And she sent them o'er the sea.

Now they hadn't been gone but about a month
I'm sure it was not four
When word came to the carlin wife
That her sons they were cast o'er.

Now they hadn't been gone but about a month
I'm sure it was not three
When word came to the carlin wife
That her sons she's never see.

I wish the wind may never cease
Nor fashes in the flood
Till my three sons came hame to me
In earthly flesh and blood.

Now it fell about the Martin Mass
When nights were long and dark
That her three sons came hame to her
And their hats were O the birk.

It didna grow in dyke nor fen
Nor yet in any ditch
But at the gates of paradise
That birk grew fair and rich.

Make up the fire my maidens all
Bring water from the well
Since I and thine shall feast this night
Since my three sons are well.

Make up the bed in the back most room
Bring out your whitest sheets

And she herself lay by the door
All for to guard their sleep.

Then up and crew the red, red cock
And up and crew the grey
The eldest tae the youngest said
Tis time we were away.

The cock doth crow, the day doth daw
The channerin worm doth chide
If we be missed out o'our place
Sair pain we maun a bide.

The youngest tae the eldest said
Lie still but if we may
If our mother wakes and finds us gone
She'll run made ere it be day.

No – it's farewell to hearth and hame
Farewell to barn and byre
And fare thee well to the bonny wee lass
That kindles my mother's fire.

> GRANDAD: *That song was sung to me in Uganda by a young Scots man and he said whenever he was on holiday he used to go and work in a lighthouse – in those days lighthouses were still manned you know – and it was quite well paid and nothing to do you know except just guard the light, so he studied his books and got paid for it, and he had a very good voice and he sang that song to me and I've remembered it ever since.*
>
> (Moore 2015)

One of the strongest novel impressions I took from this conversation was the idea of manned lighthouses as a place of singing, adding further layers to what might be conceived of as a work song. Additionally, within this anecdote, it is possible to see the song travel from Scotland to Uganda to Sussex. Many places felt gathered into the space of the single room in grandad's residential home, and this was in part due to various objects and photographs from all his travels in close proximity within this space. These items were not familiar to me either, as grandad lived in Italy for most of my life, and I don't remember his house there. He returned to Sussex when I was in my twenties, and although

our relationship was fond and respectful, there was a certain formality to our interactions. The distance was perhaps both felt and instigated by me due to a tendency to grow tense and defensive in the presence of a character I found formidable, unfamiliar, and different. However, when we went to visit him and ask him to sing, there weren't many chairs so I sat on his bed. There is a strange intimacy to sitting on someone's bed that I remember from university halls, and something about the personal nature of being on his bed and seeing his decreased mobility, brought home his ninety years of age and a vulnerability that altered the way that I engaged with him. Discussing also in the extended interview his own recording of Ugandan and Nigerian singers and storytellers gave us common ground, materialized in his edited book *The Penguin Book of Modern African Poetry* on the bookshelf which was cheek-by-jowl with the bed. A more sensitive attitude has extended beyond that meeting and into my interactions with my grandfather since. Pink discusses this folding together or environment, emplacement, and empathy in the interview process when she contends that researchers may have

> To treat the interview as a phenomenological event [. . .] a process of bringing together which involves the accumulation of emplaced ways of knowing generated not simply through verbal exchanges but through, for example, cups of tea and coffee, comfortable cushions, odours, textures, sounds and images. By sitting with another person in their living room, in their chair, drinking their coffee from one of their mugs, one begins in a small way to occupy the world in a way that it similar to theirs.
>
> (Pink 2015: p. 80)

If materiality was foregrounded by my reflections on the interview with my grandfather, it was also present in many aspects of walking and writing that day: Heddon's resonant thoughts on the topography of the walk prompting certain forms of engagement; the evocative texture of Mrs Moseley's handwriting, the delight of the ping announcing Dawn's email, ghostly traces of corpse paths, the graves dug for our final acts of landscaping and the surprise of war memorials on the walk and in the archive, occasioning more affective consideration than I had shamefully ever given the First World War. Furthermore, in these tentative steps towards connections between footpaths and folk songs, a strong preoccupation had begun to form. If both are kept in existence, preserved, and altered by each new performer, where are/were the women giving these songs and paths,

'another beginning, despite already happening'? (Clark 2013: p. 375). It is along this line of thinking that the next day begins.

When I return to this research in 2022 to write the project as a monograph, the interview evokes different and more complex emotions. Both my great-aunt Valerie and aunty Alison have died. I also have two new nephews – new walkers and singers. More endings. More beginnings.

2.2

Women

The next day's walk took me 12 miles from Cocking to Amberley. I was thinking of Charlotte Smith's *Sonnet V to the South Downs* as I began a steady climb up the hill that I had sung to from the stone steps of Cocking Church the previous evening, 'Ah! hills beloved! – your turf, your flowers, remain / But can they peace to this sad breast restore / For one poor moment soothe the sense of pain / And teach a broken heart to throb no more?' (Smith 1786). Charlotte Smith was born in her family seat of Bignor Park, Sussex, in 1749 and, although the house passed to her brother when their father died, many of her poems continued to be set around the area and focused on loss, 'her poetry is suffused with a love for and understanding of Sussex in general and the South Downs in particular' (Labbe 2007). She lived in various parts of Sussex during the course of her life including Midhurst, Chichester, and Brighton. A marriage was arranged with Benjamin Smith when they were both in their mid-teens. After twenty years of marriage and twelve children, three of whom died in infancy, she separated from her husband citing his abusive and unfaithful character, and raised her nine children alone, supporting the family with independent income from novels, translations, and poetry. Her writing is believed to have had a strong influence on William Wordsworth and Jane Austen, with Wordsworth stating in 1833 that Charlotte was 'a lady to whom English verse is under greater obligations than are likely to be either acknowledged or remembered' (Wordsworth in Bygrave 1996: p. 291). Charles Dickens drew from her father-in-law's attempt to leave her money in his will in his exploration of the ambiguities of the law in *Bleak House*, and the conditions in debtor's prisons (Charlotte lived there with her husband during his imprisonment) in his work *Little Dorrit* (Labbe 2007). Credited with the revival of the English sonnet and helping to establish the conventions of Gothic fiction, in the last years of her life she was crippled with rheumatoid arthritis and unable to write. She died in 1806 having avoided destitution by selling the rights to her books.

I took to the hills and Charlotte Smith's poetry for comfort in the relentless, tiring, and dull passage of heartbreak that set the wheels in motion for this walk. I discovered how sadness can be felt physically, the leaden aching in your limbs and the strained eyes rinsed dry from tears. The days that stick, the night you wake to realize you can't remember what their voice sounds like, the lunch where you unload the whole sorry affair to a friend and feel the weight of it pouring out, the pleading that makes you wince years later at the memory of it, a need that feels shameful and desperate as Paul Claudel wrote of Camille Claudel's sculpture *The Implorer*, 'that young woman, she's my sister [. . .] imploring, humiliated, on her knees' (Claudel 1951). What it is to have inched so gradually away from your own centre of gravity, your moral compass, an axis you had taken for granted most of your life, that you find yourself like a spinning top holding on desperately for the movement to slow or for a collision to stop it:

> What grief displays is the thrall in which our relations with others holds us, in ways that we cannot always recount or explain, in ways that often interrupt the self-conscious account of ourselves we might try to provide, in ways that challenge the very notion of ourselves as autonomous and in control. [. . .] Let's face it. We're undone by each other. And if we're not, we're missing something . . . despite one's best efforts, one is undone, in the face of the other, by the touch, by the scent, by the feel, by the prospect of the touch, by the memory of the feel.
>
> (Butler 2004: p. 23)

Affect arrives in these moments. The vulnerability of being that sad, being the person that people get bored of talking to, the rawness of daily encounters, of engagement cards, of clumsily dropped information at dinner with friends of friends that shatters like a glass on the table, everyone eating politely around the shards. All captured perfectly in Judith Butler's use of the term 'displays' and Highmore's metaphor of affect as the cuckoo in the nest:

> Affect gives you away: the tell-tale heart; the note of anger in your voice; the sparkle of glee in their eyes. You may protest your innocence, but we both know, don't we, that who you really are, or what you really are, is going to be found in the pumping of your blood, the quantity and quality of your perspiration, the breathless anticipation in your throat, the way you can't stop yourself from grinning, the glassy sheen of your eyes. Affect is the cuckoo in the nest.
>
> (Highmore 2010: p. 118)

This broken heart was formed by, and through, walking. The sparkle and the disintegration of our romance were accompanied by our footsteps in and around the streets of the capital I had begun to inhabit during my MA. One day, as we were crossing London Bridge, he moved me aside gently by the waist to make way for a large group of tourists, and I realized with a disgusting clarity that I had fallen in love with him: unbidden, unadvisedly, unavoidably, and unutterably. The Portrait Gallery will forever echo with our taut, fraught, final walk. Coloured by silence, and memories of rubbing, not against each other, but against everything left unsaid and everything we should not have said. All the ways in which we had undone each other.

My body, on the other hand, was light this morning, open rather than fearful of what my affective encounters with the world might bring that day. I curved around off Cocking Hill onto the ridge of the Downs that leads to Heyshott trig point, entering a field to see the trig point and interrupting an entire exhalation of larks. Skylarks are an extremely common sight on the Downs during the summer months, but I would usually see them in isolation, or two and threes, high up above, cresting the horizon in mid-song. It was quite extraordinary to see a field of pulsating body of birds rise up together from the grass and begin to sing – embodying vividly Gregg and Seigworth's conception of affect as an 'inventory of shimmers' (Gregg and Seigworth 2010: p. 1). I sang the next song with my back up against the trig, rather timidly in volume, feeling like an interloper. However, halfway through the song, I tipped my chin up to join the larks above, singing of their freedom:

10. *Green Bushes*

As I was a-walking one morning in Spring
To hear the birds whistle and the nightingale sing
I heard a young damsel so sweetly sang she
Down by the green bushes where she thinks to meet me.

'I'll buy my love beavers and fine silken gowns
I'll buy her white petticoats flounced down to the ground
If you will prove loyal and constant to me
And forsake your own true love and be married to me'

'I want none of your beavers or fine silken gowns
Do you think I'm so foolish as to marry for clothes?
But if you'll prove loyal and constant to me

I'll forsake my own true love and be married with thee'

'O, let us be going kind sir if you please
O, let us be going from under these trees
For yonder is coming my true love I see
Down by the green bushes where he thinks to meet me

O when he got there, and found she were gone
He stood there like some lambkin, that was all forlorn
She's gone with some other and forsaken me
So adieu the green bushes, forever, said he

Now I'll be like some schoolboy, spend my time at play
I'll never be so foolish [*sic*] deluded away
There shall never a false women serve me so anymore
So adieu, the green bushes, it's time to give o'er'.

(Spooner 1911: CC/1/116)

The singer of *Green Bushes* was Stephen Spooner, and Dorothy Marshall visited him in the Midhurst workhouse in 1911. In the corner of the song sheet there was a note that made me smile, 'a pretty tune. I have it rather badly on the phonograph. Isn't it rather nice? Mrs Stemp also sings this, I'll try to get her version' (Marshall 1911: CC/1/116). She wrote to Clive Carey after her visit, 'I have been haunting the workhouse where there is a dear old boy who seems to know a lot of songs, some of which I enclose. [. . .] I have got four records from old Spooner, shall I send them to you?' (Marshall 1911: CC/2/146). From the trig point, to the workhouse, my thoughts wandered to the Sussex singer Bob Lewis and the Heyshott of his youth:

> BOB: *So Heyshott really, the village, still was very much a close community, as many of the villages were at that time . . . and you could identify, for example say Heyshott, you could say 'Tuppers, all the Tuppers live in Heyshott' and wherever the next village was you could say it was 'all the Knights'. [. . .] What was nice about Heyshott was that people on the farms sang spontaneously, and I can remember my experience with singing, which was I worked on the farm, our next door neighbours were the Hills, and the usual thing was to sing at milking time, or any excuse for a sing song really, we didn't have any television or anything like that. [. . .] Again I did this [being interviewed] with Bob Copper years and year ago you know in the 1950s people were going round from EFDSS and the such, collecting songs in the locality – they only really scratched the surface – because I*

> counted in the immediate sort of geographical area no less than forty people who today would have been classified as traditional singers, you know because it was still very, very much a part of everyday life.
>
> There was a chap I knew that worked in the woods, Norman Spooner, he had a terrific repertoire of songs and his son-in-law sang as well. There was a Spooner that was collected from in the Workhouse in Midhurst who must be a forebear of the Spooner family. Anyway, the undertaker, old Ken Linton, he also had a terrific repertoire of songs, and he used to sing, and the chap that was, Ted Ayling I think his name was, he had a watermill out at Terwick and I can remember them singing in the pub. [. . .] So, yeah it was still very much part of the fabric of everyday life. We sang up in the woods, I can remember one day we were cutting trees down at Heyshott, felling trees out on Love's Farm, and it was a foggy day – you now, just sort of this mist hanging over everything – and Boy Knight, who came from Cocking, was working with me and he started singing 'The Galloping Major', and then the repeat verses were coming back across the Green from this chap who was the local undertaker working in his shop round the back of Heyshott Church; this sort of voice from the mist.
>
> (Lewis 2015)

Walking the path that runs through Graffam, after Heyshott, I was pleased not to hear any voices rising from the mist, which had seemed such an enchanting idea in Bob's living room. Mist in this area is still referred to as foxes-brewings, evoked by Lower in his *Compendious History of Sussex*:

> A curious phenomenon is observable in this neighbourhood. From the leafy recesses of the hangers of beech on the escarpment of the Downs, there rises in unsettled weather a mist which rolls among the trees like smoke out of a chimney [. . .] if it tends westward towards Cocking rain follows speedily. Hence the local proverb: – 'When foxes-brewing goes to Cocking, foxes-brewing comes back'.
>
> (Lower 1870: p. 119)

The tree tunnel of the wooded path in the woods created an echo of my footsteps, creating the sensation of someone walking behind me. It's very difficult, even if you know rationally there is no one behind you, not to react when you feel that prickle, that precognitive impulse to turn around, the 'shivers down the spine' that Featherstone gives as an illustration of 'affect as the experience of intensities' (Fetherstone 2010: p. 195). Singing fragments of *The Cuckoo* to distract myself, and cover the noise, worked well as it meant I did not have to hold my breath; the

Figure 4 Bennett, E, 2015. *Graffam Woods*. 1 May 2015 [Photograph].

singing belonging to Dewey's notion of the 'intrinsic connection of the self with the world through reciprocity of undergoing and doing' (Dewey 1936: p. 257):

The Cuckoo's a pretty bird, she sings as she flies
She brings us glad tidings, and she tells us no lies
She sucketh white flowers, for to keep her voice clear
And the more she sings Cuckoo, the summer draweth near

As I walked down by the side of a bush
I heard two birds whistling, the blackbird and the thrush
I asked them the reason so merry they be
And the answer they gave me, we are single and we are free.

(Trad.)

As I reached a crossroads at the end of Graffam Down, I thought of the emphasis Bob placed on singing as a fabric of everyday life: a network linking people to place, a 'meshwork of paths' weaved by daily activities (Ingold 2008: p. 180). In that part of our conversation, the examples he had given about Heyshott had been traditionally male, that is the farm, the pub, and professionals like undertakers. However, when interviewing Bob about his life, I was struck by the role of his mother. I wondered where she learnt her songs, and the way that such songs might accompany what would be historically perceived as gendered domestic activities. Steve Roud highlights an account Sabine Baring-Gould gave of his experience collecting from a female traditional singer:

> There is an old grandmother on Dartmoor from whom I have had songs. She sings ancient ballads, walking about and pursuing her usual avocations whilst singing. She cannot be induced to sit down and sing – then her memory fails,

but she will sing whilst engaged in kneading bread, washing, driving the geese out of the room, feeding the pig: naturally, this makes it a matter of difficulty to note her melodies. One has to run after her, from the kitchen to the pigsty, or to the well-head and back, pencil and note-book in hand.

(Baring-Gould 1895 in Roud 2017)

A large proportion of the anecdotal evidence we have of women singing to accompany their domestic chores is from men, Cecil Sharp in 1907 recalled, 'one singer in Langport could only sing when she was ironing, while another woman in the same court sang best on washing day' (Sharp 1907). However, Alison Uttley born in 1884 and brought up in the Peaks provides an illuminating account of her musical life at home in her autobiographical *Country Hoard* (1943), including this passage on her mother:

My mother was the singer of the household, she sang as she went to and fro between dairy and kitchen, to the garden and yard, interrupting her hymn or ballad to give a command, to call someone, then resuming where she left off. She led the rounds and catches which we all sang on winter nights – 'London's burning', 'Three Blind Mice', and 'Orange and Lemon'.

(Uttley 1943 p. 60 in Roud 2017)

If, as Cecil Sharp conjectured, every village in England was once a 'nest of singing birds' (Sharp 1907 in Roud 2017), then it would stand to reason that the domestic sphere of singing, which even then a frustratingly small amount was known, was only a partial area of the singing activities of women. In terms of a relatively contemporary study, Ginette Dunn illuminated the generative constraints of female singers in her study of the vernacular musical practices of Blaxhall and Snape in the 1970s. Conducting extensive interviews with women who were born and raised between the two world wars, she observed:

Whereas the majority of the men in Snape and Blaxhall are pub centred in their singing, very few of the women have relied upon the pub as their place of performance. They have found their audiences variously in their children, in women's club meetings, and with the men at village concerts and socials, at harvest frolics, at charity concerts and old folks' meetings, at wedding parties, and also in the pubs. . . . Overall, the singing habits of the women have been far more varied than those of the men, a strange situation to arise from constraint, both moral and physical.

(Dunn 1980: p. 112)

Roud also highlights a chapter in Mike Pickering's *Village Song and Culture* (1982) where he explores the life of Martha Gibbons from North Oxfordshire (1833–1916), who was 'well known in the village for singing at her work in the fields, and reminds us that it was not only men who were engaged in farm-work in the nineteenth century' (Roud 2017: p. 642). Pickering expands that 'she started at agricultural work whilst she was still a girl and continued it until a couple of months before her death. [. . .] Martha's favourite song while at work in the fields was the gory and treacherous *Ballad of Cruel Lambkin*' (Korczynski et al. 2013: p. 73).

One of my favourite footpaths in all of Sussex was created, in part, by working women. The Juggs Way links Lewes to Brighton, once an ancient trackway and Roman road; it is named after the wives of fishermen who walked the trading route across the Downs to the market at Lewes, with the catch of the day from the then fishing village of Brighthelmstone (1700s). They carried the salted herring and mackerel in earthenware jugs on their heads or packed onto donkeys. They walked 8 miles there and 8 miles back. Little is known about the women this involved, or whether they sang whilst they walked, perhaps to warm their voices up for their cries at market. Dr Russell evokes 'drunkards and fighting fishwives' in his account of moving to Brighthelmstone from Lewes after the publication of his seminal work on seawater: *Dissertation on the Use of Sea Water in the Affections of the Glands* (1753). However, most of the historical record of fishwives, and their reputations, comes from male writers and artists. Consider, for example, Donald Lupton's account in London, 1632, 'these crying, wandering, travelling creatures carry their shops on their heads [. . .] they are merriest when all their ware is gone [then they] meet in mirth, singing, dancing, and in the middle as a parenthesis, they use scolding' (Lupton in Fraser 2011). What these women have left, however, is a path: a path on which one can sing, walk, and imagine. A path which is both an archive and a performance.

Whilst certain spheres of work and performance may have been gendered during the nineteenth and early twentieth centuries, daily activities would have brought people together in encounters. Thus, in reading Flora Thompson's passage on occupational singing in *Lark Rise to Candleford*, I was put in mind of a photo I had seen of a fish-hawker at the doorstep in Heyshott, in conversation with the lady of the house:

> Most of the men sang or whistled as they dug or hoed. There was a good deal of outdoor singing in those days. Workmen sang at their jobs; men with horses

and carts sang on the road; the baker, the miller's man, and the fish-hawker sang as they went from door to door; even the doctor and parson on their rounds hummed a tune between their teeth.

(Thompson 2009: p. 52)

The women who lived in these houses, and bought the fish from the hawkers, did not live in a vacuum; they would have heard the songs being sung on these rounds, and it is possible to envisage that they would have learnt and sung them. As I rested by the signpost and looked back over the villages surrounding Midhurst, I pictured the hive of women whose lives these songs accompanied, walking to and from rooms, barns, work, houses, friends' houses, alone, with babies, and in company. In an area of discourse historically dominated by men – both singers and collectors – 'the vast majority of the writers of the record were male, while much singing at work was done by females' (Korczynski et al. 2013: p. 40), to envisage the lives of these women, and think of Bob Lewis's mum popping down to see her mate Edith and arriving back with a new song, felt to me to be what Jonathan Bate calls a 'necessary imagining' (Bate 2011: p. 93):

ME: *I believe your mother sang?*
BOB: *Yes, I mean I learnt . . . but my mother just sang around the house, she never, ever, ever, ever would have dreamt of performing anywhere. She certainly didn't go to the pub or anything like that, so really, essentially, it was stuff that was sung about the house. What I would say is that mother was born in 1905 and as a little girl in school she was actually indoctrinated with Cecil Sharp's 'Folk Songs for Schools', as indeed practically all of the country was, so she knew a lot more run of the mill things as well; she'd say 'oh we used to do this at school'. But, she had a life-long interest and she worked, well certainly later on after my father died, and we'd not very much to live on – quite poor really – she worked for West Sussex County Council as a home help, and she went here, there, and everywhere around in the locality, and she'd visit the elderly folk who lived right out in the sticks or in the woods and goodness knows what else, and do their washing for them and the like, and then she used to come back and say I've seen old Mrs so and so and she sang this, and out it would come, you know. [. . .] I remember this ('Spread the Green Branches') was something that Edith Wright sang, who was a friend of my mother's, my mother used to disappear down the High Street, down Heyshott Green and that, and she used to go down there and play the piano together and all that and sit in Edith's cottage – and mother came back with bits and pieces like that:*

11. *O Spread the Green Branches*

O spread the green branches, O whilst I am young So well did I like my love, so sweetly she sung
Was ever a man in so happy a state?
As me with my Flora, fair Flora so brave

I will go to my Flora, and this I will say
'Tomorrow we'll be married, it wants but one day'
'Tomorrow' said fair Flora 'that day is to come
To be married so early, my age is too young'

'We'll go for a service and service we'll get
And perhaps in a few years after, might substance and reap'
'Oh don't go to service, leaving me here to cry'
'Oh yes, lovely Shepherd, I'll tell you for why'

As it happened to service, and to service she went
To wait on a lady and it was her intent
To wait on a lady and a rich lady gay
Who clothéd fair Flora in costly array

A little time after a letter was sent
With three or four lines in it to know her intent
She wrote that she lived in such contented life
That she never did intend to be a young Shepherd's wife

These words and expressions appeared like a dart
I'll pluck up my courage and cheer up my heart
O being that she'd never write to me anymore
Her answer convinced me quite over and o'er

My ewes and my lambs I will bid them adieu
My bottle and budget I will leave them to you
My sheep crook and black dog I will leave them behind
Since Flora, fair Flora, so changed her mind.

Listening to the recording now, I can picture Bob's beautiful ruminative style of singing, where he looks just past you into the distance, and through his

expression you travel back with him. As I watched him then, I was sung into the space where he had first encountered the song through his mother. As Pink contends, 'imagination is, of course, not simply about the future – it might concern imagining a past, another person's experience of the past or even of the present as it merges with the immediate past' (Pink 2015: p. 46). The song also allows me to imagine the activities of Bob's mother Anita, whose visits to the rural elderly through her job may have provided her with an opportunity to hear their songs. She walked to these houses and engaged in physical tasks such as laundry, both of which may have been accompanied by singing. Within the song, we see a woman engaged in the occupation of service; Dorothy Marshall collected several songs from her servants that worked within her house. Thus, whilst it is possible to infer that there was a culture of singing within service, there is not the same breadth of accounts of how this singing accompanied their work that is available for male farm labourers, for example. Dorothy Marshall may have spoken to her servants but it is not clear if she would have approached them in other private houses. I once heard a story in a folk club that captured some of this mystery of songs in the domestic space. It was about Sussex singer Gordon Hall, and someone observed how he was a very different singer to his mother Mabs Hall, another person then chimed in that he had once told them that his mother had 'women's songs', which she wouldn't sing in front of him, and if he walked into a room when she was singing them, she would stop. As Korczynski, Robertson, and Pickering assert, 'women-only cultures of singing may simply not have operated in the presence of men' (Korczynski et al. 2013: p. 41).

In one of her last letters to Clive Carey, during the First World War, Dorothy Marshall writes, 'I feel I am beginning to understand what socialism means, one is conscious of a vast brotherhood, so many stupid conventions have vanished, and we are finding salvation in literally working, with our hands, for others' (Marshall 1915: CC/2/191). When I read this, sometime after my walk, I became curious as to whether there was the same volume of land girls in the First World War as have been more popularly depicted in Second World War. Through the research of Connie Ruzich on poetry in the centenary commemorations, I was able to gain an insight into the work of women on the land during First World War. Ruzich identifies numerous organizations during the early years of the war that sought to engage women assistance on the land, including 'the Board of Agriculture, the Board of Trade, the Women's Farm Land Union, the Women's National Land Service Corps, the University Association of Land

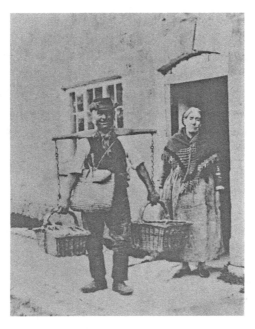

Figure 5 *Herring Salesman, Heyshott*, 1902. Gravel Roots [Photograph].

Workers, and local Women's War Agricultural Committee' (Ruzich 2016). One such splinter organization was also the Women's Institute. In the Fox Inn in Singleton, Sussex, 1915, the first branch of the WI in England was formed. The Agricultural Organisation Society, keen to emulate the success of the Canadian WI, asked Canadian-born Singleton resident Madge Watt to begin the process of establishing Women's Institutes across the UK. The landlady of the Fox Inn, Mrs Lashley, allowed them to use the pub as a meeting place, this being the first time many of the women had ever entered a pub, although the meetings took place in a back room rather than the public bar (Spiers 2014). In Sussex, Lady Cowdray and the Countess of Chichester formed Women's Agricultural Committees in the county; 'the Committees sought to provide training places, free of charge, to women for milking, hoppicking and fruit growing' (Spiers 2014). The Women's Forestry Corps also worked extensively in Sussex. In 1917, the centralized Women's Land Army was founded, and the estimated figure for women in agricultural work in First World War was over 250,000. As part of the WLA, they 'fed livestock, milked cows, trapped vermin, ploughed fields, and harvested fruits and vegetables' (Ruzich 2016). In the women's *Land Army Song*, set to the tune of *Come Lasses and Lads*, and included in *The Land Army Agricultural*

Section Handbook, their experience is distinctly romanticized: designed to create a pretty, rural picture, 'Come out of the towns and on to the Downs, where a girl gets brown and strong; with swinging pace and morning face she does her work to song' (Land Army Song 1917). Such a wholesome picture is destroyed without reverence, by Rose Macaulay (later Dame Rose Macaulay, noted writer and feminist) in her poem, *Spreading Manure*, written about her experiences as a land girl on a Cambridge Farm in 1916:

> There are forty steaming heaps in the one tree field,
> Lying in four rows of ten,
> They must be all spread out ere the earth will yield
> As it should (And it won't, even then).
>
> Drive the great fork in, fling it out wide;
> Jerk it with a shoulder throw,
> The stuff must lie even, two feet on each side.
> Not in patches, but level . . . so!
>
> When the heap is thrown you must go all round
> And flatten it out with the spade,
> It must lie quite close and trim till the ground
> Is like bread spread with marmalade.
>
> The north-east wind stabs and cuts our breaths,
> The soaked clay numbs our feet,
> We are palsied like people gripped by death
> In the beating of the frozen sleet.
>
> I think no soldier is so cold as we,
> Sitting in the frozen mud.
> I wish I was out there, for it might be
> A shell would burst to heat my blood.
>
> I wish I was out there, for I should creep
> In my dug-out and hide my head,
> I should feel no cold when they lay me deep
> To sleep in a six-foot bed.
>
> I wish I was out there, and off the open land:

A deep trench I could just endure.
But things being other, I needs must stand
Frozen, and spread wet manure.

(Macaulay 1916 in Ruzich 2016)

However, the *Land Army Song* made me curious as to if, and what, the women sang at work, and whether amongst the popular tunes from the London girls, the country dwellers might have sung some of the 'old songs'. With assistance from the work of historian Caroline Scott, author of *Holding the Home Front: The Women's Land Army in the First World War* (2017), I searched for anecdotes of musical activity during this period. *The Landswoman* magazine was first issued in January 1918. In February following, the publication launched a songwriting competition, 'Three prizes will be given for the three best Land Army songs, set to well-known tunes, which can be sung by all land workers' (The Landswoman 1918). Amongst the winning entries published in March 1918 was one set to the tune of composed folk song *John Peel*. Singing is mentioned during recruiting rallies and demonstrations; accounts observe that at a London rally in March 1918, the marching women were singing *The Farmer's Boy*, 'Can you tell me if any there be, that will give me employ, to plow and sow, and reap and mow, and be a farmer's boy?' (*The Observer*, 21 April 1918). Annie Edwards from Pulborough, Sussex, served with the WLA from 1915 to 1919 at Drayton Manor Farm, Chichester, Sussex. In an oral history interview conducted by the Imperial War Museum in 1976, Annie recalls many aspects of her work with the WLA, including singing the folk song *The Farmer's Boy* – which she had learnt from her father – whilst she looked after the horses. From a diary kept by Beatrice Bennett whilst she was a Land Army trainee in Kent at the end of 1917, there are also glimpses of song:

> After lunch we went out old job, sorting potatoes. There were five of us in the little dungeon and apart from the cold we were happy. We sang and sorted until dark and then it was time to look after the horses who had just come in.
>
> (Bennett 1917)

> We got in two loads of cabbages after lunch from the second field, that means the big field about half a mile away from the farmhouse. It was really glorious driving uphill through the woods even though the road was bumpy. By the time we got back it was nearly time for home. We watered, groomed, fed and bedded in, and went home singing all the way.
>
> (Bennett 1917)

In November 1910, fifty-five members of the WLA were recognized for their exceptional contribution to the war effort with the presentation of a Distinguished Service Bar. Princess Mary hosted the ceremony, which was followed by a 'Farewell' supper and concert. The concert comprised of clog and Morris dances and solo singers; the two songs named are both traditional (The Landswoman 1918). University students also spent their vacations helping on local farms. In 1916, Hilda Rountree, who was studying at Newham College, Cambridge, went across to Norfolk for the summer, and recalls that:

> The plan joined us with a bunch of regular village women [. . .] who treated us at first with distinct caution if not actual disdain. But we wore them down with our tomfoolery, and we sang lots of songs with good choruses.
> (Twinch 1990: pp. 43–4)

In addition to this tantalizing snatch of chorus songs, and the relaxing of enmity, there appears to me an affective joy-relief in the account of raspberry picking from a university worker who wrote their account of a summer fruit picking in Norfolk, 1916, in the *Aberdeen Journal*:

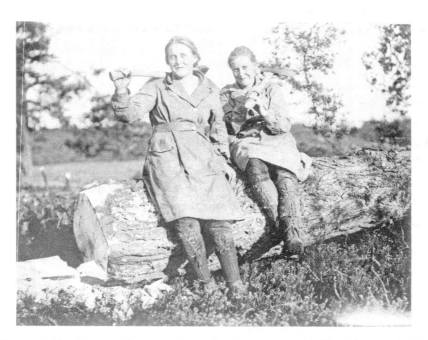

Figure 6 *The Forestry Corps in Petworth, Sussex*. Imperial War Museum WW1 Women's War Collection (Q 114810) [Photograph].

Only three times did we pick raspberries instead of strawberries, and these days were red-letter days in our fruit-picking experiences. No stooping was required, and how happy we felt to be able to stand straight once more! We all sang gaily when we were among the rasps, and bitterly regretted that the field was not full of them.

(Scott 2017)

I didn't sing walking up Bignor Hill, and the conservation of breath was worth it for the widest panoramas in Sussex. Here, the South Downs Way, intersects with Stane Street, a Roman road built in the first century CE to link Chichester to London. Whilst I was eating my lunch at the summit, two women in their sixties took an interest in the printed manuscripts I was looking at and we fell into conversation – a phrase redolent with walking and talking – about my project. They were genuinely surprised that I was walking alone that day, 'Didn't it bother me being a young woman on her own?' No, I answered truthfully, not a bit. Not on this path, at least. Not in the day. Looking at their aghast faces, I thought that sometimes we have come further than we realize. Nevertheless, there are paths I don't walk and trips I don't take. Fear stalks women. I had walked parts of the South-West Coast Path the year before, staying in campsites along the way, and been told by a man I passed that I wasn't doing it properly because I wasn't wild camping. I don't wild camp when I walk alone because I am afraid of being raped. Or killed. I didn't tell him this. Perhaps we haven't come that far after all. Women disappear from archives, and songs, and history, and walks. Some women don't come home. All women know this.

Surveying the villages ahead of me on my passage down to the Arun, I considered the songs that I might sing on my descent to the watery banks. The Arun is the first of the four major Sussex waterways on my route, and features in Charlotte Smith's Sonnet to the South Downs, 'And you, Aruna! – in the vale below / As to the sea your limpid waves you bear / Can you one kind Lethean cup bestow/ To drink a long oblivion to my care?' (Smith 1786). My choice was a happier one, I laughed as I came across *The Spotted Cow*, collected in Duncton from John Rowe in 1912 by Dorothy Marshall. The reason for my smile was the memory of the touching and heart-warming place of the sensory, domestic, and intimate environment in the performance of *The Spotted Cow* by Bob Lewis. Whilst I had interviewed him, we had sat together in the sunny living room of his home, and his wife Dorothy pottered around doing various domestic tasks in the conservatory, occasionally popping in and out to chat or

tell Bob to stick to the point. There was an affectionate and familiar exchange between them in relation to this song that really stuck with me, and always makes me think of them when I'm singing the refrain, 'and love was all our tale':

> LIZ: *And do you sing if you are walking? Do you sing if you are out and about in the countryside?*
> BOB: *Oh well . . . I sing all-round the house and in my car, but I get some funny looks for that. Right, now, what else can I do for you?*
> LIZ: *Well, you know 'The Spotted Cow', don't you? I've found a version of that collected but it would be lovely to hear how you sing it . . .*
> BOB: *(Shouts to Dorothy) You'll have to open the door!*
> DOROTHY: *(Muffled) What?*
> BOB: *(Shouts) You'll have to pull the door back . . . (to me) This is Dorothy's favourite song*
> LIZ: *(Laughs) Is it?*
> BOB: *(To Dorothy) Spotted Cow!*
> DOROTHY: *Oh yes! I'll open the door wide.*
>
> <div align="right">(Lewis 2015)</div>

12. *The Spotted Cow*

One morning in the month of May
It's from my path I strayed
And at the dawning of the day, I met a charming maid
And at the dawning of the day, I met a charming maid.

'And good morning to you, wither?' Say I
'Why so early, tell me now?'
That maid replied, 'Kind Sir', she cried, 'I've lost my spotted cow'
That maid replied, . . .

'It's no longer weep, no longer morn
Your cow's not lost my dear
I saw her down in yonder lawn, come love I'll show you where
I saw her down . . .'

Now in the grove we spent the day
All through it passed so soon
At night we homeward made our way, and brightly shone the moon
At night we homeward . . .

> Next day we went to view the plough
> And cross that flowery dale
> We hugged and kissed each other there, and love was all our tale
> We hugged and kissed . . .
>
> If I should cross a flowery dale
> All for to view the plough
> She comes and calls me 'gentle swain, I've lost my spotted cow'
> She comes and calls . . .

Bob calling out to Dorothy, and her continuing her activities whilst she listened, created a greater sense of folk songs in Bob's daily life, rather than just my experience of him as a performer in the clubs. In a bid to create a sense of tradition, the focus can easily be on looking back to a time where singing was still seen as an everyday accompaniment to working rural life, but in doing so it is possible to neglect what songs do *now*. Interviewing Bob in his home allowed me to witness singing as a domestic practice, as it is in our house, where singers are either singing with their family, for pleasure, in the shower, accompanying chores or practising in view of performing at folk clubs or festivals. Pink's notion of the 'sensory home' was vital to my appreciation of the 'nowness' of *The Spotted Cow*, the 'making and experience of the home as a multisensory environment [is] likewise integral to how self-identities are constituted through everyday practices', and how sensory ethnography may allow a means to appreciate how 'people experience, make, and maintain home [through] the performance of everyday routine domestic tasks' – and the songs that accompany them (Pink and Mackley 2012: p. 4)

As a drowsy bumblebee, or 'dumbledore' in Sussex dialect, floated past me to other walkers finishing their lunch, I recalled that it was in the *Spotted Cow* singer John Rowe's home of Duncton that Dorothy Marshall collected a wassail traditionally sung to the bees:

> I went to Duncton and got all the words and the actions for all the wassails and a nice song 'The Spotted Cow' (composed?) The man who sang it said he had once made a bet he would sing 50 songs, each to have more than 8 verses and no less than 15 [. . .] he did it and had 15 over! He is about 40 I'd say. We must go and stay in Duncton!
>
> (Marshall 1911: CC/2/164)

In Jacqueline Simpson's volume *The Folklore of Sussex*, she charts the practice of 'telling the bees', where those who held the tradition treated honeybees like members of the family, and kept them informed of all family news, including births, marriages, and even news about visitors was told to the bees as a courtesy. Should this not be observed, it was believed that the bees would either die or fly away (Simpson 1969, 2009: p. 96). The presence, and importance, of animals in our sensory homes indicates another field of affect theory, which moves towards 'more vitalist, posthuman, and process based perspectives' (Wetherall 2012: p. 3), and identified by Nyman and Schuurman in their edited collection *Affect, Space and Animals* (2016) as 'the emergence of a new field of animalhuman studies [. . .] it places the animal at the centre and perceives it as a subject and an agent contributing to the encounters observed and studied' (Nymann and Schuurman 2016: p. 2). In the *Bee Worsel* taken down by M. E. Durham of Duncton from a man in 1889 or 1891, who had wassailed 'every year since I was a boy, save the year I broke my leg', the same attitude of reverence and respect for the honeybee is present in the words (if not in the actions). As well as the more traditional apple wassailing or 'howling', the men of Duncton sang – worselled – whilst they 'danced round the beehives and then beat them with sticks' (Durham 1891: CJS2/9/77):

> Bees, bees of paradise
> Do the work of Jesus Christ
> Do the work that no man can
> God made bees
> Bees made honey
> God made man
> Man make money
> God made man to harrow and to plough
> And God made the little boy to holla off the crow!
> Holla, boys, Holla Hip, hip, hurrah!

I thought of Margaret Williams poem in her thesis *Telling the Bees*, and what my own tidings might be. Then, suddenly heavy with baggage, I continued on my way; 'Telling the bees was easy – the simplest part. After the swarm of news that broke her heart'.

(Williams 2013: p. 75)

The paths down to the Arun valley were muddy brown lines cutting through almost hallucinogenic quantities of rape in the fields. Sitting on Bury Hill in a dreamy, somnolent state from sunshine – reminiscent of Dorothy asleep in

the poppies – I considered how different the terrain was that surrounded each village the singers had lived in, the variety of practices that had formed these landscapes, in contrast to how close and uniform they had looked on the map before I set off. I surfaced from my fatigue and pushed on, aware that I was meeting people at the end of my route in Amberley. The village of Amberley runs almost indistinguishable into the village of Houghton: the stone bridge over the Arun being a rough demarcation. I met Jane Fox from the University of Brighton who had read about my project and hoped to catch me at the pub, and my supervisor Helen Nicholson, who had wound her own way to me through the networks of paths surrounding Houghton, with neither of us managing to spot the other. As Lorimer and Wylie evoke in 'LOOP (a geography)', 'Two bodies, together and part, irreducible to either an "I" or a "We"' (Lorimer and Wylie 2010: p. 7). Where we were sitting in the pub garden, we could look out at other figures setting forth on their own routes, and I considered Ingold and Vergunst's contention that to be a human is to walk. Thus, our encounters with others have always involved motion, to *meet* requires you to move:

> To make one's way through a world in formation, in a movement that is both rhythmically resonant with the movements of others around us – whose journeys we share or whose paths we cross – [. . .] not only then do we walk because we are social beings, we are also social beings because we walk [. . .] the rooting of the social in the actual ground of lived experience, where the earth we tread interfaces with the air we breathe.
>
> (Ingold and Vergunst 2008: p. 2)

Our conversation in the pub garden covered many different aspects of walking, both from that day and in our own lives. The one that has impressed itself upon my memory was our discussion of a walk, or rather walks, that Jane had been reflecting on for her own research, and the broader conversation about grief that resulted between the three of us. Jane had picked up a stone from the beach at Brighton on the day her father had died and was taking different walks with that stone as part of her grieving process: from popping to the shops, to hikes up onto the Downs. The stone enabled both a sense of proximity and a gradual letting go:

> Steadying stone. Travelling stone. Drawing stone. Moving through and across surface, along lines built up through centuries of footfall. We add by discreet removal, one step at a time – guided by paths as if treading a labyrinth. Held.
>
> (Fox 2015)

In this passage of the abstract for *Mourning Stone,* Jane articulates the same participation in footpaths as Edward Thomas's account that had made me think of paths and songs along the same lines. Yet, as these words arrive to me again on the page, I find that being added to by discreet removal is as good a description of heartbreak as I have even seen. In their own way, the copies of the songs I carried with me from the archive were my mourning stones. They sounded of a particular time in my life, when my body were leaden from absence, and my mum had coaxed me up onto the Downs to sing; experiencing there, 'the interplay of the affective airs of the landscape in question, personal narrative and memory, sounds in the landscape and cries of/to the heart' (Jones 2016: p. 108).

The George and Dragon is one of the oldest pubs in Sussex, with parts of the building dating to the thirteenth century. *The Cruel Father and Affectionate Lovers* is noted as being collected there from Mr Viney. Through the post office directory, I was able to ascertain that Mr Viney was landlord at the George and Dragon at the time the song was collected. Such collecting practices were the preserve of the male collector, able to prop up the bar, and asking for a tune. As Lucy Broadwood, a prominent Sussex and Surrey collector bemoaned, the men had the advantage of being able to 'make merry with songsters in the alehouse house over pipes and parsnip wine, or hobnob with the black sheep of the neighbourhood' (Broadwood in Gammon 1980: p. 65). I raised a glass to making merry in the alehouse with Helen and Jane – and sang:

13. *The Cruel Father and Affectionate Lovers*

It's of a damsel both fair and handsome
These lines are true as I have been told
Near the banks of Shannon, in a lofty mansion
Her father chambered great stores of gold
Her hair was black as a raven's feather
Her form and features to describe who can?
But still this folly belongs to nature
As she fell in love with her servant man

As these two lovers were fondly talking
Her father heard them and near them drew
As these two lovers were together walking
In anger, home her father flew
To build a dungeon was his intention
To part true love he contrived a plan

He swore an oath on all his mansion
He'd part his fair one from her servant man

Young Edwin found her habitation
It was secured by an iron door
He vowed in spite of all the nation
He would gain her freedom or rest no more
So, at his leisure he toiled with pleasure
To gain the freedom of Mary-Ann
And when he had found out his treasure
She cried 'My faithful young servant man'

Said Edwin 'Now I've found my treasure
I will be faithful to you likewise
And for your sake I will face your father
To see me here it will him surprise'
When her father brought her bread and water
To call his daughter he thus began
Said Edwin, 'Enter I've freed your daughter
I will suffer your servant man'

When her father found that she had vanished
Then like a lion he thus did roar
Saying, 'from old Ireland you shall be banished
Or with my sword I will spill your gore'
'Agreed', said Edwin, 'I freed your daughter
I freed your daughter, do all you can
But forgive your treasure, I die with pleasure
For the one in fault is your servant man'

When her father found him so tender hearted
Then down he fell on the dungeon floor
Saying that, 'true love should n'er ne parted
Since love can open an iron door'.
So soon they're one to be parted never
And roll in riches this young couple can
This fair young lady is blushed with pleasure
Contented with her young servant man.

(Viney 1919: CC/1/329 and Searle 1901: LEB/2/33)

Only the tune for the *Servant Man* or *The Cruel Father and Affectionate Lovers* was collected from Mr Viney by Clive Carey in Houghton. I learnt the tune from the version folk musicians Nancy Kerr and Fay Hield recorded as part of the Full English Band. The words were from a version performed for Lucy Broadwood a few years before Mr Viney sang it, by singers a stone's throw away from Houghton in Amberley. These singers were father and son, John and Walter Searle, who were both local quarrymen. It was Walter Searle's version of the words that I used. Suddenly lonely, after saying goodbye to Helen at the station, I walked to my bed and breakfast in Amberley in the fading owl light, and tried to imagine the Amberley that the Searle's had known, with the skies acrid with smoke from the limekilns. Amberley was the site of a bustling chalk quarry from the 1830s to 1968, producing lime for both building and agricultural use. In 1979, the Amberley Museum and Heritage Centre was opened on the site. Korczynski et al. state that although 'oral history testimony [. . .] shows the existence of a singing culture at work in a Devon quarry in the 1930s, beyond this there is no evidence of a singing at work culture in other quarries [. . .] there was evidence of a wider culture of singing (outside work)' (Korczynski et al. 2013: p. 55). The oral history from Devon worker Bill Hingston (1914–86) illuminates the role the songs played for him in his working day, 'Twas something to take the monotony off the job. What could be more monotonous than napping stones all day long? Oh blimee, click clack click clack, all day long' (Hingston in Korczynski 2013: p. 56). In this account, it is possible to observe the affective state of boredom being dispelled, or at least, accompanied by singing. I would also argue that one can see quarrying as a form of embodied landscaping accompanied by, if not formed with, singing. I wondered whether the Searles had sang at work and thought about the layers of labour in the Downs.

I also continued to think about Lucy Broadwood. The life of Lucy Broadwood is better documented than many other female folk song collectors, and from these documents – including her diaries and Dorothy de Val's biography *In Search of Song: The Life and Times of Lucy Broadwood* (2013) – I gained some sense of her collecting processes. Lucy Broadwood was the niece of Reverend John Broadwood, a man of private income who lived in Worthing, Sussex, and produced the first book published solely on English folk songs, *Old English Folk Songs* (1843). Although Lucy was young when her uncle died, she recalls that family tradition accounted for 'the polite boredom with which his traditional songs, sung exactly as the smocked labourers sang, were received by his friends and relations' (Broadwood 1904–5: p. 101 in Roud 2017). Lucy's family were middle-class landowners with a

piano-making business, and Lucy was able to live on a private income for her life. She lived independently and devoted her life to a broad range of musical interests, including a prolific role in the first folk song revival and the formation of the Folk Song Society. As Roud states, she was as 'one of the very first to edit and publish genuine, collected, folk songs' (Roud 2017: p. 101). The Searles, along with another local singer Mr Hoare, visited Lucy at her friend Geraldine Carr's home in Bury to 'hear some songs over supper'; often Lucy invited local singers to her home who performed for her in the billiard room (de Val 2013: p. 76). As I read more accounts of collectors, I became fascinated by the journeys of care undertaken by traditional singers who had sang the songs as accompaniments to daily chores, emotions, toils, rites, and festivities that marked the seasons, and the transfer of that knowledge to a member of a different social sphere, poised with pencil and paper, in a completely foreign sensory environment. As Gammon states, these encounters are recorded by the collectors as often giving rise to tension, and he refers to Lucy's practice of breaking the ice by 'obliging with a song', and her suggestion that other collectors do the same. Although this approach can be seen within the previously identified attitude of co-opting and transposing the rural worker's repertoire to 'folk songs in evening dress', it is also possible to consider this as Lucy's own early attempts to 'occupy or imagine [. . .] ways of perceiving and being that are similar, parallel to or indeed interrelated with and contingent on those engaged in by research participants' (Pink 2015: p. 39).

Additionally, although it is important to recognize the different contexts of collection involved in amassing the material recognized under the first folk song revival, it is also vital to understand the barriers that may have existed in terms of an 'organic harvesting' of these songs out in the fields, or asking why the singers loved them, or observing them 'at song'. Therefore, whilst I recognize Roud's assessment that the first folk song collectors 'were not interested in documenting the whole range of songs sung by working people, nor were they particularly concerned with the social context of that singing, or the lives and opinions of the singers' (Roud 2017: p. 7), I am also in agreement with Roud's aims to understand collectors as complex *individuals*, rather than just a group of middle class, educated, musically literate, bourgeoisie (Roud 2017: p. 7). One of the aspects this requires is a commitment to understanding the role of gender in these encounters:

> Like most female enthusiasts of the time, she [Lucy] could not (or did not want to) roam the countryside, popping into pubs and cottages and approaching

labourers in the lanes or fields. In nearly every case, she located singers and invited them to her house, or a friend found them and arranged a meeting in controlled circumstances. Much of her collecting was by post, either direct from singers or through intermediaries, and was the result of her position as Journal editor, which involved her in extensive correspondence with enthusiasts across the country.

(Roud 2017: p. 106)

Additionally, Lucy would have faced a common issue at the time of men not being able to, or wanting to, sing more bawdy elements of their repertoire to female collectors. Adding further layers of difficulty, and achievement, in her collecting activities (Gammon 1980: pp. 71–2). In addition, she was an unmarried woman, and recounted some of these difficulties in a 1905 presentation, recounting a 'fine old Surrey carter, who, having sung a good number of songs for her, suddenly stopped one day, saying, "I knows a wonderful deal more, but they are not very good ones. Most of them be outway rude", Broadwood expands:

> It is this 'rudeness' that makes it hard for a woman to collect. The singer is far too kind to offend her ears, but is almost always unable to hum or whistle an air apart from its words. And I have had to forego the rescue of the most promising old ballads in consequence.

(Broadwood 1905: p. 101)

Nonetheless, beyond the challenge that her gender provided, Lucy had other aspects of her life supporting her collecting activities. As Williams explores, her 'residence in London from 1893 onwards, combined with the private income afforded by her family's wealth, meant that she was able to wholeheartedly pursue her interest in folk music as well as participate actively in the music scene of the capital' (Williams 2022: p. 160).

In relation to class, some of Lucy's recorded attitudes towards the singers betray a devaluing of the very tradition the collectors were seeking to preserve (the use of the word rescue being instructive in the previous quotation). For example, on her experience of driving 24 miles with Sabine Baring-Gould to meet a songstress of repute, Lucy writes 'when we arrived she put on all the airs of a capricious operatic favourite, and declared she was not in voice enough to sing' (Broadwood in Gammon 1980: p. 66). Here, folk singers are less legitimate than opera singers. Nonetheless, thinking of my own exchange with singers, and my movement across a stretch of land that day, enabled me space to consider the complexities of collection. I was able to explore whether an important part of Lucy's practice, in

terms of relating to the singers she met, was to share with them 'obliging with a song' and hear their songs, and thus to be recognized as a fellow singer/musician, not just a member of a different social class and/or gender. In this, at least, we may see an attempt by Lucy to break down the barriers that hindered some forms of collection. Thus, by walking that day, and imagining-in-practice some elements of the lives of female collectors and singers, and the whispers of the many that passed these songs down, I join in an important shift in recognizing the gender bias of previous scholarship on folk music. As Roud asserts:

> Broadly speaking, it is the 'public' singing events which are documented the best, and it is in precisely this sphere that women's behaviour was most constrained by social and practical restrictions. It is not our intention to treat females as entirely victims, and unable, in the past or the present, to speak for themselves or to create their own singing spaces on their own terms, but the unfortunate fact is that we have to remind ourselves to make a special effort to investigate the singing practices and conventions of what is, after all, half the population.
> (Roud 2017: p. 637)

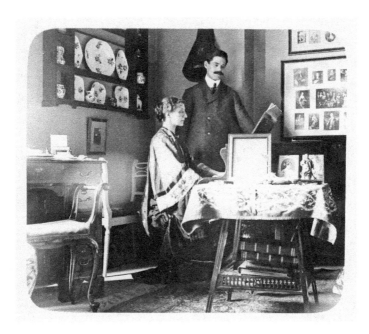

Figure 7 *Lucy Broadwood at home with James Campbell MacInnes*, 1900s. Surrey History Centre (2185/LEB/9/113).

The vast majority of my research into songs collected from the villages of the Sussex Downs took place in the Vaughan Williams Memorial Library in Cecil Sharp House; the names of men inscribed in the building leading me to ask, 'where are the women?' This observation was felt as well as thought – it was *affective* – as Ahmed states, 'feminism begins with sensation: with a sense of things' (Ahmed 2017: p. 21). In some senses, this chapter results in more questions than answers, and certainly this is a preoccupation that resounds throughout the book. However, my reflections on this day's walk have both pointed out diversions where further study on women's song tradition could prove productive, and demonstrated that it was once I was out of the archive, and walking with these materials, that I was able to allow these questions to breathe. By participating in the ongoing treads and threads of the Downs, I was able to pursue lines of inquiry which otherwise may not have occurred, as Denzin states, 'knowing refers to those embodied, sensuous experiences that create the conditions for understanding' (Denzin 2003: p. 13).

2.3

Lines

Continuing from my interest in the contributions of women to the songs I was singing on my way, a general train of thought developed during my third day's walk, along a route which encompassed 13 miles of the South Downs Way from Amberley to Upper Beeding. I began to see the reoccurrence of different types of lines within songs, paths, and conversations. Thus, I turned to Ingold's anthropology of lines. If, as Ingold states, 'everyone and everything consists of interwoven and connected lines', how might this apply to folk singing as an affective practice? (Ingold 2016: p. 1).

An insatiable morning chorus across Amberley Brooks resulted in me giving up on sleep to stare out across the Arun as the morning light slowly exposed the landscape. A small hop upstream, and a few weeks previously, I had visited the home of Chris Skinner and her partner Jim Glover in Coldwaltham. I have sung with Chris and Jim regularly since, but this was our first meeting. We had been put in touch by a mutual acquaintance who thought Chris would be an excellent person to teach me a song. I spent the afternoon in their sun-filled garden, teeming with birds, and talking with them about their careers in the RSPB, the loss of nature words from the OED children's dictionary and why we sang. Although the recording is patchy in places due to the wind, the snatches of bird songs helped me to reimagine myself back to our afternoon together. As the birds quietened down in Amberley Brooks and the sun rose, my thoughts turned to one of the songs Chris sang for me in her garden. A song that Lucy Broadwood had collected from John Burberry, her gamekeeper at Lyne House:

> CHRIS: *I've always loved folk music for the stories that the songs tell, and I'm really into history. But I didn't go to folk clubs until I moved down to Sussex and I discovered there was a folk scene here, and I met Jim who was a fine singer, and after a while you absorb so much of the songs and you join in so much of the choruses, and you end up singing them yourself [. . .] the other song that I want to sing to you is rooted in the tradition, it's a very old song, and I think it's a*

very, very old song, to me the story comes out of the 1600s if not before – it was collected in the 1890s – but I'm sure this song is older than that. It combines excellent imagery, for me, with history. I feel I could actually be walking past the people in this song doing these tasks, it's very much . . . you can imagine people stopping and having a chat or even joining in and helping, it's very much about a community at work in the landscape, here and there would have been all sorts of pathways, wood cutters working in the woods, drovers with goats, men marching off to find the fields to mow, timeless really and very much about the track ways [. . .]

LIZ: *So 'Seasons Round', is that right? Is that what the song is called?*

CHRIS: *It's called 'The Ploughshare' or it's called 'The Seasons Round', and Lucy Broadwood included this as a song from Sussex in her book 'Songs from the South Coast' (1893) and she got it from the singing of her game keeper who was 68. His son was game keeper after him and told Lucy that his father had some songs, and so she was sung this by John Burberry in 1892. It's extremely similar, almost identical, to a song The Coppers' sing, which was recorded by Peter Kennedy in the 1970s. And looking at that version some of the verses seemed to me a bit scrambled and John Burberry's version gave me a bit of sense to it, so I've cobbled it together from both of them, then to make it more inclusive I've added a bit people can join in on that comes from the 'Sussex Harvest Toast' that The Coppers' used to mention. To me this song is like a sung version of a medieval tapestry:*

14. The Seasons Round

The sun has gone down, and the sky it is red
Down on my full pillow, there I lie my head
When I open my eyes, for to see the stars shine
Then the thought of my true love comes into my mind

May the plough share never rust
May the plough share never rust

The sap has gone down, and the leaves they do fall
Through hedging and ditching our fathers will call
We will trim up the hedges, we will cut down the wood
And the farmers will all say our faggots run good

May the plough . . .

When hedging is over, then sawing comes near
We will send for the sawyer, our woods for to clear
And after he's sawed them and tumbled them down
Then he will flaw them all on the cold ground

May the plough . . .

When sawing is over, then seedling comes round
See the teams are all ready, preparing the ground
Then the man with his seedlip, he will scatter the corn
And the rows will bury it to keep it from harm

May the plough . . .

When seed time is over, then haying draws near
With our scythes, rake and pitchforks those meadows to clear
We will cut down that grass boys, and carry it away
We will first call it green grass and then call it hay

May the plough . . .

When harvest is over, bad weather comes on
We will send for the thresher, to thresh out the corn
With his handstaff he'll handle, and his swingle he'll swing
Till the very next harvest we'll all meet again

May the plough . . .

When spring time comes on, it's the maid to her cow
See the boy with his whip, and the man with his plough
And so we bring all things so cheerfully around
Here's health to the jolly ploughman who ploughs up the ground

May the plough . . .

CHRIS: *Flawing is a dialect word meaning flaying, which is to strip the bark of a tree, and a seed lip is like a seed tray or a basket with the rim at one side turned down. So, you've got it strapped round your necks, and you are walking up along the furrows, and you are broadcasting, but instead of grabbing a handful you are dragging it out and flicking it over the seedlip as you go. This is a very old form of broadcasting, you know 1600s or something.*

(Skinner 2015)

The process of how this song becomes part of the way that Chris perceives the Sussex landscape elucidated to me Pink's argument for imagination as 'a practice of everyday life' (Pink 2015: p. 45). Chris sees herself in the tapestry of the song, and the imagined past arrives in the present of the trackways as she walks them. Further, I found that Chris's phrasing of 'men marching off to find fields to mow' evoked a particular, purposeful kind of movement in that

environment, showing how such imagining is multisensory and embodied, 'rather than simply a cognitive practice' (Pink 2015: p. 46). Using the work of Vincent Crapanzano on imagination as more-than-visual, Pink proposes that if we take imagination to be 'a more emplaced everyday practice carried out in relation to the multisensoriality of our actual social and material relations', it is important to pay attention to the way in which people might articulate affect and feeling through other means, 'Can we not "imagine" the beyond in musical terms? In tactile or even gustatory ones? In propriocentric ones? In varying combinations of these – and perhaps other senses' (Crapanzano 2004: p. 23 in Pink 2015: p. 46).

Chris has a magnetically pure and soft voice, and when I was revisiting that afternoon and trying to find a word to describe it, I realized that the clue was in her body and the way she moves when she sings; she willows. There's a fluid, curving motion to her performance that both allows her the breath she needs to sing, and somehow mirrors the lithe, graceful, willowy tones of her voice. It was through listening to the recording that I was able to remember the movement of Chris's body as she sings and *imagine* the right word for her voice. Within Chris's evocation of a medieval tapestry, there is also a strong sense that this song ties all these different activities together, not as a finished product, but as a type of braid continued by each new singer. Here, it is possible to see Ingold and Hallam's argument to read creativity and traditions 'forwards' as processes rather than 'backwards' through products (Ingold and Hallam 2007: p. 2), and to consider folk singing as an improvisation, and improvisation as a way of relating to the world, following Deleuze and Guattari:

> One launches forth, hazards an improvisation. But to improvise is to join with the World, or to meld with it. One ventures from home on the thread of a tune. Along sonorous, gestural, motor lines that . . . graft themselves onto or begin to bud 'lines of drift' with different loops, knots, speeds, movements, gestures, and sonorities.
>
> (Deleuze and Guattari 2004: pp. 343–4)

This notion of joining with the world echoes David Atkinson's argument in *The Anglo-Scottish Ballad and Its Imaginary Contexts* (2014) that the ballad 'should be seen not as a closed, original and seminal utterance, but as constant and multiple production' (Atkinson 2014: pp. 22–3). Furthermore, Chris's singing of the line 'and so we bring all things so cheerfully around' conjured not just the inhabitants' relationship with the landscape and the

seasons, but their entanglement and agency in the ongoing becoming of the year. In relation to his work on performance and landscape, Mike Pearson states that

> Just as landscapes are constructed out of the imbricated actions and experiences of people, so people are constructed in and dispersed through their habituated landscape: each individual, significantly, has particular set of possibilities in presenting an account of their landscape: stories.
>
> (Pearson 2006: p. 12)

As Chris and I explored in our conversation, folk singing is one such possibility.

Sleep deprivation has an adverse effect on my adrenaline glands and, as I set off to meet my fellow walkers for the day at Amberley station, I was battling surges of anxiety and feeling that I would rather be doing anything else that day than leading a walk or performing songs. Anxiety registers for me as a sense of ebbing and surging energy, as a palpable, irrational dread and fear. A monster coming over the hill. Reflecting on that morning's sense of fight or flight, it occurs to me that walks are always more-than the individual. As knowledge is created 'with others, in movement, and through engagement with a material, sensory and social environment', so too are walks (Pink 2009: p. 272). As soon we set off up onto the hills, I was one pair of feet amongst many and the jagged edges of my form, and my personal angst began to dissolve into a different set of affective relations – a rhythmic calm, a shifting of states. As Anderson argues:

> Affect is two-sided. It consists of bodily capacities to affect and to be affected that emerge and develop in concert [...] a body is always imbricated in a set of relations that extend beyond it and constitute it [...] affects are always collective because they are constituted in and through relations.
>
> (Anderson 2014: p. 9)

James Dixon, who had conceived of and organized Public Archaeology 2015, came for the day with his wife Sinai Dixon, a Theatre PhD Student. Lorna Richardson also joined us, a fellow PA2015 participant and Sussex resident, although, as she quickly asserted, a webbed-footed fish out of water permanently longing for the flat skies of the Suffolk/Norfolk borders. If anyone might have been able to persuade her of the benefits of the Sussex landscape, it was walker and blogger Malcolm Oakley, who arrived at the same time as my friend from Brighton Vox choir, Terry Turner.

The first song I sang that morning was *The Silvery Tide*. This song was collected from John Searle in 1901 by Lucy Broadwood, in the same singing session that his son Walter had sung *The Cruel Father and Affectionate Lovers*. John Searle, a quarryman by trade, was seventy years of age at the time. Two handwritten scripts of *The Silvery Tide* are available through the Full English Digital Archive. The first is written by John Searle, and the second appears to be transcribed, either from this copy or from his singing. In the second version, the word 'roaming' is given for the activity of the male lover Henry at midnight. However, although I began to learn the song from this copy, due to the handwriting being easier to read, I felt sure that John Searle had written something different. When I returned to his manuscript, I saw that there was a clear 'G' at the start of the word, and I wondered if 'gloming' was an archaic spelling of the Scottish 'gloaming' meaning twilight, which appears often in Scottish ballads. Henry sets off at midnight, however, and this would be too late for twilight even in midsummer. I decided to look at other versions of the song to see whether that verse existed in them, and, if so, what phrasing was used. A version collected in 1908 from Somerset, printed in *The New Penguin Book of English Folk Songs* (2012), tells that 'Henry goes out at Midnight gloom' (Bishop and Roud 2012: p. 307). The second comparative version I found was from the *Barbara Ellen* singer, Mrs Betsy Moseley of Treyford, Sussex (Moseley 1912: CC/1/159). In Betsy Moseley's version of the song, Henry's midnight walk is given thus – 'a glooming way went he'. Therefore, for a whilst I worked on the basis that John Searle had misspelt glooming, in part, because of my own susceptibility, prior to further research, to the myth of illiterate or semi-literate traditional singers. Such a presentation of the singers during the first folk revival is perhaps best illustrated by this quotation from Vaughan Williams, 'I am like a psychical researcher who has actually seen a ghost, for I have been among the more primitive people of England and have noted down their songs' (Williams 1912 in Gammon 1980: p. 83). Illiteracy as a 'virtue' for the folk song collector was, as Gammon asserts, refuted by Mary Neal researcher Margaret Dean-Smith in her identification that, like the Searle family, the majority of singers were able to write down the words to their songs for the collector (Gammon 1980: p. 83). It is possible to observe in the manuscript where words are not spelt traditionally or are written in dialect – 'It was at young Mary's habsence a nobel man e' came'. As I was rehearsing this piece, I had felt uneasy singing 'glooming', and found that on further investigation 'gloming' was also an obsolete term meaning 'to mope'. Thus, similar to glooming, but not an error on the part of the singer. It felt

important to me to sing it as it had been written, and acknowledge that the 'fair' copy had been edited.

Endeavouring to be aware of dialect, accents, and obsolete words was also important to me in terms of choices singers make when performing the songs now. I once had a debate with my mum about how I was picking up Sussex affectations in the way I sung, and I wanted to know what was different between that and her singing Scottish pronunciations. When I sing Appalachian songs at gigs, I sing them in a different style to songs I have learnt from Sussex singers. This, for me, is a choice guided by the songs – they have different terrains, and they have fertilized my voice in different ways. Traditional singer George Townshend was recorded at the age of eighty in 1970 by Brian Matthews. In songs such as *The Echoing Horn*, it is possible to observe that he sings a 'h' sound in front of words that begin with an 'e', aspirating the vowel; thus 'hechoing' (Matthews 2001). This 'h' sound is also present in other Sussex singers of the period; John Searle displays that this was true in his singing style as well, with words such as 'hafter' for 'after'. These insights led me to consider that the word 'hinding' in John Searle's manuscript was more likely to be 'ending' than 'binding', which is what it was given as in the transcription. To check my interpretation, I looked back at the version of *The Silver Tide* written out by Betsy Moseley, and she sang likewise that the nobleman was guilty of 'ending' Mary's days. By the time I came to sing *The Silvery Tide* on the walk, I felt that I had been through many processes of caring for the song and nurturing it into the performance space. Therefore, it seemed important to bring copies of the different versions to share with the group. I remember that we spoke about the blank page at the end of Betsy Moseley's copy, and how it looked like an invitation to fill the space with future lines of the song – reading tradition 'forwards' (Ingold and Hallam 2007: p. 2). Betsy Moseley's *Silver Tide* refers to a river, unlike Searle's ocean, and it occurred to me as I sang on Rackham Hill, with the Arun behind us and the Adur yet to be reached, that the tune itself is sinuous and aqueous; the repeat stanza at the end bobs up and down before reaching a plateau, like a wave on a shore or a river caressing the banks:

4. *The Silvery Tide*

It's of a young fair creature that dwelt by the seaside
With lovely form and features was called the village pride
It's of a young sea captain young Mary's heart did gain
And true she was to Henry

And true she was to Henry, that's on the raging main
It was at young Henry's absence a noble man he came
Courting of pretty Mary but she refused the same
'Your vows are vain for on the main there's one I love', she cried
'So begone from me I love but one,
Begone from me I love but one that's on the silvery tide'

Then mad with desperation this noble man did say
'To prove your separation, I'll take your life away
I'll watch you late and early, and all alone', he cried
'I will send your body a-floating down
I will send your body a-floating down on yonder silvery tide'

The nobleman was walking one morn to take the air
Down by the rolling ocean he met this lady fair
Then said this fearful villain 'Consent to be my bride,
Or sink or swim, oh far from him
Or sink or swim, oh far from him that's on the silvery tide'

With trembling limbs said Mary 'My vows I never can break
For young Henry I love dearly, I will die for his sweets sake'
Then with his handkerchief bound her arms and flung her o'er the side
And her body went a-floating
Her body went a-floating down on the silvery tide

It happened Mary's true love soon after turned from sea
Expecting to be happy and fix the wedding day
'We fear your true love's murdered', her aged parents cried
'Which caused her destruction
Which caused her destruction on yonder silvery tide'

Young Henry on his pillow he could not take no rest
For the thoughts of pretty Mary disturbed his wondering breast
He dreamt that he was walking down by the ocean side
And his true love he saw weeping
His true love he saw weeping on the banks of the silvery tide

Young Henry rose at midnight, gloming went he
To wander the sad banks over down by the raging sea
Day break of the morning, poor Mary's corpse he spied
It was to and fro a-rolling
It was to and fro a-rolling down on the silvery tide

He saw it was his Mary, his own ring on her hand
He unfolded the handkerchief, which put him to a stand
The name of the base murderer in full there he spied
That proves he handed Mary
That proves he handed Mary down on the silvery tide

The nobleman was taken, the gallows was his doom
For ending pretty Mary all in her tender bloom
Young Henry was so dejected he wondered till he died
And his last words were for Mary,
His last words were for Mary who died on the silvery tide.

(Searle 1901: LEB/2/34/2)

In contrast to the seemingly linear route I'd planned, the walk that day appeared to spring out in all directions from Chanctonbury Ring, as though all paths flowed to and from there, as Ingold elucidates in *Lines: A Brief History*, 'To be a place, every somewhere must lie on one or several paths of movement

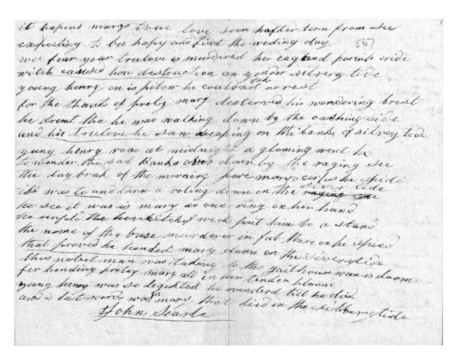

Figure 8 Searle, J, 1901. *The Silvery Tide* – Lyrics. Full English Digital Archive, English Folk Dance and Song Society (LEB/2/34/2) [Digital Image].

Figure 9 Moseley, Mrs, 1912. *The Silver Tide* – Music. Full English Digital Archive, English Folk Dance and Song Society (CC/1/159) [Digital Image].

to and from places elsewhere. Life is lived, I reasoned, along paths, not just in places, and paths are lines of a sort' (Ingold 2007: p. 4). In addition to this keen impression of lines, there were several contributing aspects to the Ring becoming what felt like a pulsing gathering of paths that day. On first reflection, the most immediate is that Chanctonbury was where we stopped for the longest time, and where I sang several songs. Second, we were joined just before the Ring by two new walkers, so our group was then at its full contingency. Third, the site has a long history of exerting a pull on the body and the imagination. This affective atmosphere was both discussed and felt on the day. Finally, the wide expanse of the avenue to the Ring of trees, and walking to it as a destination with a group, allowed me to experience a site in a different way. It had become somewhere where I regularly engaged in the everyday activity of dog walks. Yet, on that day, it felt like a pilgrimage, not necessarily spiritual, but a sense of my body being drawn towards it. A particular form of bodily engagement in the moment altered my perception of the landscape, allowing me to see what Paterson identifies as the 'transformative power' of affect, and its ability to 'allow something to stand apart, to obtrude, to reach out and touch us. It is to disrupt habitation perception through the force of altered, juxtaposed, or disordered sensations' (Paterson 2005: pp. 164–5).

Chanctonbury Ring has been famous throughout the last few centuries for its crowning ringed copse of beech trees, planted by Charles Goring of Wiston House in 1760 (the Ring lay within the grounds of the estate). The vast majority were destroyed by the hurricane of 1987 but many have since been replanted. The site is a focus of local folklore. The trees are said to be uncountable. However, if you did count them, you would raise Julius Caesar and his army. If you run seven times around the Ring, the devil is said to come amongst you and offer you a bowl of soup, milk or porridge, depending on who is telling the tale. In her work 'Legends of Chanctonbury Ring' (1969), Jacqueline Simpson gives other examples of folkloric engagements with the site. For example, the seven circuits must be performed on a moonless night, or on the night of a full moon, at seven o'clock on midsummer's day, anticlockwise, naked or backwards (Simpson 1969).

Whilst the folklore associated with the trees sprung to my mind on our approach, the landscape here has been a place of many different forms of participation in the deep past. It was Iron Age hill fort, in use between the sixth and fourth century BCE, with earlier Bronze Age pottery also found around the site suggesting earlier activity. Evidence of two Roman period temples was also found during archaeological excavations (Lock and Ralston 2017: EN3748).

There have been numerous accounts of experiencing ghosts or signs of haunting from intrepid campers sleeping within the Ring. The trees can also attract clinging mist, similar to the foxes-brewings of the Cocking hills, contributing to the unnerving atmosphere. In the villages below the Ring, such mist can also be seen as a weather warning, producing a similar saying– 'Old Mother Goring's got her cap on, we shall soon have wet' (Apperson 2006: p. 92).

I had known as soon as I had started to plan the walk that *Long Lankin* would be my choice of ballad for Chanctonbury Ring. Set in amongst the beeches, I performed a patchy rendition of the song, so used to hearing my mum sing it that to perform it went against the grain. I also played to the group a recording of a singer local to the site, giving a different rendition of the ballad. Bob Copper was sponsored by the BBC in the 1950s to travel around the Sussex and Hampshire to record traditional singers (Sussex tradition 2022). During one of his collecting ventures, he came across two singers who knew the ballad. The first, *False Lanky*, was sung by George Fosbury from Hampshire. The second, *Cruel Lincoln*, was from a singer named Ben Butcher who had learnt his repertoire from his father George Butcher. George Butcher hailed from Storrington, one of the villages that lies in the shadow of the Ring. Bob Copper gave this account of collecting the song from his son Ben Butcher:

> We went into his cottage and after a while he said, 'I'll sing you "Cruel Lincoln". That's an' old en an' no mistake.'
>
> He launched into the song with great enthusiasm and energy and even before he had finished the first verse I recognized the haunting tune and unforgettable theme of 'False Lanky'. [. . .] I listened politely until the song was over. But my patience was not put to too great a test for Ben's excellent voice and his free, unbridled style of singing added a great deal of colour to the song.
>
> 'Fancy you knowing old George Fosbury's song', I said.
>
> 'George who?' he hollered, his eyes blazing. He had neither met nor heard of George although a mere three miles had separated them for the last twenty years. 'All the songs I'm singing is my grandfather's songs', he continued with emphasis. 'My father died at eighty-one, mind you, and they was handed down from my grandfather to my father an' I got 'em now same as was given to me and I can assure you they are old songs.
>
> (Copper 1973: p. 120)

This short passage articulates many aspects of collection, including the beautifully evoked 'unbridled' style of singing, captured by both Bob's narration

and the audio recording in a way that the notation of the early collectors could not quite encapsulate. The most arresting part of this excerpt for me is the way that it illuminates the sensory and tactile nature of passing songs down. The language of the phrase 'handing down' conjures something of the haptic quality of transmission between family members, and the quirks that each new keeper may bring. Furthermore, the *lines of inheritance* that are created by the rivers of songs running through families are also conjured, lines that skip, turn and jump. Upon looking the song up in *The New Penguin Book of English Folk Songs* (2012), Mum and I realized that grandad had taught her a slightly altered version of the tune. However, as my mother said, that's the song we know now:

> MUM: *My dad learnt this from 'The Penguin Book of English Folk Songs', which was his absolute bible. Interestingly, looking at your copy now I realise he sang the tune slightly differently, so I'm going to record it the way he taught it to me. It used to fill me with the kind of appalled delight that fairy tales do, and I was trying to think today of what vision I had of Long Lankin, and it was a kind of weird oppositional vision. Long Lankin made me think of those long legs going across a landscape, but the way that the song is sung also made me think of much more like a Goblin type figure because he lives in the hay and he lives in the moss. [. . .] I see him creeping in through the little hole, and as a child it was just the most amazing song . . . it was incredibly frightening, and what I love about this song is the jauntiness of the tune juxtaposed with the horrible nature of the words, it's such a cheery little tune.*
>
> <div style="text-align:right">(Bennett 2015)</div>

5. *Long Lankin*

Said my lord to my lady, as he mounted his horse:
'Beware of Long Lankin that lives in the moss.'

Said my lord to my lady, as he rode away:
'Beware of Long Lankin that lives in the hay'

'Let the doors be all bolted and the windows all pinned,
And leave not a gap for a mouse to slip in.'

Now the doors were all bolted and the windows all pinned,
Except one little window where Long Lankin crept in.

So, he kissed his fair lady and he rode away
And he was in fair London before break of day.

'Where's the lord of this house?' Said little Long Lankin,
'He's away in fair London.' said the false nurse to him

'Where's the heir of this house?' said little Long Lankin.
'He's asleep in his cradle,' said the false nurse to him.

'Then we'll prick him, and prick him, and prick him with a pin,
And that'll make my lady to come onto him.'

So they pricked him, and pricked him, and pricked him with a pin,
And the nurse held the basin for the blood to drip in.

'O nurse, how you slumber. O nurse, how you sleep.
You leave my little Johnson to cry and to weep'

'O nurse, how you slumber, O nurse how you snore.
You leave my little Johnson to cry and to roar'

'Well I've tried him with an apple, and I've tried him with a pear.
Come down to him, my lady, and rock him in your chair'

'I've tried him with milk, and I've tried him with pap
Come down to him, my lady, and rock him in your lap'

'How durst I go down in the dead of the night
Where there's no fire a-kindled and no candle alight?'

'You have three silver mantles as bright as the sun.
Come down to him, my lady, all by the light of one'

My lady came down, she was thinking no harm
Long Lankin stood ready to catch her in his arms

Here's blood in the stairway, here's blood in the hall
Here's blood in the kitchen where my lady did fall

The False Nurse looked out from the turret so high
And she saw her master from London riding by

'O master, O master, don't lay the blame on me
'Twas little Lord Lankin that killed your lady'

Long Lankin was hung on a-gallows so high
And the false nurse was burnt in a fire close by.

In the combination of the cheery and the eerie, the 'appalled delight' that my mother felt as a child, the area of affect that considers 'mixed phenomena' is

illuminated, 'such as reluctant optimism, intense indifference, or enjoyable melancholy'. (Wetherell 2012: p. 2)

Just before the Ring, we'd been joined by Louise Spong and her husband Andrew. Louise runs South Downs Yarn, a company that creates luxury woollen spun yarn from South Downs flock, with Louise working closely with local shepherds. Since the walk, we have talked often about our work and the Sussex landscape, and I recorded a couple of songs for a new knitting pattern she launched based on Cissbury Ring, Chanctonbury's sister hill. In June 2017, on a stunningly sunny midsummer's eve, my mother and I joined Louise's family for drinks and a swim at their beach hut on Littlehampton seafront. I overheard Louise talking to my mum about *Long Lankin* and, in a thank you email the next day, I asked if she might jot down some of the impressions of the afternoon, as I had felt quite self-conscious about singing and was finding it difficult to remember the performance. The simple phrase she ends within her account moved me deeply and brought encouragement at a time when it was much needed, with the sheer quantity of affects seeming impossible to communicate or do justice to. As the anthropologist Geurts explores:

> We [ethnographers] often find ourselves drenched – not just in discourse and words, but in sensations, imaginations, emotions.... And yet, if we have become drenched, those we work with may also be soaked through and through. Such moments open up space, sound a call, to body forth fine-tuned accounts replete with an ethical aesthetics in the field.
>
> (Geurts 2003: p. 386)

LOUISE: *I first met Lizzie online via social media where the hashtags #Sussex and #SouthDowns make it easy to discover people who have a common interest in them. It was clear from the beginning that we shared a love of our local South Downs landscape, the vernacular history expressed through folklore and songs, and a desire to reimagine what these mean to us in the present.*
When Lizzie announced that she planned to walk the South Downs Way singing Sussex folk songs and offered up an open invitation to join her, I knew I wanted to share her journey for at least a part of the way as well as get to meet her in person.
I have been walking up, down, and around Chanctonbury Ring ever since I can remember so it felt appropriate that I met up with Lizzie here, just over halfway along the route.
It is rarely not windy atop the South Downs, especially Chanctonbury Ring, and this day was no exception. In order to find some shelter, our little group headed

straight into the heart of the Ring where the paths peter out and the light begins to fade. The untrodden undergrowth crackled under our feet and we cleared it away to find places to perch as Lizzie started to sing 'Long Lankin'. In the dim and enclosed space of the beeches and scrub a hush fell as Lizzie's voice rang out. Chanctonbury Ring is steeped in folklore, and on this day there was a palpable sense of the eerie and macabre as the words of the song echoed the immediate environment's nameless disquietude.

I have so many memories associated with Chanctonbury Ring layered like the soil and now I have another: the haunting unaccompanied voice of Lizzie singing. I have also made a friend.

(Spong 2017)

One of the first things that struck me about Louise's account was the sensory depth of her recollection of the crackling undergrowth as we gathered in the Ring. It made me realize how predominantly I recall visual impressions rather than auditory ones. Beyond birdsong, for which I have a limited knowledge, there are very few memories I have of the walk that would evoke the heard texture of the ground that Louise could recall. It was illuminating to become aware of my own sensory predispositions: that I visualize atmospheres as colours or mirages. If I think about Chanctonbury that day, I think about mist, and yet I don't actually think it was misty. Yet the Long Lankin of my imagination creeps into the windows like an icy fog, and this had become entwined with the performance space. The nameless disquietude that Louise so perfectly evokes also allowed me to conceive of the particular mood caused by us walking to, listening to and gathering at the Ring that day. As Anderson states, 'affective atmospheres envelope and emanate from particular ensembles that are gathered together for different durations around particular bodies [. . .] how a body's force of existing is formed in encounters' (Anderson 2014: p. 82). However, that is not to say that Louise or I, nor any other members of our group, would experience the same sense of the eerie or macabre. This may have registered in a variety of ways, each signalling some dimension of what the song *did*. In Louise's Chanctonbury Ring as a place layered with memories like the soil, once more Ingold's concept of place as formed through lines of movement and attachment to things, people, and animals is beautifully brought to the fore, 'the inhabitant is rather one who participates from within in the very process of the world's continual coming into being and who in laying a trail of life, contributes to its weave and texture' (Ingold 2016: p. 83).

In honour of South Downs Yarn, and as a nod to the sheep currently dotted around the Ring and tending to their lambs, I sang a jolly number. On 17 October 1912, Dorothy Marshall visited Harvey Humphrey. Harvey lived in Sullington, one of the villages lying to the west of Chanctonbury Ring. I hadn't been able to discover a great deal about this singer, but Dorothy Marshall wrote to Carey that Humphrey was as an old man who knew many songs and she was concerned he would die before they could visit him (Marshall 1911: CC/2/178). Unfortunately, recording him on a phonograph appears to have been unsuitable due to his bronchitis. Census data in 1911 records him in Sullington in retirement from carpentry and living with his wife Sarah, both born in the neighbouring village of West Chiltington ('Harvey Humphrey', 1911). In the 1901 census, they lived at 27 Water Lane, Sullington ('Harvey Humphrey' 1901). In the 1891 census, they lived at 34 Landry Cottages with their son James, a general labourer, and their daughter Grace, a needlewoman ('Harvey Humphrey' 1891). When Dorothy visited Harvey and Sarah, they would have been eighty-four and eighty-three, respectively. I had chosen *Young Jockey* from the various songs she had collected from Harvey, for no particular reason that I can recall, but as I began to practice it before the walk, I was pleased to discover in a note at the bottom on this manuscript that it had in fact been taken down from Mrs Sarah Humphrey, Harvey's wife, and that the song was learnt before she was sixteen. The past practice of women being referred to by both their husband's first and last names may have resulted in mistakes when recording the source of songs, particularly in large collections. This encounter allowed me to see how sustained research, and taking care of archival material, allows for an intimacy that illuminates women who have become lost in the archives. I was also able to let the team at the Vaughan Williams Memorial Library know, so that they were able to catalogue it under Mrs Sarah Humphrey:

6. *Young Jockey Walked Out*

Young Jockey walked out on a fine summer's morn
And he sat himself down beneath a green thorn
He had not long been there when a fair maid passed by
And on this gentle shepherd cast a languishing eye

She said, 'My gentle shepherd, have you seen my two lambs
Have you seen my two lambs that so carelessly strayed?'
'Oh yes my lovely fair maid I saw them go by

> They are down in yonder greenwoods – indeed it's no lie'
> She thanks him with a curtsey and turned herself round
> Young Jockey followed after and lodged on the Downs
> She came to the grove, but no lambs could she find
> But still this young shepherd kept wondering her mind
>
> Tis a sad disappointment on a sad silly maid
> She little thought he played his game so artful and gay
> Now this young couple is married as I heard say
> Down in yonder cottage they dwells both night and day
>
> They lives and loves together, all joys to renew
> And the little lambs play round them all in the morning dew.

Something I was also fortunate to be able to talk to Louise about in our subsequent friendship was the possibility that my preoccupation with finding family songs, particularly from mother to daughter, came at a period of my life when I was wondering where the line might go from me. We both share a 'desire to reimagine' what traditions might mean now, to take care of them for future generations, but do not have direct lineage ourselves, that is children. As a result of these conversations, as well as other times and places, feelings and movements, I thought much on Ingold's call for a rekindling of philosopher Henri Bergson's open-ended view of genealogy and the history of life. As Ingold expands, seen from this position:

> Every being is instantiated in the world not as a bounded entity but as a thoroughfare, along the line of its own movement and activity. This is not a lateral movement 'point to point', as in transport, but a continual 'moving around' or coming and going, as in wayfaring. How then would we depict the passage of generations, where each, far from following the previous ones in a connected sequence of synchronic 'slices' leans over [. . .] and touches the next?
>
> (Ingold 2016: pp. 122–3)

This idea of weaving, renewing, and touching allowed me to think of my connections reaching forward to potential nieces and nephews, students, scholars, and singers, and also to see the connections from before that reach towards me in the present, and through me are alive, and always becoming. No less, and no more, important than 'carrying the line on'. From this perspective, I felt less like a dead end, but rather piece of a larger tapestry. Ingold illustrates

Figure 10 Ingold, T (2016). *A Braid of Lines* [Illustration].

this touching of the family – 'the narrative interweaving of present and past lives' – movingly in his diagram depicting a standard and an alternative descent line:

> As generation B matures it follows a path increasingly divergent from that of the parental generation A; likewise C diverges from B. Yet it is from the grandparental generation A that C learns the stories that it, in turn, will carry forward in life, above all through its offspring D (who may, in fact, take the grandparental name and be regarded as a continuation of the ancestral namesake). Similarly, D's offspring E follow in the footsteps of generation B. The result is a braid of lines that continually extend as lives proceed.
>
> (Ingold 2016: p. 122)

I later thought again about lines beyond the heteronormative family, and through feminist research, when I encountered Ahmed's evocation of the potential of feminist and queer genealogies in *Living a Feminist Life*:

> Snap can be a genealogy, unfolding as an alternative line, or as a feminist inheritance [. . .] in a conventional genealogy, the woman who does not have a child of her own would be an end point. Snap, snap: the end of the line. In a feminist and queer genealogy, life unfolds from such points. Snap, snap: begin again.
>
> (Ahmed 2017: p. 192)

The notion of a desire line, first encountered in Cresswell's writings on place, kept returning to me as I considered various aspects of the thoughts that were woven in and out of Chanctonbury Ring. Desire line evolved as a term for planners and developers to identify 'an informal path that pedestrians prefer to take to get from one location to another rather than using a sidewalk, pavement, or other

official route' (Murry et al. 2007: p.1). Following Grosz's reading of Deleuze and Guattari, where desire is an 'actualization, a series of practices bringing things together or separating them', desire in this thesis relates to acting on an affective charge: Chris's impression of songs that need you to sing them, Louise's locally sourced yarn and Downland-based patterns formed through the desire to reimagine, a wish for the ploughshare to never rust – repeated, refrained, and resounded (Grosz 1994: p. 165).

As we descended towards Steyning Bowl, and past the path so poignantly evoked in *The Steyning Poem*, I amused the archaeologists with one of my 'discoveries' and my desire to believe. On an unofficial history site that I had visited about Chanctonbury Ring, there was a story that Prince Agasicles Syennesis the Carian came over in the seventeenth century to stay with a friend, and discovered that Chanctonbury Ring was a perfect spot for astrology. He spent many nights up there and died whilst star gazing, tracing on his chart in charcoal, 'sepeli ubi cecidi' (bury me where I have fallen). It transpired, upon further research, that the story comes from an incident in the book *Alice Lorraine: A Tale of the South Downs* by R. D. Blackmore (1878). This had passed into an urban myth, and I was delighted to discover a linocut inspired by the tale of Chanctonbury Ring with the Plough above it. Chris Skinner had sung me a song about the night sky written by Maria Cunningham, and when I hear Chris sing, I'm walking up to the Ring on a moonless night with the Plough above me:

> CHRIS: *I always like to sing a song because I like the song and I feel like it needs singing. In fact, this song that I'm going to sing of Maria's, about the night sky, is so strong for me because of the story, but it's also the first song I sang on my own. So, it's a very special song for me and I don't know many people who sing it. A lot of people sing Maria Cunningham's songs, she was a well-respected and much-loved singer of Sussex folk songs who is sadly no longer with us, but her songs linger on, and I often feel that when I sing one of her songs it helps to perpetuate that person's memory. It's such a simple story but the imagery really weaves through with the language [. . .]*
>
> LIZ: *Do you find that there are paths you feel need to be walked on in the same way as the songs seem to invite you to sing them?*
>
> CHRIS: *Yes, some paths ask you to walk them. The way that I've learnt songs is from people singing them and they're not necessarily recorded – some of them are – but when you are out and about driving, walking, or what have you, and a song comes in your mind, if you know the song you can sing it to yourself, it's always part of you, it's always there. So, I really think the whole point about songs is that they*

should be a part of you, that's why I learn songs and that's why I sing them. Maria's song is special because I was asked to sing it at her Memorial, so it's my last song of hers and I've made a conscious effort to always keep that song alive. Being Maria it's very well researched because Orion is a winter constellation, and you'll always spot it because the of the three stars that form his belt in a line. It's one of the most recognisable shapes in the sky . . . and I just love the story, with such an economy of words she's managed to link those songs together. I only have the confidence to sing myself if I put myself in the song or in the story, and the story is unreeling behind my eyes as it were and I'm walking through the story. And that's how I learn songs and how I remember what verse comes after the other because they are not always particularly sequential, but the way Maria has somehow managed to link all those constellations together with the story is how I remember it.

<div align="right">(Skinner 2015)</div>

7. Orion the Hunter

Orion the Hunter stalks the sky
At his heels, the dog with the fiery eye
Sirius gleams with a magical light
The brightest star in the winter's night

The hare leaps at Orion's feet
The girdle around his waist so neat
Holds the sword that is death or life
The stars shine out of his heavenly knife

With his great club raised to the Bull's horned head
To deliver the blow that will strike him dead
Aldebaran the Bull's red eye
Follows his maidens across the night sky

The Seven Sisters away they flee
From the Giant who would their master be
The Pleiades fly away as doves
To be set as stars in the sky above

Orion is king of the winter's night
With his club and his sword, through his power and might
At his heels, the dog with the fiery eye
Forever he'll rule in the winter's sky
Forever he'll rule in the winter's sky.

The act of remembering Maria by singing her song demonstrates Chris engaging with the song as an act of revisiting the past, but also as a way of pulling those memories and that person into her affective present. In addition to this form of reimagining, the song is also linked to a time in her life and a form of becoming, having a significance as the first song that she ever sung unaccompanied, and therefore being linked to all the songs she has sung since. Furthermore, Chris articulates the process of following the song as it unfolds each time, being guided by the story and navigating across the terrain of the narrative. Thus, each time Chris sings the song, a song that has become part of her, she is following a familiar route, but one that she walks differently each time. Applying Ingold's exploration of writing as a 'means of recovery' to singing allows an illumination of this repeated journey through, or with, a song:

> To read, then, is not just to listen but to remember. If writing speaks, it does so with the voices of the past, which the reader hears as though he were present in their midst [. . .] not to close off the past by providing a complete and objective account of what was said and done, but rather to provide the pathways along which the voices of the past could be retrieved and brought back into the immediacy of present experience, allowing readers to engage directly with them and to connect what they have to say to the circumstances of their own lives.
>
> (Ingold 2016: p. 16)

The last few miles of the walk down into Steyning Bowl, curving down to the river Adur, became a matter of forcing my body along the path. The 'bostals' that day had been particularly unforgiving, and we were all feeling the impact of the glaring white chalk against the ivory strips of our toe bones. After a swift drink at the Rising Sun, we wearily dispersed on our routes home. During the last stretch, I had fallen into conversation with Lorna, and I think we were discussing the lack of facilities along that day's route, but somehow, we discovered that we were both endometriosis sufferers. That creation of empathy between two bodies has been sustained and reimagined in a fairly constant correspondence in the many months that have passed since that day. We have sought consolation, black humour, and practical advice in our messages to each other, during what Lorna aptly terms as 'years of medical chaos'. That bond, mostly virtually maintained since, was created by a walking beside each other, allowing both privacy and exchange. We were sharing something intimate, but we were also looking at the view. It allowed for a predominantly verbal exchange, without the literal pressure

Figure 11 Dixon, J, 2015. *Walking Towards Chanctonbury Ring*. 2 May 2015 [Photograph].

of being face-to-face, 'I see what you see as we go along together' (Ingold and Vergunst 2008: p. 80). This was a moment of affective empathy, by which I follow the definition of 'feeling with the other' (de Vignemont and Singer 2006: pp. 435–41). Referring to his own approach of talking-whilst-walking with research participants, Jon Anderson captures something of that affective empathy in his reflection that 'emotive connections would come to us through conversation, prompted not only by questions, but also by the interconnections between the individuals and the place itself' (Anderson 2014: p. 254).

I argue, the South Downs Way may be seen as a constantly evolving desire line, 'a cumulative trace, not so much engineered in advance but generated in the course of pedestrian movement itself', and that path-making 'weave(s) another strand into it' (Ingold 2010: p. 121). In the preface to his book, Ingold asks: 'what do walking, weaving, observing, storytelling, singing, drawing and writing have in common? [. . .] they all proceed along lines' (Ingold 2016: n.p.). By reflecting on this day's walk, I have begun the work of imagining the different types of those lines and considering how they might work affectively. It was only once I began to speak to other singers that I gave much thought to the moving lines I saw in my head when I sang, such as the shape-shifting, sea-changing, scores of *The Silvery Tide*. The threads of thought created by movement that day allowed ways of seeing the 'interconnections between the individuals and the place itself', connections that may be understood in certain ways when walking and singing in people's lived landscapes and communicated affectively through folk songs. As Ingold states, 'it is along paths, too, that people grow into the knowledge of the world around them and describe this world in the stories they tell' (Ingold 2016: p. 3). Some of these stories are songs.

2.4

Childhood

The river Adur is one of my favourite places in the world. Here, the hills roll into one another, creating a line that soars. That is where my fourth day of the walk began. Many months on from that morning, in a sterile operating room, I closed my eyes and willed myself along the sweeps, curves, and falls of those hills that rise up from the river and run east: Mill Hill, Truleigh Hill, Edburton Escarpment, Devil's Dyke, Newtimber Hill, Ditchling Beacon, Black Cap, Kingston Ridge into the next waterway of Sussex, the river Ouse, and up onto the magnificent Firle Beacon. Here, the hills roll into one another, creating a line that soars. That particular stretch of the Downs always reminds me of a passage from Charles Frazier's *Cold Mountain*, which in turn recalls *The Spell of the Sensuous*:

> After a time, though, Inman found that he had left the book and was simply forming the topography of home in his head. Cold Mountain, all its ridges and coves and watercourses. Pigeon River, Little East Fork, Sorrell Cove, Deep Gap, Fire Scald Ridge. He knew their names and said them to himself like the words of spells and incantations to ward off the things one fears most.
>
> (Frazier 1997: p. 11)

Imagination and tenacity were also needed when we set off that morning for the next stage of the journey. High winds were coupled with the kind of fine drizzle that soaks you instantly despite appearances, and we had about 6 feet of visibility. Lucky, then, that this was an area of Sussex that my sister and I are very familiar with, having spent much of our childhood up on these Downs; Devils Dyke and the Beacon being within easy reach of our Preston Park home. Truleigh Hill has also been a regular path taken at the time by my stepfather and I on our daily dog walks, and it was a novelty to feel lost up on those ridges, and to have to sense the landscape in a different way: heads down and determined against the wind. Much of the first part of the walk was spent by my sister Sarah and I attempting to describe to our friend Sarah Wales the spectacular view that

lay beyond the mist. Sarah had joined us particularly on this stretch to see Devil's Dyke, and I broke it to her fairly early on that the view was lost to us on that day. What particularly marks this day out in my memory was the long familiarity between us as walking companions, and therefore not needing to feel apologetic about the abysmal weather. I have been on many journeys with Sarah and Sarah Wales before, and since, and as such have tested the ground of our abilities, temperaments and interests. As Heddon proposes:

> Friendship is not an ordained, metaphysical relationship but one that becomes and endures through practice. There is, then, a practice to friendship, to companioning. Through walking, one exercises friendship, providing a grounding and a materializing.
>
> (Heddon 2012: p. 72)

The general attitude of goodwill, perseverance, and fun was highlighted by songs and rounds we sang to keep our spirits up. Sarah and Sarah are also in a choir together, so for the most part it was them teaching me, with simple tunes such as this Elizabethan round:

Ah, poor bird,
Why art thou
Lying in the shadows
Of this dark Hour?

Ah, poor bird
Take your flight
High above the sorrows
Of this dark night

Ah, poor bird
As you fly
Can you see the dawn
Of tomorrow's sky?

At the foot of Mill Hill, near the mouth of the Adur, is the old part of Shoreham-by-Sea, where my father and his three brothers grew up. My sister and I were raised in Brighton, where my father still lives, but we spent a lot of time with my grandparents in Shoreham and, as I continued through this project, I became curious about my dad and uncle's experience of growing up by the Downs and their memories of the footpaths I would walk. The day after I finished the walk, I met with my dad Peter at my uncle Richard's house to tell them about it and ask

them about their childhoods. We sat together in Richard and Liz's living room, which I have known intimately all my life, and were surrounded by photographs of our family members, some still with us, some not. In their living room is also my grandpa's sideboard, overflowing with memories and sensations of him; the nail clippers he would use to cut our toenails, the mints he kept in one of the draws that his breath smelt of, the scent of the pipe we could light for him as a treat. Drinking tea, eating Liz's famous Victoria Sponge, and poring over her perfectly ordered photo albums illustrated Pink's contention that the interview

> Is a social encounter – an event – that is inevitably both emplaced and productive of place. It has material and sensorial components. Interviewees refer to the sensorality of their experiences not only verbally through metaphor, but through gesture, actual touching, sharing scents, sounds, images, and even tastes [. . .] interviewer and interviewee[s] communicate as embodied and emplaced persons.
>
> (Pink 2015: pp. 74–5)

Bennett men are sometimes known in the family for being private – wonderful conversationalists, sociable, warm, and humorous, but not necessarily forthcoming about their feelings. When wider family listened to the extended interview, everyone asked how I had got them to talk so much. However, I did very little. They quite quickly provided the questions and answers for each other, revisiting their roaming radius, or 'y filltir sgwâr', which Pearson translates from the Welsh as the square mile of childhood, 'the intimate landscape of our early years, the terrain we know in close-up, in detail, in a detail we will never know anywhere again' (Pearson 2006: p. 23). They remembered as they went along:

> DAD: *In our home there were four boys, and we lived in Shoreham, which was a great place to grow up because you had absolutely everything that you wanted to explore – the beach, the Downs, the river, the harbour, the playing fields, parks and stuff like that. [. . .] So, we used to be out after coming home from school until it was dark. The other basic things, I think, to remember about life then was that for us as a family we didn't have a car, so if we went anywhere it would have to be by train or by bus or by foot. Also, for quite a long time we didn't have a TV either, so we had to make our own entertainment in the evening.*
> UNCLE RICHARD: *The most amazing thing was that, although we had these friends in Windlesham Gardens, we were Strict Baptists. Every Sunday we used to walk down to Chapel. So, there would be our grandfather who was the preacher, then dad who was the deacon, and mother, and us four boys. My*

grandfather even in the middle of summer would be dressed in the long black coat with a Homburg hat on.

DAD: *There's the picture of them on the beach with their black suits and hats/*

UNCLE RICHARD: */And, of course, we had to walk past all our mates' houses and they'd be out with their transistor radios washing their cars/*

DAD: */Particularly washing their cars was a Sunday activity*

UNCLE RICHARD: */All sorts of things of Vanity Fair were going on and we felt completely separate to that on a Sunday, which we called the Sabbath/*

ME: *What was the Sabbath like?*

DAD: *Deadly boring. Really, deadly boring.*

UNCLE RICHARD: *No radio, no television, no papers, no toys. Cold meats of the roast from Saturday.*

DAD: *So, we got up and then there was Chapel at 11am, which lasted for an hour and a half; quite an effort for a child to survive that. Then there were visiting ministers for us to host, who were of varying interest or horror or whatever, some very, very strict and some very excitable from the pulpits. They usually came home with us for lunch as well so there was no respite from the Sabbath day/*

UNCLE RICHARD: */ Then Sunday School for 45 minutes or an hour, and then Chapel again in the evening. What dad and the preacher used to do on Sunday afternoons, after dinner and Sunday school, was to prepare the evening service. So, it was really . . . the day was a total wipe out as far as a young boy was concerned. But the counterbalance to these strict Sabbaths were our Saturdays and our long school holidays where our parents allowed us almost total freedom, we just ran around and roamed and roamed. I really can't understand how it happened like that, but I used to go out in the summer holidays in the morning and never used to come back until the evening, and it was the whole day playing on the Downs/*

DAD: */And that was before the By-Pass. We often used to walk up The Avenue and round to get home and I had a friend John Lewis who lived on Erringham Road, and there were others who lived up that way and we used to get together as a group then walk up on the Downs, up Mill Hill.*

UNCLE RICHARD: *So, as Pete says, before the By-Pass the Downs ran from Mill Hill to Truleigh Hill uninterrupted, and when we got to a certain age, I think it was about 8, there was an important moment where you looked over from Truleigh Hill towards Henfield . . . so, there's a big valley and eventually we actually took that step to go over further and I remember walking as far as Henfield on a couple of occasions and that was a big thing because it was like going to a foreign land (laughs)*

DAD: *You walked across the river, as well, didn't you?*

UNCLE RICHARD: *Yeah, we walked straight through it. Also, when it was snowing once it iced over, and that was perfect for walking across it.*

DAD: *And you walked across the railway bridge too.*

UNCLE RICHARD: *Yes, that's when I was older. We did all these things like fishing and tadpoling/*

DAD: */ Oh yeah, tadpoling! Where the By-Pass is now, below there, there used to be a lot of water streams so there were tadpoles and newts and everything like that. Berry picking/*

UNCLE RICHARD: *Scrumping/*

DAD: */ Yes, scrumping, that was a big thing around Shoreham.*

UNCLE RICHARD: *You did see other gangs of kids occasionally, but they were seen as intruders on your patch as it were.*

ME: *And were there farmers around?*

UNCLE RICHARD: *Not really because that part of Mill Hill wasn't really cultivated, but there was a farm on the edge of Mill Hill when we were younger, and they were nice.*

ME: *So, it would have felt like total freedom up there?*

UNCLE RICHARD/DAD: *Oh yeah, yeah!*

[. . .]

UNCLE RICHARD: *For me it was always a total fantasy land of medieval knights and things like that/*

DAD: */Yes, it was timeless really/*

UNCLE RICHARD: */And it was so easy to ride around like a horse/*

DAD: */Yes, free as the air/*

UNCLE RICHARD: */ You slap your side and go running off and imagine you were a horse/*

DAD: */High Ho Silver!*

UNCLE RICHARD: *And in summer we used to make incredibly complex structures out of the hay bales on the hill, much to the annoyance of farmer Nye. He was a bastard, he whipped me once with his riding crop because he'd caught me in his barn.*

DAD: *So, revenge was sweet when his farm burnt down?*

UNCLE RICHARD: *Oh yes.*

[. . .]

ME: *What was the house like?*

UNCLE RICHARD: *It was a semi-detached house and our grandparents lived on the ground floor, and there was the garden with big trees and our front garden led onto the street, which circled some old tennis courts in the middle and this was where we played, so it was magical to grow up there.*

DAD: *On the notice board at the Chapel they had dad's address, so tramps used to look at the various churches and then go and see what they could get from the preacher or the person identified. [. . .] Grandma would always feed them, but she would ask them to eat it outside.*

UNCLE RICHARD: *She said I used to bring them home. I can remember bringing two home in my whole life. I can remember bringing two tramps home to Windlesham Gardens, but she used to blame me for all of them. But we were brought up to help.*

DAD: *And all the tramps were fascinating, and they had moved from place to place.*

UNCLE RICHARD: *I remember one came and had really terrible sunburn on his neck/*

DAD: */We were a bit wary of them to a certain extent/*

UNCLE RICHARD: */No, I wasn't worried by them. I'm worried now I think about it afterwards, now I'm older, and I think that these strange men used to engage me in conversation when I was about five or six, and I'd take them home for something to eat. But we were brought up with this wonderful, beautiful idea of Christianity and Jesus healing the sick; it was totally natural to take people home and try and help them. We didn't have to justify it at all, in fact I thought everybody did it.*

ME: *Grandma was very involved in social causes, wasn't she? She knocked on doors raising money for children in Africa when she had four very small kids.*

UNCLE RICH: *I think even she got a bit pissed off with 16 tramps sitting on her front wall.*

[Collective laughter]

DAD: *She used to take a week every year to collect for children's homes as well.*

UNCLE RICH: *The only social outlet mother had apart from the Chapel, which I don't think she'd regard as a social outlet/*

DAD: *No, she wouldn't have/*

UNCLE RICHARD: */Was the choral society. She had a wonderful singing voice . . .*

ME: *Really?! Nobody has ever told me that. I never heard her sing!*

UNCLE RICH: *Oh yes, I remember as a boy sitting in the garden and people would stop in the street to listen to her sing.*

(Bennett and Bennett 2015)

During my conversation with Dad and Richard, different registers of memory were present in recalling the childhood activity of tadpoling; Richard prompted Dad to also recall scrumping, but there were also strongly embodied responses to each other's reminiscences, such as Dad's interjection and physicalization – 'High ho silver'. He doesn't verbalize 'oh yes, I remember that', but rather places

himself back in the moment by performing the action of slapping his leg. These exchanges, and the sense they recall of being as 'free as the air', reminded me of Lorimer's contemplations in *Homeland* when he walked a storied landscape of childhood with a lady who had grown up there:

> I found myself asking what it means to label forms of recollection, movement, and description as 'deeply childlike'. Recent geographical dialogue encourages further consideration of the question, suggesting that greater allowance be made for a world of intuition, possibility, and innocence. [. . .] Calling up past geographies from childhood – wanderings, dreams, postures, casts of mind with their own small circumference – is to walk in memories shadow and open out spaces for reverie.
>
> (Lorimer 2014a: p. 598)

Such spaces of childhood have their own contingencies, such as gender constraints and generations, my own roaming being necessarily smaller than my dad's due to a stronger societal shift towards parental supervision and our more urban house, amongst other factors. However, on the many, many camping trips we took with family friends, a similar landscape of exploration was present; a universe where adults didn't exist, the circumference of which grew bigger with each year. Further, whilst there are multiple intersectionalities surrounding particular experiences of childhood (such as race, gender, class, and disability), it is possible to see how revisiting certain ways of (re)engaging with the landscape, such as rolling down hills, scrumping or climbing trees, may, as Lorimer suggests, open out spaces for reverie and imagination.

In interviews, as with other forms of conversation, particularly I think in families, there are also things left unsaid. As Richard humorously evokes, grandma blamed him for bringing the homeless men home; this is part of a wider family joke about Richard getting the blame for everything. This myth has some of its route in Richard's adolescent rebellion against a strict religious upbringing, and resultant tales that have come down the family of his wildness. Upon listening to the recording again, something in the way that Dad voiced the question, 'So revenge was sweet when his farm burned down?', made me wonder if the fire may not have been wholly accidental. After clarifying with my dad that this was not the case, I reflected that this suspicion came from a combination of repeated and exaggerated stories in the family, my own imagination, and the gap between what was said and what I thought was possibly suggested, recalling John Berger's statement that 'stories walk, like animals and men. And their steps are not only between narrated events but between each

sentence, sometimes each word. Every step is a stride over something not said' (Berger 1982: pp. 284–5).

In this world of freedom mostly inhabited by friends and rival groups of children, the adults that both men remember are the 'tramps'; people who migrated for work or shelter, as Robert MacFarlane explores, are often overlooked for their role in creating and maintaining the footpaths of the British countryside:

> The ethical difficulties involved in celebrating the life of the road when there were many who had no choice but to live upon abjectly upon it: the jobless and the homeless, the tramps, hobos, and bindle-skiffs, the dispossessed and the overworked.
>
> (MacFarlane 2012: pp. 19–20)

Tramps continue to have relevance to ideas around landscape and place today. In his works *Tramp in America* and *In Place/Out of Place*, Cresswell has explored how the oppositions between insiders and outsiders can be traced alongside movement; place and belonging have been seen as rooted and bounded, and such fixity gives rise to 'dualistic thoughts about people that are mobile or displaced, such as tramps, travellers, or refugees' (Butler 2007: p. 893). If we return to Ingold's notion of meshworks of pathways, it is possible to see how all lives and landscapes are lived out and through mobile lines – albeit at different scales. When Pearson discusses region as 'the affective ties between people and place' (Pearson 2006), this conjures Ingold's notions of lines. Rather than being tied down, or rooted on the spot, such an idea is reminiscent of looping a rope around a tree as a marker on a journey, as we did as kids tracking and trailing in the Woodcraft Folk. The tie marks your presence in that place, but the rope carries on with you and is capable, possible, of producing other ties:

> Literally an environment is that which surrounds. For inhabitants, however, the environment does not consist of the surroundings of a bounded place but of a zone in which their several pathways are thoroughly entangled. In this zone of entanglement – this meshwork of interwoven lines – there are no insides or outsides, only openings and ways through.
>
> (Ingold 2016: p. 106)

It is my desire to be clear throughout this book that, by exploring the folk traditions of Sussex, I am not suggesting that they belong to any demographic of people or any set idea of place. Songs move, people move, borders move; these very traditions were created by movement and passed on by travellers. Any notion of tradition that suggests exclusion, purity or supremacy is abhorrent

to me. These songs belong to any and all who sing them and meet them in the affective present. They have histories, many of which are partial, but they also have futures. They form part of the tapestry of the region of Sussex and many other regions, but only part. And the tapestry will continually be added to and enriched. In *Martin Pippin in the Apple Orchard*, Eleanor Farjeon's fictional creation Martin Pippin, far from seeing tramps in oppositions to the local, housed inhabitants, stops to ask one for the way, 'for Sussex tramps know all the beacons of the Downs' (Farjeon 2013: p. 167).

Furthermore, ever present in our conversation is grandma. Grandma who fed the tramps, grandma who knocked on doors and grandma who sang at windows. It seems extraordinary to have known her for twenty-two years and not known that: lost somewhere between her modesty and religion, and my youth and self-absorption. I was disappointed not to have a song here linked to grandma; however, something about the absence of one is more telling. As is the fact that she is not in the picture (Figure 13), presumably taking it. And yet, through speaking with her children, her voice, if not her song, became present in the room. I was reminded both of Scarles's identification that 'interviews become fluid, dynamic and mutually responsive performances within which the unpredictable and the unexpected fuse with more apparent pathways of discussion' (Scarles 2010: p. 509) and of Blackman's assertion that 'practices are always more-than-human, and more-than-one, and weave the past, present, and future together in ways that open up gaps, contradictions, absences [. . .] and silences' (Blackman 2015: p. 27).

Back on the hills of Upper Beeding, the two Sarahs and I were travailing against stormy winds and footslogging through the famous Sussex mud, for which upwards of thirty dialect words exist, choice amongst them for the occasion being *stug* – a

Figure 12 Bennett, E, 2017. *New Year's Day*. Sarah Bennett, Elizabeth Bennett, and Sarah Wales. Cairngorms. 1 January 2017 [Photograph].

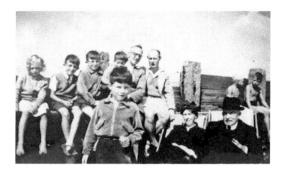

Figure 13 Bennett Family Collection, c. 1950s. *On Shoreham Beach*. Grandpa, Great-Grandma, Great-Grandpa, and the boys [Photograph].

watery mud. These hills were also the home, for a time, of the 'Singing Shepherd' Michael Blann. Blann had a reputation as a tremendous singer of traditional songs and his notoriety continued through Barclay Wills's extensive writing about Blann, including his volume *Shepherds of Sussex* (1938). He was born in nearby Poynings, in the shadow of Devil's Dyke, and began his working life as a shepherd at nine years of age. Colin Andrews notes in his book on Blann, *The Shepherd of the Downs*, that having a very musical family he also came to singing at a young age, and a favourite uncle made an impression on the young Michael with his love of a good old song (Andrews 1979: p. 4). Blann's work as a shepherd enabled him to travel around Sussex, particularly to sheep fairs, and there he was able to bolster his family repertoire with other songs. Sheep fairs themselves are sometimes the topic of folk songs; a popular example would be Devon's *Widecombe Fair*, which chronicles the journey to the annual livestock sale. One of Blann's notebook of the songs he knew has survived. It contains over twenty texts and over thirty titles; however, he didn't note down the music. Whether this is because he learnt by ear or kept the notebook simply to jog his memory of the words is not known. He was clearly musical, however, and played tunes on his tin whistle:

> By 1867, he had already begun to note down his favourite songs in a notebook and was gaining a reputation for his rich voice. During the long hours alone on the Downs tending his sheep, he would entertain himself on the tin whistle he carried with him.
>
> (Andrews 1979: p. 7)

Surveying his notebook in Worthing Museum, I was struck by a 'title only' listing of *The Bonny Light Horseman*. My mother has sung this song magnificently all

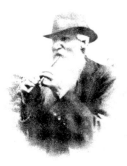

Figure 14 Worthing Museum. *Michael Blann* (1843–1934) [Photograph].

her life, but I have never associated it with our Downs. I was very moved by this discovery, and to think of the song being sung on the Sussex hills before we began our journeys on them, and I left the museum without noting a single other song by the Singing Shepherd:

> ME: *You were telling me that it was being barred from the pub you usually drank in (for being underage at 17) that led you to discover the folk scene.*
> MUM: *That's right. A friend of Grannie's suggested the Stanford Arms and that's where one of the folk clubs was. So, then I started to go and sing in the folk clubs [. . .] it was all new to me and it was very exciting.*
> ME: *What sort of things would you sing? Would you sing songs that grandad had taught you?*
> MUM: *Initially I did, and then I met a Scottish guy called Roddie Cowie. [. . .] I learnt a few songs from Roddie Cowie, one of which I'd like to sing for you, and I picked up songs from listening to other people singing them. [. . .] I think it's a Scottish song but people do know it in the clubs and they join in at the chorus. The dialect of words like 'groat' suggests to me it's Scottish. I just think of it as pastoral, it's about the ploughmen and what I love about it is that there aren't that many folk songs that are about absolutely frank sexuality towards a man. This is about pure sensual beauty and the appreciation of it. I associate it with my first boyfriend Terry, because he was a very good-looking man and he made horse drawn vehicles. I associate it with when I was first ecstatically in love with him, and that whole thing of how gorgeous men are:*

19. The Ploughman Lad

Down yonder glen there's a ploughman lad
And some summer day he'll be all my own
And sing Laddie-I, and sing Laddie-O
Ploughman lads they are all the go.

I'll love his teeth, I'll love his skin,
I'll love the very cart he harrows in
And sing Laddie-I, and sing Laddie-O
Ploughman lads they are all the go.

Down yonder glen, could've gotten a miller
But the smell of dust would have made me choke
And sing Laddie-I, and sing Laddie-O
Ploughman lads they are all the go.

Down yonder glen, could've gotten a merchant,
But all of his stuff were not worth a groat
And sing Laddie-I, and sing Laddie-O
Ploughman lads they are all the go.

Oh see him coming from yonder the town,
With all of his ribbons hanging round and round
And sing Laddie-I, and sing Laddie-O
Ploughman lads they are all the go.

And now she's gotten her ploughman lad
As fair as ever he left the plough
And Sing Laddie-I, and sing Laddie-O
Ploughman lads they are all the go.

MUM: *Oh – 'can you see him coming from yonder town, with all his ribbons hanging round and round' – it's such a picture!*
ME: *So, you are seventeen when you start to sing publicly, and you've sung sometimes frequently, sometimes infrequently since [. . .] and you felt that this was the music for you?*
MUM: *Yes, I became very, very interested and I have a vast collection of folk CDs, but I don't listen to them very often because . . . it may sound arrogant, but if you sing to yourself, which most of my life I have, except when I became depressed when I noticed I didn't sing/*
ME: */No, you didn't.*
MUM: *I sing to myself; I am my own company. If I go on a long car journey I will just sing. I can remember saying to my dad, 'how do you keep yourself amused driving 800 miles from France to Italy? How do you stay awake?', He said, 'I sing every song I know, and then I sing them again'. I can remember sitting down with my father when I arrived in France, and in the evening we said, 'let's sing all the Scottish songs we know' and three and a half hours later we were still going.*

[. . .]

ME: *After your brain surgery, when you saw the Downs, you described that as a spirit lifting view . . .*

MUM: *Well . . . I didn't think I was going to survive my brain surgery, I hoped I would, and then I had three weeks in hospital, which was a very strange and artificial environment and the only glimpse I had of the outside world was just a bit of sky [. . .] so many times I've driven that Ditchling Road, when Tony came to pick me up I was still feeling very much the worse for wear, but to drive home and to see that line of Downs it lifted my heart, it was so fabulous. And that's how I've been all my life coming back from anywhere to see that first glimpse of the Downs, my heart just sings.*

ME: *And there's that capacity in traditional songs to transport you to places that perhaps you can't access for whatever reason/*

MUM: */ Yes, but for me as well, following on from when we were talking to grandad, it's about a picture it paints in your mind. A song for me is always visual, that's how I remember it and I always have the pictures in my head. But it's not necessarily pastoral for me, it's seasonal for me rather than land specific, although Scottish songs are an exception to that, 'Loch Lomond' and 'You Banks and Brays' would be examples of thinking about a landscape and singing those songs, but not so much the Downs.*

ME: *It's a Scottish song I associate with you, 'The Bonny Light Horseman'. If you can imagine a thread running through the family as a form of inheritance, that's the song for me [. . .]*

MUM: *Well, I first heard Eliza Carthy sing it in the Royal Oak when she was a young woman, and she talked about learning it from her uncle Mike Waterson and it having been his song, but she was taking on the mantle because the family were beginning to pass songs down and somehow tacitly it had been agreed that this would become her song. And I was absolutely bowled over by it, I just loved it, and I always have done. It is so moving and it's only four verses when you think about it, and yet it's not only the most exquisite tune, but it's also packed with the deepest, strongest emotion – the utter grief of losing someone. Also [. . .] of the physical love for someone, I think that really comes over, this absolute sensual longing and desire for the dead man:*

20. *Bonny Light Horseman*

Well Bonaparte has commanded his troops for to stand
And he's levelled up his cannon all over the land
Yes, he's levelled up his cannon, the whole victory to gain
And he slew my light horseman returning from Spain

Broken-hearted I wander, all for my true lover
He's my bonny light horseman, in the war has been slain

You should see my light horseman on a cold winter's day
With his red and rosy cheeks and his curly black hair
He's mounted on horseback, the whole victory to gain
And he's over the battlefield for honour and fame

Broken-hearted I wander...

All ye wives, sweethearts, and widows, attention I pray
For me heart it is broken, and it's fading away
I'm a maiden so distracted, broken hearted I wander
For my bonny light horseman in the war has been slain

Broken-hearted I wander...

Now if I had have had the wings of an eagle I'd fly
To my bonny light horseman and there I'd lie by
And with my little fluttering wings I would build up my nest
O, my bonny light horseman you're the boy I love best

Broken-hearted I wander...

When it came to interviewing my mum, I think both of us felt a bit shy. We had been planning to go for a walk, but the weather had turned and, as we'd set the evening aside, we decided to sit instead at the dining room table. To help with feeling apprehensive, and to transition away from the boring particulars of our days, we decided to have a couple of large gin and tonics. In beginning of the recording, some of that oddly formal reserve is still there in our voices; a clear example would be mum saying 'it was all very exciting'. It's quite high-pitched, and strange sounding, as if she's talking to whoever she's imagining is listening to the recording. However, as the gin began to take effect, and with my stepdad cooking in the kitchen next door, swapping songs and chatting about being teenagers contributed to something of a holiday mood. I smile as I first write this at the same dining room table, although they live in a new house now, here in the grain of the wood is that link to knocking back a few gins with mum, singing, and talking about the boys we've loved. I smile seven years later too, in my own home in Essex, as I edit these words once more. The analysis, then, of the thoughts sparked through this encounter, is not a separate element of abstracting knowledge, but rather an ongoing recollecting through writing:

> At the same time, creating an analysis is not an activity that is itself isolated from 'experience' or from the researcher's embodied knowing. To some extent this is a process of re-insertion, through memory and imagination work.
>
> (Pink 2015: p. 142)

I listened to the recording of our conversation as I wanted to check one of the lyrics to *Ploughman Lads*. When I heard my mum saying 'it's *such* a picture', I, in turn, could picture her making the form of ribbons hanging down with her hands. She is an intensely expressive woman, and to think of my mum is always to think of hands in motion; her whole body engaged in what she is trying to say. Her enthusiasm for communicating throbs in every vein, and reminds me of Thrift's dilemma after the death of his father about how to capture his life in a way that was open-ended and interpretative of affect, not a definitive account:

> I am not sure, in other words, that he needs writing down, or, put it another way, we need a form of writing that can disclose and value his legacy – the somatic currency of body stances he passed on. The small sayings and large generosities, and, in general, his stance to the world.
>
> (Thrift 2008: 109)

From the sound of that word, to a memory of mum's actions, to a sudden burst of emotion, connected with all the times she's flung her arms around in explanation whilst singing a tale, demonstrate the value and immediacy of using multiple forms of entry back into embodied knowledge. As Pink states in relation to reviewing videos of garden tours she undertook during her research into the Cittaslow movement, 'it helped me to imagine and feel my way back into the research encounter [...] audio-recorded materials and audio memories can create strong connection to this research encounter', these strong connections enable us to think through the forces at play in our writing of these exchanges, bringing 'to the fore the sensory and emotional affects of the research encounter, and the role of these aspects of experience in the making of memories, knowledge, and ultimately academic meanings' (Pink 2015: p. 148). Thus, the resonance of needing to use Thrift and non-representational theory to begin to talk about what mum's singing does, and did, to me, in the past and in the here and now, reverberates through experiencing, remembering, and recounting that performance. Further, by acknowledging these interrelated processes, I can recognize and allow 'the analysis of the materials to be understood as inextricable from the processes through which they are produced and made meaningful' (Pink 2015: p. 148).

As Anderson states, the affective turn emerged 'from a concern with the intimate textures of everyday life' (Anderson 2014: p. 8). Through mum's sensory categorization of sensual desire in the songs, and our conversations about the Downs as a place of transgression as teenagers, places to smoke spliffs, and snog boys, I also considered the many forms of intimacy that run through this thesis – the physical intimacy of lovers prevalent in folk songs, the intimacy of bodies and their environments, the seemingly one-sided intimacy developed with archival subjects and the intimacy of memories. In the process of talking about folk songs and what they do, mum's relationship to her youth and the period in which she first encountered songs is also explicated through her focus becoming her physical desire for men, and the embodied, visceral qualities of longing and grief. These songs, and their affects, are bound up with her identity. As Lorimer states, it is important to entertain that 'the emerging narrative that speaks of the intimacies of landscape [. . .] to consider possibilities for a retelling of personhood as entwined and exchanged, situated and sensuous' (Lorimer 2006: p. 503). Echoed by Pink who reminds researchers that 'sensory categories, metaphors, and meanings are used by people to represent their lives, experiences, and opinions, [they] can often offer a key to understanding their self-identities, what is important to them and why' (Pink 2015: p. 81).

A moment of total discombobulation in the fog led me to think that we were still on the Dyke when we met the road that marks the start of Saddlescombe Farm. The rain was lifting, but aside from one other family who arrived just before we left, we were the only people at the farm cafe. The farm is at the foot of Newtimber Hill, a site of many walks during our lives, but particularly during our childhood. Being there with Sarah brought to mind lots of the games I had forgotten that we used to play up on the Downs, some influenced by the wide games of the Woodcraft Folk, but particularly a favourite involving time travel that we would play with our now stepsiblings. As Carl Lavery evokes:

> There were times, for instance, on the walk, where I had the impression that past and present had entirely collapsed, and that I had magically returned to other landscapes which, for some reason or other had, until that moment, remained hidden and out of reach.
>
> (Lavery in Mock 2009: p. 10)

Of all the paths I walked that week, these were the most peopled with memories, and yet also experienced afresh in the inclement weather:

> Even if a body's 'affective charge' is constituted through the repetition of past contexts and actions, there is nevertheless always a 'slight surprise' to affective life. For a body's affects are never fully determined, there is always openness to them.
>
> (Anderson 2014: p. 16)

Our long friendship with Sarah Wales also meant that my sister and I were not referring to people or things from our past that were unfamiliar to her, and thus conversations referred to other times of being at Newtimber, but also conversations we three had held on other journeys: 'the routes we walk and walking rhythms we share with others will always be shaded by the steps we have taken in the past' (Pink 2015: p. 111). As well the history of that landscape, Newtimber is where my stepfather would like his ashes scattered, and therefore being in this landscape has significance and resonance with an event not yet lived through. As Jo Lee writes, 'walking can be understood as a personal biography: the body moves, in part, due to its links between past, present, and future in a life' (Lee 2004: p. 4).

Whilst at the cafe, I sang *The Hare Hunting Song*, using the tune and the words from Sussex singer Samuel Willet, who was known as the 'Singing Baker'. Willet is mainly associated with Cuckfield in Mid Sussex, as that is where he was living when his songs were collected by Lucy Broadwood across the course of a long correspondence. However, Willet was born in Fulking, one of the villages scattered beneath the hills that we had just walked. In one of his letters to Lucy Broadwood, Willet writes:

> *The Hare Hunting Song* and *The Echoing Horn* have been known as chorus songs for very many years in the several villages below the Downs in the neighbourhood of the Devil's Dyke. The former song being such a favourite in the hamlet of Saddlescombe that it has long maintained the sarcastic distinction of being the Saddlescombe Anthem.
>
> (Willet 1890)

I had been in a quandary about whether to include hunting songs in my performances, as I am vehemently anti-hunting, but I felt it was important to acknowledge that they represent a large part of the singing tradition of the county, and a major landscaping activity of the past. It raises questions of what we choose to preserve, and how we contextualize songs, and what these songs might do in the affective present. Questions I continue to consider. I had originally included the song in the PhD; however, in this monograph I have chosen not to. You can record the past, without repeating it, and in the light of continuing

offences against the Hunting Act, a song that celebrates the act of hunting is one that I am happy to leave in the archives.

From Saddlescombe, we headed across to Pyecombe and up onto Ditchling Beacon, regaling Sarah with what incredible views she would have been able to see if we weren't battling against the torrential rain. As both songs and conversation began to peter out near Plumpton, and I could feel spirits dwindling, I suggested that we drop down to the pub and get a train from there to Southease, where we would walk to Rodmell; this would cut about three more miles on the ridges. When we were settled and surreptitiously drying our socks on the radiator in the Half Moon Inn at Plumpton, I remembered that a traditional singer from Sussex, George Townshend, had sung in the pub with his father, during the time that his father was landlord at The Jolly Sportsman in nearby East Chiltington. George had been born in East Chiltington in 1882 and was a regular singer of the other hunting song mentioned by Samuel Willet, *The Echoing Horn*. This was the same George who sang an 'h' before the 'e', thus the 'h'echoing horn. In the CD notes for a number of recordings taken of George Townshend's singing in his later life, Brian Matthews gives an evocative account of the process of collecting from George and the affective associations his voice conjured:

> Eighty two years of age,
> White haired and weathered
> Songs from his lips, like cream,
> Tell of shepherds, courtship
> And harsh rule of the land.
> Words drift; dew in cool night air.
> Melodies moulded by
> The lilt of the hills
> And clear running streams.
> 'Cellos in the landscape
> Throb to the rhythms of the earth
> While in deep wooded coombes
> A million branches
> Orchestrate the wind.
>
> (Matthews 2012)

Just before I had begun my walk, in the last week of April, I had met with an old friend of my mother's, and a terrific traditional singer, Sandra Goddard. She had wanted to join me for a walk but has increasing difficulties with her mobility. I showed her a list of the songs I'd been researching, and she noticed that there were a

few fragments from East Chiltington that I hadn't managed to learn. She suggested a lovely walk she knew in East Chiltington that would be about the right length for her. Sandra drove me to the church, and we walked down into the woods in late afternoon sunlight. The crunch of the gravel on the recording, and the sound of the stick as well as our feet, was crucial in taking me back to the feeling of walking with Sandra. By walking at her pace, and stopping when she needed to take a breath or have a drink of water, I was able to understand in part how her body dictates how far the paths she can walk extend. By creating correspondences, through walking together around East Chiltington, I was able to see how one 'seek(s) routes through which to develop experience-based empathetic understandings of what others might be experiencing and knowing' (Pink 2015: p. 98). Moreover, getting to know Sandra in this way added other layers of significance to the interview, where she talks of a prized walk of freedom up on the Downs as a young mother, freed from the normal constraints of pushing a buggy or holding a hand.

Once we had settled down, me on a boulder and Sandra on a stile, she sang for me with the low afternoon sun behind her, and a pheasant calling in the field. It was a song I had never heard before that day, but I have loved ever since. For Brian Matthews, George Townshend's singing 'speaks of the Sussex Downs' (Matthews 2012). Sandra, for me, sounds like a Sussex Wood in spring, blanketed with anemones – rich, earthy, and rooted, yet mellifluous and delicate. I experienced in the feel of her voice what Eve Kosofsky Sedgwick captures as 'the intimacy between texture and emotion' (Sedgwick 2003: p. 17), and Macdonald's suggestion that 'voices have textures as though perceived tactilely and visually' (Macdonald 1998: p. 52 in Pink 2015: p. 147).

21. *Searching for Lambs*

Now as I walked out on a May morning,
One May morning betimes
I met a maid, from home had strayed
Just as the sun did shine.

'What makes you to rise so soon, my dear,
Your journey to pursue?
Your pretty little feet, they tread so sweet,
Strike off the morning dew'

'I'm going to feed my father's flock,
His young and tender lambs

That over hills and over dales
Lie waiting for their dams'

'Come stay, O stay, my handsome maid,
And rest a moment here
For there is none but you alone,
That I do love so dear'

'How gloriously the sun does shine,
How pleasant is the air?
I'd rather rest upon a true love's breast
Then on any other where'

'For I am thine love and thou art mine
No man shall uncomfort thee
We'll join our hands in wedded bands
And married we shall be'

SANDRA: *That was 'Searching for Lambs'.*
ME: *Beautiful! What a lovely setting to have it in as well.*
SANDRA: *Isn't it? I shall remember this. Now I can't remember where I learnt 'Searching for Lambs', but I heard somebody singing it, I heard them quite a number of times, before I decided that I was going to have to sing it – even if they were singing it much better than me. Somebody must have given me the words because I know I didn't get them from a book. Nearly all the songs I sing I haven't got from a book; I've gotten them initially from the inspiration of hearing someone else singing them. However good or bad the singer, it doesn't really make any difference to me, the song will haunt me for a while and then I will say to someone, 'do you have the words for Searching for Lambs?' That for me is the most natural way to get to a song, you do it through people. I think the line that caught my heart really to be rather sentimental about it was, 'I'd rather rest upon a true love's breast than on any other where'. I think that's just a lovely phrase and sentiment.*
ME: *Yes, that's the phrase that came out to me just now. I could tell you really connected with that.*
SANDRA: *Like it's in italics! Because to me that's the heart of the song, it's not about whether he proposes, it's that bit . . . that what everybody needs, you know, to rest in somebody else.*
[. . .]
Years ago, I was already married, and we had one child by that point, Joanna. My husband's mother used to live nearby and we arranged that on May 1st –

> *May morning – we'd have a child free morning, and we went to Shoreham May morning [...] after the procession my husband had to go to work and I arranged [...] to get a lift up onto the Downs so that I could go for a walk. [...] I had for once a whole day free, it was just wonderful because when you've got a young child it's all you do, so you're busy all the time, and suddenly I had this free day. I walked to Chanctonbury Ring, as I walked it was still quite early in the morning and nobody was about, and it was a weekday so there were no ramblers or anything, and I thought, 'oh good, I'm safe to sing'. So, I was singing that song, 'Searching for Lambs', as I went along and as I got to the corner of a field there was this year's lambs and ewes all in the corner of the field. And as I came along they all crowded into the corner of a field, and I just stood there leaning over the gate looking at these little baby lambs thinking of that song, and whilst I was musing on all this the little lambs started to suck my fingers! And every time I sing that song I'm thinking about the people in that song, but I'm also thinking about these little lambs on my hands.*
>
> *[...]*
>
> *When I'm at home I don't really listen to folk music except in my head, I can hear all these singers that I know singing, and I don't need to listen to records really. I don't know if it's silly to say I've got a photographic memory for tunes but I can hear these tradition songs in such an exact way.*
>
> *[...]*
>
> *There hasn't been a single week since 1962 where I haven't done something to do with folk music. It's ok for it to be simple, you don't have to be clever. Even if you're elderly, even if you are hard of hearing, and even if you can't quite hold the tune anymore, you're still accepted as a singer. The songs are just as valuable even if some croaky old person is singing them, not quite as well as they sang 40 years before.*
>
> *[...]*
>
> *With folk music, you can be very low on technique, not have a particularly good voice, and yet be a <u>mighty</u> singer. It just amazes me over the years, all these people, some of whom haven't had very good voices, and yet they are revered even when they fail to sing in tune. It's just person to person to person down the ages just passing on all these lovely stories and songs.*
>
> <div align="right">(Goddard 2015)</div>

In 2019, I sang *Searching for Lambs* at Sandra's memorial service. It is a song that I treasure.

When we reached Rodmell, we were met at the Abergavenny Arms in Rodmell by members of the Brighton Vox choir, who I had been singing with for a couple of years since I had moved back to Sussex. One of the activities of the choir that

I had enjoyed the most was our walks every six months or so, where we would take in a few pubs and perform some informal chorus numbers. I'd invited them to come and sing on this walk, and as folk songs are not traditionally associated with harmony singing, I thought that a good one to pick for our choir would be a number from The Copper Family of Rottingdean. *Come Write Me Down* is informally known as the 'Sussex wedding song' for its popularity at nuptials in the county. I learnt the song from my mother, who has sung it at friends' weddings, and it was one of 'about half a hundred' recorded from James 'Brasser' Copper and Tom Copper by Kate Lee in 1899, and subsequently published in the first edition of the *Journal of the Folk-Song Society*.

The Coppers have lived and worked around Rottingdean for the past 400 years, and it is thought that for the past 200 years they have been passing their songs, many of which are sung in harmony, down through the family. As well as the writings of Bob Copper preserving for a wider audience, these songs sung at sheep-shearing suppers, harvest homes, pub sing a rounds, and family parties, the children and grandchildren of Bob continue to sing some of the repertoire. Vic Gammon discusses the six songs published by the Folk Song Society and the Copper's claim to Kate Lee that they knew half a hundred songs, as 'a modest underestimate. Luckily the repertoire of the Copper Family has been preserved well in both print and on gramophone record; had the family tradition died we might have only known them by six songs' (Gammon 1980: p. 67). In such instances, the fragility of the archive becomes clear.

22. *Come Write Me Down*

Come write me down, ye powers above
The man that first created love
For I've a diamond in my eye
Where all my joys and comforts lie
Where all my . . .

I will give you gold, I will give you pearl
If you can fancy me dear girl
Rich costly robes that you shall wear
If you can fancy me my dear
If you can . . .

It's not your gold shall me entice
To leave off pleasures to be a wife
For I don't mean nor intend at all

To be at any young man's call
To be at . . .

Then go your way, you scornful dame
Since you've proved false I'll prove the same
For I don't care, but I shall find
Some other fair maid to my mind
Some other . . .

O stay young man, don't be in haste
You seem afraid your time will waste
Let reason rule your roving mind
And onto you I will prove kind
And onto you . . .

So to church they went the very next day
And were married by asking, as I've heard say
So now that girl she is his wife
She will prove his comforts day and night
She will prove . . .

So now their trouble and sorrow is past
Their joy and comfort has come at last
That girl to him always said, 'nay'
She will prove his comforts night and day
She will prove . . .

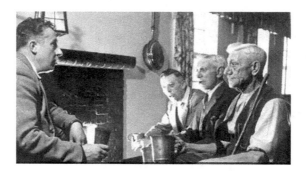

Figure 15 The Copper Family Collection, *c.* 1950s. *Central Club, Peacehaven.* Bob, Ron, John, and James [Photograph].

In this account of the fourth day of walking, I have continued my previous consideration of lines and lineage and sought to communicate what it felt like to walk in a storied landscape, a place familiar and yet always becoming 'an attempt to discover how landscape can be reanimated by intimacy in conduct and encounter' (Lorimer 2006: p. 515). Additionally, I have considered how the act of walking this stretch of the South Downs Way in a mode of companionship, both in the company of my sister and our friend, and in the company of memories, has begun to illuminate the folding together of affective past, present, and futures. Furthermore, through assembling the moments that have remained with me, I hope to have engaged with the reader in creating some *sense* of the walk that day, as 'materialities swell into modes of address' (Stewart 2016: p. xi). In the following chapter, and the final stage of my walk, I continue to develop my interest in affective legacies, and what the remains of the past may *do*.

2.5

Legacies

Over the final two days of the walk I travelled from Rodmell to Eastbourne via Alfriston and Jevington. Morning had broken in Rodmell clear and bright. With the Coppers and generations of singing families still very much in my mind, I had a contemplative stroll from my B&B to Rodmell Church, thinking on a discussion I'd with Bob Lewis about composed songs, how Bob Copper had been a fan of Belloc and how neither of us saw the point in splitting hairs over what a folk song was. If we liked it, we learnt it, and we sang it. I had arranged to meet my walking companions in the churchyard under a cherry tree in full blossom and arriving there I was able to reflect upon a quiet moment I'd had with singer and much-admired songwriter Charlotte Oliver in the churchyard the previous evening:

> ME: *Charlotte, when did you write the song?*
>
> CHARLOTTE: *I wrote the song eight years ago. What started me writing it was meeting a shepherdess from Sussex, Mary. And she was talking about how separate her life felt from everyone around her. That, years ago, people used to understand, particularly around lambing time, about how difficult it was. Now, people don't realize what she's going through, the fact she has to get up every two hours to check the lambs, 24 hours a day . . . she's walking around in dirty, smelly clothes, or having to drive to the supermarket because the village shop is shut and people just get out of her way thinking she's some kind of degenerate. I wrote this song for her, from certain things that she told me and really made me think, and I wanted to include in the song. I also went over to help her, so that she could have a break basically, and I mean there's certain images like getting up at 2am and walking across the fields in the pitch black to the lambing sheds, which was lit up, you know? I can see that now, so the song came from physical images as well.*
>
> (Oliver 2015)

23. *The Sussex Shepherdess*

Me, I'm just a shepherdess, come lambing time each day I'm dressed
In boots and jeans, my hair's a mess, and night times I'm the same.

For every two hours I must rise, to shine my torch in frightened eyes
To rescue lambs before they die, and carry them back home.

And who would be a shepherdess, come lambing time, come lambing time?
O who would be a shepherdess, all on the Sussex Downs?

I hardly notice day or night, night melts to day, and dark to light
I try to sleep but just can't quite, so switch on Sky TV.
Celebrities and dull quiz shows, my sheep dogs guard me as I doze
And that is how the Spring time goes, a lonely time for me.

And who would be a shepherdess . . .

Two business men I hardly know, bought up the farm six months ago
Try it for a year or so, then maybe sell it on.
And yet when Sundays come around, they ride their 4x4s from town
In smart green Barbers strut around, while I just wish them gone.

And who would be a shepherdess . . .

I spend my days and nights alone, for I can't venture far from home
My friends just voices on the phone, at least till lambings done.
I drink too much I'm in no doubt, I've watched the piles of bottles mount
But with a wine box I lose count, they help the weeks roll on.

And who would be a shepherdess . . .

But come those flowery April days, I'll watch my new-born lambs at play
Smile as passing walkers say how lucky I must be.
With fresh eyes I'll look around, the sweet green of the Sussex Downs
For though I've sought, I've never found, a better life for me.

And who would be a shepherdess, come lambing time, come lambing time?
I guess I'll stay a shepherdess, all on the Sussex Downs.

I was joined presently by fellow PhD students and friends; Emma and Anna; family friends Rachel, Dave, Moria, Jackie, and Mike; and my sister Sarah, mum Catherine, and our friend Sarah. Ralph Vaughan Williams, when he visited Rodmell, collected songs from singers in the Abergavenny Arms, including the tune of *The Unquiet Grave* from the inn on 10 January 1906; the name of

the singer is not given. He collected a few more songs during his stay in the village, all from male singers. As only the tune of *The Unquiet Grave* from the anonymous singer has survived in the archive or was taken at the time, I sourced the lyrics from earlier in the route. Jimmy Brown from Trotton sang the song for Dorothy Marshall in 1911. George Parrot from Minstead is also noted on the manuscript, and at the bottom on the transcript it reads, 'Jimmy Brown, helped by his mother, verse V is hers' (Brown 1911: CC/1/33):

24. *How Cold, How Cold, the Wind Do Blow*

How cold, how cold, the wind do blow
Some sprinkling fall of rain
I never, never had but one true love
In green wood he lies slain
In green wood . . .

I'll do as much for my true love
As any young girl may
I'll sit and mourn upon his grave
For twelve month and one day
For twelve month . . .

When a twelve month and one day was past
The dead began to speak
Who is it that sits upon my grave,
And will not let me sleep
And will not . . .

Tis I, tis I, my own true love
Who sits upon your grave
One single kiss of your clay cold lips
Tis all from you I crave
Tis all from . . .

My lips they are as cold as clay
My breath smells earthly strong
If you should kiss my clay cold lips
Your life will not be long
Your life will . . .

It was down in yonder garden valley
Where you and I did walk
A-gathering of those pretty, pretty flowers
Now withered to a stalk
Now withered . . .

They are withered to a stalk my love
As you may now see
When you and I and all must go
When Christ calls us away
When Christ . . .

Moving away from the cherry tree, Dave noticed the grave I sang next to bore my name, Elizabeth. I was reminded that this was a place where people came to mourn, and not just a beautiful spot for me to sing in, and then write about. I felt suddenly ashamed:

> Shame floods into being as a moment, a disruptive moment, in a circuit of identity constituting identificatory communication. Indeed, like a stigma, shame itself a form of communication. Blazons of shame, the 'fallen face' with eyes down and head averted – and to a lesser extent, the blush – are semaphores of trouble and at the same thing of a desire to reconstitute the interpersonal bridge.
> (Sedgwick 2003: p. 36)

Shame is communicated in a variety of ways in Charlotte's narrative and song; shame is present in the way that the shepherdess feels about her drinking, and in the manner in which people react to her in shops. Through this, it is possible to see how shame is 'both peculiarly contagious and peculiarly individuating' (Sedgewick 2003: p. 36). When there is someone behaving outside 'the norm' it is possible for shame to be felt for them, and communicated about them to each other, 'someone else's embarrassment, stigma, debility, bad smell, or strange behaviour, seemingly having nothing to do with me, can readily flood me [. . .] that's the double movement shame makes: toward painful individuation, toward uncontrollable relationality' (Sedgwick 2003: p. 37). However, in this double movement, grounds for change can also be felt. I felt ashamed that prior to meeting with Charlotte, and hearing her song, I had not given much thought to rural labour in a modern Sussex, a society that is out of step with relentless, demanding seasonal practices. Thus, as Heddon sees autotopography as a possible means of rewriting or reclaiming places (Heddon in Mock 2009:

p. 162), such acts of reclamation can also be found in the stories of folk songs. The practices these songs evoke allow different ways of being-in-the-landscape to remain, and to illuminate new meanings for these practices in contemporary settings.

We reached the village of Southease next and stopped to give the dogs some water (our dog Lily and Mike's dog Bertie). Here, we met up with Louise Jolly, her partner Jon, and their baby daughter Arwen. Louise had heard about the walk through the Sussex Fairy and Folk Tale Centre, and she and I quickly realized we would have plenty to discuss on folk stories and landscape. Whilst baby straps were being adjusted, shoelaces tied, and water bottles being refilled, I showed the group some copies of songs that had been collected from Southease by Ralph Vaughan Williams, on the same trip that he visited the inn at Rodmell.

These included another version of *Blackberry Fold*, and a song almost entirely unique to Sussex, *Young Collins*. They were both sung by Mr Baker of Southease. The 1901 census records Mr Robert Baker as a blacksmith at the forge opposite the Abergavenny Arms ('Robert Baker' 1901). As I was unable to find him in the 1911 census, I checked the National Archives and his death was recorded in 1907 aged 73 (National Archives 2022). He ran the forge with his partner Edward Jeffery. Baker and Jeffrey were categorized as builders, wheelwrights, and blacksmiths in local trade directories. Bob Lewis had sung a version of *Young Collins* for me when we met, and I hummed this inexpertly as I wondered where in Southease Robert Baker had lived.

After we had crossed the river Ouse, the third waterway of Sussex and the accompaniment to my daily walks since my move to Lewes in June 2015, we headed up onto Firle Beacon via Itford Hill. Here, the landscape is every inch of Kipling's *Sussex*, 'blunt, bow-headed, whale-backed Downs'. In the same poem Kipling mentions the unusual weathervane of Piddinghoe Church, a 'begilded Dolphin', which most people believe is a fish. The current vane at Piddinghoe Church was commissioned from Mr Geoffrey Baker of Rodmell in 1882 (Chapman 1987). I have become familiar with Kipling's verse after the many cross-country scampers with my stepfather where he will mournfully sigh, 'clean of officious fence or hedge, half-wild and wholly tame', in reference to the increase of sheep fencing as a result of the South Downs becoming a national park (Kipling 1902).

The sloping beauty of Firle Beacon is the shape I love most in all of Sussex, and probably in the world. I can never see it and not think of Belloc's poem *The*

South County, 'along the sky the line of the Downs, so noble and so bare' (Belloc 1920). The site of it lifts my heart, my body is physically pulled to its slopes with a yearning and my walk becomes chest-led. As Stewart states, 'impacts and energies, attunements and disorientations [are] set in motion by moving with a landscape' (Stewart 2016: p. xv). After our climb, we stopped by Firle Trig point. At last, I was able to show Sarah some of the villages falling away beneath the hills. One of these is North Chailey, at the edge of the wooded weald. Here, in 1945, Bob Copper, sponsored by the BBC to record traditional folk songs for the radio, travelled to meet a lady called Lily Cook. In his book *Songs and Southern Breezes* (1973), Bob recorded his sensory impressions of the singer and her home:

> When Lily Cook opened her door and ushered me in to the front parlour, I stepped back forty years. The chiffonier with lace-edges, lined runners, the heavy damask curtains faded into vertical stripes between the folds, the tablecloth to match . . . loved and tended, since she and her husband had moved in as newly-weds in 1909 [. . .] over her shoulder I could look out across the gorse and the healthy expanse of Chailey Common right down to the steep escarpment of the South Downs at Plumpton. [. . .] We started to swap songs and she was clearly delighted to learn that there were still people about who were aware of, and in fact cherished, the kind of songs that she had loved ever since she heard her parents and other members of the family singing when she was a tiny girl.
> (Copper 1973: pp. 43–4)

We formed a wind shield around the trig point; in my memory spontaneously, on the recording clearly orchestrated by me. Although I began by trying to stick as faithfully as I could to Lily's version, when Bertie the dog and Arwen the baby joined in, it was impossible not to relax from desires for performance perfection, and I just allowed the song to be informal and mirthful – which, upon reflection, was right both for the moment and the spirit of the song:

25. *The Lark in the Morning*

The lark in the morning, she rises from her nest
She melts into the air, with the dew upon her breast
Twas down in meadow, I carelessly did stray
Oh there's no one like the ploughboy in the merry month of May.

And when his work is over, and then what will he do?
He'll fly into the country, his wake to go

And with his pretty sweetheart, he'll whistle and he'll sing
And at night he'll return to his old home again.

And when he returns from, his wake unto the town
The meadows they are mowed, and the grass it is cut down
The nightingale she whistles, upon the hawthorn spray
And the moon is a-shining upon the new mown hay.

So, here's luck to the ploughboys, wherever they may be
They'll take a winsome lass, to sit upon their knee
And with a jug of beer boys, they'll whistle and they'll sing
For the ploughboy is as happy as a Prince or a King.

We dropped down into a hollow to eat some lunch and give our ears a rest from the wind. My mum sang a rendition of *Pleasant and Delightful*, along with the skylarks audible at interludes, sounding the Downs. The rest of us joined in with the choruses, and an atmosphere of ease and amity developed from walking together, through the laughter of forming a wind shield, and fostered by the chorus repeats, is captured in the recording:

26. Pleasant and Delightful

It was pleasant and delightful on a bright summer's morn
Where the fields and the meadows were all covered in corn
There were blackbirds and thrushes singing on every tree
And the larks they sang melodious at the dawning of the day

And the larks they sang melodious, and the larks they sang melodious
And the larks they sang melodious, at the dawning of the day

Now a sailor and his true love were walking one day
Said the sailor to his true love, 'I am bound far away,
I am bound for the West Indies, where the loud cannons roar
And I am bound to leave you Nancy, you're the girl that I adore,

I am bound to leave you Nancy . . .

Then a ring from off her finger she instantly drew
Saying, 'Take this my Willy, and my heart will go too'
And as they were embracing tears from her eyes fell,

Saying, 'May I go along with you?', 'Oh no, my love, farewell'

Saying, 'May I go along with you?' . . .

'Fare thee well dearest Nancy, no longer can I stay
For the topsails are hoisted and the anchors away
And the ship she lies waiting for the fast-flowing tide
And if ever I return again, I will make you my bride'

'And if ever I return again . . .

I sang another song as we chatted in the dip, enjoying the communal atmosphere of a group that had splintered and adjusted into different configurations along the way, and was now in a temporarily settled whole. Dogs, babies, Nordic walking poles, and blisters, all impacted upon who walked with who. As Ingold and Vergunst explore, echoing Heddon:

> People have continually to readjust the patterns and style of their walking in order to accommodate the changes undergone not only by their own developing bodies but also by the bodies of those, whom they walk *with*.
> (Ingold and Vergunst 2008: p. 17)

Dear Father was recorded from a seven-year-old traveller, Shelia Smith, by Peter Kennedy for the BBC, when her family were staying in a roadside encampment of barrel top wagons near Laughton in 1952 (Smith 1952: S191864). The visceral, intense, immediacy of her voice has stayed with me ever since I first heard the recording:

27. *Dear Father, Dear Father*

Dear father, dear father, pray build me a boat
So, all on that ocean I'd there go and float
And every big ship that I do pass by
I will enquire for my sailor boy.

O, what colour clothes does your sailor boy wear?
What colour was his sweet golden hair?
Well his jacket was blue and his trousers was white
And curly hair and eyes shining bright.
O, you know last night when the wind that blowed high
I lost my Ma beside your sailor boy.

> O, she sat herself down and she wrote her a song
> She wrote it so long and she wrote it so neat.
> And every verse did she shed a tear
> And every verse did she put, 'Sweet Willy Dear'
>
> Well if I was a blackbird I'd whistle and sing
> I'd follow the vessel my true love sails in
> And on the top rigging I'd there build my nest
> I'd sleep all night long on that lily-white breast.
> For if I was a scholar and could handle my pen One private letter to my true love
> I'd send.

As I sipped my tea from the flask, my throat dry from singing, I thought about Chris Penfold-Brown and our chat over tea in her kitchen. She had shared with me a poem about her father's yog, the Romany word for a fire, and how good tea tasted after a day's hop picking: 'Out working too, there was a yog for the tea / A nice protected place he could always see / When the yog was lit, and the kettle boiled / The tea was fit for a king, but our clothes were soiled' (Penfold-Brown 2017). Cupping the flask lid with my hands, I thought not only about wrapping my hands around a cup of tea as I had chatted to Chris in the kitchen, but also of the imagined taste of tea freshly boiled from a fire; memories and past imaginations arrived in the natal present. This sensory journey recalled Pink's discussions of the everyday practices that we engage in with our research participants:

> When we participate in other people's worlds we often try to do things similar to those that they do [. . .] or play roles in the events, activities or daily routines that they invite us to participate in. Such forms of participation do nevertheless usually involve us also participating in some 'ordinary' everyday practices, including eating, drinking, walking or other forms of movement or mobility that our research participants are also engaged in. This relates to participation in both actual practices and more generally participation through 'being there' in a shared physical environment.
>
> (Pink 2015: p. 101)

After Firle, most of my walking companions headed back to their cars, and with Anna and Emma, I continued on to Alfriston via Berwick to show them the murals painted in the church by Vanessa Bell and Duncan Grant, forgetting about singing or guiding and just enjoying a walk with friends. Anna, Emma, and I continued on a part of the path where the ever present sea soothes, cradles, and calms. The lasting image of that stretch of the way is sitting with the girls

Figure 16 Bennett Family Collection, 1992. *Firle Beacon*. Sarah Bennett, Catherine Bennett, Alison Le Mare, Grandpa Myles, Steve Le Mare, Mick Le Mare, Peter Bennett, and Lizzie Bennett [Photograph].

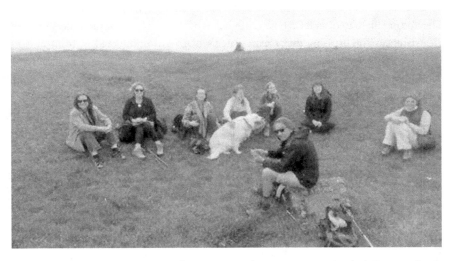

Figure 17 Faulkner, M, 2015. *Firle Beacon*. Catherine Bennett, Rachel Cooper, Sarah Wales, Lizzie Bennett, Lily the Dog, Emma Miles, Sarah Bennett, Anna Trostnikova, and Dave Reeves. 4 May 2015 [Photograph].

with my knees tucked up on the stone bench outside Berwick Church, gossiping about our lives since we had last seen each other and Anna laughing at Emma and me for not understanding the pseudo Latin joke inscribed on our seat – 'ore stabit fortis arare placet ore stat/ O, rest a bit for tis a rare place to rest at'. The effect of our laughter on my spirits spoke to Heddon's question, 'if walking alone prompts reflective reverie, what takes place when walking with a friend? What does friendship bring to walking? And what sorts of conditions for friendship does walking provide?' (Heddon 2012: p. 80).

Following a quick drink in Alfriston, and a rush to get my friends on the last bus to Eastbourne, I checked into my room at the George Inn. Cocooned in my sheets, post-bath, and listening to the rain returning outside, I felt a complete absence of sadness, dispelled by a day with friends. I have always relied upon a squeaky-clean body in freshly washed sheets to produce comfort. Thus, a weary contentment has become linked with that physical experience. Similarly, opening the zip of a tent to place my feet on dewy grass, and join the in breath of a field at 6.00 am, gives me an unparalleled sense of optimism. As Ben Highmore evocatively explores:

> The interlacing of sensual, physical experience [. . .] with the passionate intensities of love, say, or bitterness makes it hard to imagine untangling them, allotting them to discreet categories in terms of their physical or their ideational existence. The bruising that I experience when I am humiliated in front of a loved one is intractably both literal and metaphorical: I am bruised, I sit slightly slumped, more weary and wary, yet this bruising also reaches inside, I feel internally battered. [. . .] The wind that bites, that gets under my skin and gnaws at my bones with its bitter chill is a memory or a foretaste of a terrible coldness that is the feeling of isolation, homesickness, alienation, despair. The register of hot and cold, of warmth and frost, of passion and dispassion is an emotional and affective register.
>
> (Highmore 2010: p. 121)

I thought of the song my friend Will Duke had sung for me, *Ground for the Floor*, which I later discovered had also been collected from Charles Moseley by Dorothy Marshall and Clive Carey (Moseley 1912: CC/1/221). The memory of the song was redolent of resting easy, as I was in that luxurious bed. There's also a sense of ease about the whole interview that I have noticed on the recording. Will refers often to me not as a researcher but as a singer, assuming I know how whatever he is describing feels. I was still at the beginning of my public performances then,

and these easy comments encapsulate Will's welcoming manner, his dry sense of humour, and that he took me seriously straightaway as a performer. Echoing Bob and Dorothy Lewis, I also am drawn to the intimacies of people who know the performers and arrive in the presence of the room. In our conversation Will remembers to stand before he sings, under previous instruction from his wife Chris that this improves his voice. A consummate concertina player, Will is now getting the attention he deserves as an unaccompanied singer. Will sees himself as a revival singer, learning from records in the archive, and later from traditional singers on the folk club circuit, and traces of many voices from the tradition merge into this recording of his arresting, vocal embodiment of a mood of blissful comfort, and yet he makes the song his own:

> WILL: *Um, I'm not a traditional singer, I'm a revivalist singer, and an enthusiast really, so I'm not singing these songs because my parents sang them or my grandparents sang them, I wish I was, but I didn't come in through it that way. Um I simply . . . it's a very suburban way of putting it, but I managed to, I used to haunt the public libraries a lot when I was a kid. And after working my way through the books I got on to the adult books and I discovered the record collection, L.Ps, and one of my brothers was a Jazz fan so I listened to quite a lot of those, but then I found this collection of what they called folk music, and started listening to that and got hooked really. So, it's really by listening to recordings of, archive recordings of source singers that got me interested.*
> *[. . .]*
> *When I'm playing Scan Tester tunes, I still hear, it's really bizarre, I can hear him playing in my head when I'm playing it, and if I put a variation I either think, 'oh that's clever', or 'he wouldn't have done that so why am I doing it like that?', (laughs) so you can actually hear, and I'm sure you do it as well, you can hear the – if you've listened long enough to a recording of a singer, or actually just had them sitting opposite you and it's finally sunk in what they're doing – you can hear them in your head while you're doing it, it's almost sounds like hearing voice, a bit strange/*
> ME: / *Oh yeah, no, definitely [. . .] people have been talking about how they see songs when they sing them. So, Mum sees them as a set of images, so she can, with Lord Bateman she can see the person going across in the boat/*
> WILL: *Right! It's a story, it's narrative, yes/*
> ME: /*Yeah, yeah, and Chris talks about, she feels like she's walking through a tapestry, and she could almost stop off and speak to people/*
> WILL: /*Mmmm /*

ME: / And Sandra and I both see in sort of more abstract ways, we see sort of lines of a graph of a song, or colours, certain colours, when we sing/

WILL: / Oh right, ok/

ME: /so I'm always interested in, how people visualise when they're . . . to know where they are in the song, because there's like a route, isn't there, that you have to take?

WILL: Right, ok, I can see what you're saying. I think . . . I certainly go along with the narrative, what Cath does in terms of, if there's a sixteen verse narrative ballad, I'm not saying it's easy, but if it's got a story and your concentrating when you're singing it, and not being distracted by mayhem or whatever, you can follow the story and you can get through sixteen verses without a hiccup really, and it probably gets better as you're living the story really, or bringing it to life [. . .] and the other thing I found, when I was working my day job, in the last ten years I was driving around quite a bit to various libraries, because I was a librarian, and there's certain journeys where I would listen to, in those days cassettes, well still cassettes in my car, and I'd been listening to these songs and you do a familiar route, and there's one song I just remember, I just think of Piltdown Pond, because I was learning it and I was going past Piltdown Pond every day . . . I'd be listening to the same part of that tape at the same point of the road past Piltdown Pond, and when I sing this song now I just think of Piltdown Pond when I'm singing it. Now, that's strange isn't it?

ME: No, not at all. I was going to say, are there any songs that you particularly associate with places on the South Downs?

WILL: Ok, well that's interesting . . . well I sing this 'Ground for the Floor', which is the George Maynard song about the happy shepherd and I can certainly . . . you start thinking of places like Mount Caburn where there's lots of sheep and I was learning it when we were trekking up there quite a bit on a familiar walk, especially one we did with a friend who is no longer alive, but he took us out from Lewes, and showed us the route from Lewes to Glynde, which isn't as signposted as I thought it would be/

ME: (laughs)

WILL: / But I was learning 'Ground for the Floor' at the time, shall we say, and just coming up this valley and suddenly there's these hills ahead of us heading up to Mount Caburn and there's just loads of sheep, and I thought it's so, it's so reflective of the song about a happy shepherd on the Downs with his sheep . . . so I do think of Mount Caburn when I'm singing that song.

ME: I've never heard 'Ground for the Floor'

WILL: Ground for the Floor, yep, yep

ME: Would you mind singing it for me?

WILL: *I'll sing that for you, yes ok, yep, yep*
ME: *Great!*
WILL: *Ok well Christine tells me to stand up when I'm singing these days (stands) this is a song called 'Ground for the Floor' and I learnt it from a recording of George Maynard, I never actually met him, I think I was failing my O-levels in London when he died, but there's all these recordings of him singing and he was a really influential singer [. . .] anyway this is the one about a happy shepherd*:

28. *Ground for the Floor*

The sun being set and my work it is done
One more of my days I have spent
Through the meadows to my cottage, I tripped along
And I sit myself down with content
Through the meadows to my cottage, I tripped along
And I sit myself down with content.

My cottage with woodbine a-decked all around
I've just a mere green at my door
Wherein there's no trouble, no care to be found
Though I've nothing but ground for my floor
Wherein there's no trouble . . .

My beds made of flock, my sheets they are homespun
No trouble ever enters my breast
And at night when I'm weary, I will lay myself down
And so sweetly I'll there take my rest
And at night when I'm weary . . .

Like a lark in the morning, I rise to my work
No trouble ever enters my mind
If a lamb goes astray, I'll so carefully look
If I seek I am sure for to find
If a lamb goes astray . . .

My pipes made of straw, for amusement I'll play
While my lambskins skip over the plain
I am filled with content, how my time slips away
And at night to my cottage once again
I am filled with content . . .

Now thoughts about riches never enters my mind
Nor none of their honours I desire
For the chiefest of my studies is of earning my bread
Proud titles I never could admire
For the chiefest of my studies . . .

Will: [. . .] *Those songs are your songs now, you've got them so that you're singing them, and you've changed them, however much you loved hearing them sung by the singer in the first place, they've become your songs . . . I'm sure you understand that and songs that you've fallen in love with, either form your mum, or other singers, they become your songs after a while.*

(Duke 2015)

Will's articulation of the people who pass us songs, known or unknown, and the way we hear them in our heads, even after we have changed them, moulded them to our voices, and claimed them as our own, made me think of the term 'living traditions' for intangible cultural heritage. It is through affect that I can most clearly see what the aliveness to that phrase means, with singing part what Derek McCormack identifies as the 'singular experience/experiment of being living – the milieu through which new refrains might emerge' (McCormack 2010: p. 217). What other thoughts I may have had were lost under that oak-beamed ceiling to the soundest sleep I had managed in a long time.

The morning brought even stronger winds with it, and I decided it would need to be a day of church recordings for there to be any sound quality. There was also a weather warning in place for Beachy Head and the Seven Sisters, so I decided to take the inland route via Jevington. Nestled at the bottom of the hills, the churchyard at St Andrews was dappled in daylight, and I remembered that Eleanor Farjeon composed the words for the hymn *Morning Has Broken* about the beauty of Alfriston at dawn. Farjeon wrote many poems based in Sussex, some of which were published in her volume *A Sussex Alphabet*, which has recently been reprinted (Farjeon 2017). Her book, *Martin Pippin in the Apple Orchard*, is based in and around this area of Sussex Downland. Although for most of her life she lived in Hampstead, Farjeon spent many weekends and holidays beating the bounds of Sussex. During the First World War she lived for two years in a cottage in Houghton, in part recovering from the grief at the loss of her close friend, the poet Edward Thomas. An avid rambler, she is described in her element in a diary entry by Stuart Guthrie, James Guthrie's son, when he was a young boy:

> Miss Farjeon is great fun. She stumps along with her knapsack on her back and her chalala in her hand, looking for all the world like a pilgrim . . . she lights a pipe sometimes – and talks and shouts and laughs and turns the place into the very haunt of merriment. She is one of the most marvellous personalities I know.
>
> (Farjeon 2013: p. 158)

As I was the only person in the church that morning, I sang *Morning Has Broken* through several times and considered the blackbird motif that is also present in many folk songs, I wondered if on her walks where 'she encountered local characters, rustic cuisine, unique customs and native flora and fauna', she ever listened to traditional singers, or sang herself (Farjeon 2017: p. vii). Thinking of Thrift and his desire to capture his father's more-than life, it struck me that Eleanor's ability to turn a place into the very haunt of merriment is a particularly affective tribute:

29. *Morning Has Broken*

Morning has broken, like the first morning
Blackbird has spoken, like the first bird
Praise for the singing, praise for the morning
Praise for them springing, fresh from the word.

Sweet the rain's new fall, sunlit from heaven
Like the first dew fall, on the first grass
Praise for the sweetness of the wet garden
Sprung in completeness, where his feet pass.

Mine is the sunlight, mine is the morning
Born of the one light Eden saw play
Praise with elation, praise every morning
God's recreation of the new day.

The falling in love with a song that Will evoked begins for me with a total obsession, singing the song over and over again, until its part of me, thoroughly trodden in. From the church, I took the kissing gate walk across and up to the Downs, experiencing along its lines, the sheer bliss of being on the move on a new footpath on a new day, becoming infatuated in the same way as one might with a song, 'the body surges. Out of necessity, or for the love of movement' (Stewart 2007: p. 113).

Up on Windover Hill I pitted my loaded back against the gale, stopping just above the Long Man of Wilmington to look back at Firle Beacon. I loved

Figure 18 Bennett, E, 2015. *View Back to Firle Beacon from Windover Hill.* 5 May 2015 [Photograph].

admiring it from this unfamiliar angle, so used to its silhouette from the West. I felt in that moment a true sense of accomplishment, of linking these 'hills beloved' with my feet over the course of consecutive days – as my parents had done twenty-five years previously when I was still experimenting with steps – and thought of how Ingold and Vergunst spoke of the Munro mountain climbers of Scotland:

> Collecting on foot, for Munroists, is a kind of gathering or 'pulling together': at once a gathering of narratives into a coherent story of personal growth and fulfilment, and a gathering of the peaks of which they tell into a seamless landscape. Standing on the final summit, and viewing others he has climbed arrayed all around, the Munroist has the satisfaction of seeing a lifetime's effort laid out in the terrain. His "collection" is none other than the landscape itself. As they collect the mountains, Munroists collect themselves'.
>
> (Ingold and Vergunst 2008: p. 16)

When I turned back around to face Eastbourne, a newborn lamb had appeared under a dazzled looking sheep. Fortunately, I saw a shepherd patrolling the area further down the hill and was able to tell them. However, before I spotted

them, I would not describe seeing the seconds-old lamb as wonderful as I would have imagined. Instead, I found being up there on the hill in the fierce wind with no real ability to help, desolate, and lonely. Through sudden isolation I became attuned to Stewart's conception of ordinary affects and her efforts to 'provoke attention to the forces that come into view as habit or shock, resonance or impact. *Something* throws itself together in a moment as an event and a sensation; a something both animated and inhabitable' (Stewart 2007: p. 1). As an odd coincidence, when I arrived home later that day a CD had arrived from Suzanne Higgins, who had been unable to meet me but thought I might like to learn her song *Shepherd's Token*. In her haunting and bleak melody, and the ghostliness of her voice, Suzanne captures that *something* in my encounter with a freshly born lamb earlier that morning.

Suzanne was moved to write a song about burial rights after a family member had died, and she discovered that in England there was a practice of burying shepherds with a piece of wool or fleece in their hands, or on their chest, so that St Peter would know why they had been absent from church (Higgins 2015). When I looked at whether this had been common in Sussex, I found that the practice was still in use in Alfriston until the 1930s (Allen 1995):

30. *The Shepherd's Token*

Pull back the towel, so warm and sweet
Wrap me in cloth from head to feet
Dig out the chalk, lay in my bed
The wool from sheep that I have led.

I tend the sheep up on the hill
Their care and love my life to fill
The silly sheep they follow me
Their faith and trust are all my fee.

Pull back the towel . . .

The sky above, the air below
Are all I see, are all I know
My kingdom this, wherein I serve The silly creatures who I love.

Pull back the towel . . .

From year to year the seasons turn
The winter's freeze, the summer's burn The lambs are born with mewling cry
I light the fire where next they lie.

Pull back the towel . . .

I seek the lost one's when they stray
To rescue them, I make my way
Though trapped by briar, bush or thorn I seek them out, I bring them home.

Pull back the towel . . .

And when at last my season's past
I come to judgement at the last
Although to church I did not go
The shepherd's token hand may know.

Pull back the towel . . .

After a quiet hour's walk through the bluebell woods of Jevington, I reached Eastbourne station with plenty of time to spare and decided to head to the village of Glynde, at the base of Mount Caburn. The first song I sang at Glynde was the *Wraggle Taggle Gypsies*. As part of a search for Sussex folk singers, I saw a tiny sentence buried in a much larger piece about Eric Ravilious, mentioning that artist and illustrator Peggy Angus was a great singer of folk songs. Through this chance comment, I became very interested in the life of a woman I had known precious little about before. At the end of a BBC documentary about Peggy Angus, I discovered her singing *The Wraggle Taggle Gypsies* to much the same tune as my maternal grandmother Joy sings it. I was round to my granny's house in Lewes playing it to her within a day, and in her ever generous and ever resourceful way she lent me a biography of Peggy Angus. Through this book, which contributed to the weight of my rucksack, I became enthralled by Peggy's independence of spirit and gumption, carrying this with me. Most well-known through her friendship with Ravilious, Peggy Angus was working as an art teacher in Eastbourne and was looking for somewhere to live and work during term time. On one walk through the Downs she came across the deserted cottage of Furlongs and decided she would like it. The Freeman brothers, who were the farmers at Furlongs (and who in turn rented it from Glynde estate), were reluctant at first, and so she camped

outside in a tent for a few weeks until Dick Freeman gave in. Peggy was born in Chile in 1904 and raised in North London, Peggy's family were Scottish and from a young age instilled in her a strong expatriate patriotism through Scottish songs, James Russell asserts that this resulted in Peggy retaining 'throughout her life both a formidable repertoire and a fierce pride in her ancestry' (Russell 2014: p. 17). At Furlongs, Peggy held notoriously wild midsummer parties, where she served her guests homemade elderflower champagne and sang folk songs around the fire. Peggy delighted in the simplicity of Furlongs, the lack of material culture, and walked or travelled by public transport everywhere, 'be able to survive anywhere and make your life good' (Angus in Russell 2014: p. 8). She sings this in the film not as a performance, but as an accompaniment to the different daily emplaced activities of her studio, such as putting brushes away.

31. *The Wraggle Taggle Gypsies*

Three gypsies stood at the castle gate
They sang so high, they sang so low
The lady sat in her chamber late
Her heart it melted away as snow.

They sang so sweet, they sang so shrill
That fast her tears began to flow
And she lay down her silken gown
Her golden rings and all her show.

She plucked off her high-heeled shoes
A-made of Spanish leather-O
And she would in the street in her bare, bare feet
All out in the wind and the weather-O.

Saddle to me my milk white steed
Go and fetch me my pony-O
That I may ride and seek my bride
Who's gone with the wraggle taggle gypsies-O!

He rode high and he rode low
He rode through woods and copses too
Until he came to an open field
And there he espied his a-lady-O.

'What makes you leave your house and land
Your golden treasures for to go?
What makes you leave your new wedded lord
To follow the wraggle taggle gypsies-O?'

'What care I for my house and land?
What care I for my treasures-O?
What care I for my new wedded lord?
I'm off with the wraggle taggle gypsies-O!'

'Last night you slept on a goose-feathered bed
With the sheet turned down so bravely-O.
Tonight, you'll sleep in a cold open field
Along with the wraggle taggle gypsies-O!'

'What care I for a goose-feathered bed
With the sheet turned down so bravely-O?
Tonight, I'll sleep in a cold open field
Along with the wraggle taggle gypsies-O!'

My great-great grandmother on my father's side was called Mary Martin Page. It has come down to through oral tradition in the family that Mary was Russian and was adopted by a family near Lewes. A few years previous to the walk, I had begun to research her life and found that she was adopted by a couple from Glynde. I was unable to ascertain her origins, but I discovered that Lewes held hundreds of Finnish prisoners of war during the Crimean War, which was the same period. The Russian Memorial is an obelisk in St John's sub Castro's Churchyard in Lewes; it commemorates the twenty-eight Finnish Soldiers who died in Lewes whilst they were prisoners between 1854 and 1856. It was designed in 1877 by John Strong and commissioned in 1877 by the Emperor of Russia, Alexander II (Historic England 2022). The story of their incarceration led to the 2007 Orlando Gough opera *The Finnish Prisoner*. Additionally, Wikipedia suggests, 'A popular Finnish folk-song, Oolannin sota evolved from the earlier Ålandin sota laulu which tells of their capture and imprisonment in Lewes and is thought to have been written by one of the Lewes prisoners during his internment'; however, I have not been able to find academic sources to verify this (The Finnish Prisoner 2022).

The couple who adopted Mary in 1856 were called Leonard and Susannah Page, Leonard was a shoemaker and Susannah was a servant at Glynde Place.

Leonard and Susannah were married in Glynde Church in 1836, and, as part of my search for Mary, I found that their graves were in the churchyard. In my great-uncle Don's memoirs, as well as the tale that Mary was left with the couple by her young, Russian parents, there are recollections of his and grandma's mother, Janet Chalk, telling him that Mary had a beautiful voice and would sing hymns around the house. Again, I thought of grandma and how much I wished I had known that she sang. Finishing the journey in Glynde Church meant that I could sit and think about my gentle grandma and grandpa, Leah and Raymond, who loved May, Sussex, country paths, and their family, and would have loved hearing about this walk. It is befitting, then, that the most significant song of the walk for me was a song about the month of May, which took form fully in the weeks after my walk.

When I first began this project the question that many people asked me was – 'Had I found a Sussex Maying song?' Despite songs rarely heeding borders, county singers have a natural competitiveness about versions, and Sussex does not have its own song for that season. When I was researching a singer called David Miles from Heyshott, I had seen that he had given Dorothy Marshall the words to many songs, but not the tunes, and I had saved some of his songs away to look at after the walk. I found that I had missed a song called *A-Maying* and began to search archival resources and to send out emails to see if anyone knew a living version of the song (Miles 1912: CC/1/319). All I found were dead ends for a few months until, on another matter, I was reading through Samuel Willet's correspondence with Lucy Broadwood and found that he also referred to the song. She had discounted it, presumably because of its broadside origins; however, the words and the tune were still in the collection (Willet 1891: LEB/5/438). Apart from these two Sussex singers, and a broadside in the archive, I could find no other record of the song. Valmai Goodyear, who is a stalwart of the Sussex folk scene, but told me repeatedly that there were much better singers to interview for the project, finally gave into my pleas and transcribed the song for me. It is perfectly suited to her voice, and I am happy to say that she has regularly sung it since during May celebrations and has taught it to other singers. At a Sussex singers' workshop last year, when someone was asking about my PhD, they said I might like to get in touch with Valmai about the Sussex May song that she sings, *A-Maying*. It is, for me, the legacy of the walk; 'legacy is by implication linked to action: it is left, bestowed, donated, handed down, given, bequeathed. The nature of legacy is essentially performative – a legacy is constituted through an act of promise' (Roms 2013: p. 40).

32. A-Maying

O, my daddy has gone to the market a mile
And my mammy she's minding the mill all the while
In comes my dear Johnny, and this he was saying
Go with me my Betsy and we'll go a-maying.

Oh no dearest Johnny, it's a folly to ask
For my mammy's a-spinning she's set me a task,
Says he, cut the tyre, let the cows go a-straying,
For the time will go sweetly while we go a-maying.

His method I took, for I could not forbear
I loved him too well to think false of my dear
He pressed these lips gently as we were a-straying
And the time went so sweetly whilst we were a-maying.

My daddy he asked, oh where had I been?
My mammy she told him I'd the cows to fetch in
My mammy she said somewhere I'd been a-playing,
But she never mistrusted that I'd been a-maying.

If my Johnny proves true, which I hope that he will
Then we will get married and honour the mill
My daddy and mammy we will leave them a-staying
For the time went so sweetly while we were a-maying.

Furthermore, as songs may become legacies, 'remaining recognisably consistent and becoming transformed' (Clark 2013: p. 376), so too may stories and lives. In an email conversation with Louise to discover whether I may reflect on our conversations in my writing, Louise mentioned:

> It's interesting because I often feel like an inheritor from other women, I'm thinking particularly of Adelaide Gosset who wrote Shepherds of Britain and died a spinster. There are many others.
>
> (Spong 2017)

In doing so, she gave voice to how I had been feeling about the legacies of women such as Peggy Angus, Eleanor Farjeon, and Charlotte Smith, as well as members of my family. Like Ingold's lines of inheritance, these women had leant over and touched me, becoming part of a 'feminist genealogy' (Ahmed 2017). Becoming an inextricable part of my walk on the South Downs Way as I followed in their footsteps.

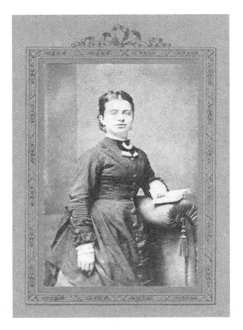

Figure 19 Bennett Family Collection, *c.* 1880s. *Mary Martin Page* [Photograph].

2.6

Dorothy Marshall

A small story

Throughout my archival research there was one name that kept appearing. That name was Dorothy Marshall, an amateur collector. Her name nearly always appeared second, after the better-known professional collector Clive Carey. During my process of taking care of these songs, I also noticed that there were some manuscripts clearly marked by her handwriting but credited only to Carey. I found that in published works on the first folk song revival she appeared only as a footnote to passages on Carey. Her name yielded no results on web-based searches of local history in the area or of female folk song collectors, and there were no images of her in the West Sussex Records Office. There was, however, an article written by George E. Frampton in 1986 for the English Dance and Song periodical, entitled 'Clive Carey, Dorothy Marshall and the West Sussex Tradition' (1986). Again, she is second. I began to read through her letters to Carey detailing her collecting activities from 1912 to 1916, the main archival source relating to her at the Vaughan Williams Memorial Library. I followed the order they were placed in the archive rather than reading them sequentially and thus came to know her through snatches of her life recorded at different moments.

During the vast majority of my research into Marshall, I was suffering from a chronic condition in the womb, which caused prolonged bleeding, extreme fatigue, and debilitating labour pains on an almost daily basis. The sensuous, tactile, at times thrilling, and often mundane, task of sifting through her letters was counterbalanced by the cotton wool feeling in my brain induced by tramadol. I worked at home with the digital archive so that I could be propped up with a hot water bottle and a heat pad and lie down on the floor and scream when I needed to. Around this time, I scribbled the following on the margins of a page of research, 'I am no longer aware of whether I am holding a pen, I feel like the

borders of my body have been erased by agony and I am dissolving. I am afraid that my identity is disappearing and all that will be left is pain.' When I discovered letters written by Dorothy in her left hand because her right hand was crippled by neuritis, it was impossible not to feel an affective bond with this woman who was apologizing for being bed ridden and not being able to go out for her 'song hunts'. I in turn made the decision to take a leave of absence from my PhD and undergo a hysterectomy. It was impossible not to be annoyed by Frampton's conclusion to his article that he felt anguish at the missed opportunities in her collecting activities, due in part to Dorothy's ill health (Frampton 1986). I wanted to honour the networks of songs and people Dorothy had taken care of despite the limitations of her body. I needed to take the material fragments of Dorothy's life and place my feet somewhere she might have stood.

I knew the one person who would instantly understand the desire to go in search of her grave would be my mum. I also knew she was also feeling increasingly concerned and protective about me, and it would give us both something to do. In the car on the way to Chithurst I filled her in on what I knew about Dorothy from Frampton's article. Dorothy Georgina Elizabeth Marshall was born in 1886. Her father was Captain John George Don Marshall of the Gordon Highlanders. John Marshall, it seems, possessed an ear for tunes, as he

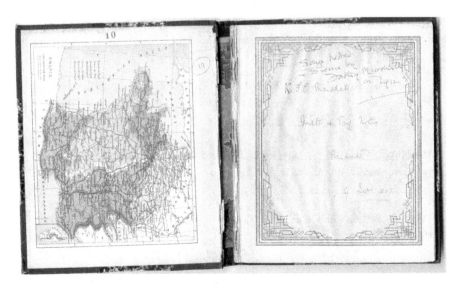

Figure 20 Marshall, D, 1912. *Dorothy's song notebook reusing her brother's Maths notebook from school.* Full English Digital Archive, English Folk Dance and Song Society (CC/4/19) [Digital Image].

taught his daughter three sea shanties which he had learnt on an 'East India Company ship' in the 1850s (Frampton 1986). John Marshall's death is recorded in 1906. Dorothy and her mother were, at the time, living with a household of servants at Chithurst House. That her family life involved some singing, we can ascertain from her learning the sea shanties, and we know that she played the piano. She also played in the local pipe band, many of whose members also comprised the Chithurst Tipteerers (the Sussex term for a Mummers play), the revival of which Dorothy greatly encouraged. However, there is no direct testimony as to how she became involved in the pursuit of traditional folk music, or as she refers it in her letters to Carey, 'song hunting'. The Espérance Guild of Morris Dancers, who Carey was working for at the time as a musical assistant, contacted Dorothy in late 1910 to ask if she could assist Carey with his first collecting trip to Sussex (Frampton 1986).

How the Espérance Guild knew Dorothy Marshall is unclear; her letters show that even before Carey's arrival in Sussex on 27 February 1911, she had already collected nearly thirty songs from the villages that surrounded Chithurst House. She undertook considerable groundwork prior to his arrival, introducing Carey to ten new singers over the course of this first visit, where he noted down fifty-one songs (Frampton 1986). His next visit was scheduled for the August Bank Holiday 1911; during this time Dorothy continued to seek out her *songsters*.

Dorothy suffered badly from neuritis in both arms, which sometimes kept her bed bound, and meant she was not able to walk long distances in the countryside she so loved:

> Dorothy to Clive Carey, Feb 1911: I have been helpless with neuritis in both arms for a bit, which has delayed collecting work.
>
> (Marshall 1911: CC/2/132)

> Dorothy to Clive Carey, May 1912: The countryside is looking lovelier than I have ever seen it, and that is saying a good deal.
>
> (Marshall 1911: CC/2/170)

> Dorothy to Clive Carey, Oct 1912: It's simply glowing here, I wish you could see the trees.
>
> (Marshall 1912: CC/2/153)

Despite her confinement, her enthusiasm appears to have affected other bodies. A man named in the letters as Moore, who worked at Chithurst House as a domestic coachman, would not only drive her to the cottages and houses of her

song hunts when she was unable travel independently, he also met with these songsters on occasions when Dorothy was too unwell to leave the house:

> Dorothy to Clive Carey, July 1911: I did not get to Heyshott last night, but Moore [was] quite the collector, and his best find is 'Lord Thomas and Fair Eleanor'.
> (Marshall 1912: CC/2/183)

Dorothy deemed herself to be musically limited and thus trusted that a professional such as Clive Carey would note the tunes down with greater accuracy. A remarkable feature of her collecting activities is that she used a phonograph to record down the tunes of the singers she met with. Many collectors of the time avoided the phonograph, afraid that it made the singers too uncomfortable or self-conscious. Dorothy writes of some singers adapting to it more easily than others, but this seems to be a case of their voices suiting the phonograph more, rather than the traditional singers being wary of the device. It is also the case that certain class-based assumptions were projected on to the traditional singers by the collectors. An example from this period was when Cecil Sharp met traditional Appalachian singer Jane Hicks Gentry and asked if she would like him to sit in the next room whilst she sang her ballads in case his presence as an English gentlemen was distracting, to which she replied, 'if you can stand to look at me, I'm sure I can stand to look at you' (Smith 1988: p. 77). As with Lucy Broadwood and her singer with operatic airs, there are also anecdotes of British collectors travelling many miles to listen to singers with enviable reputations only to find that the singer in question refusing, or unable, to sing. As with most of what we know about the first folk song revival, these encounters are framed by the collectors and therefore have tones of class prejudice throughout. By imagining-in-practice and revising these accounts through contemporary understanding of power and class, it is possible to see that there were reasons for singers not to be able to simply produce songs they sang along to their daily lives in a different and strange setting, repeating the tune to be noted down or singing into a phonograph. It is one thing to sing a ploughing song to accompany your work, and another to perform it for collectors wanting to know if that is exactly the order to verses come in. These are the nuances I hoped to illuminate through my own practice of walking and singing, and through taking care of Dorothy Marshall's correspondence and her small story.

There are no instances recorded of Dorothy being unable to hear the repertoires of her songsters. Her letters demonstrate that she understood rural life and was respectful of the patterns and practices that these songs accompanied:

> Dorothy to Clive Carey, Jan 1911: The people don't approve of singing on Sunday's and <u>won't</u>!
>
> <div align="right">(Marshall 1911: CC/2/131)</div>

> Dorothy to Clive Carey, June 1911: To be quite plain with you, I'm afraid it would only waste your time to come down here on Wednesday, for there is a lot of Hay about and most of the men you want would very probably – almost certainly – be working till dark at it.
>
> <div align="right">(Marshall 1911: CC/2/139)</div>

What resonates throughout Dorothy's letters is that that she was aware of the social natures of these songs and would organize communal singarounds for singers struggling with their repertoires to prompt their memories:

> Dorothy Marshall, Feb 1911: I want to have a dance and a 'singsong' while you're here and get the plough boys together.
>
> <div align="right">(Marshall 1911: CC/2/132)</div>

She understood that repertoires were linked to environments. She organized village concerts so that these songs continued to be in circulation and form their landscapes and not just to be published and discussed around the London table of the Folk Song Society. However, as was the case with many of the early folk song collections, there is very little information on the singers themselves beyond names, dates, and places. It was my hope that through taking care of Dorothy's archive, I might also be able to illuminate some of the sensory and social qualities of the process of collecting from these traditional singers, and thus animate and enliven the scant biographical information we have for them.

Her letters often made me laugh with her keen sense of the ridiculous:

> Dorothy to Clive Carey, Sept 1911: I am going song-hunting again this evening. I was going last night, but was delayed until too late by a <u>violent</u> game of cricket with a small boy and girl who came to tea (and stayed past 7). Moore and a chauffeur here played with a sprung tennis racket and some of Barbara's woolly balls, and went on till no one could see. Well, if I find anything exciting tonight, I'll write to you tomorrow.
>
> <div align="right">(Marshall 1911: CC/2/147)</div>

However, she never made fun of her *songsters*, as she called them, or brought the difference in class to the attention of her correspondents. She spoke of them with genuine warmth and friendship and was welcomed into the local Brown household where Morris Dancing rehearsals took place, as she writes to Carey:

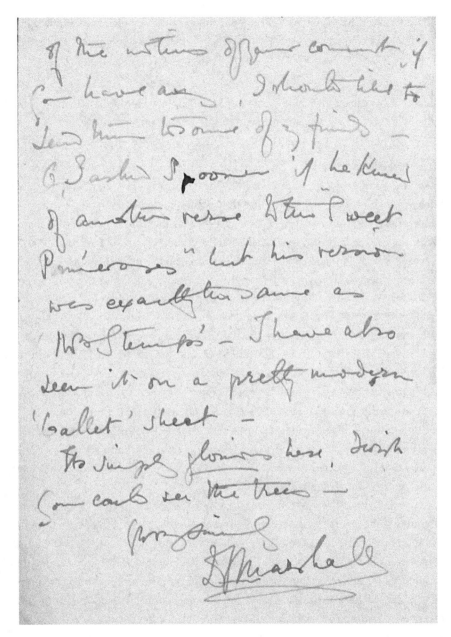

Figure 21 Marshall, D, 1912. *I Wish You Could See the Trees*. Full English Digital Archive, English Folk Dance and Song Society (CC/2/153) [Digital Image].

> Dorothy to Clive Carey, Dec 1911: You would <u>love</u> the Tipteerers all stamping about in Mrs Brown's cottage & old Brown and Alberry reminding each other of all the songs they've ever heard – lots of them!
> (Marshall 1911: CC/2/161)

> Dorothy to Clive Carey, Nov 1911: I have just had the whole of the 'whistle pipe band' here, dancing and singing in my dining room – such a racket!
> (Marshall 1911: CC/2/157)

Carey visited again from 7 to 17 August 1911, during which time around fourteen songs were collected (Frampton 1986). The labouring men were still working late, and on Dorothy's insistence that they would be busy making hay whilst the sun shone, they appear to have visited singers already known to Dorothy locally, including Mrs Stemp who lived in the neighbouring village of Trotton.

Carey next visited on 29 September and collected from Edward and Stephen Spooner, who were men with tremendous repertoires living at the time in the Midhurst workhouse, singing songs including the version of *Green Bushes* that I sang on my walk. Carey visited again on New Year's Day 1912 and met with some of these singers, and the Tipteerers came to Chithurst House and performed for Carey and the household (Frampton 1986). Dorothy wrote to him later that year to say she had over a hundred songs that needed taking down and he visited again briefly in September and October 1912 and managed to meet some, but not all, of Dorothy's new singers in the field. Thereafter, there is nothing in the archives to suggest that Carey visited Dorothy again, although the two remained in touch by letter, and she continued to send him songs. We know that Carey also returned to West Sussex in 1919, as he collected from Mr Viney at the George and Dragon, Houghton.

The majority of the villages that Dorothy collected from were not visited by any other collectors during the first folk revival. She mapped these villages into the archives and made it possible for me a century later to walk on the Downs and sing these songs. Frampton states that 'often all Carey did was to hone down the rougher edges of her jottings, or from her cylinders she sent to him' (Frampton 1986). Carey wherever possible gave Dorothy full credit for her work, and with the sense of humour that leaps out from her letters she teased him about this, and made it clear that she considered their work as a joint endeavour. I read here that Sharpist is in reference to Cecil Sharp, whom Dorothy took a dim view of:

> Dorothy to Clive Carey, Oct 1911: All right Mr Carey, I shall now go about saying that you have bagged all of our discoveries and are vaunting them as

you own in the Sharpist way. Of course, they are yours as much as anybody's. I should never have got the music but for you.

(Marshall 1911: CC/2/154)

However, amateur collections like Dorothy can become subsumed in the archive, placed under the headings of better-known collectors, and as I have explored, the work of women in the folk is also under-represented. An additional factor to the contemporary obscurity of her work is that her phonograph cylinders are thought to have been discarded in the 1960s from the archive along with other cylinders due to damage, although modern technology may have been able to restore them (Roud 2022). Consequently, the voices of the singers she collected from are now lost from the archive. However, the songs remain.

I believe by telling the story of her work, I may be able to reclaim some of this lost narrative and place her name first not second. Even small details like her songs being catalogued under CC – Clive Carey – work to hide her contribution and provide space for a rethinking of the archive through a feminist lens. Nevertheless, I had ethical concerns about telling Dorothy's story, when she herself did not want the credit. I think of this when I sing a line from *The Unquiet Grave*, 'Who is it that sits upon my grave and will not let me sleep?' Here I was in Chithurst, 100 years and a day since Dorothy had died, troubling the past. And yet I felt unable to write the story of my research into Sussex folk songs, without telling the story of hers. I continue to sing the songs she collected, and thus her activities continue through me. And, if not me, who? As Lorimer asks of researchers who seek to tell small, local stories:

> How do researcher-writers go about inviting 'throwback journeys' to the past lives of landscape? How can we better understand the complex kinds of meaning that memory (or memories of memory) is in the habit of making? And ultimately, for whose ends are such projects of recovery undertaken and then eventually written?
>
> (Lorimer 2014a: p. 588)

Today Chithurst is a hamlet in West Sussex that sits on the River Rother, with a population of around 400 people. As you drive up the central narrow lane that runs the length of the settlement, adorned with primroses, there are no modern buildings, and a tangible silence; it seems like a place out of time. Yet, a community of Buddhist bhikkhus (monks) and siladharas (nuns), formed in 1975, speaks of a place that has known, and embraced, change. The Buddhist Monastery, Cittaviveka, at the top of the lane was formerly Chithurst House where Dorothy

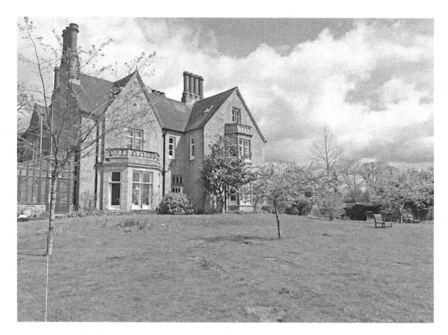

Figure 22 Bennett, E, 2016. *Chithurst House*. 25 April 2016 [Photograph].

lived with her mother. The house sits high on the ridge overlooking the villages of the Rother Valley and the paths of Dorothy's song hunts, with the blue line of the Downs to the south and the tree tops of the Hammer woods to the North.

Although it was Monday, and therefore a day of silence, we were greeted by a bhikkhu who was able to speak to visitors, and kindly allowed me permission to take photographs. As we walked the grounds, my mother commented on how much it pleased her that this beautiful house was in community ownership and lived in by so many people. It recalled the household servants who would have lived here in cramped servants' quarters, or in the village, when it was a private house, many of whom Dorothy collected from. I thought of her coachman Moore; and wondered where he had lived, and where he was buried. I had to take regular breaks because of the pain, my body bent over and distorted like Kipling's 'gnarled and writhen thorn'. In these pauses, I was wrapped in the companionship of my mother's body, tentatively discussing whether it might be time for some more surgery and raging against my declining health: 'one has constantly, as it were, to go back to the beginning, learning and relearning to walk along the way, in order to cope with ever-changing bodily capacities and environmental conditions' (Ingold and Vergunst 2008: p. 19). I thought about

Dorothy and whether she felt frustrated when her fingers were stiff and numb from neuritis and she couldn't play her piano. I thought about her despairing to Carey about visitors arriving and the duties of hospitality delaying her song expeditions, and how she pursued her passions despite these limitations and the expectations of women in her social class. I wondered if when she felt well, she ever ran down the long grassy plains from her house that lead to the woods, because she was young, and alive, and able to.

On Monday 24 April 1916, Dorothy Marshall died following a two-week long undisclosed illness (Frampton 1986). Frampton writes that she was thirty years of age. Her mother had died a few months prior to this, with both funerals taking place in Chithurst Church (Frampton 1986). Dorothy's grave lies beside her parents' at the foot of the garden of Chithurst Abbey, the medieval manor house beside the church. Mum and I both particularly wanted to see the graves. As we approached the Abbey – now a private house home run as a spiritual retreat – we saw to the right a secret garden with its own gate that seemed to stand apart from the manor, and in the distance two gravestones. The graves were under the shade of the trees that lined the river. The combination of the waterside and the wildflowers that amassed around the headstones, I can only describe it as affecting me spiritually. I want to grasp the sun willowing through the leaves and onto the graves, to put it into writing, and to give you the birdsong, I want to impart the joy it gave me to discover how wrong and naïve I was that to worry that she was buried in the dust of the archives, when actually she lay, here, under the trees that would colour in the autumn. I want to practice the kind of ethnography that Ellis writes as including 'researchers' vulnerable selves, emotions, bodies, and spirits' (Ellis 1999: p. 669), and to situate how, 'being affectively immersed in that landscape in aural, visual and other ways, [was] a balm of sorts [. . .] opening up affective transmissions by letting the body be in place' (Jones and Fairclough 2016: p. 99). It would be too easy, and too neat, to say that this was where I made my decision to have more surgery, but I think it was a significant moment on the way. In that place, in the moment, in my pain-ridden body and in the possibility of something else I felt 'a sharpening of attention to the expressivity of something coming into existence' (Stewart 2010: p. 340). Recalling Lavery's experience of feeling at moments on his walk, 'a sense of expansion, as if something fragile and hidden was on the point of emerging' (Lavery 2009: p. 42).

As we left the church, a woman pulled her car over to speak to me and my mother and ask if we needed any help. She lived at the schoolhouse and wondered

Figure 23 Bennett, E, 2016. *Dorothy Marshall's Grave Amongst the Trees*. 25 April 2016 [Photograph].

if we were here for a retreat. We told her about coming here to find Dorothy, and she told us she was glad to know the story behind those quiet graves. We remarked on the beauty of the eleventh-century church, and she explained that what had drawn her to live here was an overwhelming sense of holiness created by the combination of the church on an ancient burial site, the natural spring in the garden of the manor and the forest monastery. Leaving the drive, we saw a bhikkhu I had given an article to about Dorothy walking towards the church. He smiled at us as we indicated towards the graves.

2.7

Life-writing

Somewhere between waking and sleeping,
You, have arrived
A false message from my body
No, no, I shut my eyes
The decision has been made
This canal has borne no tiny ship into the world
These tides of pain speak only of
Absence
And yet . . .
Your formless possibility
Presses up against my walls to say
If you had wanted me, against all odds,
I would have come
Not to fill me with remorse
But to offer a parting gift
'Your will is as strong as your blood'.

One of the things that no one tells you about having a hysterectomy is that it makes you feel like you have given birth. I would wake in the night reaching for a baby through instinct; even for someone who doesn't want children, those first few days were hard going. Words like bruising and brutal take on new significance. As I revisit Dorothy's letters to write the story of my visit, I can see my mother smelling the cherry tree by Chithurst Church and saying it was the sort of spring that made her feel tremendously lucky to be alive. Tears form in my eyes. I have lost my fertility and regained my health. I am not the same person who stood by that grave. Nor, it transpires, is Dorothy. Through further research, I discovered that her date of birth was some twenty years earlier than given in the article, with her age at death recorded as forty-nine ('Dorothy Marshall' 1916). Those two decades open a gap between our lives, changing the way that I relate to Dorothy. And yet, the affective bond built through tending to the body of her work remains.

Fourteen years of leaving meetings or social occasions because I've bled through my clothes, days, weeks, months missed from school whilst I lie prone on my bathroom floor, endless GP appointments, and internal examinations, the fear I was imagining it, being told I was imagining it, medical misogyny, and moments of hallucinating taking a knife to my stomach and dragging out what was wrong, culminated on an operating table where I had my uterus, fallopian tubes, and cervix removed. I was twenty-eight years old. 'What's your PhD about then?', I heard as I slipped into the icy, nauseating, oblivion of the drugs – 'it's about Dorothy'.

Although this is an oversimplification, it did seem in that moment as though all the lines were running to and from Dorothy. The life-writing of Dorothy Marshall intersects with many of the concerns developed through the research and creation of this thesis. The relationships we create with bodies in archives, knowledge formed through footfall, being vulnerable researchers, tracing affects across places and times, and understanding tradition as it arrives to us in the present. Through recovering Dorothy's work, and during the process of my own recovery from surgery, I experienced recovery in the sense that Lavery uses it, 'not the act of retrieving something in its original, pristine, state; rather it designates a poetic or an enchanted process in which the subject negotiates the past from the standpoint of the present' (Lavery 2009 in Mock: p. 41).

Following on from the previous chapter on landscaping and landscape writing, Lorimer's work on local, small stories, landscape use histories, and life-writing all enable different perspectives and insights into the creation of fragmented stories through both direct engagement with the landscape and with the materiality of past lives. His research in relation to both archives and landscape is practice orientated. Lorimer's paper 'Herding Memories of Humans and Animals' operates within the borderlands of ethnography and ethnology. His work charts the orchestrated return of reindeer to Scotland through 'the entwined biographies of animal and human subjects' (Lorimer 2006: p. 497). Through studying Mikel Utsi and Ethel John Lindgren who conceived of and executed the reintroduction of reindeer, Lorimer 'creatively constructs correspondences' (Okely 1994: p. 47 in Pink 2015: p. 47) with these deceased research subjects. He employs what he terms a 'make-do' methodology – 'walking a sentient topography of traditional grazing grounds; renewing encounters with charismatic animals through photographic portraits; consulting an archive of herding diaries; and mapping a hidden ecology of landscape relics' (Lorimer 2006: p. 497).

Within this make-do methodology emerges a relationship between practices of archiving and practices of landscaping. Lorimer uses his body and the working environment of past herders to harness the affectivity of archival materials, both heightening the intensities and impressions of documents by bringing them into play with their sites of creation, and utilizing these materials to guide his embodied endeavours to 'reanimate a local landscape' (Lorimer 2006: p. 497). The communication of these lived landscapes and embodied research is accomplished through 'narrative that works on an intimate scale, while simultaneously gathering momentum from transnational movements humans, and traditions' (Lorimer 2006: p. 497). This, Lorimer argues, allows for 'salvage and exchange' between small stories and larger narratives, using new narrative forms to speak to existing concerns 'between geography's heritage of landscape and folk study and the sculpting of contemporary research' (Lorimer 2006: p. 497). Lorimer's notion of salvage and exchange has allowed me to see how using life-writing and embodied, landscape-based research in relation to Sussex folk song collector Dorothy Marshall enables me to trace connections between the everyday embodied existence of a historic research subject and broader questions about the role of amateur collectors, such as the importance of someone like Dorothy who – though a different social class – was embedded in the everyday life of a community.

Additionally, Lorimer's concept of a make-do methodology shares aspects of Roms's notion of 'taking care' in the archive, and related questions of tracing affectivity in past lives. My research into Dorothy Marshall comprised of repeated readings of her letters over a period of two years, visits to her home, and the region that she travelled to collect folk songs, learning and performing the songs gifted to her by the local people. The various registers of research I undertook both in the Vaughan Williams Memorial and in surrounding countryside of her residence, Chithurst House, were used in order to creatively construct correspondences with an emplaced life, reminding me again of Lorimer's questions relating to his study on herding memories:

> How best to encounter the textures and cycles of work that leave a landscape replete with meaning? What creative strategies might be employed to reanimate, however temporarily, the embodied relationship between individual subjects and an environment?
>
> (Lorimer 2006: p. 204)

The process of researching Dorothy Marshall and her collecting work resonated with these questions. It occasioned me to consider how using landscaping practices, such as folk singing in sites of collection, may facilitate affective insights into the past lives of research subjects.

Modes of enquiry, such as sensory ethnography and non-representational theory that seek to account for the sensate aspects of everyday activities, pose challenges when they are applied to historic figures, 'the inherent difficulties of tracing ways of moving, feeling or performing in the past' (Lorimer 2003: p. 202). Thus, creatively constructing correspondences with past lives, taking care of archival remains, and engaging in embodied acts of landscaping – a make-do methodology – rely upon 'a creative engagement with, and imaginative interpretation of, conventional representational sources, rather than the identification of a previously ignored, or oppositional, realm of non-representational practice' (Lorimer 2003: p. 203). Further, being attuned to the sensory qualities of composing sources such as letters and diaries, and the affective aspects of reading these materials in the 'here and now', may allow for the consideration of embodied epiphanies in the lives of historic research subjects. As performance theorist Jones asks in relation to how researchers may be altered in subtle ways by the traces of past performative works, 'how are such moments of change registered historically? How have we accessed them in the present tense of our interpretation?' (Jones in Borggreen and Gade 2013: p. 68). The sensate nature of the past in the immediacy of the present tense is encapsulated by Nadia Seremetakis, 'sensory memory or the mediation on the historical substance of experience is not mere repetition but transformation that brings the past into the present as a natal event' (Seremetakis 1994: p. 7). Chiming with principles of emplaced sensory ethnography (Pink 2015), Lorimer argues that 'the new biographies that we write into geography's history benefit from being as acutely sensitized as they are spatialized' (Lorimer 2003: p. 202). Thus, I considered how I might illuminate snippets of Dorothy's sensory life through interspersing extracts from her letters with my account of a day in Chithurst.

The emplaced, affective, and embodied lives of the subjects that writers seek to tell stories about are often the things that im*press* themselves, drawing researchers away from the discursive and into the immediacy of the past. As literary biographer Hermione Lee argues:

> What makes biography so curious and endlessly absorbing is that through all the documents and the letters, the context and the witnesses, the conflicting

opinions and the evidence of the work, we keep catching sight of a real body: a physical life.

(Lee 2005: p. 3)

I argue that one way through which affect can be used to analyse the emergent relationships between archive and performance is to consider not only the body of work an artist produces, but the body which produces the work: the physical lives of the archive. Life-writing is found in many different forms: diaries, essays, memoirs, travelogues, fiction, and letters. Literary critic Marlene Kadar discusses the various use of these forms and argues that life-writing is made up of 'documents, or fragments of documents written out of life, or unabashedly out of personal experience of the writer [. . .] blending genres, creating new genres, and derailing the once respected "objective" speaker or narrator' (Kadar 1992: p. 154). My desire to understand the collecting practices, and as time went by, the life of Dorothy Marshall, required an engagement with her letters to Clive Carey as my key source. More than this, I began to view her life pieced together from her writing of her life, and mediated through my life, or moments of my life. Fragments that resonated in my body, fragments written down in scribbled disorder on backs of photocopied archival materials and fragments that pushed forward into the future as I examined someone else's past. Lee echoes this affective resonance between self and subject in her argument that a feature of life-writing is, 'when the distinction between biography and autobiography is deliberately blurred' (Lee 2005: p. 100).

In 'Standards of Beauty: Considering the Lives of W.A. Poucher', Lorimer uses life-writing as a narrative form in order to couple 'recent experiments with the writing of geography and the writing of biography' (Lorimer 2015: p. 51). Where biographies are often 'temporal in nature', requiring the writer to follow lived lives chronologically from the subject's birth to death, Lorimer adopts a 'kaleidoscopic configuration' in his narrative rendering of W. A. Poucher's lives (Lorimer 2015: p. 51). For Lorimer, this configuration allows a mode of biography with topographical features, 'a spatial formation emerging through the multifarious spaces and landscapes produced in a life' (Lorimer 2015: p. 52). Using landscape as process and disrupting sequential lifelines retains the subject as the narrative centre whilst resisting 'any temptation to conclusively stabilize selfhood' (Lorimer 2015: p. 52). Situating his work in terms of a flourishing scene of 'imaginative approaches to biography appearing under the heading of life-

writing' in the humanities over the past decade, Lorimer also contends that such a proliferation may be seen in part as creative attempts to explore the tension identified by theorist Susan Sontag in biographical study that, 'one cannot use the life to interpret the work. But one can use the work to interpret the life' (Sontag 1981 in Lorimer 2015: p. 54). This structural tension is particularly illuminative in the field of early folk song collectors and rural singers, where scant biographical information is supplemented by rich and varied repertoires of song and dance.

Lorimer also cites philosopher Walter Benjamin's self-analytical exercise of memory mapping his life, an exercise which untethers the narrative from chronology, producing montages, visceral highlights, and sensory memories in place of a 'rigid narrative infrastructure' (Lorimer 2015: p. 54). Ethnographer Norman Denzin echoes this position in his call to autoethnographers to 'see and rediscover the past not as a series of events, but as a series of scenes, inventions, emotions, images, and stories' (Denzin 2006: p. 334). If the affective forces of emotions, images, and stories reach us from the past as a 'natal event' in the present, how are such accounts to be ordered? Furthermore, if there are inherent challenges involved in charting autoethnographies sequentially, then similar issues also arise in relation to affective accounts of historical lives. Thus, looking at the geographical attachments of biographical subjects – their lived landscapes – may offer ways of producing alternative accounts of past lives:

> Attention paid to spaces, scales, and sites, and the associations between person and place serve to lever a life open. Executed with imagination, life-writing can augment the standardized chronicle, possibly scrambling (even short-circuiting) the too exhaustively encyclopaedic literary biography.
>
> (Lorimer 2015: p. 54)

In the case of Dorothy's life, very little is known about her beyond her work. It is possible to gain only 'light-gleams' about her personal life through her letters to Carey. As such, modes of writing that allow for affective impressions and emplaced researcher relationships have opened up a way for me to celebrate and promote the fragmentary and incomplete rather than fight, or negate it, through authorial authority. Life-writing with attention paid to 'space, scales, and sites' provides a narrative form that allows for a fullness of interpretation in relation to partial information, rather than a linear, factually bare, cradle account. Thus, I suggest that researchers utilize this not to gloss over what they do not know, or doubts surrounding a subject's (or the writer's) life, but rather to

find ways of articulating affective absences in the archive, and communicating the impressions that such holes may enact upon the researcher through their own embodied practices of relating to the material remains of that life: taking care, performing, writing, sensory imagining, returning to sites of collection or creation. As Carolyn Steedman argues in her volume *Dust: The Archive and Cultural History*, missing details or materials have locations, and gaps in an archive may tell stories of their own:

> That if we find nothing, we will find nothing in a place; and then, that an absence is not nothing, but it is rather the space left behind by what is gone: how the emptiness indicates how once it was filled and animated.
>
> (Steedman 2001: p. 11)

In writing accounts of lives encountered in the archive, researchers may animate these absences – and the residues left on them from their material relations to artefacts – for their readers, conceiving of affect through the Deleuzian definition – 'a mixture of two bodies, one body which is said to act on another, and the other receives traces of the first' (Deleuze 1978).

Lorimer identifies a range of stylistic approaches that may be harnessed to appreciate and portray *elasticized lives*, a term he uses to describe life-writing where experimenting spatially introduces 'elasticity [. . .] to an otherwise rigid narrative infrastructure. Montages or moments or situations can outfox the linear logic of the form' (Lorimer 2015: p. 54). The first category he identifies is temporal experiments, modes that disrupt timelines and straightforwardly sequential biographies – 'reverse chronology, time slips, episodic focus, and counterfactual speculation' (Lorimer 2015: p. 55). As many biographical subjects are dead, it may be that the manner of their death looms large over the narrative of their lives. What drew me to Dorothy Marshall was her presumed sudden death at thirty of an undisclosed illness, and it was only though the search for her grave that I began to build affective connections to her life. Lee contends that 'it is still very unusual for death in biography to occur as random, disorderly, without meaning, without relation to the life lived, or without conclusiveness' (Lee 2005: p. 216). Yet it was the random, meaningless shock of Dorothy Marshall's death when reading Frampton's account that produced one of the strongest surges of affective intensity; deaths, like lives, are messy, complicated, and ambiguous. And as it transpired when I found her birth certificate in the West Sussex Records Office, sometimes they are wrong. This also shifted my own relationship to Dorothy; there was something particularly poignant about

researching a female collector who had died at thirty, whilst I was in my late twenties, which shifted once I was able to imagine her in her forties.

Furthermore, there is an ongoing motion to death, to the active qualities of conclusions, and loose ends on the strings that tie archival records. The second category Lorimer highlights is accounts of authorship that foreground the process of accumulation. These modes of writing make visible to the reader the ways in which 'intimate links between the dead and the living' (Lee 2005: p. 2) are formed – 'eschewing claims of neutrality to include first-hand accounts of biographical sleuthing, where the intimate exercise of recovery is a means to illuminate the subject' (Lorimer 2015: p. 55). A recurring theme in research into biographical subjects and their physical lives is that of intimacy. Perhaps some of the intimacy researchers experience with archival subjects is created in part by correspondences between their bodies and the researcher's own, or similarities between the ways that they relate to their environments, such as landscaping or emplaced attachments. As such, do researchers need ways to account for those connections, and the part they play in the recovery of stories? I was in a chronic pain when I was writing my PhD; part of my research was reading about a woman whose work was limited by severe pain, and that has necessarily become a crucial part of the narrative of my research. It raises challenges around what researchers carry with them before they enter an archive or begin writing a life. As Lee asks:

> How do biographers deal with moments of physical shock, or with the bodily life of the subject, or with the left-over parts of a life? How do autobiographers write their bodily sensations and memories – of illness, or reading, or aesthetic pleasure?
>
> (Lee 2005: p. 5)

Lorimer's third category pertains to the spatial dimensions, depths, and mysteries of a subject's life, 'where life experiences are arranged according to cardinal sites and pivotal places, offering novel thematic structure, proceeding by motif and pattern as much as by argument' (Lorimer 2015: p. 55). So closely did Dorothy and Chithurst become woven together in my mind, that it wasn't until I reread the letter sent to Carey during the First World War that I was reminded she had died in Buriton, where she lived during the war, some 10 miles away across the Hampshire border (although still on the modern South Downs Way). One of the main features identified by the singers I interviewed is that folk songs learnt by heart nearly always alter subtly in each new performance. If researchers

embody the stories they seek to tell, committing certain elements to memory, what vagaries and misremembrances may be fostered in the narratives we write? What are the implications of such slippages on the archive or performance documentation as a signifier of 'stability and permanence'? (Borggreen and Gade 2013: p. 9).

Lorimer identifies with life-writing a 'stylistic porosity and pliability' and locates this within the context of posthumanist theories that 'scramble a settled sense of the finished self' (Lorimer 2015: p. 55). Non-representational theory and related theories have enabled ways to view selfhood as formed through processes and practice of being. I began this project with a view to learn some of my mum's repertoire of folk songs; seven years on I would now comfortably call my*self* a folk singer. Similarly, Dorothy Marshall's letters span a period of four years, during which time many changes occurred, not least the outbreak of the First World War. During these four years she progressed from hobbyist to collector. Within this shift must also have been alterations in her collecting practices, such as a growing confidence with the phonograph, visiting singers without the authority of Carey by her side, and finely tuning her ability to sense a 'traditional' song. Such practices serve to remind me that whilst the letterheads on Dorothy's archived letters remain the same, belying a sense of order and constancy, the hand that wrote them was a permeable source. This affectively underlined by the letters she wrote with her left hand when her right arm was crippled by neuritis, and she was under doctor's orders not to use it. The disorder of the handwriting leaves a trace of that pain. This strengthened my bond with her, as did a growing ability to read her handwriting. Her body of work impacted on me. These impacts were specific to my embodied activities with her legacy, and affective charges produced through practices of care, which registered in my body.

Lorimer uses the term 'small story' in his creation of local, emplaced biographies. Small stories, Lorimer contends, allow for a means in which to recognize the 'local character and contingencies' of narrative (Lorimer 2003: p. 191). My small story of Dorothy's life, and the ever-changing durational relationships between us, has been a 'constellations of sites, subjects, experiences and sources dating from the past and present', as a way to 'embrace a creative biographical dimension in geographical research' (Lorimer 2003: p. 200). The telling of this small story also enabled me to see the texture and joy in the work of Dorothy Marshall, and to see how reading along 'the archival grain' may allow for more nuanced accounts of the work of the early song collectors, not

Figure 24 Marshall, D, 1911. *Isn't My Left Handwriting getting quite expert?* Full English Digital Archive, English Folk Dance and Song Society (CC/2/158) [Photograph].

disavowing their prejudices, or their impositions of 'meaning on certain aspects of the musical activities of the rural working class' (Gammon 1980: p. 85), but striving to look for the specificities of the lives of collectors so that they do not become a homogenous mass of the upper class. Such a dismissal of collectors stops us from looking at who is falling into the gaps, such as female collectors, and amateur collectors, as well as how they related to the singers they collected from. In doing so, we may also miss vital opportunities to gain some impression – however subjective or fragmentary – of the singers themselves. It is possible both to recognize the power imbalance and class politics of the first folk song revival in Britain, and not completely reduce it to this. Imagining Dorothy's life-in-practice allowed me to see how understanding folk song collectors as *individuals* illuminates these arguments (Roud 2017: p. 7). Yes, Dorothy Marshall was of a different class to most of the singers she collected from, and this will have produced uneven power dynamics that we would consider in contemporary discourse as cultural appropriation. However, she was also deeply embedded in her local community and spent time with the people that she collected from. We also know from her letters that she began to understand the arguments for socialism through the war. Her achievements were also impressive due to her gender and chronic pain. Her letters also providing nuance to the lives of the singer she collected from, and how the songs were embedded in them, such as the Tipteerers rehearsing in Mrs Brown's cottage.

This exercise in the writing of Dorothy's life is fragile, fragmentary and fissile, and it is in no sense a definitive account – I don't know what she looked like, what she sounded like, why she began to collect folk songs, what those she collected from thought of her or what she died from. As Lorimer states:

> The excavation and restoration of personal narratives can be both an unsettling and rewarding experience [. . .] treating individuals as fluid and multiple, while accepting that they are ultimately unknowable, opens out space for the experiential, interpretative reconstructions that follow.
>
> (Lorimer 2003: p. 204)

Through my desire to create an account of Dorothy that acknowledged and celebrated the 'pushing and pulling' of her body, it was also important to reflect on my own chronic pain and bleeding through endometriosis (Spry 2001: p. 725). By doing so, it was possible to see that the happy milkmaids singing whilst they were at work, or women dashing around with the smoothing iron, are not only in a perpetual May, they also don't bleed. Through the absence of

menstruation, or indeed any physical pain for these women, I am reminded of Moriarty's call to 'leave the blood' into academic writing (Moriarty 2012), and of Ellis's use of evocative autoethnography to add 'blood and tissue to the abstract bones of theoretical discourse' (Ellis 1997: p. 197). Furthermore, using one's own experiences may offer possible connections to others, in the hope of creating the conditions that Campbell explores, 'the lives of others, in written form as well as the flesh, interact with us, keep us company, and tell us about ourselves' (Campbell 1997: p. 69). Communicating my 'uncertain body' (Spry 2013: p. 497) required a level of vulnerability that at times was difficult. However, in the messiness of these emotions, I was comforted and encouraged by Spry's confession that 'whenever my work messes with my mind, I suppose that I am on to something, some truth among many that others may also find useful' (Spry 2013: p. 725). Elaine Scarry states that, 'the body of the performer is "forever rubbing up against and leaving traces of itself (of blood) on the world, as the world is forever rubbing up against and leaving traces of itself (its paint) on the human creature"' (Scarry 1994: p. 50). Thus, as both a performer and a writer it feels necessary to me to leave the blood in, and, in doing so, to perhaps leave traces of my blood on the world.

The poem that begins this chapter was scribbled on the back of a notebook at some point during my post-operative haze, amongst what Teresa Brennan describes as *The Transmission of Affect* as 'the wounding smell of sadness' (Brennan 2014: p. v). I had never experimented with poetry before in my writing, but I discovered when pain and recovery overwhelm you, the brevity of poetry can offer a means of expression, a beginning to your writing, despite it already happening. As Jane Speedy explores in *Staring at the Park: A Poetic Autoethnographic Enquiry*:

> After the stroke, life became increasingly poetic, written in snatches. I found poems in the fragments of conversation as people passed by my hospital bed [. . .] there was yet more poetry trapped within the clanking of ambulances and the passing of trolleys and equipment. There were shredded haiku between the blinds of hospital kitchens and corridors.
>
> (Speedy 2015: p. 13)

Damasio states that 'feelings of pain or pleasure or some quality in between are the bedrock of our mind. We often fail to notice this simple reality. But there they are, feelings of myriad emotions and related states, the continuous musical lines of our minds' (Damasio 2003: p. 4). Pain was the constant song of my

body for so many years and emerging from writing this chapter, it takes a bit of effort to remember that as I write this, I sit here pain free. Recalling, in turn, how extraordinary it had seemed to me post-op that I had walked the South Downs Way, as I gazed up to the hills from my bedroom window at my mum's house. I had to learn to walk and sing with my new body, to get writing again in a similarly experimental way and to begin to tell my small story of Dorothy Marshall.

Conclusion

Part 1: 2017

Two months before my PhD submission I wake up in the night with a burning fever and begin to vomit blood profusely. Luckily, I am at my mum's house and she calls an ambulance. I am barrier nursed, rushed in by ambulance and admitted with emergency internal bleeding. At 2.00 pm the following afternoon two severe stomach ulcers are diagnosed through an endoscopy. The suspected cause is fourteen years of pain medication for endometriosis. Six weeks later my mum drives me for my follow-up appointment, and in the car home she develops a headache and becomes confused. An ambulance is called, and mum is admitted back to the same hospital we had driven away from that morning, as an emergency. Two operations are performed over the next 24 hours and a serious infection in her brain is diagnosed. She spends three weeks in intensive care undergoing treatment; she does not recognize my sister and me. I edit my bibliography in the waiting room outside ICU. As I write this, she is still in a neurological ward awaiting further surgery, but the sign that she is getting better is that she is singing.

In such moments as these identities and lives are at their most palpably fragile. I was sure when I held mum's hand in ICU, the hand that first held mine, that she would recognize me. She did not. Affect swims back into sharp relief. It underscored what made me want to research traditions as they arrive to us in the present tense, to propose that folk singing is not only a matter of historical interest, it also continues to shape lives and landscapes through affects, feelings, and emotions. Nowhere do ordinary affects become more apparent than in the long hours spent in hospital corridors, on plastic chairs, staring at the same posters, 'they can be experienced as a pleasure and a shock, as an empty pause or a dragging undertow, as a sensibility that snaps into place or a profound disorientation. They can be funny, perturbing, or traumatic' (Stewart 2007: p. 2). And, once more, double existences and refrains become visible. Being well to being ill. Being ill to being well. A first ambulance, a second ambulance. Affects echoing what a 'body does or undergoes' (Comte-Sponville 2011). As Stewart evokes:

> Critique attuned to the worlding of refrain is a burrowing into the generativity of what takes form, hits the senses, shimmers. Concepts built in this way score the trajectories of a worlding's looping refrains, its potentialities, and attach themselves to the living out of what is singular and proliferative in a scene or moment, to what is accrued, sloughed off, realized, imagined, enjoyed, hated, brought to bear or just born into the compositional present.
>
> (Stewart 2010: p. 339)

Whilst writing this research has been an affective process, readership is also a place where the work will be born into a compositional present. It was always my intention to attempt to create research that would be written in such a way as to leave space for an active reader engagement. However, such an approach results in a certain amount of vulnerability, of not knowing when to draw rigid lines between ideas, or when to allow looping refrains to 'speak for themselves'. The different modes of writing I have engaged with have, at times, formed different purposes. Autoethnography has been a means through which to both value and reflect upon that vulnerability. It has also provided a way of reflecting upon the changes that the four years of writing this research have brought to my sense of self, both through the living and writing of my life and research. Furthermore, it has enabled a frame in which I could create, 'a necessarily vulnerable and evocative text that offer[s] an insight into how life is (or was) for the writer and foster[ing] empathy, understanding and meaning making on the part of the reader' (Moriarty 2014: p. 138). Furthermore, in using writing and walking 'to tease out the strange song of self' (Lavery 2009: p. 41), the creation of this text has also been an act of taking care at times when life got messy. Thus, as Moriarty states, 'we tell stories to make sense of ourselves and our experiences over the course of time, and to help us seek meanings to cope with our changing circumstances', and 'it is through this process that we can then begin to re-imagine, recover and reinvent the world as we know/knew it' (Moriarty 2013: p. 69). It is also possible to see in bodies in pain, fragmentary archives, and incomplete stories, a potential for what Ahmed calls a different orientation to breaking and broken things:

> We can value what it deemed broken; we can appreciate those bodies, those things, that are deemed to have bits and pieces missing. Breaking need not be understood only as the loss of the integrity of something, but as the acquisition of something else, whatever else that may be.
>
> (Ahmed 2017: p.180)

Both autoethnography and sensory ethnography have provided methodologies that enable me to reflect, 'inventively on where and how affect may be traced, approached, and understood' (Knudsen et al. 2015: p. 3). As Watkins suggests, 'a sense of self is formed through engagement with the world and others and the affects this generates' (Watkins 2010: p. 269). In seeking to write how my sense of self, and understanding of performances and lives, has been formed through interactions with sensory, affective environments, I have harnessed the work of sensory ethnographer Pink, and the work of cultural geographers creating landscape writing, in particular Lorimer. Applying sensory ethnography to my interactions with my participants in our walks, whilst singing songs, and during interviews, has enabled this thesis to be explicitly participatory, formed 'with others, in movement, and through engagement with a material, sensory and social environment' (Pink 2015: p. 47). Additionally, the work of landscape writers, in particular Lorimer, provided illuminative ways in which I might create an analysis that became 'a co-scripting of landscape, movement, and biography' (Wylie 2007: p. 208).

In combination with these methods, it also became necessary, as the research progressed, to find registers of writing that engaged with, and in turn created, the 'more-than' elements of our lives, affects 'that linger – recollections, memories, images, feelings' (Adams et al. 2011). As such, it was important to consider the performative elements of the texts, necessitating, for example, that the songs were written in full and embedded in the journey rather than appearing as an appendix. Aiming in doing so to create a poiesis of *making possible*, 'acts of making and giving form to the interplay of material and immaterial content intrinsic to any act of communication' (Allsopp and Kreider 2015: p. 1). Furthermore, I hoped that experimenting with different modes of writing might allow for a durational aspect of the work and to make explicit my aim to foreground my interest in the affective singing of the here and now, 'duration [as] the continuous progress of the past which gnaws into the future and which swells as it advances' (Bergson 1911 in Ingold 2016: p. 122).

In was also my hope that considering folk singing as an affective practice might open up ways of understanding performance and the archive as relational, rather than in opposition. Sedgwick contends that the 'most salient' preposition in her book *Touching Feeling* is 'beside':

> *Beside* is an interesting preposition also because there's nothing very dualistic about it; a number of elements may lie alongside one another, though not an infinity of them. [. . .] Its interest does not, however, depend on a fantasy of metonymically egalitarian or even pacific relations, as any child knows who has shared a bed with siblings. *Beside* comprises a wide range of desiring, identifying, representing, repelling, paralleling, differentiating, rivalling, leaning, twisting, mimicking, withdrawing, attracting, aggressing.
>
> (Sedgwick 2003: p. 6)

In the process of considering folk singing as an affective practice, and through such activities as handling manuscripts, walking with singers, experimenting with ways to write embodied acts of landscaping, following and contributing to long established routes and pathways, I have begun to see how the performance and the archive might be thought of as 'besides' one another. Just as two walkers might create a walk, so the archive and a performance might create a song. To be besides does not, as Sedgwick states, mean that relations are always positive or straightforward. However, it does allow for moments of reciprocity, for contributions to shared bodies of performances, as mutual sites of collaboration, and a move away from the dualistic approach of the archive as that which remains, and performance as that which disappears. If a path, or a song, is made and remade by walking and singing, are they performances or archives? Perhaps we can think of them in the way that Myers conceives of walkers and places:

> Rather, the convergence, and/or mutual alignment and adaption, of rhythm and heading *with* one another and *with* place may encourage modes of emphatic witnessing and the co-production of knowledge through collaborative and connected encounter.
>
> (Myers 2010: p. 66)

It is in the collaborative and connected encounter between archive and performance, the *with*, that songs may be felt in the affective now.

My original title for the thesis 'Singing the South Downs Way' refers not only to the idea of walking and forming landscapes through encounters, but also the many singers that have shaped my voice during my research and exist with me/will exist with me in my singing style, as Stewart refers to her Boston accent, '50 different town accents stretch jaws and vocal chords and tighten the muscles of the mouth. The exercise of a world's muscular pushing and pulling is what a subject recognizes as a state of being in place' (Stewart 2016: p. xv). I can't fill the gaps in the documentation of the early folk song collectors about how daughters

learnt songs from mothers, but I can interview my own mum and reflect on learning songs from her, and illuminate the tradition as it arrives to me today. I can seek to communicate and investigate how she makes the melody of the verse about the eagle in *The Bonny Light Horseman* sound like a bird in flight, and practice my own vocal chords and muscles to lift and soar upwards in a similar way. In that attempted flight, I understand Rebecca Schneider's call to work against the received logic of the archive and see flesh as that which remains:

> In the archive, flesh is given to be that which slips away. Flesh can house no memory of bone. Only bone speaks memory of flesh. Flesh is blindspot. Disappearing [. . .] performance does *remain* does leave residue. Indeed, the places of residue is arguable *flesh* in a network of body-to-body transmission of enactment.
>
> (Schneider 2001: p. 102)

Furthermore, when Bob Lewis sings his mum's songs, or Will Duke talks about hearing Scan Tester in his head as he plays, it becomes possible to see how performance

> 'enters' or begins again and again, as Gertrude Stein would write, differently via itself as a repetition – like a copy or perhaps more like a ritual – as an echo in the ears of a confident, an audience member, a *witness*.
>
> (Schneider 2001: p. 106)

When I sing, somewhere between opening my voice and the noise coming out, I am propelling something out, but that something is also subject to forces beyond my control. The sound rises and falls through both the intention of my body and the affects creating the in-between-ness of the performance environment. To both intend, and give yourself over, are also found to be tensions at the heart of both walking and writing by Massumi:

> When you walk, each step is the body's movement against falling – each movement is felt in our potential for freedom as we move with the earth's gravitational pull. When we navigate our way through the world, there are different pulls, constraints and freedoms that move us forward and propel us into life [. . .]
>
> When we walk we're dealing with the constraint of gravity. There's also the constraint for balance and the need for equilibrium. But, at the same time, to walk you need to throw off the equilibrium, you have to let yourself go into a fall, then you cut it off and regain the balance [. . .]

It's similar with language. I see it as a play between constraint and room to manoeuvre...

The common paradigm approaches experience as if we are somehow outside it, looking in, like disembodied subjects handling an object. But our experiences aren't objects, they're us. They're what we are made of. We *are* our experiences, we *are* our moving through them. We *are* our participation.

(Massumi 2002: pp. 10-11)

Whilst grief and its affects have formed some of the movement, experiences and participation, and songs of this thesis, so too has hope. As Massumi states, affective hope is 'where we might be able to go and what we might be able to do' (Massumi 2002: pp. 10-11). Thus, conceiving of folk singing as an affective practice not only brings the past into the present but allows a sense of possible futures. For just as taking one step after another is to walk away, so it is also to move towards.

Figure 25 Preston, J, 1990. *Cath on the Downs with Liz* [Photograph].

Conclusion

Part 2: 2022

Returning to develop my PhD into this book in 2022, I originally deleted the first conclusion. It felt too messy, too vague, not formal or academic enough to earn its place in a monograph published by Bloomsbury. I would have to start again, write something that wrapped up the work into a neat bow, and said 'look, here are my arguments'. Against this, of course, is the irony that however much you read about, theorize, and seek to write about affects, they can take you by surprise. It has been hard to immerse myself again in what was a difficult period of my life. I have found passages of my writing so raw that they make me flinch, as if I had typed at times with all the nerve endings on my fingers exposed. Much as long periods of time in the archive can disorientate, I found that I had to spend only small moments of my time back in the time of first writing the PhD and to firmly root myself in 2022. This has made the going slowly, but it has also made the book possible. It has been very tempting at times to simply shut the door on the past. However, it began to feel more and more important to keep the messiness of the first conclusion in, but to also write a second one, and to give the conclusion 'another beginning despite already happening' (Clark 2013: p. 378). In this second conclusion, I am not aiming to smooth out the edges of the first, but I am seeking to communicate some of the resonance of this work that may be seen with a bit of space and distance.

I have made tentative steps to demonstrating the importance of organizations who safeguard and promote folk traditions to remain responsive and engaged with current incarnations of intangible cultural heritage, and the evolving setting, peoples, cultures, and landscaping practices that inform it. As Taylor argues in her volume *The Archive and the Repertoire: Performing Cultural Memory in the Americas* (2003):

> It is urgent to focus on the specific characteristics of performance in a cultural environment in which corporations promote 'world' music and international

organizations (such as UNESCO) and funding organizations make decisions about 'world' cultural rights and 'intangible heritage'.

(Taylor 2003: pp. 2–3)

I believe that affect is a crucial element of people's unique experience of local landscapes and cultural environment, and it is vital to understand songs not only as texts but as continuous, continuing performances. Phrases like 'it makes me think of Sussex', or 'I love the way it feels', or 'the song haunted me' aren't irrelevant or frivolous to performance traditions, they are articulations of why people learn songs, why people sing songs, why people teach other people songs; why we are still singing those songs; in short, feelings of, about and from, songs are why we have an archive or a repertoire in the first place.

In his book *England's Folk Revival and the Problem of Identity in Traditional Music*, Joseph Williams, in reference to UNESCO's claim that intangible cultural heritage 'provides [communities, groups and, in some cases, individuals] with a sense of identity and continuity', argues that it is 'impossible to say what does or does not provide any individual with a sense of identity – or a sense of anything else, for that matter' (Williams 2022: p. 133). However, I would argue that the methodologies in this book demonstrate that it is possible to pay attention to how people articulate the role of intangible cultural heritage in their identities, and moreover, that it is important to do so.

However, I also recognize the issues of asserting any form of cultural identity that excludes in its practice, and as Williams states 'many ethnomusicologists have pointed towards the problematic outcomes that can ensue when well-intentioned efforts to promote music traditions emphasize their expression of cultural identities as a core value' (Williams 2022: p. 2). The challenge as I see it is to develop modes of celebrating traditional song and intangible cultural heritage that are inclusive and flexible. Thus, in efforts to promote and preserve contemporary folk music, it is also important to be responsive to the issues with intangible cultural heritage that Williams identifies:

> All too often, particularly in contexts involving the revival or the safeguarding of a musical tradition that is perceived as being threatened with extinction, a selected historical form of a given music is taken to represent what is ideal or essential about that particular musical tradition, and contemporary deviations from this privileged historical standard are curtailed or dismissed as 'corruptions'.
>
> (Williams 2022: p. 199)

It is my hope that in this book by encouraging any song within the 'folk style', whether traditional or composed, I took some steps towards mitigating the dangers of purism. Nonetheless, as I identified in my conclusion, there was space for considerably more attention to be paid to diversity and inclusion within my initial project for Public Archaeology 2015, and to bring in voices and traditions which represent a multicultural context. Much of this learning has influenced both practices in conferences, and teaching, and will go on to influence any further research that I do in this field. Following Catherine Grant's suggestion that the history of music is filled with instances of traditions 'blossoming and dying away' (Grant 2012: p. 35), one of the suggestions that emerges from this book is that we study traditions as they arrive in the here and now, *the affective moment*, rather than seeking to fix an ideal or promote an artificial revival, whilst also seeking to open up that affective now to be fully inclusive. Similarly, with ongoing and vital conversations about decolonization and scholarship, it is important to be clear that within the study both folk songs and the landscape are analysed through majority Western British scholarship, and both mean different things in other contexts and cultures and have their own rich academic traditions and meanings. The scope of this book does not engage directly with them, but I hope it joins a wider conversation and sets up future pathways for the research begun here to develop a more global focus.

One example of good practice to be found in this area in the ICH in Scotland initiative. As Alison McCleery and Jared Bowers explore in their chapter 'Documenting and Safeguarding Intangible Cultural Heritage: The Experience in Scotland', although the Scottish government is 'unable to ratify the 2003 Convention, due to the fact that UN conventions and charters constitute a foreign affairs matter reserved to the UK Government, which to date is not a signatory [. . .] nevertheless in Scotland (as in Wales) there is a willingness to adhere to best practice in the matter of safeguarding' (McCleery, Bowers 2016: pp. 185–6). This is exemplified in the ICH in Scotland initiative, which was developed in 2008 by the ENrich (Edinburgh Napier University Research in Cultural Heritage) project team. One of the aims of the ICH, as explored by McCleery and Bowers, was to 'stress the inclusivity of living culture within Scotland, seeing it as defined by national borders rather than by ethnicity or language' (McCleery, Bowers 2016: pp. 185–6). However, practices that originate outside of Scotland's border are also celebrated and included stressing that 'there should be no discrimination based upon the apparent point of origin of a practice, nor should there be discrimination because of different levels of

impact of or participation in activities' (McCleery, Bowers 2016: pp. 185–6). Thus, as McCleery and Bowers argue, the 'defining characteristic was a focus on inclusivity, on ICH in Scotland, and an awareness that ICH as living culture evolves over time [. . .] allowing for the incorporation of as diverse as possible a range of ICH practices and knowledges' (McCleery, Bowers 2016: pp. 185–6). All of which demonstrates productive future pathways for the preservation and performance of intangible cultural heritage in an English context.

Current initiatives at the EFDSS also demonstrate good practice in diversity and inclusivity in folk preservation and celebration, including Folk Education Network Development Days, which focus on 'diversifying folk education in relation to disability, decolonisation [. . .] and diversifying speakers and presenters' (EFDSS 2022); their Inclusive Folk Programme, which improves 'access to folk music and dance education for people with Special Educational Needs and Disabilities – and creat[es] learning resources for educators working in SEND settings' (EFDSS 2022); engaging in the decolonization in relation to their library and archives; showcasing a diverse range of artists through programming partnerships with Queer Folk and Thank Folk for Feminism, and supporting their associate company Folk Dance Remixed, 'a multi-cultural dance and music company presenting vibrant performances that mix folk and hip-hop' (EFDSS 2022). In these and other initiatives, the EFDSS are leading the way in opening up historical English folk traditions and bringing them into conversation with other English folk traditions, and new settings, cultures and contexts. Many of the current programmes at EFDSS will be also faced by significant challenges resulting from a reduction of 32 per cent of the funding from the Arts Council England in April 2023 (EFDSS 2022). However, there is still much space for these practices to influence smaller regional charities and initiatives that promote folk traditions, as well as grassroots settings such as folk clubs. This demonstrates the need for further engagement with, and training of, folk/heritage organizations, folk clubs, and folk club hosts around the country, whether through EFDSS or other channels.

In addition to contemporary folk practices, researching folk singing from a performance studies perspective has also enabled key insights into historical practices. When I first began to read folk song scholarship, whilst enormously helpful and interesting, it felt a bit 'dusty' to me, and divorced from the spaces, places, and people I knew where these – and other songs – were still sung and loved. It is my hope that by experimenting with different methodological and creative and critical registers, that book carries something of the affective

practice I and my conversational partners have experienced, and some of the affective knowledge of imagining-in-practice.

The weaving together of stories of the self, my broken body, emotionally significant people and archival subjects, the foremost being me, my mum, and folk song collector Dorothy Marshall, allowed for insights into recovery, becoming, and legacy. The action of carrying around copies of the archival material contributed to a sense of the affective processes involved in archival research; I also became aware that I was carrying stories with me. As I walked through the villages that the singers had lived in, names on the bottom of manuscripts began to gain colour and contours. I could see patterns of pain and perseverance in women like Charlotte Smith and Dorothy Marshall. As well as stories of female singers literally in the margins, Mrs Sarah Humphrey singing *Young Jockey*, and verse 5 of *Cold Blows the Wind* being Jimmy Brown's mother. It is in the detailed work that we may be able to find the gaps in the histories of folk song collecting and to take care of archives and materials as acts of feminist research: 'how we are touched by things; how we touch things. I think of feminism as a fragile archive, a body assembled from shattering, from splattering, an archive whose fragility gives us responsibility: to take care' (Ahmed 2017: p. 17). In taking care of smaller stories it is also possible to provide nuance to larger narratives. In *The Folk: Music, Modernity, and the Political Imagination*, Ross Cole argues in relation to the first folk song revival that 'what concerned collectors at the time was neither the lived experience nor the social worlds of these singers, but rather the songs themselves' (Cole 2021: p. 50). However, time spent with Dorothy's archives refutes such a universalizing statement and demonstrates a collector with an interest in the singers and their social worlds, and, at times, a sharing in these worlds. At the Women in the Folk conference, similarly smaller narratives also emerged, indicating space both for a greater attention to amateur and female collectors from the first folk song revival, and for the insights such attention might provide. Thus ends another conclusion of some sorts. Although, of course, it is just the beginning.

We have work to do.

Bibliography

Abram, D. (1997). *The Spell of the Sensuous*. London: Knopf Doubleday Publishing Group.
Access Folk (2022). *About*. Available at: https://accessfolk.sites.sheffield.ac.uk/home [Accessed 9 July 2023].
Adams, T. E., Ellis, C., Holman Jones, S. (2014). *Autoethnography: Understanding Qualitative Research*. New York: Oxford University Press.
Adams, T. E., Ellis, C., Bochner, A. P. (2021). 'Autoethnography: An Overview' in *Historical Social Research*, 2nd edn, pp. 273–90, vol 1, (138).
Åhäll, L. (2018). 'Affect as Methodology: Feminism and the Politics of Emotion' in *International Political Sociology*, pp. 36–52, vol 12, (1).
Ahmed, S. (2004). *The Cultural Politics of Emotion*. Edinburgh: Edinburgh University Press.
Ahmed, S. (2007). 'A Phenomenology of Whiteness' in *Feminist Theory*, pp. 149–68, vol 8, (2).
Ahmed, S. (2010). 'Happy Objects' in Gregg, M. and Seigworth, G. J. (eds), *The Affect Theory Reader*. Durham, NC: Duke University Press, pp. 29–51.
Ahmed, S. (2017). *Living a Feminist Life*. Durham, NC: Duke University Press.
Allain, P., Harvie, J. (2014). *The Routledge Companion to Theatre and Performance*. Oxon: Routledge.
Allen, D. J. (1995). *Sussex*. Oxford: Shire Publications.
Allsopp, R., Kreider, K. (2015). 'To Step, Leap, Fly: On Poetics and Performance' in *Performance Research*, pp. 1–3, vol 20, (1).
Anderson, B. (2009). 'Affective Atmospheres' in *Emotion, Space and Society*, pp. 77–81, vol 2, (2).
Anderson, B. (2014). *Encountering Affect: Capacities, Apparatus, Conditions*. Oxon: Routledge.
Anderson, J. (2014). 'Talking Whilst Walking: A Geographical Archaeology of Knowledge' in *AREA*, pp. 254–61, vol 36, (3).
Andrews, C. (1979). *The Shepherd of the Downs*. Worthing: Worthing Museum.
Anon (1906). *Cold Blows the Wind* (RVW2/3/156) London: Full English Digital Archive, Vaughan Williams Memorial Library, Cecil Sharp House. [Electronic Manuscript].
Apperson, G. L. (2006). *The Wordsworth Dictionary of Proverbs*. Ware: Wordsworth Editions.
Aragay, M., Delgado-Garcia, C., Middeke, M. (2021). *Affects in 21st-Century British Theatre: Exploring Feeling on Page and Stage*. Basingstoke: Palgrave MacMillan.

Ash, J., & Simpson, P. (2016). 'Geography and post-phenomenology' in *Progress in Human Geography*, vol 40, (1),pp. 48–66.

Atkinson, D. (2014). *The Anglo-Scottish Ballad and Its Imaginary Contexts*. Cambridge: Open Book Publishers.

AWARE (2022). *About*. Available at: https://awarewomenartists.com/en/ [Accessed 9 July 2023].

Baker, Mr (1906). *Blackberry Fold* (RVW2/3/153) London: Full English Digital Archive, Vaughan Williams Memorial Library, Cecil Sharp House. [Electronic Manuscript].

Baker, Mr (1906). *Young Collins* (RVW2/3/152) London: Full English Digital Archive, Vaughan Williams Memorial Library, Cecil Sharp House. [Electronic Manuscript].

Ball, F. C. *Shirley Collins Interview*. Available at: http://www.furious.com/perfect/shirleycollins.html [Accessed 4 September 2022].

Bate, J. (2011). *The Song of the Earth*. Harvard: Harvard University Press.

Belloc, H. (1920). *The South Country*. Edinburgh: Handball and Spiers.

Bennett, B. (1917). *Private Papers of Miss B Bennett*. IPWM (2762) [Diary].

Bennett, C. (2015). Interviewer: Elizabeth Bennett. Lancing, Sussex. 29th April. [Interview].

Bennett, C. M. G. (2015). Interviewer: Elizabeth Bennett. Worthing, Sussex. 25th April. [Interview].

Bennett, E. (2015). *Public Archaeology 2015*. [Online] Public Archaeology 2015. Available at: https://publicarchaeology2015.wordpress.com/ [Accessed 4 September 2022].

Bennett, P., Bennett, R. (2015). Interviewer: Elizabeth Bennett. Rustington, Sussex. 7th May. [Interview].

Berger, J. (1982). *Another Way of Telling: A Possible Theory of Photography*. London: Bloomsbury.

Biddle, I., Thompson, M. (2013). *Sound, Music, Affect: Theorizing Sonic Experience*. London: Bloomsbury.

Bishop, J., Roud, S. (2012). *The New Penguin Book of English Folk Songs*. London: Penguin.

Blackman, L. (2015). 'Researching Affect and Embodied Hauntologies: Exploring an Analytics of Experimentation' in Knudsen, T. and Stage, C. (eds), *Affective Methodologies: Developing Strategies for Cultural Research*. Basingstoke: Palgrave, pp. 25–44.

Blackmann, L., Venn, C. (2010). 'Affect' in *Body and Society*, pp. 7–28, vol 16, (1).

Bochner, A., Ellis, C. (2016). *Evocative Autoethnography: Writing Lives and Telling Stories*. Oxen: Routledge.

Boniface, H. (1909). *The Unquiet Grave* (GG/1/21/1390). London: Full English Digital Archive, Vaughan Williams Memorial Library. [Electronic Manuscript].

Borggreen, G., Gade, R. (2013). *Performing Archives/Archives of Performance*. Copenhagen: Museum Tusculanum Press.

Brennan, T. (2014). *The Transmission of Affect*. Ithaca, NY: Cornell University Press.

Broadwood, L. (1905). 'On the Collecting of English Folk-Song' in *Proceedings of the Musical Association, 31st Sess,* pp. 89–109.
Brown, J., Brown, Mrs. P. G. (1911). *How Cold, How Cold The Wind Do Blow [The Unquiet Grave]*. (CC/1/33). London: Full English Digital Archive. Vaughan Williams Memorial Library, Cecil Sharp House. [Electronic Manuscript].
Bulbeck, T. (1909). *Lady Maisry* (GG/1/21/1379). London: Full English Digital Archive, Vaughan Williams Memorial Library. [Electronic Manuscript].
Burberry, J. (1892). *The Seasons of the Year*. (S1605555). London: Full English Digital Archive, Vaughan Williams Memorial Library. [Electronic Manuscript].
Butler, J. (2004). *Undoing Gender*. Oxon: Psychology Press.
Butler, T. (2007). 'Memoryscape: How Audio Walks Can Deepen Our Sense of Place by Integrating Art, Oral History and Cultural Geography' in *Geography Compass*, pp. 360–72, vol 1 (3).
Butler, T. (2008). 'Memoryscape: Integrating Oral History, Memory and Landscape on the River Thames' in Ashton, P. and Kean, H. (eds), *People and Their Pasts: Public History Today*. Basingstoke: Palgrave, pp. 223–239.
Bygrave, S. (1996). *Romantic Writings*. London: Routledge.
Campbell, J. (1997). 'Inside Lives / The Quality of Biography' in Sherman, R. and Webb, R.(eds), *Quality Research in Education: Focus and Methods*. Oxon: Routledge.
Cansfield, D. (2017). Email to Elizabeth Bennett, 15th of June.
Cantrell, J., Stone, A. (2015). *Out of the Closet, into the Archives: Researching Sexual Histories*. New York: SUNY Press.
Carthy, E. (2022). 'Interview' in *The Guardian* [online]. Available at: https://www.theguardian.com/music/2022/oct/03/eliza-carthy-folk-music-sexy-filthy-covid [Accessed 8 July 2023].
Chapman, B. (1987). *Weathervanes of Sussex*. Market Harborough: Book Guild.
Clark, P. (2013). 'Performing the Archive: The Future of the Past' in Borggreen, G. and Gade, R. (eds), *Performing Archives/Archives of Performance*. Copenhagen: Museum Tusculanum Press, pp. 363–85.
Claudel, P. (1951). 'Ma sœur Camille' ('My Sister Camille') in *Camille Claudel*, Paris, Rodin Museum.
Clifton, T. (1983). *Music as Heard: A Study in Applied Phenomenology*. New Haven: Yale University Press.
Cole, R. (2021). *The Folk: Music, Modernity, and the Political Imagination*. Oakland, CA: University of California Press.
Collins, S. (2016). *Private Passions*. Radio 3. 16th January 2016. 12pm. [Radio].
Colls, R. (2012). 'Feminism, Bodily Difference, and Non-representational Geographies' in *Transactions of the Institute of British Geographers*, pp. 430–45, vol 37, (3).
Comte-Sponville, A. (2011). *Dictionnaire Philosophique*. Paris: P.U.F.
Cook, L. (1954/1955). *The Lark in the Morning*. London: Full English Digital Archive, Vaughan Williams Memorial Library, Cecil Sharp House. Available at: http://www

.vwml.org/search?qtext=lily%20cook%20sussex&ts=1441197932383# [Accessed 4 September 2022].

Cooke, R. (2014). 'Peggy Angus was a Warrior. Women Weren't Supposed to be Like that' in *The Guardian* [Online]. Available at: http://www.theguardian.com/artanddesign/2014/jul/06/peggy-angus-warrior-painter-designer-tiles-wallpaper. [Accessed 4 Sep. 2022].

Cooper, B. (2015). 'Intersectionality' in Disch, L. and Hawkesworth, M. (eds), *The Oxford Handbook of Feminist Theory*. Oxford: Oxford University Press, pp. 385–406.

Copper, B. (1973). *Songs and Southern Breezes: Country Folk and Country Ways*. London: William Heinemann Ltd.

Copper, B. (1988). *Early to Rise: A Sussex Boyhood*. London: Javelin.

Copper, B. (1995). *Across Sussex with Belloc: In the Footsteps of 'The Four Men'*. Stroud: Allan Sutton.

Crenshaw, K. (1991). 'Mapping the Margins: Intersectionality, Identity Politics, and Violence against Women of Color' in *Stanford Law Review*, pp. 1241–1299, vol 43, (6).

Cresswell, T. (2004). *Place: A Short Introduction*. Chichester: Wiley Blackwell.

Cresswell, T. (2012). *Geographical Thought: A Critical Introduction*. Chichester: Wiley Blackwell.

Damasio, A. (2003). *Looking for Spinoza: Joy, Sorrow, and the Feeling Brain*. New York: Harcourt.

Danbolt, M. (2013). 'The Trouble with Straight Time' in Borggreen, G. Gade, R. (eds), *Performing Archives/Archives of Performance*. Copenhagen: Museum Tusculanum Press, pp. 448–64.

Dearling, Mr (1907). *Barbara Allen* (GB/7a/39). London: Full English Digital Archive, Vaughan Williams Memorial Library. [Electronic Manuscript].

Denzin, N. K. (2014). *Interpretive Autoethnography*. London: Sage.

de Leeuw, S. (2012). 'Alice Through the Looking Glass: Emotion, Personal Connection, and Reading Colonial Archives Along the Grain' in *Journal of Historical Geography*, pp. 449–58, vol 38, (3).

Deleuze, G. (1978). *Seminar Given on Spinoza*. January 24th 1978. Available at: https://www.webdeleuze.com/textes/14. [Accessed 18th Nov 2022].

Deleuze, G., Guattari, F. (1991). *What is Philosophy?* Translated by Tomlinson, H. and Burchell III, G. New York: Columbia University Press.

Deleuze, G., Guattari, F. (2004). *A Thousand Plateaus*. London: Bloomsbury.

Denzin, N. K. (2003). *Performance Ethnography: Critical Pedagogy and the Politics of Culture*. London: Sage.

Denzin, N. K. (2006). 'Pedagogy, Performance, and Autoethnography' in *Text and Performance Quarterly*, pp. 333–8, vol 26, (4).

de Val, D. (2013). *In Search of Song: The Life and Times of Lucy Broadwood*. Fareham: Ashgate.

de Vignemont, F., Singer, T. (2006). 'The Empathic Brain: How, When and Why?' in *Trends in Cognitive Sciences*, pp. 435–41, vol 10.

Dewey, J. (1936). *Reconstruction in Philosophy*. London: Roche Press.

Dixon, J. (2015). *Public Archaeology 2015*. Available at: https://publicarchaeology2015.wordpress.com/. [Accessed 10 September 2022].

'Dorothy Marshall' (1916). West Sussex Record Office; Brighton, England; Sussex Parish Registers; Reference: Par 110/1/5/2.

Duke, W. (2015). Interviewer: Elizabeth Bennett. Barcombe, Sussex. 25th April. [Interview].

Dunn, G. (1980). *The Fellowship of Song: Popular Singing Traditions in East Suffolk*. London: Croom Helm.

Durham, M. E. (1891). *Bee Worsel* (CJS2/9/77). London: Full English Digital Archive, Vaughan Williams Memorial Library. [Electronic Manuscript].

Dyer, R. (2005). 'The Matter of Whiteness' in Rothernberg, P. (ed.), *White Privilege: Essential Readings on the Other Side of Racism*. New York: Worth Publishers, pp. 9–14.

EFDSS (2021). *Diversity in Folk*. Available at: https://www.efdss.org/about-us/what-we-do/news/10357-call-for-papers-diversity-in-folk [Accessed 9 July 2023].

EFDSS (2022). *Past Projects*. Available at: https://www.efdss.org/about-us/our-history/past-projects [Accessed 22 September 2022].

EFDSS (2022). Email to Mailing List, 10th November.

Ellis, C. (1997). 'Evocative Autoethnography: Writing Emotionally about Our Lives' in Tierney, W. G. and Lincoln Y. S. (eds), *Representation and the Text: Re-framing the Narrative Voice*. New York: SUNY Press. pp. 116–139.

Ellis, C. (1999). 'Heartful Autoethnography' in *Qualitative Health Research*, pp. 683–9, vol 9, (5).

Ellis, C. (2004). *The Ethnographic I: A Methodological Novel about Autoethnography*. Walnut Creek: Alta Mira Press.

Ellsworth, E. (2005). *Places of Learning: Media, Architecture, Pedagogy*. Oxon: Routledge.

Endometriosis UK (2022). *Endometriosis – Is it a Disability?* Available at: https://www.endometriosis-uk.org/endometriosis-it-disability [Accessed 8 July 2023].

Esperance (2020). *About*. Available at: https://www.esperancefolk.com/ [Accessed 26 April 2023].

Ettorre, E. (2017). *Autoethnography as feminist method: Sensitising the feminist "I."* London. England: Routledge.

Family Tree Designs (2015). *Hoare Family* [online]. Available at: http://www.familytreedesigns.co.uk/Angmering/Houghton%201891.html [Accessed 4 September 2022].

Farjeon, A. (1986). *Morning has Broken: A Biography of Eleanor Farjeon*. London: Julia MacRae Publishing.

Farjeon, E. (2013). *Martin Pippin in the Apple Orchard*. London: Random House.

Farjeon, E. (2017). *A Sussex Alphabet*. Sussex: Snake River Press.

Fenner, S. (2018). 'Not So Scary: Using and Defusing Content Warnings in the Classroom' in *The Journal of Political Science Education*, pp. 86–96, vol 14, (1).

Fetherstone, M. (2010). 'Body, Image and Affect in Consumer Culture' in *Body & Society*, pp. 193–22, vol 16, (1).
Folk East (2022). *Imagined Village*. Available at: https://folkeast.co.uk/the-imagined-village/ [Accessed 9 July 2023].
Ford, A. (1906–1907). *Mother, Mother, Make My Bed* (AGG/8/48) London: Full English Digital Archive, Vaughan Williams Memorial Library. [Electronic Manuscript].
Ford, A. (1906/7). *AGG/8/48*. London: Full English Digital Archive, Vaughan Williams Memorial Library. [Electronic Manuscript].
Fox, J. (2015). *Mourning Stone*. Available at: https://www.falmouth.ac.uk/whereto/jane-fox [Accessed 10 January 2022].
Frampton, G. E. (1986). 'Clive Carey, Dorothy Marshall and the West Sussex Tradition' in *English Dance and Song*, vol, 48, (3).
'Frances Hutt' (1911). *Census Returns of England and Wales, 1911*. Kew, Surrey, England: The National Archives. Available at www.ancestry.co.uk [Accessed 8 October 2022].
Fraser, A. (2011). *The Weaker Vessel: Women's Lot in Seventeenth-Century England*. London: Orion.
Frazier, C. (1997). *Cold Mountain*. New York: Grove/Atlantic.
Freshwater, H. (2003). 'The Allure of the Archive' in *Poetics Today*, pp. 729–758, vol 24, (4).
Gammon, V. (1980). 'Folk Song Collecting in Sussex and Surrey, 1843–1914' in *History Workshop* pp. 61–89, vol 10, (1).
Geurts K. L. (2003). *Culture and the Senses: Bodily Ways of Knowing in an African Community*. Berkeley, CA: University of California Press.
Goddard, S. (2015). Interviewer: Elizabeth Bennett. East Chiltington, Sussex. 27th April.
Grant, A., Short, N., Turner, L. (2013). *Contemporary British Autoethnography*. Boston: Sense Publishers.
Grant, C. (2012). 'Rethinking Safeguarding: Objections and Responses to Protecting and Promoting Endangered Musical Heritage' in *Ethnomusicology Forum*, pp. 31–51, vol 21, (1).
Green, S. E., Loseke, D. R. (2020). *New Narratives of Disability: Constructions, Clashes, and Controversies*. Bingley: Emerald Publishing.
Gregg, M., Seigworth, G. J. (2010). *The Affect Theory Reader*. Durham, NC: Duke University Press.
Gregory, E. D. (2008). 'Before the Folk-Song Society: Lucy Broadwood and English Folk Song, 1884–97' in *Folk Music Journal*, pp. 372–414, vol 9, (3)
Gregory, E. D. (2010). *The Late Victorian Folksong Revival: The Persistence of English Melody, 1878–1903*. Lanham, MD: Scarecrow.
Grosz, E. (1994). *Volatile Bodies: Towards a Corporeal Feminism*. Bloomington: Indian University Press.
'Harvey Humphrey' (1891). *Original Data: Census Returns of England and Wales, 1891*. Kew, Surrey, England: The National Archives. Available at www.ancestry.co.uk [Accessed 8 October 2022].

'Harvey Humphrey' (1901). *Census Returns of England and Wales, 1901*. Kew, Surrey, England: The National Archives. Available at www.ancestry.co.uk [Accessed 8 October 2022].

'Harvey Humphrey' (1911). *Census Returns of England and Wales, 1911*. Kew, Surrey, England: The National Archives. Available at www.ancestry.co.uk [Accessed 8 October 2022].

Heddon, D. (2002). 'Performing the Archive: Following in the Footsteps' in *Performance Research*, pp. 64–77, vol 7, (4).

Heddon, D. (2002). 'Autotopography: Graffiti, Landscapes and Selves' in *Reconstruction: Studies in Contemporary Culture*, vol 2, (3).

Heddon, D. (2008). *Autobiography and Performance*. Basingstoke: Palgrave Macmillan.

Heddon, D. (2012). 'Turning 40: 40 Turns: Walking and Friendship' in *Performance Research*, pp. 67–75, vol 17, (2).

Herbert, D. (2011). *Raggle Taggle Gypsies - Peggy Angus - Part 3* [Youtube Video]. Available at: https://www.youtube.com/watch?v=AjUg13yTSqQ [Accessed 4 Septemebr 2015].

Hield, F. (2013). 'Negotiating participation in an English Singing Session' in Russell, I. and Ingram, C. (eds), *Taking Part in Music: Case Studies in Ethnomusicology*. Aberdeen: Aberdeen University Press.

Hield, F., Mansfield, P. (2019). 'Anything Goes? Recognising Norms, Leadership and Moderating Behaviours at Folk Clubs in England' in *Ethnomusicology Forum*, pp. 338–61, vol 28, (3).

Higgins, S. (2015). Email to Elizabeth Bennett, 1st May.

Highmore, B. (2010). 'Bitter After Taste' in Gregg, M. Seigworth, G. J. (eds), *The Affect Theory Reader*. Durham, NC: Duke University Press, pp. 118–137.

Hill Collins, P., Birge, S. (2000). *Intersectionality*. Malden: Polity Press.

Hills, L., Fuller, M. (2012). *You Never Heard So Sweet*. Uppingham: Topic Records. [C.D].

Historic England (2022). *The Russian Memorial*. Available at: https://historicengland.org.uk/listing/the-list/list-entry/1043887. [Accessed 18 November 2022].

Hoare, J. (1901). *Pretty Ploughboy and Various* (LEB/2/29/9) London: Full English Digital Archive, Vaughan Williams Memorial Library. [Electronic Manuscript].

Holman Jones, S. (2005). 'Autoethnography: Making the Personal Political' in Denzin, N. K. and Lincoln, Y. S. (eds), *The Sage Handbook of Qualitative Research*. London: Sage, pp. 763–91.

Holman Jones, S. (2013). 'Autoethnography: Making the Personal Politics' in Denzin, N. K. Lincoln, Y. S. (eds), *The Sage Book of Qualitative Research*. Thousand Oaks, CA: Sage, pp. 763–92.

Holman Jones, S., Adam, T. E., Ellis, C. (2022). *Handbook of Autoethnography*. Oxon: Routledge.

Hopkins, G. M. (1877). *The Sea and the Skylark*. [Poem].

Hopper, J. (2015). *By The Mark on his Hand*. Available at: http://www.justin-hopper.com/by-the-mark-on-his-hand/. [Accessed 13 July 2022].

Hoskins, W. G. (1985 [1954]). *The Making of the English Landscape*. London: Penguin.
Howard, P., Thompson, I., Waterton, E. (2013). *The Routledge Companion to Landscape Studies*. Oxon: Routledge.
Humphrey, Mrs (1912). *Young Jockey* (CC/1/291). London: Full English Digital Archive, Vaughan Williams Memorial Library. [Electronic Manuscript].
Hurley, E. (2010). *Theatre and Feeling*. London: Macmillan Education UK.
Hutt, F. (1911). *A Farmer There Lived in the North Country* (CC/1/339). London: Full English Digital Archive, Vaughan Williams Memorial Library. [Electronic Manuscript].
Hutt, F. (2022). *War Memorial*. Available at: http://www.roll-ofhonour.com/Sussex/SouthHarting.html [Accessed 10 September 2022].
Ingold, T. (2000). *The Perception of the Environment: Essays on Livelihood, Dwelling and Skill*. London: Routledge.
Ingold, T. (2010). 'Footprints through the Weather-World: Walking, Breathing, Knowing' in *The Journal of the Royal Anthropological Institute*, pp. 121–39, vol 16.
Ingold, T. (2011). 'The Eye of the Storm: Visual Perception and the Weather' in *Visual Studies*, pp. 97–104, vol 20, (2).
Ingold, T. (2016). *Lines: A Brief History*. Oxon: Routledge.
Ingold, T., Hallam, E. (2007). *Creativity and Cultural Improvisation*. Oxon: Routledge.
Ingold, T., Vergunst, J. (2008). *Ways of Walking: Ethnography and Practice on Foot*. Farnham: Ashgate.
Jackson, J. B. (1984). *Discovering the Vernacular Landscape*. New Haven, CT: Yale University Press.
Jackson, J. B. (1997 [1960]). *Landscape in Sight: Looking at America*. New Haven, CT: Yale University Press.
John, S. (1901). *The Silvery Tide* (LEB/2/29/5). London: Full English Digital Archive, Vaughan Williams Memorial Library. [Electronic Manuscript].
Jolly, M. (2011). 'Life Writing and Intimate Publics' in *Biography*, pp. v–xi, vol 34, (1).
Jones, A. (2013). 'Unpredictable Temporalities: The Body and Performance in (Art) History' in Borggreen, G. and Gade, R. (eds), *Performing Archives/Archives of Performance*. Copenhagen: Museum Tusculanum Press, pp. 52–72.
Jones, C. E. (2016). 'The Pain of Endo Existence: Toward a Feminist Disability Studies Reading of Endometriosis' in *Hypatia*, pp. 554–71, vol 31, (3).
Jones, O., Fairclough, L. (2016). 'Sounding Grief: The Severn Estuary as an Emotional Soundscape' in *Emotion, Space and Society*, pp. 98–110, vol 20.
Kadar, M. (1992). *Essay on Life-Writing: From Genre to Critical Practice*. Toronto: Toronto Press.
Kipling, R. (1902). *Sussex*. [Poem].
Knudsen, T., Stage, C. (2015). *Affective Methodologies: Developing Cultural Research*. Basingstoke: Palgrave.
Korczynski, M., Pickering, M., Robertson, M. (2013). *Rhythms of Labour: Music at Work in Britain*. Cambridge: Cambridge University Press

Labbe, J. (2007). *Charlotte Turner Smith*. Available at: http://www.bignorpark.co.uk/index.php/about/charlotte-smith [Accessed 10 September 2022].

Land Army, London Rally (1918). *The Observer*. 21 April. [Newspaper Archive].

Land Army Song (1917). Available at: http://www.womenslandarmy.co.uk/ww1-womens-land-army-songs/. [Accessed 10 September 2022].

Lavender, A. (2016). *Performance in the Twenty-First Century: Theatres of Engagement*. Oxon: Routledge.

Lee, H. (2005). *Body Parts: Essays on Life-Writing*. London: Chatto and Windus.

Lee, J. (2004). 'Culture from the Ground: Walking, Movement and Placemaking', paper at *Association of Social Anthropologist Conference*, Durham, NC.

Lea, J. J. (2009). 'Post-phenomenology/Post-phenomenological Geographies' in Kitchin, R. and Thrift, N. (eds.), *International Encyclopaedia of Human Geography*. Elsevier, Oxford, pp. 373–8.

Lewis, B. (2015), Interviewer: Elizabeth Bennett. Saltdean, Sussex. 20th April. [Interview].

Lock, G., Ralston, I. (2017). Atlas of Hillforts of Britain and Ireland. Available at https://hillforts.arch.ox.ac.uk/records/EN3748.html. [Accessed 13 November 2022].

Lorimer, H. (2003). 'Telling Small Stories: Spaces of Knowledge and the Practice of Geography' in *Transactions of the Institute of British Geographers*, pp 197–217, vol 28, (2).

Lorimer, H. (2005). 'Cultural geography: the busyness of being `more-than-representational", in *Progress in Human Geography*, vol 29, (1), pp. 83–94.

Lorimer, H. (2006). 'Herding Memories of Humans and Animals' in *Environment and Planning D: Society and Space*, pp. 497–518, vol 24.

Lorimer, H. (2014a). 'Homeland' in *Cultural Geographies*, pp. 583–604, vol 21, (4).

Lorimer, H. (2014b). 'Excursions: Telling Stories and Journeys' in *Cultural Geographies*, pp. 543–7, vol 21, (4).

Lorimer, H. (2015). 'Standards of Beauty: Considering the Lives of W.A. Poucher' in *Geohumanities*, pp. 51–79, vol 1, (1).

Lorimer, H., Daniels, S. (2012). 'Until the End of Days: Narrating Landscape and Environment' in *Cultural Geographies*, pp. 3–9, vol 1, (19).

Lorimer, H., Wylie, J. (2010). 'Loop (A Geography)' in *Performance Research*, pp. 4–11, vol 4, (10).

Lower, A. (1870). *Compendious History of Sussex*. Available at: https://archive.org/details/acompendioushis08lowegoog [Accessed 10 September 2022].

MacFarlane, R. (2012). *The Old Ways: A Journey on Foot*. London: Penguin.

MacFarlane, R. (2015). *Landmarks*. London: Penguin.

Mackinlay, E. (2022). *Writing Feminist Autoethnography: In Love With Theory, Words, and the Language of Women Writers*. Oxen: Routledge.

Mainlynorfolk.info, (2015). *The Brisk Lad / The Sheepstealer / All I Have Is My Own (Roud 1667)* [Online]. Available at: https://mainlynorfolk.info/watersons/songs/thebrisklad.html [Accessed 4 Sep. 2015].

Mainlynorfolk.info (2015). *The Wife of Usher's Well* (Roud 196; Child 79) [Online]. Available at: https://mainlynorfolk.info/steeleye.span/songs/thewifeofusherswell.html [Accessed 4 September 2012].
Marshall, D. (1911). *CC/1/161*. London: Full English Digital Archive, Vaughan Williams Memorial Library. [Electronic Manuscript].
Marshall, D. (1911). *CC/1/339*. London: Full English Digital Archive, Vaughan Williams Memorial Library. [Electronic Manuscript].
Marshall, D. (1911). *CC/2/131*. London: Full English Digital Archive, Vaughan Williams Memorial Library. [Electronic Manuscript].
Marshall, D. (1911). *CC/2/132*. London: Full English Digital Archive, Vaughan Williams Memorial Library. [Electronic Manuscript].
Marshall, D. (1911). *CC/2/139*. London: Full English Digital Archive, Vaughan Williams Memorial Library. [Electronic Manuscript].
Marshall, D. (1911). *CC/2/146*. London: Full English Digital Archive, Vaughan Williams Memorial Library. [Electronic Manuscript].
Marshall, D. (1911). *CC/2/147*. London: Full English Digital Archive, Vaughan Williams Memorial Library. [Electronic Manuscript].
Marshall, D. (1911). *CC/2/154*. London: Full English Digital Archive, Vaughan Williams Memorial Library. [Electronic Manuscript].
Marshall, D. (1911). *CC/2/157*. London: Full English Digital Archive, Vaughan Williams Memorial Library. [Electronic Manuscript].
Marshall, D. (1911). *CC/2/161*. London: Full English Digital Archive, Vaughan Williams Memorial Library. [Electronic Manuscript].
Marshall, D. (1911). *CC/2/164*. London: Full English Digital Archive, Vaughan Williams Memorial Library. [Electronic Manuscript].
Marshall, D. (1911). *CC/2/170*. London: Full English Digital Archive, Vaughan Williams Memorial Library. [Electronic Manuscript].
Marshall, D. (1911). *CC/2/178*. London: Full English Digital Archive, Vaughan Williams Memorial Library. [Electronic Manuscript].
Marshall, D. (1911). *CC/2/191*. London: Full English Digital Archive, Vaughan Williams Memorial Library. [Electronic Manuscript].
Marshall, D. (1912). *CC/2/53*. London: Full English Digital Archive, Vaughan Williams Memorial Library. [Electronic Manuscript].
Marshall, D. (1912). *CC/4/19*. London: Full English Digital Archive, Vaughan Williams Memorial Library. [Electronic Manuscript].
Marshall, D. (1915). *CC/2/192*. London: Full English Digital Archive, Vaughan Williams Memorial Library. [Electronic Manuscript].
Massumi, B. (2002). *Parables for the Virtual: Movement, Affect, Sensation*. Durham, NC: Duke University Press.
Matthews, B. (2001). *Just another Saturday Night*. Available at: https://www.mustrad.org.uk/articles/saturday.htm [Accessed 9 July].

Matthews, B. (2012). *George Townshend*. Available at: http://www.mustrad.org.uk/articles/townshe2.htm [Accessed 20 November 2022].

Maynard, G. (1960). *Ground for the Floor*. (S335003). London: Full English Digital Archive, Vaughan Williams Memorial Library, Cecil Sharp House. [Sound Recording].

McCleery, A., Bowers, J. (2016). 'Documenting and Safeguarding Intangible Cultural Heritage: The Experience in Scotland' in Stefano, M. L. and Davis, P. (eds), *The Routledge Companion to Intangible Cultural Heritage*. Oxen: Routledge, pp. 185–201.

McCormack, D. P. (2010). 'Thinking in Transition: The Affirmative Refrain of Experience/Experiment' in Anderson, B. and Harrison, P. (eds), *Taking Place: Non-representational Theories and Geography*. London: Ashgate, pp. 201–20.

Merleau-Ponty, M. (1979). *The Essential Writings of Merleau-Ponty*. New York: Harcourt, Brace and World.

Merleau-Ponty, M. (2002). *Phenomenology of Perception*. London: Routledge.

Miles, D. (1912). *Barbara Allen* (CC/1/314). London: Full English Digital Archive, Vaughan Williams Memorial Library. [Electronic Manuscript].

Miles, D. (1912). *A-Maying* (CC/1/319). London: Full English Digital Archive, Vaughan Williams Memorial Library. [Electronic Manuscript].

Mitchell, J. (2020). *Post War Politics, Society, and the Folk Revival in England, 1945–65*. New York: Bloomsbury.

Mock, R. (ed.). Heddon, D., Lavery, C., Smith, P. (2009). *Walking, Writing, and Performance: Autobiographical Texts by Deirdre Heddon, Carl Lavery and Phil Smith*. Bristol: Intellect.

Moore, G. (2015). Interviewer: Elizabeth Bennett. Worthing, Sussex. [Interview].

Moriarty, J. (2012). *Leaving the Blood in: Experiences with an Autoethnographic Doctoral Thesis*. Available at: http://arenaresearch.org/wpcontent/uploads/2013/08/chapterCBA2jan13-2.pdf [Accessed 10 September 2016].

Moriarty, J. (2013). 'Leaving the Blood in: Experiences with an Autoethnographic Doctoral Thesis' in Short, N. P., Turner, L., Grant, A. (eds), *Contemporary British Ethnography*. Boston: Sense Publishers, pp. 63–78.

Moriarty, J. (2014). *Analytical Autoethnodrama: Autobiographed and Researched Experiences with Academic Writing*. Rotterdam: Sense Publishers.

Morrish, J. (2010). *The Folk Handbook: Working with Songs from the English Tradition*. London: Backbeat Books.

Morrison, A. (2022a). Available at: https://www.theguardian.com/music/2022/oct/07/angeline-morrison-i-can-count-on-one-hand-the-times-ive-been-in-a-folk-club-with-other-people-of-colour [Accessed 9 July 2023].

Morrison, A. (2022b). *The Sorrow Songs: Folk Songs of Black British Experience*. [C.D].

Moseley, C. (1912). *Ground for the Floor* (CC/1/221). London: Full English Digital Archive, Vaughan Williams Memorial Library [Electronic Manuscript].

Moseley, Mrs (1912). *The Silver Tide* (CC/1/19). London: Full English Digital Archive, Vaughan Williams Memorial Library. [Electronic Manuscript].

Moseley, Mrs (1912). *Barbara Ellen* (CC/1/161). London: Full English Digital Archive, Vaughan Williams Memorial Library. [Electronic Manuscript].

'Betsy Moseley' (1901). *1911 Census of England*. Available at: http://www.1911census.co.uk [Accessed 6 June 2022].

'Betsy Moseley' (1901). *1901 Census of England*. Available at: http://www.1911census.co.uk [Accessed 6 June 2022].

Murray, N., Shepherd, N., Hall, H. (2007). *Desire Lines: Space, Memory and Identity in the Post-Apartheid City*. Oxon: Routledge.

Myers, M. (2008). 'Situations for Living: Performing Emplacement' in *Research in Drama Education: The Journal of Applied Theatre and Performance*, pp.171–80, vol 13, (2).

Myers, M. (2010). '"Walk with Me, Talk with me": The Art of Conversive Wayfinding' in *Visual Studies*, pp. 59–68, vol 25, (1).

Myers, M. (2011). 'Walking Again Lively: Towards an Ambulant and Conversive Methodology of Performance and Research' in *Mobilities*, pp.183–201, vol 6, (2).

Myers, M. Harris, D. (2004). 'Way from Home' in *Performance Research*, pp. 90–1, vol 2.

Nash, C. (1996). 'Reclaiming Vision: Looking at Landscape and the Body' in *Gender Place and Culture*, pp. 149–69, vol 3.

Nash, C. (2000). 'Performativity in Practice: Some Recent Work in Cultural Geography' in *Progress in Human Geography*, pp. 653–64, vol 24, (4).

National Archives (2015). *The Forge, Rodmell | The National Archives* [Online]. Available at: http://discovery.nationalarchives.gov.uk/details/rd/af19d2f4-5f8e-49bb-b194-6b13bc5cfcfe. [Accessed 4 September 2022].

National Archives (2022). 'The Forge, Rodmell' in *The National Archives*. Available at: https://discovery.nationalarchives.gov.uk/details/r/af19d2f4-5f8e-49bb-b194-6b13bc5cfcfe [Accessed 9 July 2023].

Nymann, J., Schuurman, N. (2016). *Affect, Space and Animals*. New York: Routledge.

Oliver, C. (2015). Interviewer: Elizabeth Bennett. Rodmell, Sussex. 24th April.

Parksandgardens.org, (2015). *Ladyholt Park*. Available at: http://www.parksandgardens.org/places-and-people/site/5265/history [Accessed 4 Sep. 2022].

Paterson, M. (2005). 'Affecting Touch: Towards a Felt Phenomenology of Therapeutic Touch' in J. Davidson, L. Bondi, M. Smith (eds), *Emotional Geographies*. Aldershot: Ashgate, pp. 161–76.

Pavis, P. (2016). *The Routledge Dictionary of Performance and Contemporary Theatre*. Oxon: Routledge.

Pearson, M. (2006). *'In Comes I': Performance, Memory and Landscape*. Exeter: University of Exeter Press.

Pearson, M., Shanks, M. (2001). *Theatre/Archaeology: Disciplinary Dialogues*. Oxon: Routledge.

Pegg, B. (1981). *Rites and Riots: Folk Customs of Britain and Europe*. Poole: Blandford Press.

Pelias, R (2014). *Performance: An Alphabet of Performative Writing. Oxon*: Routledge.

Penfold, D. (1907). *The Turtle Dove* (RVW2/1/253). London: Full English Digital Archive, Vaughan Williams Memorial Library. [Electronic Manuscript].

Penfold-Brown, C. (2017). Email to Elizabeth Bennett, 1st July.
Person, M (2000) in Adrian Heathfield (ed.) *Small Acts: Performance, the Millennium and the Marking of Time* (London: Black Dog Publishing).
Phelan, P. (1993). *: The Politics of Performance.* London: Routledge.
Pink, S. (2007). *Doing Visual Ethnography.* London: Sage.
Pink, S. (2009). *Doing Sensory Ethnography.* London: Sage.
Pink, S. (2015). *Doing Sensory Ethnography*, 2nd edn. London: Sage.
Pink, S., Mackley, K. (2012). 'Video and a Sense of the Invisible: Approaching Domestic Energy Consumption Through the Sensory Home' in *Sociological Research Online*, vol 17, (1).
Pollock, D. (1998). 'Performing Writing' in Phelan and Lane (eds), *The Ends of Performance.* New York: New York University Press, pp. 80–95.
Pollock, D. (2007). 'The Performative "I."' in *Cultural Studies ↔ Critical Methodologies*, vol 7, (3), pp. 239–255.
Prakash, B. (2019). *Cultural Labour: Conceptualizing the 'Folk Performance' in India.* Oxford: Oxford University Press.
'Private Frederick Arthur Moseley' (2022). *Rother Valley War Memorials.* Available at: http://ww1memorials.midhurstu3a.org.uk/private-frederick-arthur-moseley/ [Accessed 8 October 2022].
Purvis, J. (1914). *The Steyning Poem.* Available at: http://steyningmuseum.org.uk/purvis.htm [Accessed 10 September 2022].
Queer Folk (2021). *About.* Available at: https://queerfolk.co.uk/ [Accessed 23 April 2023]
Rajagopalan, M. (2017). *Building Histories: The Archival and Affective Lives of Five Monuments in Modern.* Delhi, London: University of Chicago Press.
Reason, M. (2006). *Documentation, Disappearance and the Representation of Live Performance.* Basingstoke: Palgrave MacMillan.
Reyes, A. Z. (2016). *Horror Film and Affect: Towards a Corporeal Model of Viewership.* Oxon: Routledge.
'Robert Baker' (1901). *Census Returns of England and Wales, 1901.* Kew, Surrey, England: The National Archives. Available at www.ancestry.co.uk [Accessed 8 October 2022].
Rogers, J. (2015). Shirley Collins: 'When I Sing I Feel Past Generations Standing Behind Me' in *The Guardian* [Online]. Available at: http://www.theguardian.com/music/2015/may/31/shirley-collins-sing-past-generations-standing-folk-music [Accessed 4 September 2022].
Roms, H. (2013). 'Archiving Legacies: Who Cares for Performance Remains?' in Borggreen, G., Gade, R. (eds), *Performing Archives/Archives of Performance.* Copenhagen: Museum Tusculanum Press, pp. 35–52.
Rose, G. (1993). *Feminism and Geography.* Cambridge: Polity Press.
Rose, M. (2006). 'Gathering "Dreams of Presence": A Project for the Cultural Landscape' in *Environment and Planning D: Society and Space*, pp. 475–9, vol 24, (4).
Roud, S. (2017). *Folk Song in England.* London: Faber and Faber.

Roud, S. (2022). Email about Dorothy Marshall. [personal correspondence]
Rowe, J. (1912). *The Spotted Cow* (CC/1/312). London: Full English Digital Archive, Vaughan Williams Memorial Library. [Electronic Manuscript].
Rubin, I., Rubin, S. (2012). *Qualitative Interviewing: The Art of Hearing Data*. London: Sage.
Russell, J. (2014). *Peggy Angus: Designer, Teacher, Painter*. Eastbourne: Towner.
Ruzich, C. (2016). *The Land Girls of the First World War*. Available at: http://ww1centenary.oucs.ox.ac.uk/author/cruzich/ [Accessed 10 September 2022].
Scarles, C. (2010). 'Where Words Fail, Visuals Ignite. Opportunities for Visual Autoethnography' in *Tourism Research Annals of Tourism Research*, pp. 905–26, vol 37, (4).
Scarry, E. (1985). *The Body in Pain: The Making and Unmaking of the World*. Oxford: Oxford University Press.
Scarry, E. (1994). *Resisting Representation*. Oxford: Oxford University Press.
Scarry, E. (1999). 'Participle Acts: Work and the Body in Thomas Hardy' in Payne, A. (ed.), *Lie of the Land: Earth Body Material*. Southampton: John Hansard Gallery.
Schneider, R. (2001). 'Performance Remains' in *Performance Research*, pp. 100–8, vol 6, (2).
Schultz, L. L. (2013). 'The Archive Is Here and Now: Reframing Political Events as Theatre' in Borggreen, G., Gade, R. (eds), *Performing Archives/Archives of Performance*. Copenhagen: Museum Tusculanum Press, pp. 199–220.
Scott, C. (2017). *Holding the Home Front: The Women's Land Army in the First World War*. Barnsley: Pen and Sword.
Searle, J. (1901). *The Servant Man* (LEB/2/34/1). London: Full English Digital Archive, Vaughan Williams Memorial Library. [Electronic Manuscript].
Searle, J. (1901). *The Silvery Tide* (LEB/2/31). London: Full English Digital Archive, Vaughan Williams Memorial Library. [Electronic Manuscript].
Searle, W. (1901). *The Old or Rich Merchant* (LEB/2/29/8). London: Full English Digital Archive, Vaughan Williams Memorial Library. [Electronic Manuscript].
Searle, W. (1901). *The Old or Rich Merchant* (LEB/2/32). London: Full English Digital Archive, Vaughan Williams Memorial Library. [Electronic Manuscript]
Searle, W. (1901). *The Servant Man* (LEB/22/3). London: Full English Digital Archive, Vaughan Williams Memorial Library. [Electronic Manuscript]
Sedgwick Kosofsky, E. (2003). *Touching Feeling: Affect, Pedagogy, Performativity*. Durham, NC: Duke University Press.
Sedley, S. (1967). *The Seeds of Love*. Essex: Essex Music Limited.
Seremetakis, N. (1994). *The Senses Still: Perception and Memory as Material Culture in Modernity*. Chicago, IL: University of Chicago Press.
Sharp, C. (1907). 'Folk-Song Collecting' in *The Musical Times*, pp. 16–18, vol 48, (767).
Shaughnessey, N. (2012). *Applying Performance: Live Art, Socially Engaged Theatre and Affective Practice*. Basingstoke: Palgrave Macmillan.
Silverman, D. (2013). *Doing Qualitative Research*. London: Sage.

Simpson, J. (1969). 'Legends of Chanctonbury Ring' in *Folklore*, pp. 122–31, vol 80, (2).
Simpson, J. (2009). *The Folklore of Sussex*. Derby: The History Press.
Skinner, C. (2015). Interviewer: Elizabeth Bennett. Coldwaltham, Sussex. 24th April.
Smith, B. (1988). *Jane Hicks Gentry: A Singer Among Singers*. Kentucky: University of Kentucky Press.
Smith, C. (1786). *Elegaic Sonnets*. London: J. Dodsley, H. Gardner, and J. Bew. [Online Manuscript].
Smith, S. (1952). *Sweet William*. (S191864). London: Full English Digital Archive, Vaughan Williams Memorial Library. [Sound Recording].
Smyth, L. (2015). Email to Elizabeth Bennett, 1st June.
Speedy, J. (2015). *Staring at the Park: A Poetic Autoethnographic Enquiry*. Oxon: Routledge.
Spiers (2014). *Singleton Sussex*, First Woman's Institute Meeting. BBC 4 Woman's Hour. 11th February. [Radio].
Spong, L. (2017). Email to Elizabeth Bennett, 17th September.
Spooner, S. (1911). *Green Bushes* (CC/1/116). London: Full English Digital Archive, Vaughan Williams Memorial Library. [Electronic Manuscript].
Springgay, S. (2012). *Mothering a Bodied Curriculum: Emplacement, Desire, Affect*. Toronto: University of Toronto.
Spry, T. (2001). 'Performing Autoethnography: An Embodied Methodological Praxis' in *Qualitative Inquiry*, pp. 706–32, vol 7(6).
Spry, T. (2013). 'Performative Autoethnography: Critical Embodiments and Possibilities' in Denzin, N. K., Lincoln, Y. S. (eds), *Collecting and Interpreting Qualitative Materials*. Thousand Oaks, CA: Sage, pp. 213–44.
Steedman, C. (2001). *Dust: The Archive and Cultural History*. Manchester: Manchester University Press.
Stemp, Mrs (1912). *Unquiet Grave* (CC/1/83). London: Full English Digital Archive, Vaughan Williams Memorial Library. [Electronic Manuscript].
Stemp, Mr & Mrs (1912). *Green Bushes* (CC/1/86). London: Full English Digital Archive, Vaughan Williams Memorial Library. [Electronic Manuscript].
Stewart, K. (2007). *Ordinary Affects*. Durham, NC: Duke University Press.
Stewart, K. (2010) 'Afterword: Worlding Refrains' in Gregg, M., Seigworth, G. J. (eds), *The Affect Theory Reader*. Durham, NC: Duke University Press, pp. 339–225.
Stewart, K. (2016). 'Preface' in Campbell, N. and Berberich, C. (eds), *Affective Landscapes in Literature, Art and Everyday Life Memory, Place and the Senses*. Oxon: Routledge.
Stoler, A. L (2009). *Along the Archival Grain: Epistemic Anxieties and Colonial Common Sense*. Princeton: Princeton University Press.
Stradling, R. (2015). *George Townshend*. Mustrad.org.uk. Available at: http://www.mustrad.org.uk/articles/townshen.htm [Accessed 4 September 2022].
Stringer, R. (2016). 'Reflections from the Field: Trigger Warnings in University Teaching' in *Women's Studies Journal*, pp. 62–6, vol 30, (2).

Sussex Wildlife Trust (2022). 'Wood Mill: Home of the Turtle Dove'. Available at: https://sussexwildlifetrust.org.uk/news/woods-mill-home-of-the-turtle-dove#:~:text=The%20Turtle%20Dove%20has%20the,just%20over%202000%20pairs%20left.&text=This%20is%20a%20tragic%20situation,challenges%20facing%20the%20Turtle%20Dove. [Accessed 10 July 2023].

Taylor, D. (2003). *The Archive and the Repertoire: Performing Cultural Memory in the Americas*. Durham, NC and London: Duke University Press.

'The Forge, Rodmell' (2022). *East Sussex Records Office*. Available at: https://discovery.nationalarchives.gov.uk/details/r/af19d2f4-5f8e-49bb-b194-6b13bc5cfcfe [Accessed 8 October 2022].

The Landswoman (1918). *The Journal of the Land Army and the Women's Institutes*. vol 1, (2). London: W. H. Smith and Son.

Thomaidis, K., Magnat, V. (2017). 'Voicing Belonging: Traditional Singing in a Globalized World' in *The Journal of Interdisciplinary Voice Studies*, pp. 97–102, vol 2, (2).

'Thomas Bulbeck' (1901). *Census Returns of England and Wales, 1901*. Kew, Surrey, England: The National Archives. Available at www.ancestry.co.uk [Accessed 8 October 2022].

Thompson, F. (2009). *Lark Rise*. Oxford: Oxford University Press.

Thompson, J. (2009). *Performance Affects: Applied Theatre and the End of Effect*. Basingstoke: Palgrave Macmillan.

Thrift, N. (1996). *Spatial Formations*. London: Sage.

Thrift, N. (1997). 'The Still Point: Resistance, Expressiveness Embodiment and Dance' in Pile, S. and Keith, M. (eds), *Geographies of Resistance*. London: Routledge, pp. 124 – 151.

Thrift, N. (2008). *Non-representational Theories: Space, Politics, Affect*. Basingstoke: Palgrave.

Thrift, N., Dewsbury, J.-D. (2002). 'Dead Geographies – And How to Make them Live' in *Environment and Planning D: Society and Space*, pp. 411–32, vol 18.

Tilson, G. (1912). *How Cold the Wind* (CC/1/217). London: Full English Digital Archive, Vaughan Williams Memorial Library. [Electronic Manuscript].

Tolia-Kelly, Divya P (2006). 'Affect: An Ethnocentric Encounter? Exploring the "Universalist" Imperative of Emotional/Affectual Geographies', in Area, vol 38 (2), pp. 213–17.

Trezise, B. (2014). *Performing Feeling in Cultures of Memory*. Basingstoke: Palgrave Macmillan.

Truss, L. (2008). *A Dictionary of the Sussex Dialect*. Alfriston: Snake River Press.

Twinch, C. (1990). *Women on the Land: Their Story During Two World Wars*. Cambridge: Lutterworth Press.

UNESCO (2002). *Intangible Cultural Heritage*. Available at: https://www.unesco.org/archives/multimedia/subject/13/intangible+heritage [Accessed 9 July 2023].

Unravelled.org.uk (2015). *Unravelled Press Releases* [Website]. Available at: http://www.unravelled.org.uk/press-releases.html [Accessed 4 September 2015].

Val, D. De (2011). *In Search of Song: The Life and Times of Lucy Broadwood*. Burlington: Ashgate.

Viney, Mr (1919). *The Cruel Father and Affectionate Lovers* (CC/1/329). London: Full English Digital Archive, Vaughan Williams Memorial Library. [Electronic Manuscript].

Walkerdine, V. (2010). 'Communal Beingness and Affect: An Exploration of Trauma in an Ex-Industrial Community' in *Body and Society*, pp. 91–116, vol 16, (1).

Waring, P. (1978). *A Dictionary of Omens and Superstitions*. London: Souvenir Press.

Warner, M (2014). *Once Upon a Time: A Short History of the Fairy Tale*. Oxford: Oxford University Press.

Watkins, M. (2010). 'Desiring Recognition, Accumulating Affect' in Gregg, M. and Seigworth, G. J. (eds), *The Affect Theory Reader*. Durham, NC: Duke University Press, pp. 269–85.

Waterton, E., Howard, P., Thompson, I., & Atha, M. (Eds). (2013). *The Routledge Companion to Landscape Studies*. Oxon: Routledge.

Wenger, E. (1998). *Communities of Practice: Learning, Meaning, and Identity*. Cambridge: Cambridge University Press.

Welton, M (2012). Feeling Theatre. Basingstoke: Palgrave MacMillan.

Wetherell, M. (2012). *Affect and Emotion: A New Social Science Understanding*. London: Sage.

Wetherell, M. (2012). *Affect and Emotion: A New Social Science Understanding*. London: Sage.

Willet, S. (1890). *A Word on Sussex* (LEB/2/70). London: Full English Digital Archive, Vaughan Williams Memorial Library. [Electronic Manuscript].

Willet, S. (1891). *A-Maying* (LEB/2/85). London: Full English Digital Archive, Vaughan Williams Memorial Library. [Electronic Manuscript].

Williams, J. (2022). *England's Folk Revival and the Problem of Identity in Traditional Music*. Oxon: Routledge.

Williams, M. A. (2013). *Telling the Bees: A Collection of Poems with a Critical Preface*. Doctoral thesis (PhD), University of Sussex.

Winter, T., Keegan-Phipps, S. (2013). *Performing Englishness: Identity and Politics in a Contemporary Folk Resurgence*. Manchester: Manchester University Press.

Wylie, J. (2005). 'A Single Day's Walking: Narrating Self and Landscape on the South West Coast Path' in *Transactions of the Institute of British Geographers*, pp. 234–47, vol 30, (2).

Wylie, J. (2007). *Landscape: Key Ideas in Geography*. Oxon: Routledge.

Acknowledgements

Academic research is by its nature collaborative, and this project has had input from many individuals. This is my attempt to acknowledge them. However, inevitably I will miss someone out, for which I ask forgiveness, and give thanks to whomever they are.

To begin with I would like to thank the team at Bloomsbury Academic Sound and Music Series, particularly the editorial team of Leah Babb-Rosenfeld and Rachel Moore for their care, time, and faith in this book. I would also like to thank my peer reviewers at various stages of the manuscript for their attention and generosity.

For photo permissions, my sincere thanks to Jon Dudley, The English Folk Dance and Song Society, Imperial War Museum, Surrey History Centre, Worthing Museum, Gravel Roots, Moira Faulkner, Helen Bradley, James Dixon, Sue Knight, and Richard and Liz Bennett.

To the team at the Vaughan Williams Library, and everyone involved in the Full English Digital Archive, without your expertise, hard work, and skill with the archive, none of this would have been possible. Particular thanks to Nick Wall, for his patience, good humour, and assistance. Thanks also to the Sussex Traditions Team (particularly Steve Roud, Laura Hockenhull, and Anita and Mark Broad), University of Sussex (Dr Margaret Jolly), and Cecil Sharp House (Laura Smyth), who helped make the Women in the Folk conference happen. Steve Roud has also been a great help at various other stages of this project – thank you.

I have been lucky to have some brilliant academic mentors, including Prof Helen Nicholson (my PhD supervisor), Prof George McKay, and Dr Annecy Lax; thank you for everything that you have done to bring this work to print. I have also been lucky to have wonderful support from my colleagues at the University of Essex, with special thanks to Dr Nora Williams, Dr Sarah Smyth, Prof Liz Kuti, Prof Katherine Cockin, Dr Daniela Wachsening, and Dr Liam Jarvis for their input and encouragement. Thanks also to Dr Lavinia Brydon for being my amazing research mentor and guiding me through this process,

and Dr Nancy Stevenson for her incredible writing retreat, which got me across the line.

I am fortunate to have brilliant friends who make everything better, including the Brighton OGs, Diva Cats, PhD Buddies, the Lewes Lot, and the Essex Girls (you know who you are). To my brilliant family, close and extended, for everything they do/have done for me and this book and all their support (practical, emotional, and financial), with special mentions for my mum Catherine, my dad Peter, my sister Sarah, and my stepdad Tony. I have also been lucky to be cared for by a menagerie of animals during my research, including Tufty the Wonder Dog, Mr Budge, and our current scruffs, Lyra and Britta. Enormous thanks go to my partner Dr Philip Hughes, for his careful proofreading and suggestions, and for being my favourite person to talk to about this book (and everything else).

Finally, to my wonderful conversational partners for trusting me to take care of their stories and songs, and to everyone who walked, talked, and sang with me – thank you, thank you, thank you.

Index

affect 15–17, 19–20, 23–31, 33–5, 37–8, 46, 53, 59–60, 63–5, 67, 74–7, 81–2, 87–8, 100, 104, 115–16, 133, 145, 151, 154–5, 178–80, 202, 205, 224–9, 231–9, 241–4
affective 1, 7, 8, 15–32, 35, 37–40, 43–4, 46–8, 51–2, 54, 58–9, 62–4, 69–70, 76, 78–80, 88, 92, 101, 104, 112, 116, 128, 134, 136, 140–1, 145, 156, 160, 162–3, 171–2, 179–81, 187, 198, 203, 213, 221, 223, 226–31, 238–42, 245–7
Affect theory 15, 23, 27, 31, 34, 132
Alfriston 118, 196, 198, 202, 205
Amberley 114, 133, 136, 141, 145
Angus, Peggy 206, 211
archival 1–4, 10–11, 14, 16, 19, 33, 35, 41, 47–50, 53–4, 57–8, 60–5, 67–8, 72–4, 76, 78, 81, 83, 94, 96, 157, 179, 209, 212, 225–7, 230, 247
archive 1, 4, 7, 14, 23–6, 28, 29, 31, 33, 35, 49, 51, 53–76, 87, 89, 94, 100, 112, 121, 134, 140, 157, 181, 185, 190, 199, 209, 212, 216, 218–19, 221, 224–7, 229–31, 238–41, 244, 247
atmosphere 25, 29, 30, 51, 99, 107, 151–2, 156, 194–5
autoethnography 1, 10, 15, 16, 20, 32–8, 41–4, 52, 62, 71, 79, 80, 234
 autoethnographers 33, 35, 37, 41–2, 79, 228
 autoethnographic 33, 35, 38–9, 41–2, 87
autotopography 41–2, 191

Baker, Robert 192
Belloc, Hilaire 81, 82, 107, 188, 192–3
Bennett, Catherine 174–7, 197
Bennett, Peter 166–71, 173, 197

Bennett, Richard 166–71, 173
Bepton 98, 100, 101
Blann, Michael 173–4
Brighton 5, 6, 114, 133, 165
Broadwood, John 2, 136
Broadwood, Lucy 2, 134, 136, 139, 141, 142, 146, 180, 209, 215
Brown, Jimmy 190, 247
Bubbling Tom 65–72
Butcher, Ben 152
Butcher, George 152

care 16, 19–29, 40–1, 57–9, 63–8, 73–6, 94, 107–8, 137, 157–8, 212–13, 215–16, 225, 226, 229, 237–8, 247
Carey, Clive 94, 101–2, 117, 124, 136, 198, 212–19, 227
Carthy, Eliza 1, 176
Chanctonbury Ring 95, 149–63, 184
Chichester 114, 125–9
childhood 88, 100, 164–87
Chithurst 50, 94, 101, 213–30
class 2–11, 34–5, 50, 60, 74, 94, 136–9, 170, 215–16, 225, 233
Claudel, Camille 115
Cocking 89, 105–7, 114–18, 152
Coldwaltham 141
collectors 2–5, 11–18, 25, 50, 60–74, 84, 94–6, 122, 136–9, 153, 212
Collins, Shirley 64, 70–1
Copper, Bob 5, 107, 117, 152, 188, 193
Coppers, The 142, 185, 188
Corpse Paths 104, 112
cultural heritage 4, 8, 245
Cunningham, Maria 160

Didling 99
disability 10–12, 24, 170, 246
diversity 1, 6–15, 41, 245–6
Duke, Will 198–202
Duncton 129–32

Index

Eastbourne 188, 198, 204, 206
Elsted 98–102
embodiment 28–34, 44–6, 62, 72, 199
emotion 1, 15–16, 18–20, 23–37, 44,
 50–8, 60–75, 79, 81, 87, 95, 113,
 137, 155, 176, 178, 182, 198,
 221, 228, 234, 237, 247
endometriosis 11, 162, 223, 237
England 2–20, 31
English 1–18, 29, 65, 89, 109, 136,
 153, 246
English Folk Dance and Song Society 1,
 4, 10, 12, 117, 246
Englishness 1–8, 109

Farjeon, Eleanor 106, 202, 211
feeling 16, 20–30, 33, 44, 51, 75, 87, 94, 99,
 104–5, 116, 144–5, 158, 162–3,
 166, 198, 226, 234, 237–9, 244
feminism 8–10, 24–7, 35, 79, 140, 246–7
Firle Beacon 164, 192, 203–4
First Folk Song Revival 2, 3, 5, 11, 13,
 25, 74, 137, 212, 215, 233, 247
folk clubs 2, 7–11, 14, 16, 37, 42, 48, 160,
 172, 210
folklore 66, 88, 107, 132, 151, 155–6
folk Music 1–15, 24, 43, 105–6, 138–9,
 141, 184, 191, 214, 244, 246
footpaths 43, 47, 87–113, 121, 134,
 165, 171
Fosbury, George 152
Full English Digital Archive 1–6, 18, 23,
 101, 107, 146

Gardiner, George 96, 107
gender 7–10, 30, 35, 44, 137–9, 170, 233
Gilchrist, Anne Geddes 96
Glynde 200–9
Goddard, Sandra 82, 181–4
Goodyear, Valmai 209
grief 33, 113, 115, 176, 179, 202, 242
Guyer, J. F. 96, 107

Ha'nacker Mill 82, 83
Hampshire 89, 152, 230
Heyshott 97, 116–25, 209
Hicks Gentry, Jane 215
Higgins, Suzanne 82, 205
Humphrey, Harvey 157

Humphrey, Sarah 157–8, 247
Hutt, Francis (Frank) 93–5

identity 1–15, 25, 35–7, 108, 179, 191,
 213, 244
imagination 48, 50, 67, 76, 78, 124,
 143–4, 151–6, 164, 170, 178,
 196, 228, 247
imagine 19, 45–7, 66, 71, 121–4, 136–7,
 142–4, 168, 178, 198, 230
 imagined 44, 58, 69, 143, 196, 205, 238
 reimagine 13, 25, 141, 155, 158–62
Imagined Village 6, 11
inclusive 7, 10–13, 142, 244–6
 inclusivity 7–8, 13, 245–6
Intangible Cultural Heritage 13–14, 31,
 57, 61, 87, 202, 243–6
intersectionality 8–10, 35, 79, 170

Jevington 188, 202, 206
Juggs Way 121

Kennedy, Peter 142, 195

landscape 7, 15–20, 23–4, 29, 31, 36,
 40–52, 67–71, 76–8, 80–2, 87–8,
 99, 105, 134, 141–5, 151–5,
 164–6, 170–1, 176, 179–81, 187,
 192–3, 219–21, 225–7, 239, 245
landscape writing 1, 15–17, 20, 33–4,
 78–80, 224, 239
landscaping 17–20, 29–30, 41–8, 52–4,
 64, 68, 77–83, 108, 112, 136,
 180, 224–30, 240–3
Lee, Kate 85
Lewes 5, 121, 192, 200, 206–8
Lewis, Bob 82, 89, 117–18, 122–4
Lewis, Dorothy 130–1, 199
life-writing 1, 19–20, 33–4, 80, 223–35
loss 33, 37–40, 60, 82, 87, 114, 141,
 202, 238

Macauley, Rose 126–7
Marshall, Dorothy 14, 19, 43, 49–50, 74,
 92–4, 101–2, 117, 124, 129–31,
 157, 190, 198, 209, 212–35, 247
Maynard, George 200–1
Midhurst 91, 96, 106, 114, 117–18,
 122, 218

Milkmaids 112–14
Moore 214–20
Moseley, Betsy 54, 101–3, 146–50, 198

Neal, Mary 146
Neuritis 213–31
Newtimber Hill 164, 179–80
Non-representational Theory 78, 99, 226
nostalgia 40, 82

Oliver, Charlotte 82, 188–9

pain 4, 11, 32, 73, 212–13, 220–3, 230–8, 247
Parrot, George 190
Penfold, Alice 96
Penfold-Brown, Chris 97, 196
performance studies 1, 7, 15–16, 20, 23, 27–9, 31, 53, 58, 246
performative 10, 17, 20, 29, 41, 44, 51, 64, 68–70, 82, 87, 91–3, 97
performative writing 71, 72, 76
phonograph 68, 117, 157, 215, 219, 231
Poynings 173
Public Archaeology 88, 145, 245
Pulborough 155

queer 12, 16, 20, 24, 159, 246

racism 7
repertoire 14–19, 23, 31, 53, 57–61, 68, 87, 108, 118, 137–8, 152, 173, 185, 207, 231, 243–4
Rodmell 181, 184, 188–9, 192
Rowe, John 129–31

Saddlescombe 179–81
Searle, John 136, 146–9
Searle, Walter 136
Second Folk Song Revival 2, 5, 25
sensory 1, 15–18, 28, 31–54, 59–81, 129–37, 145, 153–6, 178–9, 193, 196, 226–9, 239
sensory ethnography 1, 15–16, 32–52, 61, 76, 80, 131, 226, 239
sexuality 9, 35, 157, 173, 174, 185, 189, 192

Sharp, Cecil 3–6, 25, 89, 120–2, 140, 215–18
sheep 99–100, 106, 123, 134, 157, 173, 200, 204–5, 210
shepherd 99, 123, 155–8, 173–4, 181, 200–6
shepherdess 82, 188–91
Skinner, Chris 29, 141–5, 160
Smith, Charlotte 114–15, 221, 247
Smith, Shelia 195
South Downs 16–17, 36, 71, 88, 105, 114, 129, 155, 192–3, 200
South Downs Way 1, 17, 30–1, 43, 64, 67, 74, 87–9, 129, 141, 155, 163, 187, 211, 230, 235, 240
Southease 181–92
South Harting 89–94
Spooner, Stephen 116–17, 218
Sullington 157
Surrey 50, 134, 138
Sussex Dialect 18, 76, 131, 143, 146, 172

Third Folk Song Resurgence 1–15
Thomas, Edward 87, 134, 202
Townshend, George 147, 181
travellers 96–7, 171, 195
Treyford 96–8, 101–6, 146

United Nations Educational, Scientific and Cultural Organisation (UNESCO) 13–14, 31, 243–4
Upper Beeding 141, 172

Vaughan Williams, Ralph 105, 147, 189, 192, 212, 225
Vaughan Williams Memorial Library 4, 23, 43, 89, 140, 157, 212
Viney, Mr 134–6, 218

Walking Artists 15, 39–43, 65–7
Walking Interview 36, 46, 79
Wassailing 49, 131–2
Whiteness 6–11
Willet, Samuel 180–1, 209
Women's Forestry Corps 125–8
Women's Land Army 125–8
Woodcraft Folk 171, 179
worthing 108, 136, 173–4

Printed in the USA
CPSIA information can be obtained
at www.ICGtesting.com
LVHW022136130524
779921LV00003B/235